Ancient Muses

Ancient Muses
Archaeology and the Arts

Edited by
JOHN H. JAMESON, JR., JOHN E. EHRENHARD,
AND CHRISTINE A. FINN

THE UNIVERSITY OF ALABAMA PRESS
Tuscaloosa and London

Typeface: ACaslon

∞

The paper on which this book is printed meets the minimum requirements of American
National Standard for Information Science–Permanence of Paper for Printed Library
Materials, ANSI Z39.48-1984.

Library of Congress Cataloging-in-Publication Data

Ancient muses : archaeology and the arts / edited by John H. Jameson, Jr., John E. Ehrenhard,
and Christine A. Finn.
 p. cm.
Includes bibliographical references and index.
 ISBN 0-8173-1273-0 (alk. paper) — ISBN 0-8173-1274-9 (pbk. : alk. paper)
 1. Archaeology—Methodology. 2. Archaeology—Social aspects. 3. Archaeology—Philosophy.
4. Art and archaeology. 5. Arts and society. 6. Public art. 7. Public history. I. Jameson, John H.
II. Ehrenhard, John E. III. Finn, Christine, 1959–
 CC75.7 .A53 2003
 930.1—dc21

2002015040

British Library Cataloguing-in-Publication Data available

Contents

CONTENTS OF ACCOMPANYING COMPACT DISC

1. Images and clips from the stage production of the opera *Zabette*
 John E. Ehrenhard and Mary R. Bullard (See also book chapter 3)

2. Interpretive art paintings and sketches, color image scans
 Martin Pate (See also book chapter 4)

3. Examples of archaeological interpretive art images and educational posters, color image scans
 *Martin Pate, John E. Ehrenhard, and John H. Jameson, Jr.
 (See also book chapters 4, 5, and 6)*

4. Popular histories and other online volumes of the Southeast Archeological Center, National Park Service
 *Martin Pate, John E. Ehrenhard, and John H. Jameson, Jr.
 (See also book chapters 4, 5, and 6)*

5. Color photos of public art sculptures
 David Middlebrook (See also book chapter 8)

6. Book covers and comments on *Spirit Bird Journey* and *National Treasure,* published by RKLOG Press
 Sarah M. Nelson (See also book chapter 16)

7. Video: *Is Archaeology Fiction? Some Thoughts about Experimental Ways of Communicating Archaeological Processes to the "External World"*
 Nicola Laneri (See also book chapter 18)

8. Multimedia hypertext: Sample reading of *Crafting Cosmos: The Production of Social Memory in Everyday Life among the Ancient Maya*
 Jeanne Lopiparo (See also book chapter 19)

Figures

Plates

Ancient Muses

Introduction
Archaeology as Inspiration— Invoking the Ancient Muses

John H. Jameson, Jr., John E. Ehrenhard, and Christine A. Finn

. . . may our hands immortalize the day
When life was sweet, and save from utter death
The sacred past that should not pass away.
—George Santayana, from the poem "The Power of Art," 1894

Only imagination fleshes out the sound and taste of time past,
anchoring the flavor of lost moments in the welter of objects left behind.
—Carmel Schrire, in *Digging through Darkness: Chronicles of an Archaeologist*, 1995, p. 11

As a subdiscipline of anthropology, and as an indispensable tool in the construction, elaboration, and interpretation of history, archaeology uses material culture and vestiges of the past, such as artifacts and historical accounts, to refine, expand, and update our knowledge of the history of humankind. Archaeological methods are used in scientific investigations of past human behavior to produce more accurate historical accounts and interpretations, helping us to understand the relevance and importance of the present as well as the past. The last 50 years have brought an increasing number of archaeologists who have entered the public archaeology arena. Some have recognized the importance of direct involvement by archaeologists in developing effective public interpretation programs (Jameson 1997; South 1997). Since the 1990s, the emergence of educational archaeology has helped focus the public eye on the importance and relevance of archaeology in preserving and protecting multicultural values for diverse audiences (Jameson 2000, 2003). In the National Park Service and elsewhere, archaeologists, interpreters, and educators are collaborating to interpret archaeology more effectively. They are using their knowledge and skills to create opportunities for the public to form intel-

lectual and inspirational connections to the meanings and significance of the archaeological materials and the peoples who created them (National Park Service 2000).

In ancient Greek mythology, the original Mother Goddess, or Muse, was regarded as the provenance of all forms of inspiration. Later mythological elaboration produced a threefold goddess and eventually nine sister goddesses who presided over song and poetry as well as the arts and sciences. To the Greeks, the Muses were catalysts for all forms of human inspiration. The Greek philosopher Herodotus, known as the father of history as well as the father of anthropology, used stories that he heard from his travels, along with his own observations, to write a history of mankind. Entitled *Clio* by the Romans after their name for the Muse of History, we know it today as the *Histories.* Herodotus's accounts use historical narrative as both a structuring principle and a means of historical explanation of why things happened. His accounts were ethnographical in that they described and compared many of the foreign or "barbarian" customs and lifeways.

In the tradition of the ancient Muses, modern archaeology also serves as a catalyst for human inspiration. The practice of archaeology, and the concomitant archaeologically derived information and objects, can inspire a wide variety of artistic expressions ranging from straightforward computer-generated reconstructions and traditional artists' conceptions to other art forms such as poetry, opera, and storytelling. Although some level of conjecture will always be present in these works, they are often no more suppositious than technical interpretations and have the benefit of providing visual and conceptual imagery that can communicate contexts and settings in compelling and unique ways. These connections broaden the significance and relevance of archaeology for scholars as well as the general public.

The cognitive connections between archaeology and art reflect an inductive approach in defining and explaining archaeologically derived information and making it meaningful to the public. An emphasis on using artistic expression in interpretations is consistent with a new direction in archaeological practice that challenges the positivist paradigm of processual archaeology and promotes the relevance and validity of inductive reasoning over deductive reasoning. This new philosophical framework represents a fundamental change in how archaeologists plan and conduct research and evaluate significance. These approaches are important for archaeological practice in that they can provide testable observations and hypotheses using conventional modes of archaeological research (see chapters 1 and 2 in this volume).

We invite you to explore the essays in this book as they describe a variety of examples of this new approach as it applies to more meaningful and effec-

tive approaches to interpretation that emphasize public awareness, access, and inspiration.

John P. McCarthy and James G. Gibb articulate our philosophical underpinnings by explaining the importance of the development of interpretive narrative archaeology and interpretive historical fiction that employ the imaginative uses of storytelling and drama in making the past come alive for public audiences. Lance M. Foster explains how archaeology can reveal the artworks of the ancestors to new expression and vitality among contemporary Native American societies. Claire Smith and Kirsten Brett describe how Aboriginal people in Australia use visual arts to establish and maintain connections with the world around them. Beyond mere indicators of cultural interaction (Hyder 1997; Morwood and Smith 1996), rock art images are used to convey social and cultural information and provide visual cues for oral histories.

In a multimedia project at two museums in New York, Nicola Laneri urges archaeologists *not* to reject the notion that it is possible to consume archaeology in the same way that people consume fast food. "Fast-food archaeology" exists, and we cannot decide to cast it aside as belonging to an undesirable "external world." Popular historical movies such as *Gladiator*, Laneri points out, should not be condemned. Instead, one should understand their value as fiction and learn how to use them and other popular media to control the process of communicating mainstream messages about history and archaeology.

Some of the essays cover topics and case studies focusing on instances where archaeology has inspired particular artistic expressions:

POETRY AND WRITING

Christine A. Finn explores the ways in which both the poet and the archaeologist "see" what is not so obvious. Both continually reinterpret inanimate objects, or "things," that they try to explain or enable to "speak" to us about their meanings. Sharyn Kane and Richard Keeton share their experiences in meeting the challenge of breathing life into the findings of technically oriented archaeological reports. Sarah M. Nelson makes a case that novels written by professional archaeologists are the most authentic, no matter how good the research team of the non-archaeologist is, and that historical authenticity is enhanced by the experiences of the archaeologist/writer. David G. Anderson draws analogies between the subject matter and goals of archaeology and science fiction and mystery writing and explores why many archaeologists spend time reading such works. In her piece on the 1996 film *The English Patient*, Christine Finn looks at the translation of a "too perfect" novel into film and the process of transformation of text and image over time.

OIL PAINTING AND SCULPTURE

Artist Martin Pate was tasked by the National Park Service to produce inter-
pretive artworks that help tell the stories derived from the archaeological rec-
ord. "In the Sara's Ridge painting," he writes, "it was my hope that the viewer
would be not only an observer of the scene but a participant as well." David
Middlebrook relates how he has been inspired by his exposure to archaeology
and cultural history in creating public sculpture. He describes his public sculp-
tures, inspired by the Lascaux cave paintings, as "a celebration of humankind's
endless quest to understand this world and the mysteries of life."

MUSIC AND OPERA

John E. Ehrenhard and Mary R. Bullard tell an intriguing tale about how
the collaboration of an archaeologist and a historian on Cumberland Island,
Georgia, resulted in the creation of an original libretto and eventually a full
production opera. Citing examples from her research on the context of per-
formance of music and dance in the American Southwest, Emily Donald ex-
plains how some aspects of a society's ideology can be materialized, leaving
observable traces in the archaeological record. David G. Orr explains how the
discovery of Pompeii had an immense impact upon European cultural history
in the eighteenth century, inspiring and influencing the creation of music, op-
era, literature, and painting in profound ways well into the twentieth century.
 Other essays, such as those by Harold Mytum and John H. Jameson, Jr.,
provide examples of the use of commissioned interpretive art as public inter-
pretation and educational devices. Michael J. Williams and Margaret A.
Heath explore the boundaries between what is archaeological and what is ar-
tistic and how these attributes are recognized and blended for presentation to
diverse audiences in a museum setting. Jeanne Lopiparo and Rosemary A.
Joyce give an excellent example of creating understanding through the experi-
ence of navigating hypertext.
 In her chapter on the connections and analogies to archaeology in the mak-
ing of *The English Patient,* Christine Finn comments that the original novel
"had as its narrative spine the classical gaze of Herodotus. . . . Herodotus left
important textual evidence for consideration alongside the archaeological
data." Harrison (1998) has observed that references to Herodotus provide the
thread that ties together the events in the film. Both the book and the screen-
play, like Herodotus's *Histories,* use historical narrative as both a structuring
device and a didactic device in explaining the context and in developing the
sequence of events and human relationships.

In the classical tradition of Herodotus, we must summon the ancient Muses to provide inspiration from archaeology and material culture and, working with our public interpretation, education, and artisan colleagues, create inspirational and emotional connections that will enhance the public's appreciation of archaeology.

We, the contributors to this book, do not take for granted the fact that we live and work in prosperous and free societies that allow us to be educated and make a living in archaeological and artistic pursuits. Recognizing these intellectual privileges, we should challenge ourselves, on behalf of those colleagues less advantaged, to carry and instill the knowledge, inspiration, and excitement about the past that archaeology offers to every public audience we can reach.

The materials in this book and on the accompanying CD-ROM stem from a symposium organized and chaired by John H. Jameson, Jr., John E. Ehrenhard, and Christine A. Finn for the annual conference of the Society for American Archaeology, New Orleans, Louisiana, in April 2001.

Why We Were Drawn to This Topic

from the Contributors

DAVID G. ANDERSON: I am an archaeologist at the Southeast Archeological Center of the National Park Service in Tallahassee, Florida. I enjoy technical writing, and I have produced over 200 technical papers and monographs on prehistoric and historic archaeology in various parts of North America and the Caribbean, as well as several published books on local archaeology. I also enjoy reading and collecting science fiction and mystery novels, meeting and talking with authors at book signings, and listening to a wide range of music. I and my wife of 20 years, Jenalee, live in a small town in rural South Carolina, where we have restored a plantation house and barn that now houses several cats and dogs, thousands of books, and extensive quantities of home-brewed beer and aging mead. I also enjoy writing poetry ("If writing poetry would pay my way . . . then write I would for many a day") but as of now have made little effort to inflict these efforts on others.

KIRSTEN BRETT: As an archaeologist, coming from a family with a strong interest in the arts, I have been inspired to use visual art, music, and writing to capture experience. The Wugularr Aboriginal community in southern Arnhem Land, Australia, has inspired me to use the arts as a vehicle for explaining Aboriginal archaeology, rock art, and cultural heritage. The Wugularr elders, adults, and children have welcomed me and granted me the privilege of accessing their beautiful oral tradition and their incredible art and music (both traditional and contemporary), not to mention allowing me to see some awesome dancing during ceremony and the local disco (way to go kids!). My challenge has been to use these arts, which are imbued with great cultural significance, and to present them in forms that are relevant to both the local community and a wider national and international audience.

MARY R. BULLARD: I have published four major books and numerous scholarly articles on aspects of the antebellum South, especially along the Georgia coast. Of particular interest to me is the sea island known as Cumberland, where I spent my childhood. From my vast store of historical knowledge and research I recently wrote a full-length opera entitled *Zabette*. This three-act opera narrates a story of a free woman of color in nineteenth-century Georgia and is based on the historical personages of Elizabeth Bernardey (Zabette) and Robert Stafford, the most prosperous plantation owner on Cumberland Island, Georgia. The world premier of *Zabette* was performed at the Rialto Center for the Performing Arts, Atlanta, in 1999.

EMILY DONALD: My interest in music and archaeology began at an early age. I have been playing musical instruments of one kind or another since I was seven years old, and the pieces of prehistoric pottery and projectile points I found on my parents' property in northern New Mexico as a child aroused an enduring interest in the prehistoric cultures of the Southwest. As an undergraduate I double majored in both music and cultural anthropology, and I have continued the practice of mingling disciplines in my graduate research, using archaeology to look at physical and social contexts of music and ritual among prehistoric southwestern cultures.

JOHN E. EHRENHARD: I have spent the last thirty years of my professional career preparing analyses, interpreting findings, and writing reports so that other archaeologists might better understand what I was learning and thinking about. However, my rather limited approach was convincingly challenged in the 1980s when, as the result of my daughter's beginning kindergarten, I began visiting schools to talk with young children about what archaeologists do and why. In the two decades since then, I have become firmly committed to visual learning and routinely look for innovative ways to reach out to the national community and involve it in the rich diversity of the American experience. I believe that art forms such as poetry, storytelling, painting, and opera should all be recognized as legitimate venues for interpreting the past and enhancing our appreciation of humankind's incredible journey. I am excited about new public interpretation endeavors this book may inspire.

CHRISTINE A. FINN: I grew up immersed in the past, playing among the vestiges of World War II German occupation in the Channel Islands and on the beaches of England's southeast coast, at Deal, where Julius Caesar is said to have landed after crossing the Channel. I have seen childhood homes, schools, and landscapes erased and changed, and I believe that my passion for the past,

and its inspirational potential, is rooted in the sense of remembrance of such echoes and shadows: places, people, and things.

LANCE M. FOSTER: I am a monster; I profess to be both an Indian artist and an archaeologist. I have always been Indian, and I have always been an artist, from my first scrawling as a toddler. But I have not always been an archaeologist. Many of my Indian friends do not believe that I can be both. In examining the relationships between Indian art and archaeology, I believe I have found a unique personification. In my initial attempts at writing this article, I used a conventional, scholarly tact, full of quotes, bibliographic notations, using plenty of "therefores" and "thuses." But, halfway along, I realized that anyone could have written that way, given the proper research and sources, and it would have been just as dry and postmodern as you please. So I tossed that first draft into the wastebasket. I wanted to talk about art, from the gut, from my experience as both an Indian artist of the Iowa tribe and as an archaeologist.

JAMES G. GIBB: I earned a B.A. in anthropology at Stony Brook University and an M.A. and Ph.D. in anthropology at Binghamton University, both parts of the State University of New York system. Anthropology departments in both universities were unrelentingly bookish and theoretical, qualities I adored and greatly miss in my workaday setting of a sole proprietorship archaeological compliance firm. And for 25 years I have tried, often unsuccessfully, to bring the higher aims of anthropological and historical inquiry bandied about in seminars and the graduate student lounge to my surveys and studies of prehistoric and historic sites. The search for understanding, however, never struck me as quite enough. Early on, before earning my master's degree, I developed a commitment to sharing what I had learned with "the public," namely, those not a part of the academy. My principal approaches were, and continue to be, public lectures and articles published in a variety of local venues. A museum administrator complicated my life greatly one day when she asked that I turn my conventional historical writing approach to the writing of a play that interpreted, educated, and entertained. That play, a subsequent play produced by the same institution, and the ground-breaking work of Mary and Adrian Praetzellis launched me in the most unexpected, rewarding, and ineffable twists in my career as a professional archaeologist.

MARGARET A. HEATH: I have taught archaeology, anthropology, and history to students of all ages in both formal and informal settings. Museums have always provided an important teaching link to "real things" that my students were studying. Early in my career I became interested in Ancestral Pueblo

pottery and had the privilege of spending one summer doing preliminary analysis of pottery from Coyote Village and Mummy Lake in Mesa Verde National Park. As time progressed I felt I could identify pieces created by the same potters by looking at style and technique. The pottery became not just artifacts but also objects created by artists for everyday use. Thus the seeds were laid for the paper I coauthored on the conflict between art and archaeology in a museum situation. Currently I am Chief Heritage Education Project Manager for the Bureau of Land Management based out of the Anasazi Heritage Center, the museum that is the setting for my chapter.

JOHN H. JAMESON, JR.: In my 20-plus years as a public-agency archaeologist, I have always been intrigued by what appears to be a natural fascination of people to things historical and archaeological. I have wondered whether this is simply a human response to self-interest and cultural identity. Indeed, why was *I* attracted to the subjects of anthropology and archaeology to the point of trying to make a living at it? Most of my college chums became medical doctors (as is my own father) or lawyers or pursued other more "practical" and lucrative professions. I think it was the holistic approach of anthropological studies and the attempted objectivity of archaeological methods and inquiry, plus the challenging and interesting people and places associated with archaeology, that won me over. When I came to the National Park Service in 1988, I looked around and wondered why more attention was not given to helping people understand and appreciate the archaeological gems that the agency was charged to preserve and protect for posterity. For over a decade, I have been privileged to work with archaeologists, interpreters, and educators of the highest caliber in promoting the public interpretation of archaeology in the national parks and other public lands. For me, the conceptual relationships between art and archaeology provide important but too seldom recognized opportunities for stimulating public access to, appreciation for, and inspiration from archaeology and cultural history.

ROSEMARY A. JOYCE: I knew I wanted to be an archaeologist when I was seven years old, when I was given a child's edition of the *Aeneid* with a description of the "discovery" of Troy, so I know the power of non-academic representations of archaeology. As a high school student I was able to participate in a dig in western New York fostered by a local history society of Germans whose predecessors moved into the area in the nineteenth century. While consolidating my commitment to archaeology, this experience also reinforced for me that archaeology was important to a public that felt a sense of deep connection with the past. Partly due to this experience, mediated by a local museum, I decided I wanted to work in museums as an archaeologist communicating

with diverse audiences. Despite the series of accidents that has led me away from employment in museums, I still think that archaeology is compelling on a personal level to people in general, and I want to contribute to dialogue outside the discipline. My own sense of how we can connect with people through writing is further influenced by being the sibling of writers, who serve, among other things, to remind me not to speak in jargon and provide a model of how the beauty of language can move people.

SHARYN KANE AND RICHARD KEETON: We are a married team of writers who have written six books and many articles. We are also frequent lecturers about writing and have taught writing classes for all ages. We were first attracted to this topic because we wanted to go to New Orleans, hear great jazz, and eat gumbo. Apart from those reasons, sharing our ideas about art and archaeology is a favorite pastime. Archaeologists are often fascinating people who work in obscurity. We enjoy bringing them into the spotlight where a wide audience can appreciate their ideas and discoveries.

NICOLA LANERI: What is archaeology? Since the beginning of my archaeological career this question has been constantly running through my mind. I suppose archaeology is analyzing ancient objects . . . writing reports . . . reconstructing ancient landscapes . . . re-creating histories . . . yes, probably this is archaeology. But no! First of all, archaeology must give the non-academic public a chance to experience the past in the present! But how? It should be possible for us to create sensory experiences that allow the outside world to feel the past through the use of senses. This is the aim of the "Art-aeology Experience," a group of international archaeologists, anthropologists, and artists who have worked on the communication of archaeological and anthropological subjects in a sensory way through the use of all kinds of different media (video, sound, performance, etc.). Crossing boundaries between academia and the external world should be a primary goal for all archaeologists; otherwise archaeology will slowly die inside the walls of the universities, buried underneath archaeological reports.

JEANNE LOPIPARO: Ever since I first pressed my nose against a museum display case, my childhood exposure to archaeology was a series of multimedia events: the feel of the cold glass signaling something rare or important beyond my (literal and figurative) grasp, the drone of a parental voice allegedly "explaining" the diorama, "subsistence patterns . . . blah, blah . . . seasonal acorn gatherers . . . blah," but, oh, the pretty objects, the shiny sharp things, the heavy stone things—and they had a squirrel! And they didn't have to wear

shoes! Who were these people? I was hooked. Perhaps the stories my five-year-old mind wove around these representations were not compelling for the right reasons, but they certainly stimulated a set of previously unimaginable questions. Since then, I have been trained to analyze, classify, refine, distill, and monologize multisensory sources of information and inspiration into primarily single-medium master narratives—a process I have often found troublesome. Not only was the genesis of my understandings a multivocal, disorderly process—from archaeological fieldwork (the ultimate, and extremely visual, multimedia experience) to the weaving together of scholarly and nonscholarly voices and images—but the "understandings" themselves were constantly changing, contingent, contextual. In order to communicate the disorder and complexity of both the "objects"/subjects of our investigations and of our practices of producing knowledge, I have been seeking means of restoring access to and juxtaposing all of these media, of opening up monologues, and maybe even stimulating a previously unimaginable question or two.

JOHN P. MCCARTHY: As a child I was fascinated with the past, with those who had come before and the stories they would tell if they could. Much to the dismay of my parents, this fascination manifested itself in my late teens in a desire to major in anthropology and American Studies and pursue a career as an archaeologist attempting to tell the stories of past peoples from the detritus of their lives. From my earliest professional experiences, and throughout the nearly 25 years I have been privileged to be a practicing archaeologist, public interpretation and explanation have been integral to my understanding of the purposes and goals of the discipline. My chapter in this volume is purposefully self-reflexive and narrative in form. My interest in narratives is closely tied to my understanding of the role of my belief in agency, the ability of individual people and communities to act in what they perceive to be their best interests, given the constraints of what they believe to be true about the past, present, and future. Archaeological narrative can highlight agency in the past and nurture agency in the present.

DAVID MIDDLEBROOK: I believe our ability to survive the last ice age has given us our present-day intelligence. What attracted my interest were the thirty-thousand-year-old cave paintings of southern France, which I believe were the first signs of the intellectual revolution. Thus, I have incorporated these images into many of my large scale public art pieces. In recent years I have become at one with the technical and esthetic challenges of combining natural materials with intellectual and emotional content. The engineering tension and balance are part and parcel with the intent and substance of the work.

HAROLD MYTUM: I am an archaeologist who has been directing field school excavations at the Iron Age fort of Castell Henllys for 20 years. As part of the project, we have reconstructed several buildings on their original sites; they have created a certain ambience that provides a unique environment for scholars and the public. While experiencing these buildings from inside and out, I became aware of the effects of changing details such as wall texture and color and began to consider the role of visual effects both in the expectations of scholars and in their impact on visitors. The use of Celtic art on the Iron Age buildings and objects within them was the logical next step in exploring visual identities and associations. Other reconstruction sites have also used Celtic art, though in a less determined manner, and I am keen to experiment further with the use of art in reconstruction.

SARAH M. NELSON: Since I was a child I have had two ambitions: to write novels and to study ancient things. I have accomplished both goals by earning a Ph.D. at the University of Michigan in 1973, for which I wrote a dissertation on Korean Neolithic archaeology. Although the emphasis (appropriate to the time and place) was on subsistence and settlement, there were important questions of gendered social, economic, and political arrangements that seemed unanswerable. Answers continued to elude me for prehistoric Korea, so in the late 1970s I began to look at the protohistoric period, where historic documents could be used along with archaeological discoveries. I also went to China as soon as it was open to tourism because Koreans believe their ancestors came from northeast China. When I was the first foreigner taken to see the "Goddess Temple" site in Manchuria, it seemed appropriate to turn my attention there. However, Korea was not abandoned, and these two areas continue to be the twin foci of my research. The novel *Spirit Bird Journey* brought me full circle back to Neolithic Korea, where imagination and knowledge of traditional Korea, ancient China, and the Ainuin Japan helped to fill in the gaps. Readers can decide, from their own perspectives, how successful that effort was, both as a novel and as a reconstruction of the prehistoric past.

DAVID G. ORR: I have been interested in ancient Pompeii since my elementary school days. Pompeii was the first archaeological site I knew and appreciated. After attending graduate school at the University of Maryland under noted Pompeianist Dr. Wilhelmina Jashemski, I received the Prix de Rome in Classics at the American Academy in Rome. For the subsequent three decades I have been engaged in projects focusing on the material legacies of the Vesuvian region. I have just completed two Earthwatch projects that deal with this area. But Pompeii's gift to us is more than archaeology. Pompeii is a powerful force in literature, philosophy, and especially the arts. Recently it is this facet

of Pompeii's heritage that has influenced me, and I have been examining this rich assemblage of diverse source material ever since. As the oldest continually excavated archaeological site in the world, Pompeii has never lost its grip on us and has made multiple inroads on the ways in which we consider the past.

MARTIN PATE: I grew up with art all around me. Landscapes by my grand-mother hung on the walls. For a while my aunt, a painter, lived and worked in our home. My brother and I were always drawing soldiers, Indians, and super-heroes. I never seriously considered any other career. Bringing archaeological sites to life combines my love of painting and a keen interest in history while also serving as a great mechanism to teach and educate.

CLAIRE SMITH: I didn't plan to be an archaeologist, and I didn't like art when I was a kid. In fact, when we had art classes I used to beg the teacher to let me do math instead. I liked the elegance of math, the order, the balance of it all. Art, on the other hand, seemed chaotic, something that could only be mas-tered by someone with inherited skill. And it took me a long time to get to college. When I finished school my husband and I traveled for eight years, doing a range of odd jobs, living in different places, meeting all sorts of inter-esting people. Finally, when I started college, I enrolled in an economics de-gree but found I was hopeless because by that time I had forgotten how to add up and I didn't want to learn those kinds of skills anymore. I came across Australian Aboriginal prehistory as one aspect of an economic history topic, taught by an inspiring teacher, John Fisher. As I studied with John I found myself drawn to the idea of trying to work out what people did in the past. Sitting up at 2:00 one morning rewriting an essay I'd already handed in, I decided to become an archaeologist. I moved to the University of New En-gland, Armidale, Australia, where my training included a course on the ar-chaeology of art. I was amazed to find that "art" had meaning, that it wasn't chaotic but coded with social information, and that it was possible to acquire the skills to decode it. My teacher, Mike Morwood, directed me to Howard Morphy's Ph.D. thesis (published subsequently as *Ancestral Connections: Art and an Aboriginal System of Knowledge*), and I was hooked. I knew I had to study art and I knew I had to take an ethnoarchaeological approach to it so that I could work out the rules in a living system and try to apply them to the art of societies in the past. I conducted my doctoral research with Aboriginal people from the Barunga-Wugularr region of the Northern Territory, Austra-lia. I learned about the social complexity of the art and the sophistication of the social system, including the (mathematical) elegance of the kinship sys-tem. I'd found the thing that captured both my mind and my heart.

MICHAEL J. WILLIAMS: I learned to ride horseback during the 1970s among the oak hills, thatch villages, and unexcavated Mayan ruins of Chiapas state in southern Mexico. My instructor was Gertrude Duby Blom, an expatriate octogenarian Swiss firebrand for cultural and archaeological preservation (she was an unreformed Stalinist, too). Her Centro de Estudios Cientificos was my first exposure to museum work. Here I first found an emotional connection to a prehistoric culture, and to its living descendants, who kept at bay both academic theorists and the international culture of tourism. I believe that a museum is the only educational institution that specializes in using tangible objects to teach prehistory and archaeology. Images, lectures, and texts are available elsewhere, but a museum offers a direct, concrete encounter with the unknown. Concrete experiences provoke deeper emotional responses than do intellectual insights. Emotional response is the key to learning.

1 / More Than Just "Telling the Story"

Interpretive Narrative Archaeology

John P. McCarthy

INTRODUCTION

An increasing number of American archaeologists are turning to a narrative approach in presenting and interpreting data. This trend has sometimes been described as simple "storytelling," usually, but not always, in the third person. Its goal is to make the results of archaeological research more relevant and more meaningful to the members of the public in whose interests such work is undertaken. In other cases, it is a first-person attempt to personalize, contextualize, and demystify the research process. In a few cases, it is a combination of both. In all cases, when well done, it is an art form.

These narratives are strongly grounded in archaeological and historical data, although in some cases this is difficult to assess. The narratives generally follow an approach described by some historians as "microhistory," in which broad social patterns are described through the detailed study of specific events and individual experiences (e.g., Wood 1994). This chapter describes this trend toward narrative, places it in context, and assesses its potential to fundamentally change how American archaeologists think about and conduct research. I will argue that this new focus on narrative is more than just "telling the story." It recasts interpretation at the center of the archaeological enterprise, and for this reason I will be referring to this approach as "interpretive narrative archaeology."

INTERPRETIVE NARRATIVES

At the January 1997 meeting of the Society for Historical Archaeology in Corpus Christi, Texas, I attended a session called "Archaeologists as Storytellers." I did this in part because a number of my close friends and colleagues were

participants and I wanted to be supportive of their efforts. However, I also attended because I was curious about what they were going to do and, frankly, how it would affect what I, as an archaeological practitioner, do. I was treated to more than ten papers presenting diverse narratives. Some of them were presented in the first person and focused on how the excavation was conducted and the data interpreted. Some were presented in the third person and discussed the everyday lives of the people who once inhabited the sites, using artifacts and other site data to "flesh out" the description. The most unusual papers, however, were presented in the first person and told the fictionalized story of an event or events in a past life as informed by archaeological data. The papers were entertaining as well as informative. Following the conference I began to think about what I had heard and what it really meant. The "problem," as I had come to think of it, of these narratives was reinforced when volume 32, number 1, of the journal *Historical Archaeology* arrived on my desk just over a year later. It contained nine of the papers presented in the session.

The "Archaeologists as Storytellers" session was not the first instance of an interpretive narrative approach in American archaeology. James Deetz made use of short, fictionalized narratives for introductory purposes in his volumes *In Small Things Forgotten* (1977) and *Flowerdew Hundred* (1993). However, neither of these volumes was truly "interpretive" in focus or intent in the sense that I am using the concept here.

This recent trend toward interpretive narrative has it roots in two complementary trends in American archaeology. First, there has been a growing realization that the public could not understand and did not care about the "narratives" that archaeologists were producing, even though the archaeological endeavor increasingly relies on public support and financing (e.g., Klein 1999). At the same time, increasing disenchantment with the scientific paradigm of the New Archaeology led to the growing influence of postmodern theoretical perspectives that emphasize understanding over objective description and that recognize constructed and contingent aspects of the nature of knowledge (e.g., Beaudry et al. 1991; Leone et al. 1987).

During the first half of the 1990s, several monographs appeared introducing first-person narration of archaeological enquiry. Notable among these were Leland Furguson's (1992) *Uncommon Ground,* which focused on the importance and origins of Colonoware, an African-American pottery tradition found throughout the slave South; Janet Spector's (1993) *What This Awl Means: Feminist Archaeology at Wahpeton Dakota Village,* which discusses how she undertook the investigation of a nineteenth-century Dakota settlement in Minnesota, made contact with descendants of the inhabitants of the site, and then made considerable use of informant information to interpret the site; and

Anne Yentsch's (1994) volume on the eighteenth-century Calvert family of Maryland and their slaves, titled *A Chesapeake Family and Their Slaves.*

Perhaps the first, and certainly the most influential, use of first-person "fictionalized" interpretive narrative, however, is found in Carmel Shrire's (1995) *Digging through Darkness.* Shrire, a native South African, teaches at Rutgers University, and I know from conversations that *Digging* had considerable impact on some of the participants in the "Archaeologists as Storytellers" session.

The "Archaeologists as Storytellers" session was important, not because it broke entirely new ground, but because it represented a breakthrough from isolated academic production of interpretive narratives to the wider "mainstream" of archaeological practitioners. Most archaeologists in the United States (60 to 70 percent) are employed in cultural resources management (CRM), a broad category of applied practice that includes the public and private sectors and that relies on legislation requiring the identification, evaluation, and management of archaeological resources (Elston 1997). Four participants were full-time CRM consultants, three were academics who spent at least a portion of their time involved in CRM activities, and only two were academics not actively involved in CRM work, although one had been a full-time practitioner earlier in her career and the other has been involved in CRM projects from time to time.

Each of the papers that appeared in volume 32, number 1, represented an act of archaeological interpretation that gave form and meaning to lifeless and often dull archaeological and historical data. As Rebecca Yamin (1998:85), author of the paper on the notorious Five Points area in New York City, stated, "The stories are a kind of hermeneutic exercise in drawing . . . strands of information into a coherent whole. The construction of a narrative vignette provides a methodological beginning point." Yamin here draws on Hodder's (1991) notion of "coherence" as the explanation that makes the most sense of the most data. However, while Hodder (1989a) argued that the narrative report should be a process of argument, Yamin (2003) uses narrative as a process of understanding and communicating.

Each of the authors focused on telling a story rather than presenting data; in so doing, they moved the interpretive process to center stage. More traditional forms of archaeological discourse focus on data and their presentation, leaving interpretation to last—and too often least—priority. The narratives were personal, impressionistic essays and were definitely not science as traditionally understood. The papers and the movement they reflect, in fact, constitute an explicit rejection of objective, positivist science. To understand this turn of events, we need to place it in context and examine the nature of science and scientific reasoning in archaeology.

CONTEXT: THE DEVELOPMENT OF
HISTORICAL ARCHAEOLOGY

In North America, historical archaeology has it roots in the 1930s with the restoration archaeology of the National Park Service at Jamestown (Cotter 1958) and other sites (e.g., Harrington 1957) and of the Colonial Williamsburg Foundation (Hume 1994). These investigations were undertaken to support the restoration and re-creation of historic structures on a massive scale. At this time, historical archaeology was seen as an adjunct to history, specifically architectural history (Harrington 1955). Archaeological undertakings at this time were site-specific and humanistic in their focus if informed by theory at all. A typical research question in this period might have been, "Is there any evidence documenting the size, shape, and stairway configuration of the porch that documentary sources suggest was built on the east side of the building sometime between 1750 and 1780?"

The 1960s saw the increasing application of "hard science" techniques to archaeological problems. This, coupled with an increasing emphasis on the mechanisms of social processes and cultural change (e.g., Binford 1962; Willey and Philips 1958), was the New Archaeology, a more technically and methodologically sophisticated and productive approach (Trigger 1989). By the 1970s, the New Archaeology seemed to have succeeded in changing everything: we were scientists, archaeology was anthropology or it was nothing, and historical archaeology was going along for the ride (e.g., Schulyer 1970). In 1977, Stanley South's *Method and Theory in Historical Archaeology* introduced quantitative functional analysis of artifact assemblages and study of quantitative patterns reflecting cultural "universals." One was to develop formal hypotheses to be tested with our formally organized and presented data sets. Unfortunately, these data were all to often left to "speak for themselves" when no lawlike, "nomothetic" statements were forthcoming (e.g., Otto 1977). Even when forthcoming, these statements were banal and obvious statements of the human condition. Although this approach came to be criticized for a wide range of reasons (e.g., Meltzer 1979; Trigger 1978), its basis in a flawed understanding of science is of significance to this discussion.

SCIENCE AND OBJECTIVITY IN ARCHAEOLOGY

Popular notions of science privilege the "scientific" as being based in proven, true, objective knowledge. Science is believed superior to other forms of inquiry based on this assertion. Yet in practice, science is usually based on the collection of facts based on minor inductive predictions of limited applicability. A number of critiques of science have developed from various postmodern

viewpoints, including feminism (e.g., Harding 1991; Martin 1993). While these analyses present some interesting arguments—attacking, for example, notions of objectivity and rationalism—the most powerful critiques are found among philosophers of science.

Bhasker (1978) argues that science cannot be limited simply to showing relationships between sets of events. In seeking to explain what the world is really like, scientists make generalizing statements that are tested experimentally. However, such experiments are closed systems in which some variables are isolated while others are frozen or removed. Although the purpose of this approach is ostensibly to allow underlying laws to show themselves, in this sense experiments are not "true," objective representations of reality but are specially constructed for particular purposes. Although replicable, they tell us nothing, in themselves, about the reality of nature.

A further problem exists in science's understanding of lived reality, which Chalmers (1982:168) has attempted to address in what he terms "unrepresentative realism." This construction allows a theory to be assessed from the point of view of the extent to which it successfully comes to grips with some aspect of the world, whereby rejection of correspondent truths is possible. Hence, Newton's laws of motion can be used in a wide variety of circumstances, but they can be equally rejected in favor of relativity theory to the extent that it applies elsewhere. Light can have the properties of both a particle and a wave.

Archaeology is not an experimental science. It deals with complex phenomena. Sites are unique manifestations of past behavior, and replication of results is rarely possible. Although archaeology is based in a material reality that represents an objective record of past events, the discipline of archaeology is socially constructed. Investigators' biases color not only the questions asked of the record but also what data are observed, recorded, and interpreted. Perceptions are subtly colored by preconceptions of reality that may preclude an awareness of the full range of data and possible interpretations (Trigger 1989:382–384).

As archaeologists have become aware of the contingent and limited nature of science and the socially constructed nature of all knowledge, the positivist paradigm of processual archaeology has been increasingly eroded. In this process, deductive reasoning is being abandoned in favor of inductive reasoning.

DEDUCTIVE AND INDUCTIVE REASONING IN ARCHAEOLOGY

The term "deductive reasoning" refers to the process of concluding that something must be true because it is a special case of a general principle that is known to be true. For example, if you know the general principle that the sum

of the angles in any triangle is always 180 degrees, and you have a particular triangle in mind, you can then conclude that the sum of the angles in your triangle is 180 degrees. Deductive reasoning is always logically valid, and it is the main means by which science advances.

In the context of archaeology, deductive reasoning applies concepts known to be true to interpret a site, region, and so forth. Thus, for example, stratigraphic superposition and the ways that humans interact with the natural environment are applied to deduce conclusions about the site, region, or other factors being considered. This has been the main approach of American processual archaeology. In my view, this fact represents the principal reason why truly nomothetic results did not emerge very often or were trivial if forthcoming at all. The production of generalizing statements from the specific case ran counter to the structure of the thought processes used to analyze the specific case in the first place.

Further, the quality and validity ("soundness" in rhetorical terms) of a conclusion are wholly dependent on the soundness of the premises from which it was deduced. Hence problems with the structure or content of a premise can produce any of a number of deductive fallacies, resulting in an unsound conclusion.

"Inductive reasoning" (not to be confused with "mathematical induction") is the process of reasoning that a general principle is true because the special cases you have seen are true. For example, if all the archaeologists you have ever met have been very strange, you might then conclude that "all archaeologists are strange." That is inductive reasoning: constructing a general principle from special cases. Conceptually, this process "goes" in the opposite direction from deductive reasoning.

While inductive reasoning is empirical and is based on experience and observation, it is not necessarily logically valid. The fact that all the archaeologists *you* happen to have met were strange is no guarantee that *all* archaeologists are strange. Yet, reasoning from the data available to you, you may legitimately develop the *theory* that all archaeologists are strange. Thus, inductive reasoning leads to conclusions in which an observer may have a high level of confidence but not absolute certainty.

Historical archaeologists seem to have been comfortable with inductive thinking. In fact, many had never really embraced the New Archaeology's deductive approach beyond the most superficial level. Working within a postprocessualist framework, many of my colleagues found they were addressing broad sociocultural phenomena (e.g., slavery, industrialism, capitalism, etc.) through the detailed study of specific events and individuals. This is essentially what many social historians have been doing for years under the rubric "microhistory" (e.g., Wood 1994).

SOME IMPLICATIONS

The trend toward an interpretive narrative archaeology raises a number of fundamental issues about what archaeology is and how it is to be done. I briefly consider three of these here: (1) the potential for archaeology that is relevant and meaningful to the public; (2) implications for our understanding of archaeological significance; and (3) the implications for narrative "truth."

Public Relevance

As noted above, the majority of archaeologists in the United States work in the field of cultural resources management, not in academic posts. This work is done in the public interest and often with public dollars. For too long archaeologists have written for their professional colleagues and only rarely for anyone else. Clearly, some archaeologists writing more accessible interpretive narratives have been motivated by the need to curry public favor and raise support for archaeology in times of regulatory reform and increasingly tight budgets inadequate to society's many conflicting priorities. Others regard public interpretation as a professional responsibility no less important than any other, and some find such efforts personally rewarding (see, e.g., chapter 2 in this volume).

The public thirsts for reliable, credible information about the past and often satisfies that thirst through heritage tourism. Heritage tourism is on its way to being a leading sector of the economy, not only in the United States but internationally as well. Archaeology is particularly well suited to telling compelling stories, supported by material evidence that allows a tangible connection to the human past that no other discipline can match. While there is a danger that we engage in the creation of some kind of *Archaeology for Dummies,* this need not be the case. The public is smarter and more willing to listen to complex stories than academics generally imagine, as the success of Ken Burn's multipart television documentary *The Civil War* attests. However, the stories must be compelling and they must be well told.

Site Significance

My colleague Terry H. Klein (1999) has argued that the most important issue facing American archaeology is that of site significance. This characteristic influences where we perform an archaeological survey, what methods we use for the survey, how we investigate the sites we identify, and how we treat the sites (once we find them) in terms of excavation, analysis, and management.

Archaeological significance is generally defined under provisions of federal

law and regulation as the quality of having yielded, or being likely to yield, "information important in prehistory or history" (Title 36, U.S. Code of Federal Regulations, Section 60). Klein (1999) noted that this conception of significance and National Park Service guidance regarding how this criterion is to be applied are inherently and explicitly positivist, requiring that sites have the ability to "test hypotheses about events, groups, or processes in the past that bear on important research questions in the social or natural sciences or the humanities; or corroborate or amplify currently available information suggesting that a hypothesis is either true or false" (National Park Service 1991:21).

Klein (1999) has also noted that the trend toward archaeological narrative infuses the archaeological enterprise with new criteria. These new criteria focus on the people who lived on a site and the site's potential to support the development of narratives to tell the stories of those people. This trend has the potential to affect how the bulk of American archaeologists—the majority of whom still practice some form of processual archaeology—look at the archaeological record and order their survey, evaluation, and excavation priorities.

Narrative "Truth"

As with archaeology in general, there is a danger that the stories told may be more a reflection of the archaeologist than of the historic period, site, or artifacts. While Trigger (1989) has argued that there are limits to what a practitioner can honestly believe is true based on the archaeological record, our various weaknesses as human actors in a particular sociocultural context can radically affect our ability to observe, record, and interpret the objective reality of the past that the record offers. There is also the possibility that archaeological narratives will be used for purposes other than those intended by the archaeologist. Silberman (1989), for example, has vividly shown how archaeology has been manipulated to serve nationalists' ends in the Middle East, and Kohl and Fawcett (1995) have broadly analyzed the political uses of archaeology.

Interpretive narrative archaeology provides a way to try to explain the things that we, as archaeologists, *feel* are true about a site, the people who lived there, and the times in which they lived. The use of the techniques of fiction—plot, setting, character, and so forth—to tell a story in either the first or third person suggests the potential to "overcome" limits inherent in data. However, use of fictional techniques also suggests the possibility that any and all fictionalized accounts of the past, or the present for that matter, may be equally valued and held valid.

As James Gibb suggests in the following chapter, we need to be aware of the distinctions between historical fiction and interpretive historical fiction.

Carnes has also addressed the dynamic difference between historical fiction and historical narrative, noting that the fictive account allows translation of events of the past in a way that may speak more powerfully to our needs and concerns in the present than facts alone may be able. He writes: "Novel history, like alchemy, is an inaccessible science and elusive art, but to readers who seek understanding of themselves and the world, its riches are real" (2001:25).

If we have, for example, the goal of empowering historically, socially, or economically disadvantaged communities, then we may deem it acceptable to sacrifice aspects of the "truth" suggested by the data, or overcome inadequacies in the data, in order to address a conceivably "higher" goal through historical fiction. Any such effort must be undertaken only with the utmost care and with explicit statements of the liberties taken.

However, as archaeologists we stand on firmest ground when we remain true to our data and the facts as we understand them in the creation of our narratives. It is our unique and privileged position to discover the material past and make it meaningful in the present, and we do a disservice to the archaeological record when or if we lose touch with that fact. Our professional ethics should require that our narratives remain firmly grounded in historical and archaeological data.

Finally, this approach cannot become a refuge for those practitioners unable or unwilling to organize and present their data coherently. The data upon which our narratives are based must be available for independent review and reinterpretation by others, even if only relegated to fine-print appendices at the back of the report.

Notwithstanding any of the above, the future of the interpretive narrative in archaeology appears bright. I look forward to reading many more interpretive narratives and to trying, myself, to make the past come more alive through this technique.

ACKNOWLEDGMENTS

This chapter is based on an essay originally presented in the session "Narrative Archaeology" at the 1999 meeting of the Theoretical Archaeology Group, Cardiff University. I would like to thank John Jameson for the invitation to submit a paper to this volume. I was greatly assisted by comments by and discussions with the following in the refinement of my thoughts on this subject: Anna Agbe-Davis of the Colonial Williamsburg Foundation; John Beech of Coventry University School of Business; Elaine Elinson, novelist, of San Franciso, California; James Gibb of Annapolis, Maryland, independent archaeological consultant; Robert Hedin, director of the Anderson Center for Interdisciplinary Studies in Red Wing, Minnesota; Leslie "Skip" Stewart-

Abernathy of the Arkansas Archaeological Survey at Arkansas Technical University; Rebecca Yamin of John Milner Associates, Inc., Philadelphia; and the mother of my children, Jeanne Ward of Applied Archaeology and History Associates, Inc. I am especially indebted to Terry Kline of URS Corporation for his analysis of the implications of narrative archaeology for assessing site significance. Any errors of fact or interpretation, of course, are solely my responsibility.

2 / The Archaeologist as Playwright

James G. Gibb

INTRODUCTION

Stage plays can teach through aesthetic experience, creating settings in which facts, figures, and historical relationships are depicted in an integrated, meaningful manner. Plays also can serve as tools for exploring the past, the archaeologist-playwright experimenting with interactions among individual roles and larger historical events, first on paper and then in production. The use of interpretive historical fiction in general, and play writing specifically, acknowledges the limitations of mainstream theoretical approaches, but it does not reject them; on the contrary, the imaginative use of drama elicits insights into the actions and motivations of past peoples that may be testable through more conventional approaches. In this chapter, I illustrate this approach with a discussion of two plays I wrote and produced at the London Town historic site in Edgewater, Maryland.

Archaeologists as Playwrights

A report of some five hundred pages bound in plastic spiral binding, on top of a spreading pile of books and note-filled binders, occupies the right corner of a desk. A tablet with several pages covered in scribbled notes and quotations, many with accompanying marginalia, lies on the left corner and forms a small ramp to an overflowing stack of inbox/outbox trays. In the middle is a computer, its screen full of carefully worded comments and enumerated points. This is my desk, and my thoughts are equally jumbled. Years of university training ingrained in me the idea that archaeological research, inadequately reported, isn't archaeology. And yet, here on my desk lies perhaps the most scrupulously documented and fussily organized technical report I had ever read, much less peer reviewed, and reading it has made me none the more

knowledgeable about anything I regard as worth knowing. The few insights garnered from the notes and books sliding eastward across the desk add little of consequence to the investigator's observations and results.

Critical deposits at the site were recently disturbed (I can take a perverse sense of comfort in that), and an underdeveloped research design foreshadowed disappointment. But even exemplary reports on well-preserved sites—replete with testable questions, detailed descriptions of appropriate methods and findings, and rigorous analyses—often hit a blank wall and fall in heaps next to earlier reports of greater and lesser quality. There is little or no real advancement in knowledge and understanding and, worse yet, no view of what may lie beyond the wall. What wall? The wall we have created, occasionally modify, and generally maintain through the questions and methods that compose contemporary archaeology and science in general. The formulation of non-overlapping categories of phenomena and the rigorous collection and analyses of data, although essential to the development of a reputable field of inquiry, create their own artifacts—walls, if you will—that impede further development. Art can help us scale the wall without permanently abandoning the firmament.

Scientists of all sorts resort to imagination, and science without creativity probably isn't science. But science has limits more constraining than those of art. Taking a somewhat conservative view, I see what Ehrenhard and Bullard (see chapter 3 in this volume) characterize as an intersection of science, humanities research, and art, where art transcends experience. I argue, however, that art also creates experience that can be subject to analysis. Art produces not data but perceptions of reality for which scholars can generate expectations of the archaeological and documentary records. Archaeologists can draw together disparate data from artifacts (including, among other things, buildings, music, poetry, and paintings), archaeological deposits, and conventional historical documents and, through drama, posit relationships and processes that they can then test through more conventional archaeological methods. Play writing may not allow archaeologists to leap over the wall, but it might provide a glimpse over the top to see what lies beyond.

PLAY WRITING

Play writing and science can be inspired, but in the end, both grow out of what we know, or want to know, and what we want to share. And the idea I want to explore and share is that stage plays not only can convey what we have learned through science but can be part of the scientific process itself, a means of constructing and refining hypotheses about people, places, and events and how each shaped the other. The argument does not dismiss the power of ar-

chaeology and history to provide inspiration for artistic expression and to explore our common humanity: several of the essays in this volume demonstrate that very well (e.g., chapters 3, 7, 16, and 17). Nor does this argument overlook interpretive art's very considerable potential for education and public interpretation (see chapters 4 and 5); rather, it recognizes that archaeologists and historians are as much a part of the public as individuals in any other occupation. We too can learn from the plays we write and, we hope, see produced, and then we can bring what we have learned back to our research.

Few archaeologists have ever considered writing a play, fewer have actually written one, and fewer still have had a play produced. One might argue that, given the apparent lack of training and interest in the art, we might best devote our time and energy to artifact studies and becoming more comfortable with non-parametric testing. But here's the rub: there are lots of writers and producers and directors and actors—professional and avocational—involved in historical plays. Some manage not just to get the facts right but also to accurately portray the behaviors and motivations and attitudes of a past people. Most don't, and many, in my judgment, don't try. The usual results: bad history well told and lost opportunities to explore the past. I am convinced that many archaeologists and historians have the ability to write good plays, and I know that many historic sites have the interest and resources to support the production of such works.

I don't expect to turn most of my readers into playwrights: our first responsibility is timely production of detailed technical reports, the data and analyses of which provide the raw material for what I have termed "interpretive historical fiction" (Gibb 2000a, 2000b). For those who choose to write plays, I offer a few suggestions. For those who choose not to, I hope to convince you that some of the suggestions may prove useful in analyzing plays for insights into the past. I briefly discuss play writing and offer suggestions by way of an example: an original play in two acts written and produced to interpret reactions in the provincial port town of London, Maryland, to events in Lexington and Concord in April 1775.

PLAYS AS EXPERIMENTS

Many writers have mined the past for plots, scenes, and characters that best suited their interests in a particular problem or aspect of humanity. Canadian playwright Robertson Davies (1913–1995), for example, set his *At My Heart's Core* (1950) in the forests of Upper Canada (now Ontario Province) during Mackenzie's 1837 rebellion. Armed conflict in the province drew many of the "gentlemen" homesteaders to York, now Toronto, to defend the provincial government, and many families sent their children to distant towns where they

might be better defended. This dispersal aggravated the social and intellectual isolation of three women who remained on their homesteads, surrounded, in the case of Frances Stewart, by good-quality furniture in a log house, itself surrounded by a recent clearing in the midst of the forest primeval. Each succumbed, at least in part, to discontent, tempted by a visitor with remembrances of what they left behind in Dublin and London.

There is nothing in *At My Heart's Core* to indicate that Davies was trying to elicit a greater understanding of pioneer Canadian women; indeed, a review of his oeuvre suggests a tendency to use Canada's rural past allegorically. Davies was more interested in the struggle of the individual spirit in the face of intellectual starvation. But he was a teacher and a man of letters, not a scientist. Like many other writers, he mined the past for literary material to put in the service of the present. Reversing this relationship, scientists can use literature to understand the past.

Think of a play as a well-planned experiment: the writer selects a setting, one or more characters, and possibly a specific time and place, then allows the people, places, and events to interact—each to a greater or lesser extent shaping the others, often with one asserting considerable influence over the others (see chapter 1 on the limitations of conventional hypothesis testing). Although not quantitative, this sounds a bit like hypothesis testing, identifying dependent and independent variables, holding some variables constant to see how the others react. And that is as good a way as any to think about it.

The use of "interpretive art" (see chapter 5) in science requires imagination but is not purely imaginative. Archaeology and archival research establish the time, place, and historical context of the action to be portrayed (see chapter 3). Archival research provides the characters, some well documented, others distillations or stereotypes drawn from period literature. Documents provide specific historical events as well as the perspectives of some characters at the time of each event. (Whether as technical writers or fiction writers, we owe it to our subjects to ask them what they thought they were doing and why, and it is the writer's responsibility to consult and critique at least a representative sample of pertinent surviving documents.) Architectural and archaeological analyses establish the setting and identify the props. Each of these fields— archaeology, architectural history, general history and its constituent subfields, and even literary theory and criticism—provides the questions or issues around which a play revolves. They also provide the methods and techniques of scholarly analysis.

I have written two short historical plays, not as experiments, but because the marketing director of the London Town Foundation asked me to (Gibb 1998, 1999). She saw the plays as fund-raisers and as educational programs. Each work incorporated archaeological and archival data from a multiyear research program in London, Maryland, an active port town in the eighteenth

century. I filled gaps in the research, particularly concerning attitudes and motivations, with material from the works of novelists Daniel Defoe and Samuel Richardson in much the way that Robertson Davies borrowed from nineteenth-century Canadian writers, including at least one of the principal female characters in *At My Heart's Core,* novelist Susanna Moodie. In some instances I lifted blocks of dialogue wholesale from period documents and a poem, editing for clarity, brevity, and dramatic intensity.

I designed each act in each play to convey up to three ideas, including different perspectives of colonists and modern scholars. In one act, for example, an archaeologist stands in front of a partially excavated tavern cellar, interpreting the findings for the audience. Ghosts of the tavern owners (it was a Halloween play) engage both the archaeologist and the audience. The archaeologist demonstrates how careful archival research and excavation allowed the project team to identify the tavern's owners and clientele and to document the appearance of the building and how it changed. The ghosts confirm some of the observations, but they are incensed by the suggestion that they habitually threw kitchen trash into their cellar, a critical assumption in the archaeological interpretation of the site and its assemblage:

ARCHAEOLOGIST: The Rumneys dumped *broken* artifacts under the floorboards of their tavern, the abandoned cellar hole also providing a convenient place to dump oyster shells and bones from fish, poultry, deer, pigs, sheep, and cattle. Needless to say, the trash reeked, and the tavern probably smelt bad.

To which tavern keeper Elinor Rumney responds:

ELINOR: If ya don't like it here, try the tavern down the road, there y'll see filth. And there y'll sit with the servants. [Sassily] Ah, but what am I saying, ya needed shovels to find my tavern, can you find the road? [Elinor leaves the scene in a huff.]

Earlier in the act, the issue of cultural diversity arises, the pith of which appears in these few lines between the tavern owners and the archaeologist:

ELINOR: I don't begrudge him for spending so much time about his boats and ferries, but I think the man spends more time talking to travelers than movin' them.
EDWARD: Hold your tongue there, Mrs. Rumney. Who moves them barrels of ale for ya and who kept digging out this damnable cellar after every rain! And . . .
ELINOR: Settle, Mr. Rumney, settle, I didn't . . .

EDWARD: Ya calt me a skellum . . . a blethering, blustering, drunken blellum!

The archaeologist has no idea what this line, lifted from a Robert Burns poem, means. Elinor Rumney explains:

ELINOR: He says I've called him a worthless drunken fool! And, as you can see, he can't speak His Majesty's English.
EDWARD: Damn you English and your cursed tongue, and damn. . . .

Well, you get the idea. This, the first of three acts, provided the opportunity to discuss issues both archaeological and historical. It raised the perennial question of what all that trash was doing in a building that supposedly was still occupied, and it needled the archaeological crew, of which I was a part, about our inability to find the road—the main road through a town we had been studying intensively for several years.

The exchange between the Rumneys, with the archaeologist as an onlooker, reminded the researchers and audience alike that not all of London's residents spoke "His Majesty's English." Elinor's comment about "the tavern down the road" where "y'll sit with the servants" grew directly out of the hypothesis that different taverns in London and nearby Annapolis catered to different clienteles, reinforcing the class structure and culture of deference that pervaded eighteenth-century Maryland and colonial society throughout North America (Thompson 1999). Those differences should be manifested in the types of vessels and food remains recovered from the tavern deposits. Elinor also clearly emerges as the principal manager of the tavern, cooperating but not wholly working with her boatwright-ferryman husband. (Regrettably, the text of the play did not make clear that Edward owned the tavern and that Elinor, under English law, could not own property: as a married woman, she was property.)

Let's now turn to method, drawing examples from my second effort.

METHOD

Writing a play is easier if begun with an abstract, or argument, that identifies the theme and, perhaps, a central reflector—a pivotal idea, person, object, place, or event of which all of the characters have an opinion. Here is the argument guiding the writing and production of *Revolutionary Spirits*, appearing verbatim in the playbill:

The mood in town is tense, the residents still trying to decide where one another stand on the great issue of the day: relent and accept the

will of Parliament, or hold fast to the principle of no taxation without representation. William Brown and many of his neighbors would rather boycott British imports than pay what they believe an unfair tax, but even they are hesitant to disobey their King. The mood rapidly changes, however, when news of the skirmishes at Lexington and Concord reaches town. The residents polarize, and talk turns from boycott to armed resistance. Civil war is in the offing and the characters know—although they are loath to express it—that their lives are heading for a dramatic turn; a turn forced by events seemingly beyond their control.

The play begins in the main hall of the William Brown House. Anne Arundel County's Committee of Observation has just finished discussing the boycott, unaware of events that occurred in Massachusetts just days before. Join the Brown household and its neighbors as events unfold and they try to come to grips with passions that will tear apart their community.

Each act had its own abstract, although these did not appear in the playbill. They were prepared for my own benefit.

Act I: The main room of the Browns' tavern. Susanna hurries her slave, Sall, in cleaning up after the meeting of the Committee of Observation. Some of the participants can be heard returning, having just seen off their departing colleagues. [Lacking an appropriate actor to fill Sall's role, we used the fictional indentured servant "Pamela" introduced in my first play. In either case, this character plays a more prominent role in the second act, appearing again at the end of the first to lead the audience to the kitchen, the second act.] William Brown and Stephen West, soon accompanied by Tory Anthony Stewart, debate the issue of non-importation, discussing the loss of trade, loyalty to their king, and the new philosophy phrased in the language of ancient English rights. Stephen supports the Association, hinting at violent action, while Anthony despairs at the prospect of civil war, alluding to Proverbs 11:29—trouble our own house, and leave nothing but waste and emptiness. William has been drawn into this whirlwind of passion, siding with the patriots, but convinced that the issue will be settled amicably, if only cool heads prevail. The act ends as William Brown, Jr., enters, a letter in hand, agitated and bold: he brings word, just received in Annapolis—British regulars and Massachusetts militiamen clashed at Lexington seven days earlier, men

killed and wounded on both sides. A state of war exists, and events have overrun philosophy.

Act II: The kitchen in the basement of the Browns' tavern. Three principals—Margaret, daughter of William and Susanna Brown, Pamela, their indentured servant, and Charles Lansdale, freeman and staymaker in the employ of Elizabeth Ferguson—react to the growing schism between the King and the colonists, each against the background of their own social position tempered by their close personal relationships. Women, servants, freemen, and slaves left little record of themselves, their attitudes, or motivations. This act is less well founded on documentary records than the previous act; nonetheless, these lives must be explored.

The archival record is largely mute on how Londoners reacted to the news from Massachusetts, but enough material survives, and archaeological and architectural studies were sufficiently detailed, to mount a convincing portrayal of events, settings, and sentiments. But the piece demanded characters, both richly drawn and archetypal.

CHARACTERS AND CHARACTERIZATION

Developing characters for the play was relatively easy. The research team combed land and judgment records and compiled a list of everyone known to have been associated with the town. I selected several contemporaries about whom we had the most information and developed biographical sketches for each. The theme of London on the brink of revolution made the final choice of characters even easier, although the availability of actors necessitated some changes.

William Brown, Sr.: Born in Anne Arundel County in 1727 and descended of Scots, William Brown died in Annapolis in 1792. He is a carpenter and joiner by trade, but he runs a ferry and a tavern as well. He has taken on the construction of Dr. Upton Scott's brick mansion in Annapolis and has opted to build one for himself. He is ambitious, seeking not only material wealth but also a position of honor and prestige in the community. He may have served on the Committee of Observation in the early 1770s, possibly as recording secretary, looking carefully into the activities of his neighbors and doing his best to support the American non-importation of British goods. He lost his wealth in the economic depression after the Revolution, and his house was sold at a sheriff's sale in 1793. At the time of the play's action, William Sr. is 47.

Susanna Brown: About Susanna, or Anna, apart from her marriage to William and her children, we know virtually nothing.

Elizabeth Ferguson: Widow of the recently deceased Alexander Ferguson (died 1770), Elizabeth (age 45) had relinquished executorship over her husband's will, claiming that she was "unacquainted with Business and therefore incapable of executing the Trust." Anthony Stewart assumed full control of Alexander's estate, with realty in both London and Annapolis, and a tailoring and staymaking shop in London. (William Brown, Sr., and Jr., witnessed his Last Will and Testament.) Nonetheless, at least from 1770 through 1773, Elizabeth ran the tavern and the tailor/staymaker shop, employing staymaker Charles Lansdale, indentured servants Joseph Gibson, John Elain, and Ruth Murphy, and Beck (a 22-year-old woman), her child Pomfrey (age 3) and a man, Abram (age 20). Alexander's probate inventory lists numerous articles of furniture indicative of an operating tavern, or ordinary. Elizabeth's household, apart from the servants and slaves, probably includes her three youngest children, Ann (16), Isabelle (14), and Elizabeth (10), and possibly her three sons, Alexander (23), David (22), and Andrew (19), all of whom would enlist in the Colonial military the following year. The Fergusons probably lived on Lot 91 since 1741, across Scott Street from the Browns and next door but one.

Anthony Stewart: Merchant and shipowner and a principal in the firm of James Dick & Stewart, Merchants, Anthony Stewart was an outspoken Tory, a supporter of King and Parliament.

Stephen West, Jr.: Although he was raised in London Town, born in 1727 the son of Stephen West (died 1752) and Martha Hall (also died 1752), Stephen Jr. moved to the Woodyard near Upper Marlboro, Prince George's County, in 1754. There he died in 1790. He was a merchant, planter, shipowner, provisioner for the Continental Army and the Maryland militia, politician, slave owner, and supporter of St. John's College in Annapolis. In 1775 and 1776 he supplied gunlocks, gunpowder, flour, blankets, and other materiel to the Maryland Council of Safety. Several of his letters to the council and to other prominent Marylanders survive, reporting his views on the procurement of military supplies and the prospect of manufacturing muskets in the colony.

Margaret Brown: Born in Anne Arundel County in 1759 of William and Susanna Brown, 15-year-old Margaret assists her mother in the operation of the tavern. She works alongside her friend, indentured servant Pamela—whom she affectionately calls Pammie—but their relationship is not on an equal footing.

Pamela: The fictional character Pamela was indentured to William Brown and was employed about the tavern, cleaning, serving, and generally doing the bidding of her master and mistress and of her friend, Margaret. She is slightly

older than Margaret, roughly 17, and has reached a quiet, indeed unspoken, understanding with freeman Charles Lansdale.

Charles Lansdale: A freeman Elizabeth Ferguson employed as a staymaker in her late husband's tailor shop, Lansdale probably is in his twenties or thirties. We know nothing else about him; hence his character is largely fictional.

All of the characters in the second act are stereotypes, drawn largely from English-language literature of the period, in contrast to the other, more richly drawn characters for which we have some information. The actors developed each character, some in ways I had not anticipated.

SETTING

Because we lacked a theater and funds for sets, venue selection became simple: we used the three-story brick mansion at the core of the historic park. The two principal areas visitors see in the house are the upstairs tavern room and the kitchen below; a pair of sets that begged a two-act play focusing on the upstairs-downstairs dichotomy and the very real social distance that existed between the characters who frequented those two places. The relatively well documented individuals played out their scene upstairs, struggling to comprehend events. The characters downstairs dealt with the very personal impact that impending civil war would have on their lives.

The tavern room was an ideal set for a very public event. It was a place in which Anthony Stewart (the preeminent Tory), Stephen West (the radical patriot), William Brown (the fence-sitter), and Susanna Brown and Elizabeth Ferguson could naturally come together and interact politically and socially. It was also the logical place to which the Brown's son brought the fateful letter from Philadelphia that reported events in Massachusetts. The audience seated around the perimeter of the room played the part of tavern guests, at times brought into the action.

The basement kitchen was darker, more private, the haunt of servants and certain members of the household. Here the Browns' daughter Margaret, freeman Charles Landsdale, and fictional indentured servant Pamela come together, exploring the meaning of freedom and confronting war's dire personal consequences. All of the characters and their relationships develop in the face of events that lie outside their direct control.

ANALYSIS

Although the plays were not written as scientific experiments, they could be turned to that purpose. After all, as both archaeologist and playwright I was fully aware of the limitations of the available data and the kinds of questions

that required answers if the London Town Foundation's staff was to fully understand and interpret London, its growth and demise. Some of these questions I addressed, if not conclusively, through dialogue; others I missed or opted not to address. Let's look at one of those questions that I only partially addressed: non-importation and the politics of things.

Revolutionary Spirits opens with Susanna Brown and a servant cleaning the main tavern room after the Committee of Observation has left, William Brown accompanying them out. Susanna, audible to the audience and half addressing them, mumbles about her husband's involvement in the committee, neglecting his family and business. She chides him when he returns with radical patriot Stephen West and argues with West over the propriety of the committee's activities: spying on neighbors, arresting those suspected of trading with the British, confiscating their goods, and denying them due process. *Things* figure more prominently in the American Revolution than perhaps in any other American conflict. The issue was representation, but embargo and home manufacturing became principal expressions of collaboration and resistance, Toryism and Republicanism, loyalty and independence (Evans 1989). Here are a few of the opening lines:

SUSANNA: Haste, wench! Clear that table and be off to the kitchen. I will see to the others myself. Mind your master's children. [Half under her breath, half to a member of the audience.] Such heated talk . . . fueled rather than cooled with drink.

[William Brown enters leading Stephen West.]

SUSANNA: Your friends are gone, then, husband?

WILLIAM: Yes, Anna. Our son accompanies them on the ferry, but not so far as Annapolis.

SUSANNA: He would do well to mind his work, sir, as would you. Don't encourage his meddling in affairs that do not concern him.

STEPHEN: Surely, Mrs. Brown, the late troubles concern your son, and all of us. A young man starting out in the world must look to his rights. He must . . .

SUSANNA: He must look to his young wife and my grandchildren. He must see his way clear of his Majesty's jail and of his Excellency the Governor's gallows! And you sir, . . .

WILLIAM: Enough, Mrs. Brown. We speak of the affairs of men. Such is not the province of women. Tend to your own affairs, and let Mr. West and I . . .

SUSANNA: [Sarcastically] and let Mr. West and I talk rubbish and neglect business.

STEPHEN: There is no business, Mrs. Brown, nor will there be until

King George redresses our grievances, withdraws his troops, and repeals taxes imposed without our consultation or consent.
SUSANNA: Secret meetings and spying on neighbors will not alter the king's opinion, nor will they bring business again to our town.

Susanna and Stephen continue their argument, briefly rehearsing some of the principal issues of the boycott. William finally intercedes, cutting short their argument. He expects Elizabeth Ferguson momentarily and will try to buy her late husband's dry goods on behalf of the Committee of Safety:

WILLIAM: Peace, Mrs. Brown. Stephen, enough prattle. Mrs. Ferguson attends us soon and we've more to discuss. A militia unclothed and unarmed will little persuade the king of our convictions.
SUSANNA: If you've time later, husband, discuss the clothing and feeding of your children. [She leaves.]

While William and Stephen continue their conversation, Elizabeth arrives. Susanna offers tea to her friend and, when she sees Stephen West's shocked expression upon thinking that British tea would be served in this household, qualifies her offer: it is an ersatz tea made of herbs and grains. This scene offered an opportunity for experimentation, an opportunity I failed to recognize at the time: what did they drink tea from? Carl Steen (1990, 1999) has offered a compelling argument for the widespread use of American-made slip-decorated red earthenwares as an overt expression of American identity and, by extension, sympathies. These were vessels readily recognizable as products of American potters, particularly those of Pennsylvania. Would it have been too melodramatic if Stephen West were to snatch the Queensware cup from Elizabeth and dash it into the fireplace in the midst of an invective against English manufacturers and merchants? How might London's residents have felt about vessels of colonial manufacture? Would slip-decorated teawares have offended their sense of what was appropriate for tea, real or ersatz? Tory Anthony Stewart might have refused tea served in such a vessel: he certainly would refuse the grain beverage that passed for tea in patriot households. Patriot Stephen West might have relished ersatz tea so served, for political if not necessarily gustatory reasons.

Revolutionary Spirits also touches on an important historical issue for which archaeological evidence exists and has the potential to inform upon: the political power of women in colonial society and their role in a republic. Evans (1989), for example, cites private letters and newspaper articles of the 1760s demonstrating that women increasingly spoke out on political issues and became particularly prominent in maintaining the boycotts, the latter politiciz-

ing their daily activities of shopping and home manufacturing. Groups of women pledged to abstain from tea and organized spinning bees: "Women who refused to buy British goods, who made herbal teas, spun and wove their own cloth, and insisted on 'buying American' were engaging in defiant political acts in the course of their domestic responsibilities. That some enacted their intentions in more public and formal ways through meetings and petitions demonstrates not only the reality of their political commitments but also a new level of self-perception as political actors" (Evans 1989:50). The war, explained Evans, "offered increased opportunities for women to act politically and aggressively from within their role as housewives" (1989:54). Women's consumer choices, their political choices, should be visible archaeologically, particularly in the presence or absence of British manufactured goods—ceramic dinner and teawares, for instance.

Steen has pointed out that clothing—fabrics and styles—was more important symbolically than ceramics in claiming one's allegiance in the late 1760s and 1770s: "By wearing home-spun cloth, people were effortlessly able to make a strong political statement. Ceramics, on the other hand, were relegated more to the privacy of the home and would require effort and explanation for their significance to be evident" (1999:70). For archaeologists, he continued, Philadelphia earthenwares "are a clear manifestation of a political movement that swept through the colonies" (1999:70). Steen's observations might be qualified on two points: not all ceramics were used in purely domestic settings, and all purchases during the period were public acts, regardless of how the items were actually used.

I know of no historian or archaeologist who has explored the issue of what American householders did with British ceramic tablewares in the 1770s and again after implementation of Jefferson's and Madison's embargo acts (1807–1809 and 1813–1814, respectively). Ceramics certainly were accorded political symbolism, as museum catalogs and collections demonstrate. The meaning of a chamber pot with the king's likeness on the bottom interior transcends cultural differences, and numerous examples can be cited of porcelain and faience punch bowls commemorating military victories and the new American republic (e.g., Howard 1984). Perhaps individual householders refrained from using British ceramics, but taverns and coffeehouses, hotbeds of political activity, publicly used all sorts of ceramic, glass, pewter, and treen vessels. Whether or not British wares were used in a public house, the proprietor made a statement about allegiance for all to see, as did those patrons who used or refused to use certain kinds of vessels.

On reflection, Stephen West should have grabbed Elizabeth Ferguson's teacup and saucer and hurled them into the fireplace. Recovering some vestige of gentlemanly demeanor, as defined by the day, West might have then, in gentler

tones, asked Susanna Brown for another cup, but one made by American hands and more suited to a daughter of liberty. As a playwright, I can do that. I can even bring Pamela back into the scene to clear away the sherds and toss them into a slop bucket that, in the second act, might be emptied out the back door, narrowly missing the incoming lover and staymaker, Charles Lansdale. Through play writing we can identify the correlates of overt and covert use, and of public discard, and then test those correlates. But tested or not, play writing and other art forms allow us to imagine and express different attitudes and to suggest moral ambiguities and community conflicts in the past too easily dismissed in conventional archaeological analyses.

CONCLUSIONS

Play writing will never become the principal means for developing and testing hypotheses, but it can allow us to examine complex interactions where the data are too sparse or require imaginative organization. *Revolutionary Spirits* taught audiences about an important part of American history in a way that was entertaining and memorable and that suggested the emotional and social turmoil experienced by the colonists. It also allowed me to examine the relationship between people and objects in ways that cannot be duplicated through conventional analyses, and it suggested research approaches and complex relationships that I had not considered or only partially appreciated.

Play writing is not something I trained to do or that I ever had thought of doing. But archaeology has a way of introducing us to new things in unexpected ways. Completing the two plays required no Muse for inspiration: a concept, a venue, data, an understanding of historical and archaeological issues, and a deadline were all I needed. We might invoke the Muses, but it is unwise to wait for those fickle creatures: they are too easily swayed by pleasures of the moment and the demands of other gods. A workman-like hand that is turned to play writing in the same way we apply knowledge and discipline to report writing will serve well enough to help us peek over, if not scale, that wall we have inadvertently built. And, of course, one can never go amiss with a well-organized desk.

ACKNOWLEDGMENTS

London Shades was first performed at London Town Historic Park in Edgewater, Maryland, during the last weekend in October 1998 and was reprised on Halloween weekend of the following year. *Revolutionary Spirits* was performed during the last two weekends in April 1999. I thank director Renee Tilton and producer Barbara Gimperling for their support, enthusiasm, and

respect for the ideas I tried to convey through the scripts. Special thanks go to the London Town Colonial Players and technical crew: Jen Fisher, Kelly Fisher, Barbara Gimperling, Cory Gimperling, Tony Lindauer, Len Pimental, David "D.L." Smith, Greg Stiverson, Emily Strotman, Renee Tilton, Todd C. Withey, and Becki Yazel. I have benefited from subsequent discussions with independent playwright and occasional instructor Mike Field of Johns Hopkins University.

3 / Archaeology Goes to the Opera

John E. Ehrenhard and Mary R. Bullard

The greatest danger in the narrow scientific outlook is the assumption that because analytical and statistical methods cannot properly be applied to values that most differentiate man from the other animals, those values must be ignored.

—Hawkes 1946:79

EN ROUTE

August 16, 1866
Stafford Plantation Slave Village
Cumberland Island, Georgia

Abraham Trimmins, free person of color, and his mule were almost invisible. There was no sound other than the gentle whisper of the wind through the thick draping of Spanish moss. He was crouched on his haunches in front of the old animal, and anyone standing in the glaring noonday sun would not have seen them among the three enormous branches that arched out of the trunk of the live oak and curled down to softly touch the dull gray sand. The great tree moved gently in the breeze. Abraham stared out beyond the limbs at the rows of small wood-plank houses, which only two short years before had been a chattel enclave of over 250 inhabitants. A prison, yet the only home he had ever known until recently.

Now, at age 38, he was a free man on his way to Fernandina, Florida, for a short stay before heading off to Louisiana. He shook his head ever so slightly, and in the second it took to rise up to move on, a myriad of memories rushed through his mind. . . .

When Union General William T. Sherman issued his famous order locally known as the Sea-Island Instructions in January 1865, Abraham, his friends Rodgers Alberty and Henry Commodore, and the other 231 former chattel still residing on Cumberland were jubilant. The Instructions reserved

and set apart for the settlement of the now free blacks all of the islands south of Charleston, South Carolina, all the abandoned rice fields along the rivers for 30 miles back from the sea, all the way down to the banks of the St. Johns River in north Florida! "Now we free, de sey we own de lan." The euphoria was soon replaced with disappointment when President Johnson overturned Sherman's Sea-Island Instructions. Now, all that had been gained was lost, and most everyone Abraham Trimmins had ever known was gone, a result in part of the Southern Homestead Act of June 1866, which enticed hundreds of former sea island slaves to immigrate.

"De al gon," thought Abraham as he stepped out from beneath the live oak and headed south down Main Road toward a barge trip into an unknown future. Just before the road made a sharp bend to the left, Abraham turned back for one last look at the village. He was surprised that he could not see it through the thick green haze of live oaks, magnolias, and red cedars. It was there but invisible. Humming his favorite ring shout, Abraham continued down the road and soon vanished into the forest blanket. Only the sound of the wind rustling through the Spanish moss remained.

> Gabriel en da valley / Blowen his horn
> Gabriel en da valley / Blowen his horn
> Gabriel blowen / Blowen his horn
> Gabriel blowen / I be lisnen
> Gabriel blowen / I be lisnen
> Gabriel blowen / Blowen for me
> I be lisnen / My time commen
> Gabriel blowen / Blowen for me
> Gabriel en da valley / Blowen his horn
> Gabriel en da valley / Blowen his horn

For the next hundred years, the slave village and the lives, culture, hopes, dreams, songs, and prayers of the hundreds of indentured people who had passed through its gates would be no more visible or of concern than the sound of the wind blowing through the Spanish moss.

June 21, 1978
Stafford Plantation Slave Village
Cumberland Island National Seashore, Georgia

Newly appointed National Park Service archaeologist John Ehrenhard peered through the sweat dripping into his eyes to tie off the string that marked the outline of the test unit he was preparing to excavate. He was still relishing his appointment as field supervisor for the stabilization evaluations of the chim-

ney stands at the slave village. "Wow, what a site, what a primo place to work in . . . man, it's hot! . . . damn sweat bees . . . aghhh! . . . Just doesn't get any better than this," he chuckled to himself.

Ehrenhard stood up, turned around to get his shovel, and found himself staring into the black pit of a snub-nosed .38. As if in a voice of its own, the .38 challenged, "What do you think you're doing?" Stammering to come up with an explanation, Ehrenhard stepped back far enough to see that the gun was attached to the outstretched arm of a steel-eyed woman standing next to a white truck driven by an old black man with a shotgun.

After a tense explanation of the preservation/stabilization operations being conducted by the National Park Service and assurances of the landowner's permission to work at the chimney site, the gun was exchanged for a quirky smile and a handshake. "I am the landowner," the woman said, "but I don't have much faith in you park service people—if you want to know anything about this place you better go see Mary Bullard. She knows everything. But, don't expect her to tell *you* anything!" With that final comment, she slammed the truck door and drove off.

May 26, 1988
Driving along Main Road toward Brickhill Bluff
Cumberland Island National Seashore

Bullard and Ehrenhard slowly made their way up the heavily rutted road in Bullard's old Ford Bronco. They were on their way to check her newly uncovered information relating to the dispossessed freedmen of Cumberland, who had established a small community in the vicinity of Brickhill Bluff in the early months after General Sherman posted the Sea-Island Instructions. The conversation drifted in and out of several topics covering plantation life during the Stafford era. "You know, Mrs. Bullard, your recent book on Robert Stafford is just a gold mine." After a pause, Ehrenhard added, "and all that neat stuff you've found out about Stafford's relationship with Elizabeth Bernardey! What a great movie that would make."

Mrs. Bullard laughed heartily. "And how would we do that?" she quizzed.

Ehrenhard thought for a minute before admitting, "I have no idea." The conversation returned to speculations of the Brickhill Bluff freedmen and how best to avoid the deep ruts.

August 10, 1995
Newnan, Georgia

"Mr. Ehrenhard!" boomed the voice over the telephone.

"Hey, Mrs. Bullard, what's up?"

"Well," Mrs. Bullard enthusiastically replied, "I have just written a libretto. It's called *Zabette!*"

April 29 and 30, 1999
Rialto Center for the Performing Arts
Atlanta, Georgia

Zabette, an opera in three acts by Mary R. Bullard, librettist, and Curtis Bryant, composer, debuts (see plate 1).

April 20, 2001
66th Annual Society for American Archaeology Meeting
Marriott Hotel, New Orleans

Tacatacura, Missoe, Wissoo, Ile de la Seine, San Pedro, Isle of Whales, St. Andrew, The Highlands—all are former names of a sliver of land formed sometime in the late Pleistocene in the Atlantic Coastal Plain physiographic province. Now known as Cumberland Island, it is the largest and southernmost barrier island in the Georgia sea island chain. The past 20,000 years of terrestrial weathering and erosion have molded the island's present landscape. Dense oak forests, rolling salt marshes, island sloughs, and ponds are skirted by an unbroken fringe of Atlantic coastal beach and, of course, an endless surf. Today, Cumberland Island exists in a semiwild state, somewhat protected by its status as a national seashore. But human occupation over the centuries has left the imprint of a checkered social history on the natural beauty of the island.

For over 3,500 years, Native Americans had uncontested dominion over all the barrier islands. Then, in 1562, French explorer Jean Ribault made the first European claim to Cumberland Island. French activity in the area immediately drew the attention of the Spanish, who successfully ousted the French by 1569. Spain's influence was not seriously questioned for the next 160 years— not until the arrival of the English in the Carolinas under the command of General James Oglethorpe. While little of note appears to have been happening during the English tenure of the sea islands, the tidewater areas were quietly being transformed by agriculture. Cumberland was standing at a new threshold where a grim legacy was beginning to unfold.

The eighteenth century saw a renewed interest in Cumberland, beginning with timber harvesting. Soon long-staple cotton, indigo, and rice were being cultivated. The introduction of these crops marked the beginning of what was to become the colonial tidewater plantation economy. Certainly by the 1780s, large-scale rice and cotton production was driving the southern economy, as though with a will of its own. But these successes had sinister undertones, for

the planting and harvesting of these island crops required the exploitation of another resource—African slaves.

The annals of Cumberland are filled with much adventure, misfortune, and sorrow. Against a backdrop of awe-inspiring beauty, the chronicle of human events seems so often to be shadowed in tragedy and suffering. Based on historical personages, actual accounts, and archival and archaeological data, the account of one Elizabeth Bernardey, or Zabette, as she was called, like that of Abraham Trimmins, is but one page of the thousands that make up this record. *Zabette* is the story of one woman's endeavor in the world of strict social codes and laws of nineteenth-century Georgia. It is a story of love, trust, and betrayal. It is the story of tragedy in an American family, but also of triumph of the human spirit.

ONE STOP ALONG THE WAY

Zabette: The Backdrop

One fleeting condition of the new nation's post–Revolutionary War enthusiasm was a more lenient attitude toward manumission. Free Negroes came to be a sizable class, numbering over 32,000 by 1790 in the territory then defined as the South. Most of them were in Virginia and Maryland. An influx of "light-skinned refugees" from the Caribbean insurrections of 1798–1801 expanded the free Negro population in South Carolina and Georgia well beyond the bounds of natural increase. In 1810, Georgia invited free Negroes to take white guardians to supervise their affairs.

However, in most southern states free Negroes had to register before a county court, and applicants were generally required to furnish bonds for good behavior. Georgia's first statewide Registration Act was passed in 1818. One author wrote that with the rising numbers of free Negroes came a growing sentiment from the white establishment that free persons of color constituted a class of people both "dangerous to the safety of the free [white] citizens and destructive to the comfort and happiness of the slave people" (Prince 1822:794–795). Changing attitudes toward free Negroes led to the adoption of various laws providing for their expulsion from their state of residence. Obviously, these laws were designed to keep persons of color from competing economically with whites.

In the 1820s, Georgia's laws became more restrictive. Despite a ban on freeing slaves, illegal manumission by southern slave owners continued. Would-be protectors often resorted to arranging guardianship by sympathetic friends who were known as *prochains amis* (Berlin 1974:94–95, 144–146). Southern legislatures, including Georgia's, attempted to close all loopholes. Unregistered

persons of color were required to prove their status as free Negroes. While both free Negroes and poor whites were outcasts of southern society, the former were still subject to many legal restrictions not imposed upon the latter. Contrary to common-law principles, the rule came to be recognized in the South that in the case of a Negro there was the presumption of slavery; the burden of proof rested on the Negro. Even if their papers were in order, unemployed free Negroes could be jailed or enslaved and their children bound out (Hurd 1858). And as time went by, the definition of color became increasingly broad. Nearly everywhere the same presumption was being applied to mulattoes and others with even more fractional black heritage.

The Opera *Zabette:* An Imaginative Interpretation

Elizabeth (Zabette) Bernardey was the illegitimate daughter of Pierre Bernardey, a French plantation owner, and Marie-Jeanne, a family servant of mixed African descent from Martinique. Owing to certain political realities, the timing of Zabette's birth, around 1822, greatly influenced her life. Under the Georgia code of laws governing relations between blacks and whites at the time, Zabette would be considered a person of color and registered as such. Her French grandmother Madame Marguerite Bernardey was determined to protect her granddaughter from the laws that would make her a slave by virtue of her mixed blood. She did this by declaring her a white girl to the county census enumerator. Zabette was thus raised as a white girl and taught reading and medicinal skills. However, the ruse was uncovered. Mrs. Bernardey was forced to declare Zabette her ward and a free person of color. This decision eventually had complex ramifications for both of them. This option could be enforced only for as long as Marguerite remained alive. As she approached old age, she realized that the only way she could prevent Georgia law from closing in upon her granddaughter was to sell her to a sympathetic friend, Robert Stafford. When Stafford became Zabette's owner in 1842, he knowingly assumed the responsibilities implicit in becoming the guardian of a free person of color. He also recognized the potential for severe penalties.

Sometime in the 1830s, when Zabette was probably in her early twenties, Stafford, the owner of the largest plantation on the island and eventually one of the richest slave owners, employed Zabette as a nurse. Stafford (who never married) and Zabette had a relationship that lasted in some fashion for over fifty years and resulted in six children.

However, unanticipated events, social upheaval, and despair punctuated the relationship. After Zabette became Stafford's mistress, a suitor from a plantation on Jekyll Island visited Cumberland with the intent of making Zabette his wife. The suitor knew Marguerite and Pierre Bernardey as well as Zabette's

mother, Marie-Jeanne. He was fully aware of Zabette's status as a free person of color and asked Marguerite, her "guardian," to agree to the marriage. Marguerite would only agree to a civil marriage accompanied by a property settlement. The suitor considered such a proposal ridiculous, and the union never came to pass.

After this event, the aging Marguerite realized that upon her death she would not be able to protect Zabette from Georgia's laws. As "guardian" she conveyed Zabette to Robert Stafford for the sum of one dollar, believing that Zabette would be safer as Stafford's "property" than as a light-brown-skinned female without a guardian. Stafford, understanding Mrs. Bernardey's intentions, agreed to her plan. Legally, Stafford now owned Zabette, and as such he had the right to sell her and her children. Zabette's new status was a devastating blow to her.

In 1851, Stafford decided to move Zabette and their children out of Georgia and set about establishing a new home for them in Groton, Connecticut. In 1852, Zabette moved north, and she remained there until 1866. Meanwhile, Stafford remained on Cumberland Island, making frequent trips to Groton until 1860, when the Civil War erupted and the Union coastal blockade prevented him from traveling north.

At the conclusion of the war, Zabette returned to Cumberland Island a freedwoman only to find that Stafford had taken another mistress. She felt humiliated and deceived. However, in testament to the indelible power of the human spirit and the will to survive, Zabette overcame this crushing despair and accepted the terms of her life. By recognizing who she was, she overcame the inequity dealt her. Free of the bondage of the past, Zabette moved on to a new life with new horizons.

THE INTERSECTION

Three Trajectories

Through the study of material remains, archaeologists seek to order and describe cultural process so as to explain the human cultural and social behavior of the past. An archaeological site can be loosely defined as a spatial clustering of artifacts and features; it is also a moment in time.

Humanists focus on human nature and the dignity and worth of humankind and our capacity for self-realization through reason. While "a site" is more vague in humanistic studies, its practitioners would begin by identifying the "spirit" of the specific location, individual, group, or society manifesting their particular interest. To rise above the demands of evidence is the duty of the humanist. Material culture cannot tell all.

Archaeologists are not expected to be humanists. In fact, even if an archaeologist wished to be called a humanist, the imperatives of the profession would interfere. Archaeological investigators look for ever-enlarging rules to categorize artifactual assemblages and site layouts. Historical investigators search in much the same way, but their assemblages consist variously of groups, or social classes, or of ethnic and religious subgroups. Archaeologists have been slow to broaden their research domains, and only in recent decades have they attempted to increasingly incorporate documentary evidence. Seemingly, archaeological techniques alone would never show the Stafford-Bernardey friendship, but as it turned out, neither was it possible to verify their friendship through traditional historical methods. No letters or primary sources existed except for the deed of gift. The investigators were obliged to fall back on those traditional harbingers of ill will: gossip, hearsay evidence, and scurrilous newspaper accounts. Thus the first challenge becomes distinguishing the authentic from the imaginative.

Artists are not obliged to do any of the above. They practice skills in which conception and execution are governed by imagination and taste. For example, an opera such as *Zabette* is an extended dramatic composition in which music is essential and predominant factor, consisting of recitatives, arias, and choruses with orchestral accompaniment, scenery, acting, and sometimes dancing. An opera site is an arena, theater, courtyard, or perhaps studio. The best operas are those in which the music—vocal and orchestral—is remarkable and captivating all by itself but also heart seizing and transcendentally affecting when experienced as the vehicle for a human drama about which one can care. It can describe inner thoughts; it can comment on events; it can create fear or suspense. Another attribute of music—whether opera, pop, or solo drumming—is the simple satisfaction derived from the performance. Thus, the artists' tools are the unique, yet timeless, the remarkable, yet profoundly human, conditions of each human heart.

It would seem that the trajectories of the three—art, archaeology, and humanism—differ radically from one another. So, where do art, archaeology, and humanism intersect? Quite simply, at a place—in this instance, at the Stafford Plantation slave village on Cumberland Island.

A Point of Intersection

Robert Stafford's early-nineteenth-century plantation on Cumberland Island, famous for its production of Sea Island cotton, represents more than just an agricultural complex. County civil records verify that Stafford was one of the richest slave owners on the Georgia coast. A slave buyer, rarely a seller, he tended to purchase slaves already working on the island along with their mas-

ters' property. At one point Stafford owned as many as 348 indentured workers, who were housed in several settlements around the island.

One of these settlements, called The Chimneys, is located a quarter mile east of the plantation's "Big House." The twenty-six chimney ruins represent what were once twenty-four individual structures—the only vestige of a nameless, disregarded community. Constructed as exterior end-wall chimneys utilizing tabby brick masonry and wood lintels, they stand in three parallel rows along a north-south axis, terminating at the north with an intersecting double row running east-west. In some cases, the chimneys have collapsed into piles of rubble. Others, severely tilting into the cabin interiors almost beyond the point of equilibrium, are in danger of breaking apart. To correct this problem, the National Park Service proposed a preservation and stabilization program. Archaeological investigations were undertaken to understand what adverse effects such a program might have.

From the investigations, we know that it was in these specific cabins that Robert Stafford's slaves lived; and from these specific places, human beings, no more than chattel in the eyes of some, went out to labor in the cotton fields. The events unfolding in the opera *Zabette* could not have taken place elsewhere. Archival evidence helps identify historical particularities and human events, just as archaeologists dig, sift, collect, sort, and analyze the physical evidence of particular times and places. When the paths of the archaeological record and the human record cross, we can begin to analyze the symbolism of our discoveries. Conversely, when the symbols we find touch upon elements of the human condition—birth, death, love, despair, fear, exile—we begin to rise above empirical evidence. Thus the union of archaeology and humanism helps us form the grid of a new cartography as we attempt to "map out" the human spirit. In so doing, we find the third path at this intersection—the materialization of imagination, that is to say art. Perhaps we have validated Hawkes's argument that the ultimate goal of archaeology is to understand what it is to be human (Finn 2001a).

4 / Archaeology in Two Dimensions
The Artist's Perspective

Martin Pate

In 1991, my neighbor John Ehrenhard, director of the Southeast Archeological Center (SEAC), approached me about doing a painting for the National Park Service. At the time, I was working as a commercial illustrator and portrait artist. I approached the job as if it were any other assignment, but the subject matter was significantly different from what I was used to. The scene was to illustrate presumed domestic day-to-day activities at a Late Archaic site in Georgia on the Savannah River. This site, known as Sara's Ridge, was part of the land that was covered with water as a result of the Richard B. Russell Dam project.

I was excited at the chance to paint a scene of such interest, but, I must admit, I felt somewhat apprehensive about working with archaeologists. Until that time, I had done most of my work for advertising clients and art directors. As difficult as those folks could be to work with, they at least had a history of working with artists and photographers on a regular basis. I wasn't sure if the collaboration between scientist and artist would produce a pleasing work of art. In the back of my mind, I could see perhaps an overemphasis on artifacts and details that might interfere with creativity. My concerns were not to be realized, though, as the project went over extremely well. The archaeologists were thrilled to see "their site" come to vivid life. The archaeologist in charge of that site even told me that my painting was just as he had imagined it and that it looked as if I had actually been there myself. The success of this painting was to set the tone in many ways for a continuing series of paintings of various subjects and time periods.

In the Sara's Ridge painting (plate 2), it was my hope that the viewer would be not only an observer of the scene but a participant as well. The main character, a women heating stones in a fire, turns to look at you with somewhat of a scowl, saying perhaps, "Don't you have anything better to do?" The painting, along with other illustrations and photographs, was used in the book *Beneath*

These Waters by Sharon Kane and Richard Keeton and as the image on South Carolina's Archaeology Week poster in 1992.

Working one-on-one with the archaeologists, park rangers, SEAC personnel, and others involved with these projects has been a pleasure and an education. They do an outstanding job of informing me as to what it is they want depicted. At the same time, they are usually very open to artistic viewpoints. I have been asked on several occasions what I think about when I am working. When I was in art school, an instructor asked me abruptly in the middle of an assignment what I was thinking about at that moment. I realized that I couldn't answer the question. I was totally unaware of what I had been thinking about just a moment before. Later I found out that this is not uncommon with creative activity and that during the process of creating art the brain has a way of picking up what it needs to, such as someone asking you a question or a telephone ringing, but otherwise seems to operate in more of a subconscious mode. With the work I have done for the National Park Service, however, things seem to be different. I often find myself thinking about the time and place I am trying to portray. I try to imagine myself in the scene and living among the inhabitants. What would I see? What would it smell like? What would I be hearing? What would my daily needs be? What would those needs require me to do? For all but a few paintings, there are no photographs of what this place would look like—I have to take the information given to me and then use my imagination to create the scene. I often think of it as "mental time travel."

Many of the projects that I have worked on combine the visual image with well-written text that students, teachers, and others can understand. Along with good creative writing, visual imagery is critical in getting this information across to the public. In many ways I consider myself a member of the general public, and perhaps this has been a benefit to me in my attempt to bring these scenes to life. I can relate to how people who are not involved in the field of archaeology think. As a commercial illustrator, it was my job to get the attention of the viewer so that he or she would take the time to read a particular advertisement. I feel that this is also the case in my work for the Park Service. If the purpose of a poster is to educate someone about a specific historical event or to point out to them the importance of a specific site, then an exciting, colorful, and well-executed image is one of the best ways to catch his or her interest. This is especially true with students and children. Since posters and books have to compete with television, computers, and video games, attention-getting images and design are necessary to gain an edge. Art is truly a universal language, and all cultures can relate to visual imagery. I think of myself as being part of a team whose job is to educate the uninformed. Most

of the graphic art I have produced is associated with written information about the archaeology, time period, and/or the specific cultural events. It is up to the writer to explain in greater detail the story behind the scene and some of the effort involved in the archaeological study. It is my job to get the viewer's attention and give him or her a mind's-eye view of what was actually happening.

Bringing the past to life is my goal in the projects I have been involved with. Someone once asked me if creating these scenes was fun. Well, it is a unique feeling, and yes, I guess you could call it fun. There are often deadlines to meet and changes to make, but I do enjoy my work. Whether I'm creating an entire mound village or a single warrior, I can't imagine a more satisfying career. If someone looks at my paintings and says, "That's really interesting! I didn't know life was like that then!" I would consider that job successful. Of the many projects I have worked on, the following are a few of the highlights.

Yuchi Town was a Creek Indian village that thrived along the edge of the Chattahoochee River on land that is now part of the Fort Benning, Georgia, reservation. In many ways it was typical of other Creek villages, but according to the journal of William Bartram it was larger than most. Bartram, a naturalist, was making his way through Georgia in 1776 when he happened across Yuchi Town. He described this large encampment in his journals and provided me with much of the information needed for the scene. His writings along with archaeological research contributed to what I feel is a very accurate image (plate 3). In the background, along the river, I depicted William and his pack train entering the village. Military personnel at the base like the bald eagle flying overhead.

The second of three paintings in a series for Fort Benning shows an early-twentieth-century mill community known as Eelbeck. Like other similar communities in this area, Eelbeck disappeared during the buildup of the military base. This scene shows a typical busy day at the mill and was created using a few grainy photographs of the actual mill, information from descendants of those who lived there, and research on mills of the same time period. Indications of the mill, race, and dam still remain, but no structures survived (figure 4.1).

A more recent period in history is shown in the third painting completed for Fort Benning. This is the portrayal of an intramural football game played in Doughboy Stadium on December 23, 1928 (figure 4.2). According to newspaper articles at the time, it was the best show in town. One article we researched was so descriptive of everything from the weather to the attire of the audience that we decided to base the painting on this one specific game. This scene tries to capture the excitement of the audience (which included both locals and people from the surrounding counties) as well as accurately show

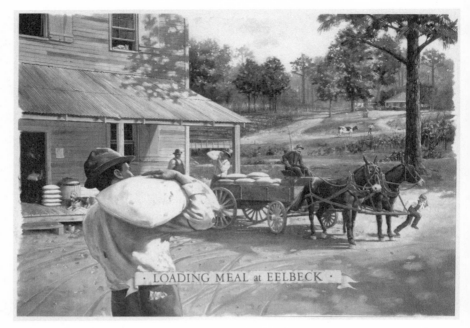

4.1 Painting of "Loading Meal at Eelbeck"

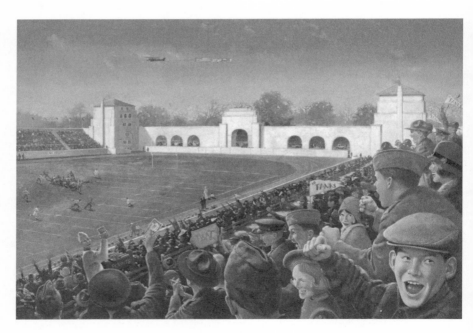

4.2 Painting of "Doughboy Stadium, 1928"

the historic stadium. Doughboy Stadium remains basically unchanged to this day and is still used. Most of the research for this painting centered on period dress of military and civilian personnel.

The WPA period was the inspiration for a painting of an excavation from the early 1940s. The WPA (Works Progress Administration) was created in 1935 and provided work for about 8.5 million persons. While the scene is intended to be representative of many such mound sites, actual photographs from excavations at Ocmulgee, Crooks, Hiawassee, Marksville, and others were used as reference. I even included portraits of people I found in those photographs. Many of you are familiar with this art, as it was used on the poster commemorating the 60th annual Southeastern Archaeological Conference (plate 4).

Among the most exciting projects I have done for SEAC would have to be the six paintings of the Battle of Monroe's Crossroads. This battlefield is located within the boundaries of Fort Bragg, North Carolina. The Civil War was a favorite subject of mine to draw as a child, and I have done several paintings on the topic as an adult. However, most of my previous work has been limited to single figures and very little action. These paintings were to show an intense cavalry battle from beginning to end. From the moment Confederate forces discovered the tracks of Union cavalry, through the dramatic dawn charge in the early-morning fog, to the heroic firing of a cannon by Lieutenant Stetson to turn the tide, this series will always remain high on my list of accomplishments. This was also a chance to paint horses, which have always been a favorite subject (plates 5 and 6).

In addition to the Monroe's Crossroads series, I have done three other paintings detailing cultural scenes in history on lands now occupied by Fort Bragg. *The Storyteller* is a large canvas that depicts the Paleolithic period, specifically, an evening in 11,003 b.c. (plate 7). You may wonder why we chose such a specific year. We knew that the positioning of the stars would be slightly different that long ago, and we assumed that the Big Dipper would be the one constellation that almost everyone would be familiar with. John Ehrenhard contacted the planetarium at Florida State University, and they were delighted to assist in "rolling back" the sky. The date of 11,003 b.c. gave us the best Paleolithic period stellar view that put the Big Dipper and a crescent moon on the northeast horizon of Hoke County, North Carolina. That sky and its slightly different arrangement of stars are examples of the reality that SEAC and I want the public to expect in our work.

Next in chronological sequence for the Bragg paintings is one of a prehistoric Woodland Period camp. This scene shows an elder female teaching younger girls her prized techniques in pottery making (plate 8). The nineteenth-century farm scene, shown in Fort Bragg's final painting and sub-

sequent poster, shows a group of boys enjoying a rousing game of marbles while a younger girl, helping her mother with the laundry, looks on in envy. My references for the house and farm were an actual farm in the area that has been preserved with many of its outbuildings.

Protecting fragile sites from looters is a challenge for the National Park Service. Continuous monitoring of sites is often not possible, and there are many stories that quite frankly make one shudder to hear. I have heard of everything from occasional surface hunters to the much more ambitious diggers who bring in heavy equipment to remove entire mounds. I was asked by SEAC to create a painting showing ghostlike figures from the past looking on with much sadness at a heavily looted site (plate 9). The painting was to represent the various themes of national parks in the Southeast. This was not only a great chance to depict characters from many different time periods but also a unique opportunity to help make a difference, even if in a small way, in the protection of irreplaceable resources. I believe that education through publications is one way to let people know there is a problem and to generate interest in doing something about it.

The mound village that illustrates the Lower Mississippi Delta Initiative poster is representative of many such sites that would have been scattered along the Mississippi Delta region. The village in the painting was inspired by many typical villages, including Poverty Point, Cahokia, and Emerald. I was impressed by my studies of mound people and their culture and wanted to convey a feeling of pageantry, grandeur, and social achievement in a complex prehistoric society.

The largest, most detailed, and most time-consuming project I have yet to be involved in is the wayside exhibit program for the Little Bighorn Battlefield National Monument. Seventeen paintings show Custer's final battle from its inept beginning to its tragic end (plates 10 and 11). The main objective was to use the images, along with text, graphics, and historical photographs, to inform visitors of the sequence of events. Many visitors know only of the action on Last Stand Hill. The paintings depict the pre-battle Indian village and Major Reno's attack along with other events that led up to the famous end. While some images show troop and warrior movements through graphics, others show detailed battle scenes of the warriors and the Seventh Cavalry. The wayside exhibits are set up in such a way that the visitor can look at the sign to see what occurred there in 1876 and then look directly up from the image to see that same area today. Striking a balance between the roles of the Indian warriors and the cavalry in the battle was part of the objective in telling the story. Of paramount importance was to correct some of the misinformation that persists with regard to this battle. Information for this series

came from some of the many books written on this subject, from park historian John Doerner, from personal observation and photographs of the present-day park, and from recent archaeological digs at the site.

Many people in this country know Native American history only from an occasional John Wayne western or a visit to Cherokee, North Carolina. They know little or nothing of the 20,000-plus years of history that transpired before Columbus. It is not news that the average American doesn't know much about the plight of archaeological resources or the onslaught of our heritage by looters and treasure hunters. Noted American historian David McCullough alarms us all when he observes that the nation is raising a generation of young Americans who are historically illiterate.

The painting of the storyteller (plate 7) shows a crowd that includes children, gathered around a fire listening perhaps to a tale of a recent exciting hunt or maybe of a well-known myth handed down by generations of ancestors. This, I'm sure, is not unlike similar present-day gatherings in the children's sections of a library or a cool summer night at a youth camp where stories are still being told. It is my hope that the illustrations I have prepared for the many thought-provoking posters, brochures, and books have aided the educational intent of these materials and have served to interest viewers into learning more. I can think of no better role for my work.

EPILOGUE

While putting together material for this book, John Jameson approached me about doing a painting for the cover. His idea was to create a face from objects and artifacts that would relate to the subject matter in the book. Creating the human image out of a collection of human tools and works of art sounded intriguing. It also sounded like a fairly simple process. He sent me several images of faces created from ancient Roman mosaics as inspiration, and one stood out. We had agreed from the beginning that the face would be most effective if it was somewhat abstract and not necessarily recognizable at first glance. The face I chose to use as my "muse" was made from crude, chunky pieces of tile and looked like it was created in a flash of creativity and rather quickly put together. It is, however, deceptively simple in its design. The more I studied it and tried to capture its spontaneity in my own work, the more I began to realize how amazing it was. As a realist painter I found it difficult to simplify my work to that level. It seems as if a child or a naive artist might have created it. The cover's arrangement of the Roman mosaic, a preliminary sketch, and my finished art (plate 12) were "accidentally" put together that way by Jameson and add to the idea of past and present, inspiration, and creation

(plate 13). The vertical three-image arrangement represents transitions—from representational to abstract, from antiquity to the modern era—that capture the theme of this book in showing the cognitive connections between archaeology and art; the mosaic of antiquity is transformed in the modern era to an anthropomorphic arrangement of artifacts that "[anchor] the flavor of lost moments in the welter of objects left behind" (Schrire 1995:11).

5 / Art and Imagery as Tools for Public Interpretation and Education in Archaeology

John H. Jameson, Jr.

INTRODUCTION

The practice of archaeology, as well as archaeologically derived information and objects, can inspire a wide variety of artistic expressions, ranging from straightforward computer-generated reconstructions and traditional artists' conceptions to other art forms such as poetry and opera. Although some level of conjecture will always be present in these works, they are often no less conjectural than technical interpretations, and they have the benefit of providing visual and conceptual imagery that can communicate contexts and settings in a compelling or unique way. We can look at archaeology's connections to art as a different way of valuing and defining the resource and making it more meaningful to the public (Jameson 2003). In this chapter I examine a variety of examples of these phenomena, especially two-dimensional paintings and popular history writing, as they apply to interpretive art as a tool for public interpretation and education.

As an interdisciplinary field of study that investigates the past by finding and analyzing evidence from material culture and the natural environment, and with a focus on predicting human behavior, archaeology has always attempted to address and explain "art" objects. Its early history as an academic field in the United States is related to the Victorian preoccupation with classical antiquity in both the Old and New Worlds, coupled with emerging ethnological concepts that concentrated on Native American cultures. These factors helped to create a philosophical and theoretical framework for early American archaeology that attracted scholars from the academic fields of history, classical studies, and anthropology as well as the art world. The American

Institute of Archaeology was, in fact, founded in 1879 by specialists from these fields who were looking to the emerging methodologies of archaeology for answers to old questions about the nature of human experience. Although archaeological method and theory in the twentieth century were expanded and transformed in many ways, drawing heavily from the physical and social sciences, the philosophical and conceptual links to the study of art have always been present (Baker 1997).

It is generally accepted today among public archaeologists in America that both technical and public interpretations of research findings are indispensable outcomes of their work. After all, is not the ultimate value of archaeological studies not only to inform but also ultimately to improve the public's appreciation of the nature and relevance of cultural history? This improved appreciation results in a higher quality of life for Americans.

The emergence of educational archaeology as a specialty and major thrust within the discipline in the 1990s marked an era when many in the archaeology profession came to the realization that they could no longer afford to be detached from mechanisms and programs that attempt to convey archaeological information to the lay public. In the face of an increasing public interest and demand for information, archaeologists have collaborated with historians, museum curators, exhibit designers, and other cultural resource specialists to devise the best strategies for translating an explosion of archaeological information to the public. The 1980s and 1990s saw a great proliferation of efforts to meet this demand with varying degrees of success (Jameson 2000).

Staff members of the Southeast Archeological Center of the National Park Service have been leaders in the United States in promoting the objectives of educational archaeology by helping to develop archaeology-related curricula, both in formal school settings and at more informal settings such as national parks and museums. They have coordinated a series of activities called the Public Interpretation Initiative, a long-term, interdisciplinary, and internationally focused program of academic symposia, training workshops, seminars, and publications with the goal of promoting educational archaeology in both the private and public sectors. A recent important project of the Initiative has been the development of an interdisciplinary course of study for cross training of National Park Service archaeologists and front-line interpreters. The goal of this effort has been to facilitate improved interdisciplinary communication and teamwork in presenting more effective and more accurate archaeological stories and exhibits.

In all these efforts, we have realized the value and power of artistic expression in helping to convey archaeological information to the public. Using the broad sense of the term, what we have called "interpretive art" has been used

successfully in paintings, drawings, posters, teaching guides, reports, popular histories, and World Wide Web presentations to engage, inform, and inspire the public about the value of archaeology.

Two-dimensional oil paintings, three-dimensional exhibits, and popular history writing are three of the most effective techniques in the public interpretation of archaeology. To be successful, these techniques must not only inform but entertain. The goals are to connect, engage, inform, and inspire, resulting in a lasting and improved appreciation of the resource.

THE ARCHAEOLOGICAL STUDY OF IMAGERY: BEYOND UTILITARIANISM

Public interpretation of archaeology involves methodologies associated with conveying factual and stimulating explanatory information to the public (Jameson 1997). There is a growing public awareness of the importance of archaeology and the ways in which the past is represented, including the inherent value of understanding imagery both from and of the past.

Archaeologists, both historians and prehistorians, have had a long-standing interest in art and the relationship between archaeology and art. Today we can find university curricula that teach archaeological approaches to the study of art that are distinct from those of the other disciplines that study art. Here, an "archaeology of art" takes an anthropological approach that often challenges Eurocentric and traditional Western interpretations.

Archaeologists, and especially public and educational archaeologists, are increasingly concerned with how the past is presented to and consumed by nonspecialists. Thus we want to examine how archaeological information is communicated in national parks, in museums, by popular literature, film, and television, through music, and in various multimedia formats, as well as its overall effectiveness. We want to explore the potential of cognitive imagery that springs from an association with archaeology and its attempts to reconstruct past lifeways. We want to know how certain interpretive methodologies, in various settings, using certain media formats, can contribute to both public and professional understanding of human history.

Webster's defines art as "skill acquired by experience, study, or observation; the disposition or modification of things by human skill, to answer the purpose intended." To me, art is something created by humans that is evocative; it is more than symbolism or simple representation. It causes the viewer to feel something: anger, joy, sadness, fear, energy, violence, tranquillity, loneliness, awe. It causes the viewer to think. It makes a social or cultural statement. It makes us see humor where we have not seen it before. It places us in settings

and moods that we have not yet encountered. It allows us to experience something in a new way. It is much more and different than mimicry. Art can do many things to us at the same time.

UTILITARIAN VERSUS AESTHETIC

An artist shows imaginative skill in arrangement or execution. Rendering an aesthetically pleasing effect is the rendering of an altered nature or an altered material world. Aristotle in the fourth century B.C.E. wrote that this modification of nature and objects produces two types of art: utilitarian art, which is necessary for life, and pleasurable or aesthetic art, which is produced for recreation. Art in the latter sense is the conscious use of skill and creative imagination in the production of aesthetic objects. But the classification of objects as art is cultural, subjective, and at times controversial (Baker 1997).

We know, or think we know, how important aesthetic art is in our own culture and in cultures around the world since the beginning of recorded history. Yet archaeologists rarely ask questions about aesthetic art in their research designs, choosing to concentrate instead on the utilitarian explanations. This strategy has been not only convenient but perhaps partially justified if one assumes, as many have, that the purpose for aesthetic art is lost with an unrecorded culture. But if only unsatisfactory utilitarian reasons can be found to justify an artifact and its attributes, then the motive for its being or creation must be aesthetic. Perhaps it is time for archaeologists to more earnestly address and relate to aesthetic art forms that have been so important in all cultures as ways of showing imaginative skills. Perhaps more accurate interpretations will be rendered, and apparent theoretical contradictions in the archaeological record explained, if the aesthetic arts are more fully considered.

Paleoanthropologists have long been at a loss, beyond utilitarianism, to explain the remarkable skill levels and apparent "artistic" attributes in many varieties of PaleoIndian projectile points and tools (figure 5.1).

Baker (1997) has pointed out that the knowable dimensions of a given culture are inversely proportional to its remoteness in time. More hard data are available as we come to more recent time periods and thus a less speculative starting point for the interpretive artist as well as the technical experts. As a result, in attempting to observe and interpret past cultural systems it is difficult for archaeologists to define or differentiate between utilitarian and aesthetic art forms. Paleolithic cave paintings in southern France were created over 30,000 years ago. However, a limited knowledge of the culture seriously impedes us from defining functional aspects of these artifacts and images. In contrast, we recognize that PaleoIndian projectile points manufactured 10,000

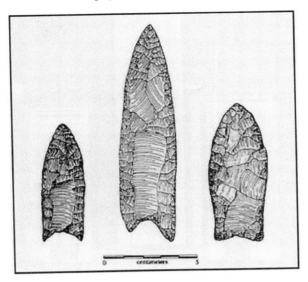

5.1. Drawings of Clovis spear points, from figure 7 of
Beneath These Waters (Kane and Keeton 1994:12).

to 15,000 years ago were produced with what appears to be a utilitarian func-
tion of cutting and piercing as part of the food-gathering process.

So, with a paucity of observable material culture, are we left only with sub-
jective or logical explanations? Do the "flutes" on the PaleoIndian projec-
tile represent a pleasurable or aesthetic art form in addition to its utilitarian
function?

Those of us familiar with PaleoIndian traditions often do not consider
these prime examples of lithic craftsmanship to be works of aesthetic art. Oth-
ers, however, speculate that they may represent some kind of ceremonial func-
tion, possibly within the realm of magic or religion. But these are vague specu-
lations at best. We suspect that some utilitarian objects through time and
culture change are embellished or elaborated, sometimes to a point where the
original utilitarian forms are barely, if at all, recognizable. We observe what
appears to be a combining or blending of aesthetic and utilitarian attributes,
and this combination has occurred across all time lines.

The painted designs on the Anasazi pottery, Mississippian carved marble
statues, carved shell gorgets (plate 14), elaborately carved pipes, carvings and
etching on gun stocks—all of these are examples of embellishments that do
not improve the function of the object. They are added because the particular
culture deemed them appropriate and aesthetically desirable. What does this

tell us about the values and cognitive imagery of the people who created these objects and attributes? How much of this is attributable to the idiosyncrasies of the individual craftsman/artist as opposed to his or her cultural environment?

ARCHAEOLOGY AND INTERPRETIVE ART

In our outreach and public interpretation efforts at the Southeast Archeological Center, we have teamed up with painters and writers to produce artistic works that complement and help explain the archaeological record while also engaging, entertaining, and inspiring the audience. Paintings can also help dispel false or stereotypic imagery by offering an alternative, more plausible scene. Aesthetically pleasing paintings can attract and engage while also serving a number of other interpretive objectives, such as supplying detailed information about the resource and carrying a conservation or commemorative message (plate 15).

Some parallels to this teamwork strategy can be drawn from recent developments in the realm of so-called dinosaur art. Expert paleontologists have learned to work cooperatively with dinosaur artists rather than dismiss what the experts perceive as inaccurate depictions stemming from the public's fascination with these fantastically large, powerful, and grotesque creatures (Weed 2000) (plate 16).

As with archaeology, the public's attraction to dinosaurs does not usually spring from a scientific source. The paleontologist's inability to say what dinosaurs really looked like has no power to drive away inaccurate icons. Media-savvy paleontologists have learned to wait to publicize a dinosaur discovery until they have commissioned a painting of the creature to show. They have learned that, by working with the artist, the experts can at least inform the public about what is known. The artists usually want to be as accurate as possible because this lends credence and prestige to their work. Most dinosaur images today, including those depicted in television and movies, are guided by hard data, although hard data can only be a starting point. Archaeologists should likewise take advantage of the public's natural curiosity in working with artists to create images grounded in hard data—announcing new discoveries and new interpretations—even if this is just a starting point, as with dinosaur art.

One aspect of our partnership with painters has been the observation that sometimes works of art can take on a life of their own. A compromise was reached between the National Park Service and the U.S. Army when it was realized that the arm slung upward in one scene was not historically accurate, yet army personnel had "fallen in love" with the geometry and overall arrange-

ment of the scene and did not want changes made (see plate 6). This speaks to the power of the medium and the skill of the artist. This is not necessarily a detriment, however, in that a good artistic rendering can enhance the effect of the piece in firing the imagination of the viewer in a more accurate path.

ARCHAEOLOGY AND POPULAR HISTORY WRITING

I want to discuss at least one other type of artistic expression where archaeology has inspired the creation of innovative and engaging works that, in turn, help to inspire the public: popular history writing. Effective writers of popular accounts know the importance of dramatic and skillful writing as well as accuracy. Popular writers of cultural resource themes can tell stories inspired by archaeology that are appealing because of the nature of the material and because of how the story is told. They are artists and entertainers who contribute both to the aesthetic expressions of art and to human understanding and increased knowledge. The most effective stories are the ones that reveal how people and societies have actually functioned. They conjure up thoughts about the human experience in other times and places. These aesthetic and humanistic expressions of cultural history inspire us to immerse ourselves in efforts to reconstruct more distant pasts, exploring the ways people constructed their lives. This evokes in us a sense of beauty and excitement and gives us added and enhanced perspectives on cultural history, society, and the human condition (Stearns 2001).

In preparing the highly successful popular history *Beneath These Waters*, the National Park Service chose a team of professional writers adept at the art of effectively translating technical information for the lay public (see chapter 6). Because contract writers Sharyn Kane and Richard Keeton were not formally trained archaeologists or historians and were unfamiliar with the world of federal contracting, they faced distinct disadvantages in taking on the task of writing these books. Their task was to take the results of two decades of research from the Richard B. Russell Reservoir cultural resources studies, strip them down to the essentials, and re-clothe them in a fashion readily acceptable to a general audience without losing the fundamental integrity of the original material (Kane et al. 1994).

The praise that *Beneath These Waters* received from the educational, scientific, and local communities attests to the book's success in providing informative access to research findings. Again, as with the oil paintings and other interpretive art, the task was to engage, entertain, inform, and inspire.

In order to provide a richer conceptual imagery to the accounts of prehistoric lifeways and to augment the large collection of available photographs, the producers of *Beneath These Waters* made use of two original oil paintings by

Martin Pate (see chapter 4), commissioned by the Southeast Archeological Center. These paintings greatly enhanced the attractiveness of the volume. They depict prehistoric scenes based on archaeological findings reported in the Russell Papers, adding an entertaining yet informative dimension not commonly seen in government-sponsored popular accounts (plate 17).

CONCLUSIONS: WORKING WITH OUR COMMUNICATION PARTNERS

The preservation of archaeological sites and objects depends on the cooperation and interest of non-archaeologists who are most often the conveyors of archaeological knowledge to the lay public. In fact, the most effective presentations and the most inspirational experiences come about when archaeologists and non-archaeologists work together as a team.

If we want more effective and inspirational appreciation of archaeology, we need to reach out to our communication partners: to park interpreters, exhibit planners and designers, to writers, poets, musicians, screenwriters, and maybe even operatic composers, and to artisans of all types to produce inspirational imagery and stories based on archaeological and historical facts.

In recent years, archaeologists and artists have combined forces to use artistic renderings as public interpretation and education tools. And, just as importantly, we observe that archaeology and archaeological information and objects have inspired artistic expression in unique and interesting ways, expanding our understanding about the value of archaeology. These artistic expressions and reactions are important enhancements to archaeology's traditional role of analyzing and interpreting evidence from material culture and the natural environment. Perhaps most importantly, they enable the general public to gain new and unique perspectives as well as a greater understanding of and appreciation for the contributions of archaeology.

6 / Archaeology as a Compelling Story
The Art of Writing Popular Histories

Sharyn Kane and Richard Keeton

Because the human past is the foundation of the science of archaeology, relating both the exciting and the everyday details of how earlier people lived is the goal behind the popular histories we write. For the past dozen years we have had the pleasure of learning about recent archaeological discoveries and sharing them in accounts intended to inform and entertain. From the start, National Park Service archaeologists John Ehrenhard and John Jameson have encouraged us to be creative in our efforts and not to be bound by what has been done before.

Taking the archaeological and historic record and weaving the facts and theories into compelling stories to capture the imagination is where science and art meet in writing popular histories. Dramatic events, character sketches, and vivid settings are among the important elements we use to try to create dynamic portrayals far removed from dry, scientific writing, but accounts that nonetheless accurately convey research findings.

Finding a way to make this information accessible to readers who have little or no familiarity with archaeology is an ongoing challenge, particularly because technical reports, which we cull for much of our information, are, well, awfully technical. We discovered this difficulty firsthand as we prepared to bid for the our first contract with the National Park Service to write a popular history about archaeological studies along the Savannah River in Georgia and South Carolina. Although we had written about technical subjects as reporters for the *Chicago Tribune* and as magazine writers, we were taken aback by the unfamiliarity of so many archaeological terms. We pored over two and three reports at a time, written about the same archaeological sites, as we tried to understand theories, findings, and conclusions. The more we read, the more we were hooked by the excitement inherent in archaeology, and soon we were

submitting our own 100-page proposal for *Beneath These Waters,* the story of 11,500 years of human life.

This first project, which began our experience in cultural resource interpretation, led to writing a companion volume about African-American history, another book about archaeology at Fort Benning, Georgia, and another about the archaeology and history concerning a Civil War battle at Fort Bragg, North Carolina. We have also explored the dusty past surrounding Brownsville, Texas, and the more recent story of Eglin Air Force Base, Florida. All of these experiences have deepened our understanding of how what happened yesterday affects what will happen tomorrow. In short, we have a longer view of human existence, and that, we think, strengthens our writing. The art of writing about archaeology, for us, comes in our attempt to stir an emotional response in readers. We want them to feel the terror of waiting at dawn for the bugle call to battle, along with gaining an understanding of how a talented archaeologist re-created the long-ago battle by interpreting spent bullets.

A skilled painter such as Martin Pate (see chapter 4), who illustrates books and other projects for the National Park Service, draws the viewer into a painting. As writers, we try to do the same thing by creating passages that we hope are vivid enough for readers to be able to see, hear, touch, smell, and taste the things we describe. To achieve this, the words must be full of sensory details that reveal something of what life was like in a particular era. In the Middle Archaic period, for instance, we might describe the barking of dogs as they fight over a piece of meat near a campfire or the screeching of an eagle soaring overhead while a Native American chips stones to make weapons. Our objective is to bring people of the past to life in a realistic setting so that readers can understand how they lived.

Here, in a passage from chapter 2 of the book *Fort Benning: The Land and the People,* we describe an early hunting scene to introduce details about an excavation at Fort Benning:

> In the early morning quiet 10,000 years ago, hunters along Upatoi Creek moved stealthily into place. They had camped overnight on a high ridge overlooking the rushing waters, a spot they chose for its strategic advantages. Downstream about 100 yards, the creek rolled over a series of sandstone ledges, creating small rapids. Behind the rapids, the water backed up into a calm pool where deer drank in the quiet just before dawn.
>
> As the deer leaned over to lap the waters, there were no unusual noises hinting of danger. Four animals stood in the creek. A fifth, a large buck, stood cautiously to the side, waiting, sniffing the air, before

he also waded in. Birds chattered wake-up calls. A mother raccoon waddled away from the stream with young raccoons strung behind her. A woodpecker hammered a dying tree. The largest deer reared his head, his antler rack barely visible in the shadows. Water cascaded from his alert face. The rest of the deer also lifted their heads and stood watchfully. Suddenly, shouting and terrible loud noises burst the calm. Men and women, waving their arms, darted from hiding places.

Startled, the deer bounded away, rapidly putting distance between themselves and their pursuers. Then, confused by all the sudden sound and motion, they noticed for the first time that other hunters were stationed on the opposite side of the creek on the bluff slopes. These hunters also shouted, waved wildly, and made banging noises. The deer plunged forward, straight into a trap. (1998:13)

Besides sensory details, action is essential to bring the importance of archaeological findings into focus for a general audience. Most readers today are accustomed to being entertained, no matter what the subject. They have little patience for endless pages of facts. Although they want to learn, they also want to enjoy the experience. Consequently, popular history scenes must be compelling, varied, and full of movement if the reader is to be expected to absorb scientific information.

We also use other storytelling techniques to lure the reader into another world. Surprise, drama, mystery, and pathos all play a role. In *Beneath These Waters*, we began with a detailed description of a Mississippian village excavated by a team led by David Anderson. We used his research to describe everything from the size of the defensive ditch that nearly enclosed the settlement to the daily habits of the prehistoric residents, including the games they played and the ceremonies they practiced. To build suspense, we finished the first chapter by outlining a scientific mystery:

Life for the villagers was closely attuned to the changes brought by the seasons and to the river flowing steadily by them. In many ways, their lives were identical to those led by their ancestors. Mothers and fathers taught their children the same beliefs and customs they had learned from their parents, and so on for generations. And when death came, family members were not buried in some isolated spot rarely visited, but beneath the floors of their homes or in earth nearby.

Then, as if carried away by a wisp of smoke, everyone was gone. No new children took up the traditions so carefully passed down over the years in this riverside setting. And not only did these people disappear,

but others for miles along the waterway also vanished. When the Spanish arrived in 1540, they found only lonely miles of lush uninhabited land, all but empty of human beings.

Five hundred years later, as part of one of the most extensive archaeological undertakings of its kind, traces of these two long-abandoned settlements emerged in northeast Georgia. From analyzing fragments, some as small as pollen grains and as ephemeral as pale stains in the dirt, and by studying accounts written by the earliest European explorers, archaeologists pieced together a partial portrait of what life was like for these people who had left no written records of their own.

But even with the abundance of knowledge gained in the years of investigations in the Russell Reservoir area, there are still blank areas on the canvas, still many remaining questions. . . . Among the more intriguing mysteries to be solved is why the people who once lived on this terrace overlooking the Savannah River disappeared. (1994:Chapter 1)

With luck, readers now will want to continue turning the pages to discover theories about what happened to the vanished residents.

In another volume, *Fiery Dawn*, which describes some of the archaeological findings of National Park Service archaeologists Douglas Scott and William Hunt at a Civil War battlefield on Fort Bragg, we try to convey the experience of an early-morning surprise assault by Confederate forces.

On a foggy, cold morning in March, nervous men and horses waited in the woods, moments before charging into the sleeping Union camp.

There was one final conference before the charge. General Joseph Wheeler met with General Wade Hampton to review last-minute details. He suggested the best results would come from soldiers dismounting before charging into the Union forces, but Hampton disagreed.

With great dignity, according to a private who viewed the exchange, Hampton replied, "General Wheeler, as cavalrymen, I prefer making this capture on horseback."

Wheeler didn't argue. Everything was set, except for one last graceful gesture. Hampton, demonstrating again the deference to Wheeler he had shown since being appointed his superior, asked the general to command all the Confederate forces and to lead the charge.

Wheeler swung onto his white charger, raised his pistol, and rode

with his escort to the front to take his place at the center of the bris-
tling semicircle of troops. A bugler rode beside Wheeler.

The rain had stopped. A thick fog floated up from the swamp and
drifted into the Union camp. Birds chattered. Horses flicked their
tails. Soldiers' hearts thumped inside their chests.

Wheeler gave the command, "Forward!"

His white horse took its first steps. Officers echoed Wheeler's
orders down the line. Wheeler commanded, "The Walk!"

Now, most of the cavalry, a sea of uniforms and horses, was mov-
ing. On Wheeler's right, many of the cavalrymen hadn't yet seen the
Union camp because they had formed in the dark behind the long
ridge. Even when they reached the ridge summit, they couldn't see
much because of the fog, but they could make out the Monroe House
above the fog about 500 yards away.

The Union general Judson Kilpatrick stepped onto the porch,
perhaps not yet fully awake. He must have intended to be outside
only briefly because he wore only a shirt and long underwear. . . .
He leaned over the porch. All around him, hundreds of soldiers slept.
Here and there, a few stirred. Some yawned as they rolled up their
blankets. . . . A few early risers had coffee brewing and breakfast cook-
ing over open fires.

Wheeler shouted, "To the Trot!"

Horses quickened their pace. Soldiers gritted their teeth, clenched
their sabers, checked their revolvers. Some must have murmured
prayers and wished their friends good luck. On Wheeler's right, the
cavalry rode down the ridge slope into the fog. On his left, soldiers
were now almost in the open.

Wheeler yelled, "Gallop!"

The entire force leaped forward almost as one. Wheeler and hun-
dreds of others streaked toward the Union camp. Wheeler lowered
his pistol, pointing it straight ahead. The bugler lifted the horn to his
lips to play the notes signaling charge. Loud, chilling war cries knifed
through the air. (1999:62)

By describing the moments before the battle, we hope to give readers a
better understanding of why the archaeological findings are important. The
bullets and other objects uncovered at the site are more than just interesting
artifacts. They are the last remnants of a terrifying episode in the waning days
of a bloody war.

Most of us have looked at a painting we didn't like. Often, the reason an
image is disagreeable is that the artist has tried to do too much, to pack too

many objects or themes into one work. The best paintings tend to blend components seamlessly. Once again, the same is true of good writing. Although it's tempting, because we find them fascinating, to include as many scientific details as possible in an account, the average reader has little patience for minutiae. When we find that we have too many ideas in a particular passage, we pull out some of the information and present it elsewhere in brief sidebars and captions. However, this does not mean that we underplay the complexity of the researchers' findings. Quite the contrary. We never underestimate the reader's intelligence. We try to give a thorough account in clear language that is readily understood, avoiding needlessly obscure vocabulary that would send most scurrying to the dictionary. The more complex the information, in our view, the simpler the language to describe it should be. "The difference between the right word and the wrong one is the difference between lightning and a lightning bug," Mark Twain said. Taking his advice to heart, we strive for precision.

By their nature, popular histories are intended for the broadest possible audience. Therefore, we strive to find the universal elements in the archaeological record that will resonate with the most readers. Unlike the archaeologist, who tries to learn and catalog every fact possible about a site and present multiple theories about possible activities there, we try to choose only the most important facts and emphasize them.

Readers can digest immensely intricate topics if these topics are written about persuasively. One secret to such writing is never assuming that the reader understands unfamiliar terms. We explain jargon, and if we use the same technical term in the next chapter, we explain it again.

Always, we try to emphasize the human component underlying the archaeological findings. For example, in explaining research at a Yuchee village in Alabama, near the Chattahoochee River, we told of the explorer William Bartram's journey to visit the Yuchee Indians. We excerpted passages from Bartram's wonderfully descriptive writing, carefully deleting long, winding sentences that would lose today's reader. Bartram traveled with a band of rough-and-tumble horse traders who seemed to unnerve him with their fierceness. One even bit an unruly horse on the ear to quiet it down.

Conditions [for the caravan] took a turn for the worse. . . . A cloud of biting flies "so thick as to obscure every distant object" swarmed about the riders and their horses. The tormenting insects stung the horses' necks so many times that large drops of blood formed and were "rolling down like tears." Bartram added that "the heat and the burning flies tormented our horses to such a degree as to excite compassion, even in the hearts of pack horsemen."

Some of the flies were quite large, virtually the size of bumble bees, and were "armed with a strong sharp beak or proboscis, shaped like a lancet, and sheathed in flexible thin valves," which they used to puncture the skin of their victims. Three or four other species of flies were smaller but vastly more numerous, and just as bothersome. Particularly vexing for animals and humans alike was a fly colored a "splendid green" all except for a gold head. The sting of this fly was "intolerable, no less acute than a prick from a red-hot needle, or a spark of fire on the skin. These are called burning flies."

Bartram, ever the scientist, carefully catalogued details about their tormentors. . . . Try as he might to keep at his dispassionate studies, Bartram, and everyone else, was suffering.

"Almost sinking under the persecutions from the evil spirits who continually surrounded and follow us over the burning desert ridges and plains," the caravan finally moved into a grove of trees, apparently near a brook, that offered hope of relief and somewhat cooler air. When the riders halted, however, there was no respite after all. They were ambushed by still another form of fly that was "small and perfectly black." (1998:80, 82)

Those are just a few examples of how we use the storytelling art to convey the exciting discoveries in archaeology. We are frequently struck by the similarities in the traits that archaeologists and writers bring to their professions. Both, to succeed, must be able to imagine things that others can't see and to persist in a painstaking struggle for exactitude. Digging for information and enjoying the search are also shared experiences, as is a willingness to alter preconceived notions if conflicting information appears. There are also mutual rewards, such as the exhilaration of discovery and the pleasure of sharing our work with others and helping them see for themselves what we have imagined. Finally, perhaps we also share a wish to leave our own marks in the sand for others to find when we're gone.

7 / Poetry and Archaeology
The Transformative Process

Christine A. Finn

> The object is inexhaustible, but it is this inexhaustibility which forces the viewer to new decisions.
>
> —Pearce 1994

Poets are editors of the inspirational world. They observe and choose seemingly disparate people, places, and things, essentialize them, and pare and trim and hone the words in the heart, in the head, and on the page. This consideration of poetry as a process is at the center of this chapter. I could have taken a straightforward approach to poetry as it relates to archaeology and, within this scope, considered the many poems inspired by such things as artifacts, sites, and the peopling of the past (see, for example, Henig 2001). But I have been fascinated by this material for nearly ten years, and returning to it after an absence, I find an alternative presentation: the idea has morphed into a text that considers the "how" of poetry as it relates to archaeology, an approach that places the poet in hand with the archaeologist.

This chapter brings together ideas relating to the transformative process. It gathers artifacts, places, and bodies seen in a particular context, that is, the work of the northern Irish, and Nobel Prize–winning poet Seamus Heaney. I have written elsewhere about Heaney's use of the curious northern European finds known as "bog bodies," and I used the material as a basis for a doctoral thesis that considered how Heaney and W. B. Yeats made use of antiquity and archaeological tropes over a period spanning the late nineteenth to late twentieth century (Finn 1999a, 1999b, 2000, 2003). It was a period in which archaeology can be said to have emerged as a discipline. But neither Yeats nor Heaney was an archaeologist; they ingested their sense of the past from other places, such as books and museums, and from being among archaeologists.

Seamus Heaney first saw the bog body with which he is most often associated—the Tollund Man (figure 7.1)—as a photograph in a popular book, *The Bog People*, by Danish archaeologist P. V. Glob. Heaney used his craft to transform that image into a poem, "Tollund Man," which was published as the last poem in one collection, *Wintering Out*, and spawned another, *North*, in which he draws on other bog bodies, and bog finds, as inspiration not to articulate archaeology but to create a metaphor for the Irish Troubles. The "how" of this transformative process is the crux of this chapter.

I consider both the archaeologist and the poet to be mediators of sorts. In the manner of an archaeologist, Heaney, the poet, digs down through layers of personal memory to bring some "thing" to the light, to mind, and to the surface of the page. The process has associations connected with the poet as a seer, and it can be taken further, as both the poet and the trained archaeologist can "see" what is not obvious. In my treatment of the "things" in the poet's work I am mindful of continual reinterpretation that is part of the understanding and interpretation of poetry and archaeology.

The idea of archaeologists communicating on behalf of inanimate objects can be extended here to poetry to show how Heaney's words allow "bog finds" to "speak." And it is a two-way process. As Heaney has noted, the bog bodies helped him articulate personal feelings about the atrocities in Ireland (see, for example, Heaney 1999), while his use of such ancient motifs gives the objects a new audience, outside archaeology, and in the realm of literature.

What is apparent here, then, is a process of transformation. American archaeologist and anthropologist Michael Schiffer (1976) has described the effect of "C-transforms," the cultural changes at work on objects consigned to the archaeological record that arise out of social behavior or, more plainly, use. These include things becoming discarded and consigned to a temporal wasteland, only to be retrieved and given status hundreds or thousands of years later as valuable data. Objects from the bogs of northern Europe were originally found during the cutting of the bog for fuel. We do not know what has been discarded; by the time of the Tollund Man find, such curiosities as bodies arising out of the landscape prompted a call from their finders to an archaeologist, such as P. V. Glob. The body was a "thing," an artifact, and archaeologically classifiable. But in Heaney's eyes it was a wondrous still-person, one who prompted poetry.

Schiffer's work moved away from New Archaeology's main tenet that a "thing" was entirely quantifiable and scientifically classifiable. Schiffer goes so far as to claim that the cultural past is knowable, but only when the nature of the evidence is thoroughly understood. The archaeological record, as he saw it, was "a distorted record of a past behavioral system" (1976:12). The attachment

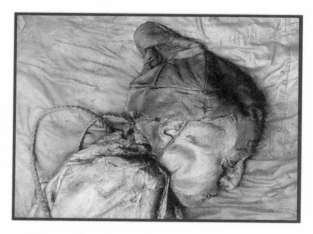

7.1. Photograph of Tollund Man. Copyright Silkeborg
Museum of Denmark. Photograph by Lennart Larsen.

of a certain meaning to a "thing" is increasingly problematic because of the
sheer range of possibilities available for the interpretation of objects and sites,
both within and without the field of archaeology.

The relationship between meaning and time changes over years, decades,
centuries, and millennia. This opens up philosophical possibilities that are ap-
parent to the poet as much as the archaeologist. Martin Heidegger's theses
concerning poetic expression and the construct of time seem appropriate here,
as Terrence C. Wright has shown by taking Seamus Heaney's work explicitly
into the domain of philosophy (Wright 1994). Wright suggests that the dis-
cussion of Heaney's work in this context illuminates because it draws on
Heidegger's idea that poetic expression is essentially temporal and that it
is distinguished by its ability to project possibilities for language, thought,
and action. This feeds back into the notion that a poetic interpretation of
archaeology—and by that I mean one that moves into the metaphysical to
consider the essence of a "thing"—should be included in the armory of inter-
pretative tools available to the archaeologist.

Heaney's armory regularly includes taking objects, "things," and transform-
ing them as tropes for poetry through personal reinterpretation. The possi-
bility afforded by a "thing" is considered in a different context by Susan Pearce,
whose citation at the beginning of this chapter comes from a discussion of
objects in a museum. She notes that the meaning accumulated in an object is
such an intensely individual experience that it is "often of limited interest to
anybody else" (Pearce 1997:20). But then she goes on to describe in great detail
the research that has attached considerable meaning to one museum artifact,

an infantry officer's jacket, a red coatee, as worn by Lieutenant Henry Anderson at the Battle of Waterloo on Sunday, June 18, 1815. As Pearce's story of the man unfolds, the reader's interest is tuned in to the life of a soldier, through which the jacket "speaks." Pearce's selection of the object and the results of her research provide the detail; the jacket, its piquant color of red, and its positioning on the back of a soldier in a historic battle perform the role of poetic metaphor. Through her narrative, the jacket is transformed from an article of clothing to property that once belonged to someone. Since the owner is long dead, we realize that the jacket left behind has "witnessed" history and so can "speak" to us.

This is precisely what Heaney is doing with his use of things that take us back in time to witness, through objects and their imagined social and cultural context, the ritualization of the bog body. We are transported through this transformation because the poet has, to take Pearce's idea, been forced to a decision to use or disregard, either to add this object to the fieldwork collection —his word-hoard—or to pass on by. In another Heaney poem, "Victorian Guitar," this time focused on an inanimate object rather than a preserved body, the poet considers a simple engraved plate on an instrument case and, through the clues it offers to owner and date, constructs a biography that goes beyond the pragmatic and knowable, into the imagined and possible. Having taken a stand on the object, the poet has transfigured it from palpability into metaphor and back to the palpable as words on the page of a book as a poem in the collection *The Spirit Level* (1996).

In sensing and realizing this potential for animating the inanimate, the poet is employing intuition and imagination; in effect, he is fulfilling the ancient role of "seer." He is a conduit between the nonsentient "thing"—and I include here the skeleton or corpse as an archaeological artifact—and the realm of the senses. In what may appear to be a bold leap, I suggest that intuition, with its associations with divination and prophecy, seems hardly at odds with the scientific techniques appropriated by archaeologists in the realm of "remote sensing." The techniques of "seeing beneath the soil" include probing and imaging—the word is, after all, close to "imagining"—and I will discuss these to further my argument that both the poet and the archaeologist mediate between the past and the present.

The title of this chapter implies a connection between the transformative actions of the poet and the archaeologist, and I should make this more distinct. Both have the capacity to change material in concept. Heaney takes the domesticity of a whitewash brush and with his crafted words takes the reader into the incident of his memory; the archaeologist, with a deft movement of soft bristle, reveals the sherds of a Beaker burial and opens up the Bronze Age.

In comparing the poet's "fieldwork" with that of the archaeologist, I am

suggesting that there are similar processes of selection and recovery. Processes, and the products of those processes, change over time but retain an ability to derive a sense both from their original context and from the context of the archaeologist or poet.

For example, in the minutes before the discovery of the Tollund Man, the body lay in the state in which it had been left two thousand years before, there being no subsequent evidence of tampering to disprove this. When the body—or he—was found, partially exposed by agricultural work in peat cutting, it—or he—was brought into the twentieth-century world of the person wielding the spade. When fully exposed and recovered from the bog by archaeologists, the body became an artifact; when examined under autopsy it became a corpse; when displayed, it became an attraction in a museum; when published in text and photographs, "it" began to take on the characteristics of "he," the name "Tollund Man" becoming significant. These are all stages of mediation; Heaney's intervention continued this change over time still further. His response as a poet to the photographs prompted words that articulated his feelings about victims of the Irish Troubles. In a sense, he rescued the Tollund Man from the archaeological classification "artifact," plumping out the body's flesh again to provide a metaphor for sectarian killings.

The concept of rites of passage is more generally used in anthropology or sociology to mean the ritualized movement of persons as they pass through certain states that make them different from others around them. Arnold Van Gennep's Les Rites du Passage, first published in 1909 but not translated into English until 1960, is a useful study for the consideration of the idea of change in Heaney's poetry (Van Gennep 1960). Van Gennep, a prehistorian and ethnographer, argued that three stages are in play in social behavior: separation, transition, and reincorporation. Archaeological material may be said to pass physically from underground into the air, this exposure making its state transitional with regard to meaning, that is, open to interpretation. The material is then reincorporated as data in a research context and/or placed in a museum, where it is exposed and made observable to a group wider than, and different from, the archaeologists.

Without delving into the philosophical argument governing states of being, it is apparent that the objects existed as "things" before transformation into poetic metaphor or archaeological artifact. The state in which the bog body, for example, lay before discovery was a place of liminality, between the world of prehistoric northern Europe and twentieth-century Denmark, a relationship between time and space dictated by the layers of bog that had accumulated over the body. It is fair to note that this in-between-ness is only pertinent because we know the body was raised, or displaced, out of its original context

and that for the two thousand years or so during which it was unknown it was in a state of liminality.

In other words, bog bodies that are hitherto undiscovered in the boglands of northern Europe are examples of speculation, suggested by the finds of others. There may be hundreds more under Tollund Fen. On the other hand, there may be no more anywhere. One further consideration is that bog bodies may have been found and not recognized, or badly damaged or not survived. However, my interest here is with the known bodies, those held "waiting to be found," as Heaney once described the mythological duo Diarmuid and Grainne in the poem "Glanmore Sonnets," in *Field Work* (1979).

Van Gennep was fascinated particularly by the idea of liminality as a part of ritual; it occupies a "place between" the unknown and the known, one in which time and space may be suspended. In anthropology the liminal is the realm of the shaman, the magician, the diviner, the childbearing woman who is dangerous, and the blacksmith who has the power to charm metal. Overall, Heaney's poetry shows a number of examples of what may thus be termed "liminality" in the use of words and images drawn from these realms. The poet and the archaeologist mediate through this area of liminality. I am concerned particularly with the effect of the mediation, namely, the process, and results, of transformation.

"Surviving poems can, like the artifacts discovered by an archaeologist, be arranged in chronological sequence that may reveal something of their evolutionary development" (Bloomfield and Dunn 1989:1). Morton Bloomfield and Charles Dunn's study, *The Role of the Poet in Early Society*, notes the value of approaching ancient poetry in the manner of a series of "things." Although analysis is archaeological in this respect, they turn to social anthropology to attempt a definition of the function of the poet. This discipline complements archaeology by opening up discussion of a "thing" as having a biography that is contingent on social practices. The fieldwork undertaken by archaeologists (or poets) makes it necessary to consider arrays of material and changes of state as the transformations of objects over time, the potential rewriting of biographies. These are processes of transition, where the steps may be re-created from archival evidence or details of personal history.

The practice of poetry is "transformative," an association with magic reinforced by the role of the poet as a seer. This is particularly apparent in oral cultures; in the present day, Western anthropological studies have highlighted the considerable power of the poet in African and other premodern societies, in a tradition that links shamanism with the ancient Celts, notes Nora Kershaw Chadwick in an early and important study of the relationship between poetry and prophecy. "Over a wide area of the earth," she maintains,

"poetry and prophecy are the two essential elements in the coordination and synthesis of thought and its transmission" (1942:xiii).

The ideas of the past being kept alive and of the dead living accord with that of resurrection, with which archaeology and poetry are both connected, where the objects and the dead of the past come into the present. The power necessary for this transformation is implied by the structure in which it takes place. In the case of poetry, the metaphor allows a "thing" to reverberate. "This stone's alive with what's invisible," Heaney writes, and he converses with the dead in *Station Island* (1984).

In places of oral tradition where the poet holds sway, the spiritual aspect of society is fundamental to the notion of divine kingship, a status upheld by the skill of the poet as inspired seer. Ruth Finnegan and others have noted this power structure in contemporary societies (Finnegan 1970). The role of the poet in pastoralist societies, such as the Nuer of East Africa, is relevant in comparison with another cattle-based society, the prehistoric Celts. Bloomfield and Dunn's thorough analysis of oral societies offers interesting analogies between archaic Irish literature and that coming out of present-day, premodern, oral contexts.

The word "file" in Celtic corresponds to "poet" in English but corresponds etymologically to "seer," and it is this ability to "see" with which ancient poets are associated that I wish to explore further in my analogy of poetry and archaeology. Bloomfield and Dunn point out that the training of the chief poet-seer involved twelve years of "mastering the intricacies of meters and in memorising myths, legends and genealogies" (1989:48), as well as understanding the traditions of law. They point out a similarity with the training of the Brahmin scholar in Hindu society. The role of poet is not easy to define, being less clear-cut than how a specialist writer may be described in present-day Western society. Bloomfield and Dunn note that in the most archaic descriptions of the early Celts, the function of the *fili* (the one who sees, the poet seer) is not distinguished from the *breithem* (the one who bears judgment) or of the *senchaid* (the one who knows past history) (1989:48).

Given the lack of written texts relating to pre-Christian Celtic society in Ireland, knowledge of the role of the early Celtic poet is derived mainly from two textual sources: classical texts emanating from outside the society, which may be said to describe the Celts as the "other" and include risk of bias, and the early Irish laws written down by monks and dating from the early medieval period. Among philologists and archaeologists it has become accepted practice to consult the documents of the later period with caution. The argument for their use rests on the apparent non-Romanization of Ireland, which therefore has implication for "pure" sources from a period when the rest of the Celtic world—including Ireland's neighbors Spain, France, England, Scot-

land, and Wales—was under the influence of the Roman Empire. In terms of the analysis of the "ancient poet's word-horde," as Bloomfield and Dunn (1989:48) describe it, this poses some interesting allusions.

Kenneth Jackson's study of comparative literature looks for traces of Greek myth in the Irish vernacular of the *Ulster Cycles* (Jackson 1964). He suggests that the ruined hill-fort of Emain Macha, or Navan Fort, near Armagh in the north of Ireland may be regarded as an "Irish Mycenae" (Mallory 1989). Jackson compares Homer's *Iliad*, an epic thought to date from around 800 B.C.E. but describing events of the earlier Bronze Age of Mycenae, with the Irish epic the *Tain bo Cuailnge:* Agamemnon is equated with Conchobar, the Achaeans with the *Tain*'s Warriors, Achilles with the hero Cu Chulainn, and Nestor with Fergus the Druid.

Jackson suggests that the oldest Irish hero tales "belong to a pre-historic Ireland" (1964:4) and that the background of Irish epic tales predates changes brought about by Christianity. Mallory and others have argued, however, that the *Tain* reveals Viking influences, and both may be correct (Mallory 1986). Other contentions include comparisons of archaic Irish texts with ancient Sanskrit, raising an argument for common Indo-European origins debated through archaeology and philology (Dillon 1947). Dillon bases his argument, in part, on the value ascribed to truth in both societies.

It is the power of the word—the poet's armory—with which I am concerned in this context, and in particular its connection with magic and inspiration. Bloomfield and Dunn note the importance of charms—"Our gift of language is a magical gift"—and they cite the contention that "in Homeric epic, words in the form of prayer, magic charm and suggestive of fascinating speech are used to heal" (1989:10, and note Entralgo 1970:240). I am reminded of Heaney's potent elegies in which the conjoining of the physical with the metaphysical offers the power to soothe. The incantations found in Heaney's various bog body poems provide numerous examples: the "almost love" breathed over the Windeby Girl in "Punishment," the gentle "pillow of turf" the poet places under the head of the "Grauballe Man," who is "bruised like a forceps baby" and yet, says Heaney, he is "perfected in my memory" (Heaney 1975b).

There is, of course, an inherent problem in classifying material as archaeological—or I should say there are problems for the pragmatist applying scientific rigors to reach one conclusion or interpretation, but increasingly less so for archaeologists open to the suggestion that the interpretative process is active and contingent. This is in effect the argument between the method of interpretation associated with the so-called processual archaeology of the 1960s and 1970s, led by David Clarke and Louis Binford (1983), and their critics who argued for a less scientific and more relative approach that incorpo-

rated social and poststructuralist archaeology. Ian Hodder's contextualized archaeology has proved the most successful, and enduring, reconsideration of interpretation, his early ideas being based not on the material culture of prehistory but on ethnographic analysis of artifacts in Kenya to determine their meaningfulness. Hodder asserted that all objects are meaningfully constituted by their context (Hodder 1982, 1986, 1987; see also Hides 1997).

However, it is important to realize that considerations of precise interpretation are less significant for the creative writer, and a description of evidence as "ambiguous" should not concern a poet, in particular, who is already dealing in the shifting language of metaphor. In my argument, Heaney is drawing primarily on things and events that, by the nature of poetry, may be metaphorically primed in a myriad of ways. Heaney's interest in the bog bodies was linked with his own biography; his "receiving stations," as he calls them, were open at the time he was writing his bog poems. My interpretation of Heaney's poems as "archaeological" comes largely from the way he tackles this "change over time."

Farmworkers in Ireland, particularly those working on bogland, continue to turn up materials that may be categorized as "archaeological" to a trained eye but still retain a folklore element. This ongoing reinterpretation is a useful way to approach poetic metaphor through the idea of a "displacement of concepts" (Shone 1963), a shift in perception necessitated by cultural change, such as the technology of which archaeological science is a part.

The activity of digging opens up questions regarding the nature of archaeology and of where the practitioner's action differs from the digging of the farmer or the peat-cutter. How does the digging that uncovers bodies from prehistory or history differ from other types of digging in its responsibility for the dead? The issue here is not the repatriation of bones but the act of raising from the "dead"—in this sense, the world of the past which is that unknown to the contemporary society of the archaeologist. How does this act inspire the poet? It is clear that the idea that a body is a body is a body is not applicable here. And the same can be said of other materials valued by archaeologists, peat-cutters, and poets in their different ways.

Heaney has resurrected the "it" of the Tollund Man—the body is in the present—through the process of poetic metaphor. The same could be argued of the archaeological process, in which the body is brought to light as exposed, analyzed, and displayed. The Tollund Man, now referenced in archaeological reports, has been brought into the present of archaeology as an artifact classified in a discipline. With everyday activity a two-thousand-year-old body, unnamed, entered into the twentieth-century world of a Danish peat-cutter.

Heaney's more recent work has taken him out of the earth and into the air, offering mediations that are also part of the archaeological process. "The

Thimble," a poem from *The Spirit Level* (1996), offers examples of an object's change over time almost in the manner of self-conscious archaeological interpretation. The five-stanza poem traces the movement of a thimble from its beginnings "In the House of Carnal Murals" as a container for "a special red" used by a painter. Then it gains provenance as "Under the Reformation, it was revered / As a relic of St. Adaman," being a bell that "shrank miraculously" and which "henceforth was known to the faithful / And registered in the canon's inventory / as Adaman's Thimble."

The poem's third stanza explores the size of a "a thimbleful" as "a measure of sweetest promise." The fourth makes it a fetish of a modern age:

Now a teenager
With shaved head
And translucent shoulders
Wears it for a nipple-cap.

And further transformed in the three-word final stanza, the artifact is sent on its way through time like a projectile:

And so on.

Heaney's poetic reinterpretations are clear, concise, observable, and highly personal. The same is proposed for the transformations of objects to artifacts in the context of public archaeology.

8 / Reflections on the Design of a Public Art Sculpture for the Westin Hotel, Palo Alto, California

David Middlebrook

I have always been interested in forgotten people, in the outsiders, the ancient tribes, and Native Americans. *Step in Stone* (plates 18 and 19) measures 21 feet, 6 inches high by 18 feet wide and weighs 17.5 tons. Completed in 2000, it towers above the El Camino Real in Palo Alto, California, across from the Stanford University campus. This piece, featured in the book *Artifacts* (Finn 2001b), which is about technology and material culture in Silicon Valley, is a statement of anthropology as well as art. The stone came from the Cascade Mountains in the northwestern United States. At the tiered sculpture's base are three large basalt timbers that lean on each other to form a tripod. On the underside of two of the tripod columns are carved renditions of 30,000-year-old cave paintings found in Lascaux in southern France. A short piece of basalt caps the base structure, which reaches approximately 12 feet. The next tier is a hollow granite cube perched atop the tripod on one of its corners. The sculpture's crown is a bronze blue patinated three-dimensional parallelogram that weighs 200 pounds. The sculpture is reminiscent of the Greek letter π, used in geometry. I spent an entire year fabricating the stone and bronze structure.

The design is at the core of my being. I was thinking about how quickly the United States has downplayed the integrity of primal art. The work was inspired by the Lascaux cave paintings. At my studio near Los Gatos, I projected transparencies of those images onto the full-scale maquette for the basalt base and played around with the shapes and textures. It was an intense experience. I was virtually in a trance. I was imagining myself as a caveman. The piece uses

themes from archaeology and also science, in keeping with the nature of Silicon Valley's connection with technology over time. I often use themes from the past and rework them in my public artworks.

I also see the piece as a celebration of humankind's endless quest to understand this world and the mysteries of life. The time period it covers is basically the evolution of thought—from cave paintings to cyberspace. The subterranean cave paintings, plus the use of basalt formed by underground magma during volcanic eruptions, celebrate the earth as a canvas. The precariously balanced granite cube refers to the postmodern era of style coupled with the engineering superiority that has seduced us into thinking we can control natural forces. Many of the people who visit the Westin Hotel in Palo Alto are in the area for business and research purposes, perhaps searching to understand where cyberspace and technology will lead, much as early humankind sought to comprehend what the future might hold.

9 / Pompeii
A Site for All Seasons

David G. Orr

... it is not at all the business of an observer to attempt to explain the effects of which he has been eyewitness; his duty is to describe faithfully what he hath seen, without adopting any system or particular opinion; otherwise he may impose upon the learned as well as the ignorant.
> —Father D. J. Marca de la Torre, Description of a Torrent of Fire that issued from Mount Vesuvius in the year 1751, in Bellicard 1753:207.

All that is past we seek to treasure here,
All that may make the past a thing of life;
And we would save what else in worldly strife
Might perish, though the present hold it dear.
> —H. R. Wadmore, "Time's Footsteps," in Stewart 1994:143.

How many times has the ancient town of Pompeii been rediscovered? Some would first argue that it was never lost. Indeed, the mesa of volcanic rock upon which it resides so prominently was called "La Citta" in the medieval period. Before that it must have been known to the curious inhabitants of the region who marveled at its odd contours and washed-out artifacts. In the late sixteenth century, Domenico Fontana, a multitalented architect and engineer, accidentally uncovered the site when an aqueduct that he designed and built cut through the buried city. Little was made of Fontana's discovery; the excavations in Rome were far more impressive in the unearthing of statues and other Roman treasures. Throughout the seventeenth century the wonders of Pompeii remained hidden from the scrutiny of baroque Europe. Ultimately it was in the eighteenth century that Pompeii made its rich material legacy from the first century C.E. known to Western civilization. Pompeii's immediate impact on the Enlightenment in eighteenth-century modern Europe is well known.

The excavations of Pompeii and Herculaneum worked a powerful influence on the decorative arts, architecture, and what was later called the neoclassical movement in art. But Pompeii also greatly influenced a broad range of human behaviors and an equally diverse spectrum of disciplines and media. From Virginians to Iranians, from poets to painters, from art critics to historians, from operatic composers and set designers to photographers, Pompeii's wondrous ruins stimulated a wide range of creative processes. Some of these we will describe and interpret in the context of the archaeological landscape of Pompeii itself.

Our knowledge of Pompeii at the present time describes a fairly flourishing town that was founded as early as the late eighth or early seventh century B.C.E. In the seventh century the Oscan-speaking Italic peoples of Pompeii came under the sway of the Greeks from across the Bay of Naples at Cumae and later the Etruscans who had moved into Campania from the north. After the Greeks had defeated the Etruscans in the early fifth century B.C.E., the Samnites (a strong Italic culture from the spine of central Italy) ruled Pompeii until the final conquest of the town by the Romans in 80 B.C.E. The victorious Romans established a colony under Publius Sulla, the nephew of the great dictator Lucius Cornelius Sulla. Latin began to replace Oscan as the city's lingua franca, and Roman customs and material culture gradually changed the town's urban landscape. In 62 C.E. a great earthquake severely disrupted the town and seriously damaged its institutions and major buildings. Pompeii was not fully occupied, with many of its structures standing empty, when the great catastrophe of August 24, 79 C.E., occurred. By the next day a combination of pyroclastic flows and rains of ash covered the town and the surrounding countryside of Campania to a depth of almost seven meters. Although some of the structures (e.g., the amphitheater and the walls) must have been recognizable under the ash, the city lay fairly well protected until the advent of modern excavation and was never reoccupied (for a series of good summaries of the above material see Bongers et al. 1973; Brilliant 1979; Della Corte 1965; De Vos and De Vos 1982; Jashemski 1979, 1993; Maiuri 1960; Mau 1902; Orr 1978; Varone et al. 1990; Wallace-Hadrill 1994; Zanker 1988). From the beginnings of the first systematic excavations of the early second quarter of the eighteenth century, Pompeii holds the distinction of being the longest continuously excavated archaeological site in the world. From 1860, when Giuseppe Fiorelli became site director, the town was divided into nine regions, the city blocks in each region (insulae) were numbered, and each opening into the ruined structures was given a number. The result of this management plan was that every separate structure was given three numbers (region, block, opening) in order to facilitate provenience and administration. This system persisted to the twentieth century, when large-scale excavations followed the

main streets of the city (plate 20). Today, excavations are generally confined to subsurface probes designed to show the evolution of the town, its actual origin, and the structures overlain by the present buildings.

Pompeii's impact upon European cultural history in the eighteenth century was immense. News of the discoveries filled the imaginations and curiosities of both collectors and humanists (Leppmann 1968). Horace Walpole wrote enthusiastically to Benjamin West: "There is nothing of the kind known in the world; I mean a Roman city entire of that age, and that has not been corrupted with modern repairs. . . . 'Tis certainly an advantage to the learned world that this has been laid up so long" (Brilliant 1979:56). The newly unearthed cities of Vesuvius were also important stages on the so-called Grand Tour, a peregrination by the well born of Europe who, accompanied by tutors and guides, avidly sought the antiquities that had been so recently unearthed (Hibbert 1987). Sir William Hamilton, British envoy to Naples since 1764, had an enormous collection of antiquities, much of it harvested from the haphazard excavations at Pompeii and Herculaneum (Aine 1861; Garguilo 1861). His residence in Naples, the Palazzo Sessa, was an important stop on the Grand Tour where the uninitiated were oriented to Pompeii's archaeological treasures. The art movement precipitated by the discoveries of the buried cities of Pompeii and Herculaneum was neoclassicism, and it quickly coupled itself to the theories of Winckelmann (Vermeule 1964:132–133). Johann Joachim Winckelmann visited Naples many times and was the first to appreciate fully the archaeological context of Pompeii and the great gulf that separated Greek from Roman art (Brilliant 1979:47–48; Hatfield 1943). The mural paintings discovered in the Pompeian excavations contributed much to the mural treatments of the architect Robert Adam (Vermeule 1964:2). On the educational front, cheaply produced guides to Roman antiquities, emphasizing Pompeian matters, were made available "for the use of Neapolitan seminaries" (Aula 1778: the illustrations of a banquet scene on a triclinium are evocative of Pompeian examples; see the two plates between pp. 56 and 57 in volume 2). But in a larger sense the impact of the Campanian excavations of the eighteenth century was in the simple truth of discovery itself. An entire Roman city had been revealed with its associated artifact assemblage; a new way to look at the past indeed! Simultaneously, Samuel Wallis in 1767 had discovered Tahiti, and with the subsequent Polynesian voyages of Cook and others, England and the Continent experienced the discovery of both dead and living cultures. Such a sense of discovery quickly had its effect also to the more abstract world of poetry. An excellent example is David Mallet's "The Excursion":

Thus all day long: and now the beamless sun
sets as in blood. A dreadful pause ensues;

Deceitful calm, portending fiercer storm.
Sad night at once, with all her deep-dy'd shades,
Falls black and boundless o'er the scene. Suspense,
And terror rules the hour. Behold, from far,
Imploring heaven with supplicating hands
And streaming eyes, in mute amazement fix'd,
Yon peopled CITY stands; each saddened face
Turn'd towards the hill of fears.

Mallet 1759:91–92

By the nineteenth century, Pompeii was again "rediscovered." This time the discovery took a decidedly romantic turn and was extolled by poets, artists, and musical composers. The excavation of the Temple of Isis in Pompeii was a big event on the eve of the romantic period in European philosophy and art. After Napoleon's Egyptian expedition of 1798, a taste for things Egyptian swept the Continent. Pompeii's Temple of Isis seemed to inspire productions of the *Magic Flute* and similar operas (De Caro et al. 1992:15 n. 168). In a letter of March 1787, Johann Wolfgang von Goethe describes Pompeii within the world of nascent romantic feeling: "On Sunday we were in Pompeii. Many a calamity has happened in the world, but never one that has caused so much entertainment to posterity as this one. I scarcely know of anything that is more interesting. The houses are small and close together, but within they are all most exquisitely painted. . . . Over the back (of a priestess's tomb bench) you have a sight of the sea and the setting sun—a glorious spot, worthy of the beautiful idea" (Goethe 1911:194).

The great spectacle of Italian opera used the dramatic story of Pompeii's destruction as a fitting setting for a grand romantic epic. By the early nineteenth century both set designs and costumes began to show a growing awareness of historical authenticity. This development owes much to the dissemination of the discoveries made at Pompeii (Kimball 1991:210). The best example of this can be found in the operas of Giovanni Pacini (1796–1867). The composer of scores of such historically based works (e.g., *Cesare in Egitto*, 1821; *Messandro nelle Indie*, 1824), Pacini wrote *L'ultimo giorno di Pompei* (The Last Day of Pompei), which debuted on November 19, 1825, at the Teatro San Carlo in Naples. Later, in Milan in 1827, Sanquirico provided the scenic backdrops and set design for the opera; the finale was especially dramatic. Elaborate scenery was the order of the day in Pacini's operas, and *L'ultimo giorno di Pompei* was certainly no exception (Parker 1994:193). Unfortunately, Pacini's classical operas are not researched to the level that we would wish, and they are rarely performed. The title of this opera immediately brings to mind *The Last Days of Pompeii*, written by Edward Bulwer-Lytton in 1834, based upon two

years of residency in Naples. From this base at Naples he frequented the ruins of Pompeii and Herculaneum. He probably heard of the Pacini opera, and according to Brilliant (1979:173) he attended an exhibition of the paintings of a Russian artist named Karl Bryullov. Among the works exhibited in that Milanese gallery was *The Last Days of Pompeii,* painted in 1828.

Bulwer-Lytton's novel *The Last Days of Pompeii* was the Pompeian tour de force of the nineteenth century and was a huge success, contributing immensely to his eventual knighthood. Bulwer-Lytton paid his great debt to Pompeii in the preface of his most famous work:

> On visiting those disinterred remains of an ancient City, which more perhaps than either the delicious breeze or the cloudless sun, the violet valleys and orange groves of the South, attract the traveler to the neighbourhood of Naples; on viewing, still fresh and vivid, the houses, the streets, the temples, the theaters of a place existing in the haughtiest age of the Roman empire—it was not unnatural, perhaps, that a writer who had before labored, however unworthily, in the art to revive and to create, should feel a keen desire to people once more those deserted streets, to repair those graceful ruins, to reanimate the bones which were yet spared to his survey; to traverse the gulf of eighteen centuries, and to wake to a second existence—the City of the Dead!

Bulwer-Lytton's novel was one of the most broadly distributed works of English popular culture, and it influenced much of what has come to be called "Pompeian."

In our most recent past, several motion pictures have been made based on the novel, and a *Classics Illustrated* comic book of the tale appeared in the 1950s. An unproduced play by the noted American playwright George Henry Boker, entitled *Nydia* (the blind Greek slave heroine of the novel), was written in 1885 (Boker 1929:xv). Nydia had earlier been a favorite subject of neoclassic sculptors. Bulwer-Lytton dedicated his novel to Sir William Gell, whose *Pompeiana* was an important source book for decorators, architects, and antiquarians (Gell and Gandy 1852). Gell had argued against the practice of removing the paintings, mosaics, and artifacts from the structures of Pompeii: "It is much to be regretted that means could not have been devised for [the paintings, mosaics, etc.] preservation *on the precise spot* at which they were originally found, and where locality would have thrown around them an interest which they entirely lose when crowded with other curiosities, into the Museums of Portici or Naples" (1852:9, emphasis added).

Although the emphasis in the above is mine, the dilemma Gell expresses is one that archaeologists still face in the interpretation of objects in context. The

practice continues to the present day in Pompeii. The romantic poet Robert Byron knew Gell very well and referred to him in "English Bards": "Of Dardan tours, let dilettanti tell, / I leave topography to classic Gell" (Clay 1976:3). Mariana Starke's *Travels in Europe* probably relied on Gell's work for an impressively long (1839:314–352) section on Pompeii. Starke also documented an early example of Pompeian "living history" when she relates that a dinner for twenty persons was prepared in the original kitchen of the triangular forum of Pompeii (1839:347–348).

Others were taken with Pompeii as well. In August 1864, German historian Ferdinand Gregorovius visited Pompeii, accompanied by the director of excavations, Guiseppe Fiorelli, and commented on what he saw: "The four figures—cast in plaster—of Pompeian fugitives, who were turned to stone (!) while in the very act of flight, make an indescribable impression: life incarnate in its most awful tragedy. . . . Wandered a long time about Pompeii, went to the house of Diomede, and reflected on my own career, especially on the time when I wrote the poem of 'Euphorion.' Even this too is covered, as it were, with ashes; the sensations I then experienced have passed away" (Gregorovius 1911:211–212). Pompeii's renown had spread to the Near East as well. A prominent Persian named Haj Sayyah visited the site and recorded his observations in his diary: "Pompeii had been a city in the old days. It had been destroyed and buried by the eruption of Mount Vesuvius. All Pompeii could still be seen—the walls, the open places, the rooms, the shops, the theater—all had been on fire and buried. About four years earlier they had found the place and taken the antiques and strange objects found there to a museum. . . . The shops were in straight lines but no one lived there" (Deyhim 1993:56).

Americans were not absent from the ruins of Pompeii in the nineteenth century. Herman Melville seemed to have liked the site: "Pompeii like any other town. Same old humanity. All the same death (whether you be dead or alive). Like Pompeii better than Paris. Silent as Dead Sea" (Melville 1955:176–177). Mark Twain also was amused by the site and was struck by the contrast between the narrow-gauge railroad that brought the visitor to the site and the strange quality and "solemn mysteries" of "this city of the Venerable Past" (Twain 1869:42).

One of the most unheralded influences Pompeii (and by extension, Roman culture) had on America was its hold on the Old South. Richard Eppes, the owner of Appomattox Manor at City Point, Virginia, kept a diary through most of the nineteenth century and recorded his observations about practically everything. His home served as the headquarters for General Ulysses S. Grant from September 1864 until April 1865. In the 1850s Eppes had visited the Levant and even Arabia Deserta and kept a diary (unfortunately incomplete) recording his observations. As a slaveholder, he was much struck with the con-

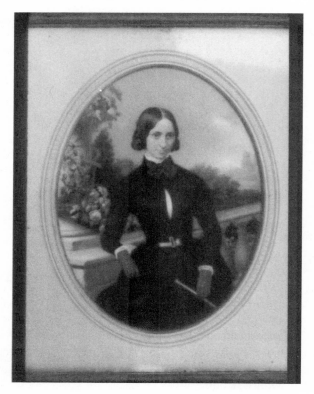

9.1. Portrait of Josephine Eppes painted in Florence in
1852. Virginia Historical Society, Richmond, Virginia, ©
2002. Used by permission.

dition of servitude in the Near East. He had earlier received his medical de-
gree at the University of Pennsylvania, where he had fallen in love with a
professor's daughter, Josephine Horner. After they married, they went to
Europe for a prolonged honeymoon. She left a very important account of this
trip, which included an extended tour of Pompeii. She was painted by a Flor-
entine artist just before her visit to the excavations on the Bay of Naples (fig-
ure 9.1). Her tour through Pompeii, guided by a local inhabitant, was fairly
complete and exists as the best-documented visit to the excavations in the first
half of the nineteenth century. She was especially impressed by the public fa-
cilities (bath, amphitheater, etc.). The diary is in five parts and is preserved by
the Virginia Historical Society. A full annotation of this diary is currently
under way.

By the end of the nineteenth century, Pompeii was ripe for yet another
rediscovery. The time of romantic classicism had passed, and the excavations

of Pompeii, once so novel and strange, were replaced in the public's eye by those of Heinrich Schliemann at Troy and Mycenae and the new discoveries originating with the Precolumbian sites of Mesoamerica. Even though Pompeii and the other buried cities and villas of Campania had taken a decidedly secondary position in the eyes of the world, there was still much to learn. The late-nineteenth-century paintings of Lawrence Alma-Tadema echoed the last gasp of classicism, but it was generally an archaeologically correct classicism. After a visit to Pompeii, Alma-Tadema fairly well dedicated his career to classical subjects (Prettejohn 1997:45–58). Yet even at the turn of the century Pompeii was "The City of the Dead" and was still held in "awe and reverence" by its numerous visitors (Acker 1899:95). In the early twentieth century, Pompeii still provided source books for interior design. For example, Pierre Gusman's *Mural Decorations of Pompeii,* published in 1924, emphasized the bold colors and clean lines of the art deco period.

This discussion can only serve as an introduction to the role Pompeii has played in Western culture for almost four centuries. The landscapes of the buried cities and villas of Vesuvius are now being more systematically studied. Cultural anthropological products are sought by those asking important questions of the long-exhumed material evidence. Pompeii possessed territory, practiced self-government, and seemed to enjoy considerable autonomy under the empire (Orr 1983:83). It is left for the new millennium to properly evaluate the previous data and to create new syntheses to explain Pompeii's past. It is inevitable that within this framework the arts once more will receive inspiration from Pompeii's truly stunning remains from another time and civilization.

10 / Evoking Time and Place in Reconstruction and Display
The Case of Celtic Identity and Iron Age Art

Harold Mytum

INTRODUCTION

The aim of site reconstruction and interpretation is to inform and educate the public while also offering entertainment. This may be achieved through displays of structures and artifacts, by presenters in role, by actors offering an interpretation of the past, or by the use of music, language, and art. Museums authenticate their interpretation with the support of artifacts from the past; reconstruction sites do so through the coherence and integration of the various forms of newly produced material culture, sometimes linked to experimental archaeology. The role of art in interpretation and in the reconstruction of particular times and places has not previously received attention. This chapter explores general issues regarding the integration of art in archaeological reconstruction and illustrates, through the specific case study of Celtic art, tensions that exist at both an academic and contemporary cultural level.

Visitors come to archaeological sites because they are different from everyday life, representing a past that was in so many ways alien to that of today. On sites with reconstructions, visitors expect to experience that difference through their senses, and sight is one of the most important. The concept of the tourist gaze has been developed by Urry (1990), who challenges Hewison's critique of the heritage industry (1987), arguing that visitors gaze on the same presentations in varied ways and draw from them their own conclusions. This is certainly the stance taken here, supported by many years of observation of and interaction with visitors at Castell Henllys Iron Age fort in Pembrokeshire,

Wales. Heritage tourism and education are part of an interactive process between the physical remains, interpretative frameworks, and the consuming visitors' preoccupations and concerns.

Art can form an important component in the gaze, as it is something to which the visitor can react, using his or her prior experience, cultural values, and intuition. That the art had one or more functions and meanings in the past (which we may or may not know anything about) can be explored in due course, but it offers a point of engagement. Moreover, unlike the obviously functional elements (such as food and shelter) often provided in interpretation, it offers up in the minds of the visitors ideas of symbolism and other, past, ways of thinking. This can be used to indicate that even the more functional aspects of life could also be imbued with meanings in the past. Art was not and is not a record of perception, as Gombrich (1960) argues, but is a sign with meanings in the past, a sign that also acquires meanings throughout history (Bryson 1983). This can be seen to be a particularly appropriate concept for understanding and using Celtic art, where its abstract quality immediately takes the observer away from obvious artistic comparisons colored by representations dominated by photographic reproduction.

A CASE STUDY: THE IRON AGE IN BRITAIN

The past is "other," and in Britain there are many different pasts to explore. The Iron Age is the most remote period that has attracted sustained and widespread attempts at reconstruction and interpretation, beginning with Butser in the 1970s (Reynolds 1979). All subsequent periods have been the subject of such reconstructions, with the Romans at sites such as the Lunt, Coventry, and South Shields, Tyne and Wear (both military); the Anglo-Saxons at West Stow; and the Vikings at Jorvik in York. Medieval structures have survived, and some have been dismantled and subsequently rebuilt with the removal of any later accretions at outdoor museums such as Singleton, Sussex, and Avoncroft, Worcestershire. Moreover, from the Middle Ages onward, many buildings survive in a sufficiently coherent form for interpretation without the need for full-scale reconstruction.

The "other" of the Iron Age offers unique difficulties because the public comes with very little prior knowledge. For later periods, what is popularly known may need to be challenged, but for the Iron Age little more than barbarity is assumed. Another problem with domestic reconstruction is its cross-cultural similarity in the traditions of British display. Although archaeologists may be trained to spot the nuance of pottery profiles at twenty paces, one dull, unglazed pot looks much like another to most people. Likewise, figures in rather shapeless, roughly woven tunics of vaguely tartan style patterns inhabit

illustrations and three-dimensional displays of most periods. In these situations, the use of art to differentiate culture and time can be extremely important. In this respect, the use of art may be one way of identifying the Iron Age "other" from different pasts.

THE ART OF THE IRON AGE

Iron Age art is famous, appealing, and sometimes dramatic (Megaw 1970). The most widespread and popularly known style within the Iron Age is La Tene art, named after the type-site in Switzerland. It is the most common art style found in Iron Age Britain. During most of the Roman period the La Tene style was a minor component in the artistic repertoire, but post-Roman cultures in western Britain and Ireland revived the style. It peaked in sophistication with illuminated manuscripts, carved stone, and various forms of metalwork in the eighth and ninth centuries (Chadwick 1971; Thomas 1986). Revivals in the eleventh and twelfth centuries and—more significantly, for some modern assumptions behind the art—in the nineteenth century have meant that the style has never really been forgotten.

La Tene art is often called Celtic art (Megaw and Megaw 1989, 1995a:346). This use of the word "Celtic" has recently received much academic attention because this word has acquired a number of significant associations (Champion 1996; Chapman 1992; Collis 1996; Dietler 1994; James 1998, 1999; Megaw and Megaw 1995b, 1996, 1997). The deconstruction of the Celtic associations has led to an acrimonious debate which, while not about the art per se, is about what the art (and sometimes other evidence such as language) means. It also relates to popular perceptions formed by the archaeological interpretations, and these are significant in the consideration of interpretation and display. Many contemporary Iron Age archaeologists may consider the Celts and Celtic art within a more reflexive and self-critical framework than did their peers 20 years ago. However, the public perception has yet to be greatly challenged, despite the attempts of James (1999), and this is important when it comes to public interpretation and display.

In this study, the art will be called Celtic not because of an agreement with the Megaws but rather because it is recognized as being actively used in contemporary Celtic culture. While the deconstruction of meanings such as "Celtic" has become a popular form of academic discourse, as revealed in the above debate, the archaeologist has a duty to offer one (or more) interpretations to the public. There is nothing like reconstruction for forcing the archaeologist's hand. The professional archaeologist's term La Tene is not value-free. It conjures up connotations equally inappropriate, with its French-language

and different pan-European implications. The term *Iron Age* is little better, implying a technological basis that is misleading, and in any case other styles of art were current within the time and space covered by the British (let alone European) Iron Age.

Celtic art has been a potent source of inspiration for much New Age illustration, associated with medicine, religion, and mythology linked to the Celts. This major strand of British subculture encourages a constant stream of publications and to a certain extent attracts an interest in the interpretation centers discussed here. The romantic notion of the Celts and their powers can be seen to arise from antiquarian speculation regarding Druids that was reworked and imaginatively developed in nineteenth-century nationalistic movements in Wales and Ireland (Piggott 1968). This tradition has now been given a more mystical quality and forms part of the New Age repertoire. Some archaeologists, notably Ann Ross (1967, 1995) and Miranda Green (1986, 1989, 1992, 1993), have reinforced this view through their popular and academic publications, from which many of the New Age derivatives have probably spawned.

Although it has a cultural association with the European Iron Age in the period from the fifth century B.C.E., Celtic art has many later associations with varying degrees of archaeological authenticity. Some associations are indeed authentic but irrelevant for the Iron Age, as they were acquired in one of the later resurgences of the style, but most are much more recent accretions of meaning. The display of art has the opportunity both to evoke time and place and to confuse and engender inappropriate assumptions in the audience. The use of Celtic art in displays is both potent and dangerous. It is therefore worthwhile to explore the ways in which art has been used within site interpretation of Iron Age settlements in Britain.

As with prehistoric sites in most areas of the world, Iron Age settlements survive at best as earthworks. Some of these, such as Maiden Castle, are impressive in their own right, but limited understanding of the settlement within the defensive earthworks can be gained on the ground. Most Iron Age sites, particularly those in lowland areas, have nothing of note visible on the surface and so are not interpreted for the public. The British Iron Age is therefore most imaginatively offered in traditional museum displays and in reconstructions. Four locations have been chosen for analysis here, as these are the ones in Britain with the greatest archaeological input and a primary concern with public interpretation of the Iron Age. Wessex in central southern England is a region long used as the basis for the writing of British Iron Age narratives, and this provides the Museum of the Iron Age, Andover, and Butser reconstruction site, Hampshire. The other two examples, Castell Henllys fort, Pembrokeshire, and St Fagan's Museum reconstructed farmstead, come from south

Wales, where the questions of Welsh nationalism and Celtic identity make interpretation of the Iron Age particularly potent.

ART IN RECONSTRUCTION AND INTERPRETATION

Museum of the Iron Age, Andover

Most traditional museums in Britain do not greatly concentrate on the Iron Age, and the one considered here is an exception. The Museum of the Iron Age is based largely on the artifacts recovered from the extensive excavations at the nearby hillfort of Danebury, directed by Barry Cunliffe (1993). Material from other sites in the Wessex region is also included in this museum, which is part of the Hampshire Museum Service, but Danebury is its central focus. Cunliffe has published extensively on the Iron Age and the Celts, and he has created an elegantly functionalist synthesis of British Iron Age archaeology that has become the orthodoxy since the late 1970s (Cunliffe 1991). His interpretations of Danebury and hillforts more generally have a strong socioeconomic emphasis, only slightly modified by the finding of votive deposits, including human remains, in some abandoned storage pits. This view has been challenged by others, some offering different socioeconomic models (Stopford 1987), and, more recently, by those with more symbolic emphases (Hill 1995). The amount of art found at Danebury itself has been relatively slight, and it has not featured significantly in any of the interpretations.

The museum display follows the interpretation of Danebury and the Iron Age at large as envisaged by Cunliffe. A vast array of material is displayed, within a series of rooms, covering topics such as defense, agriculture, and crafts. However, the whole display suffers somewhat from an antiseptic functionalist aura, where it seems that the people of the Iron Age were eminently sensible and not as "other" as one might have expected. This can be seen with the display case of pots which, while attractive, are not explained in terms of cultural references. The otherwise well designed grain processing display gives no significance to cereals, food, or cooking; it would seem that Iron Age people ate merely to survive. There is some display of religion with a few human burials and skulls, but these are not integrated with the rest of the exhibition. The art is tucked away in a small corner at the end of the display, just before the coming of the Romans. No art is prominently displayed on the illustrated scenes or full-size figures, and the simulated house within the museum has limited decoration, with a single head carved into a post.

This display is extensive and intensive, yet art is not integrated into life. From warfare to farming, from domestic life to politics, art is not used to differentiate people, time, or place. Only on the website can a warrior wearing

Celtic decorated metalwork be seen, but even here the significance of this is not brought out. The "other" comes from the level of technology and subsistence economy, though in fact this is not dissimilar to all periods until the recent past. The difference between then and now is only highlighted toward the end of the display by the simulated round, single-room dwelling and perhaps the treatment of the dead. This is slightly ironic in that Cunliffe is one of the great proponents of the use of the term *Celtic*, of a distinct Celtic culture, one in which the art is a significant element (Cunliffe 1979, 1997).

Butser Iron Age Farm

The functionalist, culturally neutral view of the Iron Age is to be seen in perhaps its most extreme form at the Butser reconstruction site. The Butser farm was an innovative experimental site established to test, again in a functionalist paradigm, hypotheses regarding the construction of buildings, storage pits, and agricultural regimes (Reynolds 1979). These experiments have been carried out at several places as the project moved from one location to another, and gradually the role of public education and particularly school parties has become more important to the project (Reynolds 2000). Here "other" is mainly emphasized through building type, though the efficiency and eminent good sense of Iron Age people are again celebrated. Here, only what can be "proven" is shown, though in places this ideal has been modified to serve the requirements of the school parties.

The bare but bold shape and character of the roundhouses is what makes the Iron Age "other" at Butser. The outdoor environment gives a sense of space and place and shows off the profile of the pyramidal roofs of the roundhouses. On entering the buildings, one is impressed by the sense of scale produced by large, single-roomed round structures, but because so little is known of Iron Age roundhouse interiors, the houses are not filled with artifacts and evidence of activities. The absence of evidence in the archaeological record is the reason for this absence in the houses, yet that vacuum in itself has a great impact on the visitor. The presence of such space gives an undoubtedly false impression and one where the few objects (such as the firedogs and the loom) appear almost as art exhibits in a gallery. Art is not used as a medium for interpretation in the houses, and indeed some of the features of style of reconstruction restrict the ways in which art could have been used. At Butser, for example, all timbers are used in the round and with their bark retained, making the decoration of structural timbers themselves impossible.

The site has been used for a number of film locations, when it has been transformed into a bright, lively, luxurious, and highly decorated settlement. Both interior and exterior features included artistic elements, a dramatic con-

trast to its normal dour but safe appearance (Reynolds 2000). The only art prominently used at Butser in normal circumstances are firedogs and associated metal vessels around the hearth, and carved human figures set up outside to provide schools with a link to religion within their curriculum.

Castell Henllys

The only site-based reconstruction and interpretation of the Iron Age in Britain is that of Castell Henllys, a small Iron Age inland promontory fort in southwest Wales (Mytum 1991, 1999a). I have been excavating the site for over 20 years, and it has been partially reconstructed and interpreted for the public and schools first under private and now National Park ownership (Mytum 1996, 1999b, 2000). Castell Henllys shares all the advantages of the Butser site in appreciating the "otherness" of the roundhouses in terms of form and texture, the materials, and their treatment (figure 10.1). Because of its attractive setting, the quality and number of reconstructions, and its location on an actual Iron Age fort, Castell Henllys has acquired something of an iconic status, with images appearing in many publications. Its very popularity, though, creates its own dangers, and it would be easy to settle for a complacent acceptance of its accuracy. Challenging what has been created and trying modifications must now be part of the interpretation policy. This is particularly important because many visitors return year after year and different emphases and images can confront them. In this regard, even within existing structures that are expensive to build it is possible to alter appearance, function, and meaning through portable items and decoration, including art.

The original owner, Hugh Foster, incorporated some art in the reconstruction of the roundhouses, particularly in the interior decoration. This took the form of painting on the walls of one building and painted shields within another (figures 10.2 and 10.3). Carving on the exterior faces of the doorposts of roundhouse 3 provided another vehicle for the display of art (figures 10.4, 10.5, and 10.6). Very little Celtic art of the Iron Age has been recovered from west Wales, but a design from one of the few local pieces of metalwork was used as inspiration for the carving. A spring on the side of the inland promontory was decked out as a religious site, its location on the tree-covered slopes giving it a natural atmosphere that could be easily enhanced. Hugh Foster was more concerned with exploring how it felt to live in the Iron Age, and relating to the public's interests, than with an academic purity with which archaeologists might feel comfortable (Mytum 1999b).

After Foster's death, the Pembrokeshire Coast National Park took over the site and developed a coherent policy of interpretation and display. This policy was on the one hand cautious, academic, and unemotional, yet on the other hand it catered to the needs of the National Curriculum for Wales, which

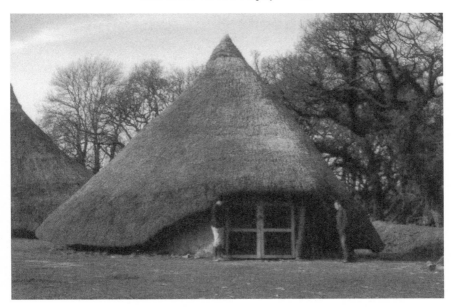

10.1. Castell Henllys Roundhouse 1, exterior view prior to any decoration. Courtesy Harold Mytum.

placed emphasis on the Celtic nationalistic and cultural aspects of the Iron Age (Mytum 2000). The resulting interpretation has a balance of emphases, with relatively traditional, finely produced bilingual display panels, which only on occasion emphasize the Celts. In contrast, the buildings have gradually become more cluttered with movable artifacts and fixed furniture such that they are now much more full and decorated than at any other Iron Age reconstruction site. The spring has also been developed with the placing of several carved wooden figures, and Celtic art is experienced by school parties through the application of face paint to pupils and the braver teachers (figure 10.7).

I have recently encouraged the National Park to use Celtic art to a greater extent in the roundhouses. This experiment in emphasizing the "other" of the Iron Age through art has been both exciting and rewarding. This process of interior transformation has been most dramatically enhanced through the fitting out of the buildings for a BBC television series, *Surviving the Iron Age*. This was an exercise in survival by modern people living in a version of Iron Age conditions mediated by the needs of modern regulations, expectations, and the requirements of the experience (Firstbrook 2001). The art has been painted onto the exterior walls around the doors of roundhouses 1 and 2, based on generic Celtic art, and these provide a cruder version of the appearance created by the carved and painted designs already existing on roundhouse 3. The interior walls of the largest reconstruction, roundhouse 4, have also been

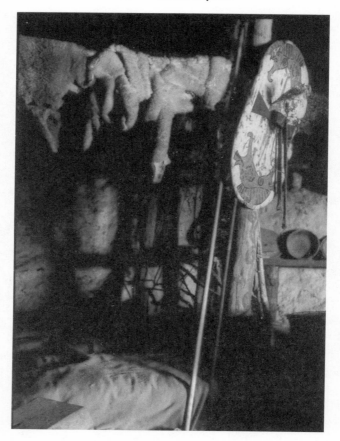

10.2. Castell Henllys Roundhouse 1, interior view of bed area. Courtesy Harold Mytum.

decorated, here based on a specific design found on pottery at Glastonbury, Somerset. There is no archaeological evidence from any site for interior mural designs, but they create a clear cultural reference for visitors.

Another significant feature of the Castell Henllys experience is the use of modern art, inspired by Celtic art and literature, along the pathways leading to and from the hillfort site itself. These works, largely in wood, link with the stream, woodland, site, and landscape and create an atmosphere within the reconstruction and interpretation sites. Thus, at Castell Henllys art in many forms allows the public to imagine, experience, and reflect. How this might develop is unclear, but further experimentation is certain. It is worth noting here that the audiences for Castell Henllys are many and varied, and each will read and interpret the site, its archaeology, reconstructions, and art in different

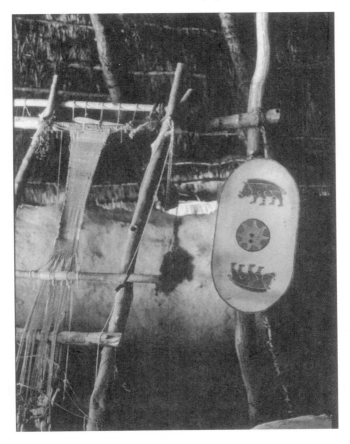

10.3. Castell Henllys Roundhouse 1, interior view of area to the left of the doorway. Courtesy Harold Mytum.

ways. The audiences include local schoolchildren and their teachers, tourists from many countries, students on the large training excavation and field school, New Age "incomers" who see the spring as sacred, recreation groups, and local residents. For all these, the site and its reconstructions hold different significances and meanings, and these are often reinforced and highlighted by the art.

St Fagan's Folk Museum

The Iron Age reconstruction at St Fagan is part of the National Folk Museum with its large collection of buildings moved from all over Wales and its extensive collections of folk culture displayed in associated galleries. The Iron Age

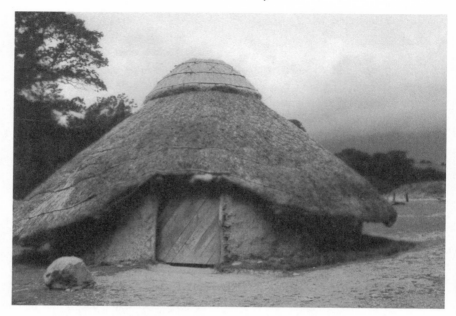

10.4. Castell Henllys Roundhouse 2, prior to exterior decoration. Courtesy Harold Mytum.

settlement—a few buildings enclosed by a bank and ditch and approached through a timber gateway—plays an important role in education, as does the Castell Henllys site (Mytum 2000). Designed with advice from Peter Reynolds of Butser, it has many influences that convey the functionalist view. However, the Celtic theme of the National Curriculum for Wales and the location in the nationalistic museum context mean that there is an interpretative emphasis on Celts. The site is misleadingly called the Celtic village, despite its size.

The "Celtic village" is placed at the edge of the museum park, and this liminal position has both advantages and disadvantages. The strength of the site is its wooded setting, allowing it have an ambience of its own. The drawback is that visitors have to pass by buildings of the historic period to reach it, giving little opportunity to appreciate the time period or the sense of "otherness." Moreover, all the historic structures are largely authentic buildings that have been moved and restored, but the farm is a reconstruction. Variability in structure is shown through the use of timber and stone walling for different roundhouses, though this is not explicitly highlighted. The enclosing bank and ditch make the site feel quite claustrophobic; the low-lying location and limited space between the buildings mean that it is often muddy, giving the site a

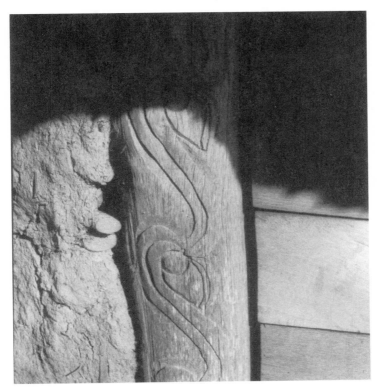

10.5. Castell Henllys Roundhouse 3, carved decoration on the door frame. Courtesy Harold Mytum.

very different impression from that of the well-drained sites of Butser and Castell Henllys. Here there is an impression of squalor not created elsewhere.

There is relatively little overt art at the reconstruction, apart from the inevitable head being carved on a post (and here having horns, suggesting a link to a deity). The houses have been made more inhabited than at Butser, but, in museum style, they are to be viewed rather than actually experienced by touching and sitting within the building. Some of the material culture within the buildings displays style, but it is not greatly emphasized. The St Fagan's reconstruction may well, as local interpreters adapt it, move to a more Celtic interpretation than at present. It is less decorated and culturally linked than Castell Henllys, but more so than Butser or the Museum of the Iron Age.

The St Fagan's reconstruction has the potential to develop the role of art very effectively, both in the context of art in the other buildings and artifact galleries at the site itself and also through the schools program. Most school parties visit both the reconstruction and the main National Museum in Car-

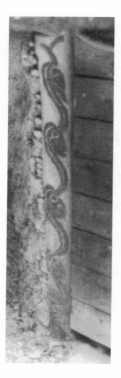

10.6. Castell Henllys Roundhouse 3, carved decoration on the door frame, now painted red. Courtesy Harold Mytum.

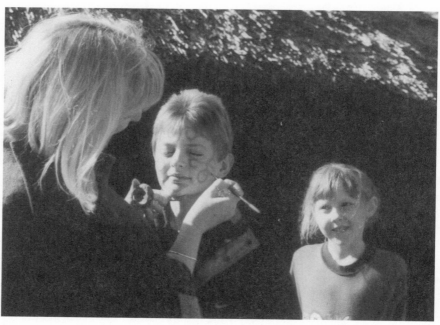

10.7. Schoolchildren having Celtic designs painted on their faces. Courtesy Harold Mytum.

diff where the collections of real artifacts are displayed (Mytum 2000). These include some impressive examples of decorated metalwork (Savory 1976), and the art could provide an important link between the two sets of evidence used by the schools. The staff at the museum already highlight the issue of past and present Celtic identity in their training of teachers, so the use of art at the reconstruction could be more extensive and brought into the discussion. It would seem that the reconstruction emphasizes functional aspects of life, while the formal museum elements engage in wider cultural issues. Unfortunately, this underplays the reconstruction's potential in linking together many aspects of past activity and thought, and art could be one of the main threads that draw interpretation together.

WHY HAS ART BEEN SO LITTLE USED?

There are perhaps three main reasons why Celtic art has made such a small contribution to displays about the Iron Age. The first and foremost is the archaeologist's traditional caution regarding details of reconstruction. The second is the fear of incorporating original, bright colors by those used to handling the dowdy detritus of millennia. The third concerns the web of contemporary meanings associated with Celtic art, which makes its use even more controversial than the more functional elements of a reconstruction display. Each of these reasons deserves further examination. Some of the details may relate only to the Iron Age in Britain, but all of the issues are much more widespread and relate to the use of art in many forms of reconstruction over time, space, and culture.

Archaeologists, and prehistoric archaeologists in particular, are often cautious when it comes to interpretation and reconstruction. Even the most simple, functionally constrained item of material culture or set of behaviors can take more than one form. This weakness of the simplistic functionalist interpretation lies behind much of the debate regarding style, highlighted in Sackett's (1986) term "isochrestism," meaning "equivalence in use." Even the most basic form of interpretation and reconstruction makes many assumptions about how things were done in the past. Function was not and is not all, but archaeologists often minimize the cultural, even though that is what makes any particular time and place special. There is a strong argument for starting in reconstruction from the functional—things did, after all, have to work in the past. But the archaeologist, in deciding which version of what would work to choose, is creating a style for that past culture. An example of this would be Reynolds's choice of timbers in the round, with bark on, for structural timbers in Iron Age buildings. This has a functional logic—minimal woodworking prior to construction—but has both functional and aesthetic alternatives. Debarked timber has less chance of insect infestation, and cutting back to the

hardwood gives timbers placed in the ground a longer life span. The aesthetic variation is obvious between timber with bark and timber that has been debarked, shaped, and even carved. Another aspect of the style debate is relevant here. The function of the timbers may have been more than merely structural, and their appearance could have given out messages of explicit or implicit kinds to members of the household and wider community.

Adding complexity, sophistication, and decoration to a reconstruction requires a confidence the archaeologist can rarely sustain, yet in doing any reconstruction the choice between the functionally viable, "isochrestic" alternatives already moves the decision beyond the automatic. If the decorative interpretations can be seen to resonate with the style already selected from within the functionalist choices, then the cultural reconstruction can be seen to make a coherent whole.

The integration of art into reconstruction is often made more difficult by the limited range of media on which such art survives in the archaeological record. For the British Iron Age there is some decorated metalwork, but much reliance has to be placed on a few sites where waterlogged preservation has allowed the recovery of a wide range of items in material not normally found in excavation. Glastonbury and Meare in Somerset were excavated in the late nineteenth and early twentieth century, and Celtic art was found on a range of wooden and ceramic containers and on some other portable items (Bulleid and Gray 1911; Coles and Coles 1986; Gray and Bulleid 1948). Decorated Glastonbury ware pottery, named after this type site, has been found widely in the southwest of England. By inference, art motifs may have been carved on structural timber, embroidered on textiles, burnt into hide, tattooed on skin, painted on ovens and roundhouse walls, and integrated into the structural features of defenses such as gates, towers, and palisades. There is no reason to see Celtic art as having a particularly restricted presence in the material culture, though it is certainly the case that not everything was covered in such art. Presumably Celtic art carried meanings, though to date most archaeological interpretations of decorated metalwork have been concerned only with reflections of status. The metalwork could, in its many associations, provide a source for exploring other meanings; it also offers the opportunity to explore the second reason for the limited use of art, the fear of bright colors.

Celtic art of the Iron Age shows a concern with and delicate appreciation for form, particularly in metalwork. The delicate balance and control of curves, the deliberate slight asymmetry and use of light and shade, make the art a source of inspiration. There is also a lively concern with color, achieved by the use of coral and other insets and, more commonly, enamel, usually red. Other small items, such as glass beads, show a fine appreciation of polychrome designs, though rarely sufficiently distinctive to be termed Celtic in style. While

it is possible that a few categories of material culture were bright and colorful, and so stood out from a dowdy ordinariness of everyday life, it is surely more likely that the use of color was widespread. Perhaps in this respect the media representation of gaudy brightness may be nearer the mark than the subdued and rather dull worthiness of archaeological "authenticity" time (see film images in Reynolds 2000). The painting of roundhouse walls can bring bright coloring that echoes the enameled metalwork with its original shiny brashness, now hidden by the mellow green patina of antiquity. Celtic art was lively and part of Iron Age life, and it should be used to suggest that past bravado. It situates our interpretation in a time and place that was culturally specific. The Iron Age was not just another part of the identity of the "other" of the remote past, but distinctive and unique. That unique past can itself be placed in the context of the present if the multiple meanings of Celtic art are addressed by the archaeologist.

The varied meanings the public may bring to Celtic art are a strength, not a weakness. They give a point of engagement, of dialogue, that can allow alternative models to be offered. Celtic art is a style the public at least recognizes, unlike so many things from the remote past, though it is not so familiar that it degrades the sense of "other." Indeed, the associations that Celtic art holds in the popular imagination are ones of mystery and romance, an ideal point from which to start an engagement with those not trained in the interpretation of the past. This gaze of the visitor can be challenged by interpretation. Hiding the art from the reconstruction of the Iron Age avoids the issues associated with alternative readings of the past. The orthodox archaeologist who may decry New Age interpretations does nothing to confront them and argue for any alternatives if the art remains hidden. Ironically, Celtic religion is often depicted in archaeological displays with heads and cult deposition, as in the Museum of the Iron Age; these suffer from the same public misconceptions as the art but are somehow more acceptable. Perhaps this is because functionalists often do not know what to do with religion beyond the social role of cult, and so public interpretation can be left to run free. By using the art in reconstruction, we could widen the debate over function and meaning to all aspects of past life, thereby revealing much better the ways in which present associations have been built up.

CONCLUSIONS

Archaeologists must acknowledge that interpretations of the past need to convey some sense of culturally specific time and space that evokes a spirit of that age. Reconstruction inevitably will convey to the public, by absence as much as presence, an aura that can be more memorable and more engaging

than authentic artifacts in glass cases. Art can be used positively to emphasize differences between then and now and to identify particular cultural associations in the past. The "otherness" of the past can be reinforced through art, and the differences between one art style and another can demonstrate different cultural identities in the past—that the past was not uniform over time and space. Art gave meanings and sense of place to people in the past, and it can function in reconstructions in the same way today.

Art can be used to suggest differences within a particular cultural context, such as religion, status, gender, time, and region. This has not yet been attempted for the British Iron Age, where the use of art is still rudimentary. This is certainly a way in which not only differences between then and now but also differences within the Iron Age could be highlighted and explored. The visitors to Castell Henllys have already responded to the different forms and degrees of decoration between the reconstructed roundhouses; this leads to their asking about differences within the community. They immediately think of status, but this can be widened to explore the possible social structures, gender relations, and religious associations. The aspiration is to suggest that the art could have meant different things to different people at any point in the past. We may not know what the meanings were, but showing the complexity and richness of Celtic culture, if not its detail, is an ambitious task indeed.

Art deserves a higher profile in reconstruction. It is celebrated in artifact-based museums and coffee-table books but rarely in site interpretation. The art was not made for museums but rather for use in settlements such as those we are reconstructing and interpreting. Let us take the art out of the gallery and put it back into life. The everyday was enlivened in ways that the utilitarian mediocrity of functionalist models cannot portray, and with meanings that we may not know but which we can recognize would have been there.

ACKNOWLEDGMENTS

I would like to thank all those who have helped me in researching this topic, particularly the Pembrokeshire Coast National Park, which has allowed the experimentation at Castell Henllys and enabled me to continue the interpretive input begun under Hugh Foster. The views expressed here, however, are not necessarily those of the National Park or its staff. Thanks also must be given to the Department of Archaeology, University of York, for the excellent research facilities and supportive environment, and for the students from the department and my field school for their stimulation and input to the Castell Henllys Project.

11 / Art and Archaeology
Conflict and Interpretation in a Museum Setting

Michael J. Williams and Margaret A. Heath

Unless the heart sees, the mind will never see.

—Maori proverb

INTRODUCTION

Is it possible to provide art-oriented museum visitors with a fulfilling experience without harming the cause of archaeology education or shortchanging archaeology-oriented visitors who come to learn about a past culture? Can a museum's art be prominently displayed without promoting the demand for (looted) antiquities? This chapter will explore the conflicting values of visitors, art historians, and archaeologists that must be met by museum interpreters. It will focus on the ways these demands are addressed by one southwestern United States institution.

The Anasazi Heritage Center in Dolores, Colorado, opened to the public in 1988 as one product of a reservoir construction project on the Dolores River that flooded a rich archaeological district (figure 11.1). Over the course of seven field seasons (1978–1984), researchers surveyed 16,000 acres in the project area, mapped about 1,600 archaeological sites, and excavated over 100 of these. The center is a Bureau of Land Management federal repository for cultural materials recovered during and since the end of that project on public lands throughout southwestern Colorado. Its public exhibition space includes one main gallery of 4,000 square feet devoted primarily to local archaeology. Additionally, a second gallery and other spaces cover topics such as modern Native American culture and recent local history.

The Anasazi Heritage Center has more than one interpretive mission. It introduces the public to prehistoric cultures of the Four Corners region. At the same time, it attempts to teach visitors about modern archaeology—its re-

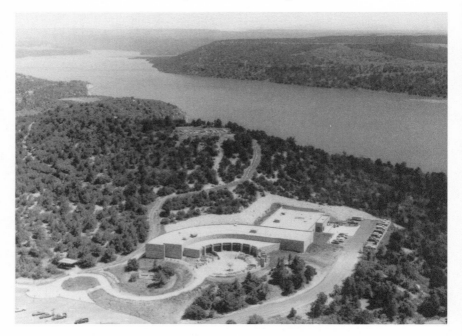

11.1. Aerial photo of the Anasazi Heritage Center. Courtesy Michael Williams, Anasazi Heritage Center.

search techniques, perspectives, and ethics—and it displays prehistoric artifacts in a manner that reveals human social behavior and connects them to living cultures of the modern era.

The museum's exhibits show archaeologists' tools, maps, graphs, replicas of excavation test-trench profiles, displays explaining ceramic analysis and dating methods, and a variety of artifacts representing the Ancestral Puebloan occupants of the region and their modern descendants. In terms of public appreciation, arguably the most popular and widely recognized of these artifacts are decorated ceramic vessels, created between about 800 and 1300 C.E. Their appealing, bold geometric patterns in black paint on a white background have spawned a thriving underground market among collectors (plate 21 and figures 11.2, 11.3, and 11.4).

The public's reaction to the museum is usually very positive, but not always. A search of the visitor's log found the following comments: "Bring more stuff out of the basement!" (Cortez, Colorado, 6/18/96); "I think you spent too much on too little" (Cortez, Colorado, 5/29/95); "Where are the other artifacts??" (Littleton, Colorado, 5/16/97); "Would love to see more of the pottery than is currently on display" (Montrose, Colorado, 8/23/98). More commonly

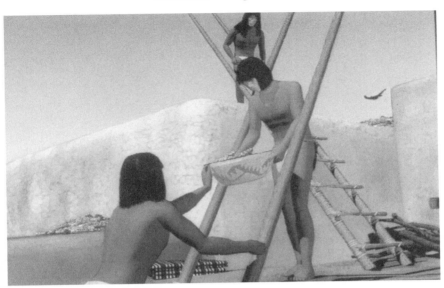

11.2. Men on ladders. Art created to teach archaeology: Ancestral Puebloan villagers in southwest Colorado ca. 1100 C.E. From the computer learning program "People in the Past." © 1997 Public Lands Interpretive Association. Art by Theresa Breznau.

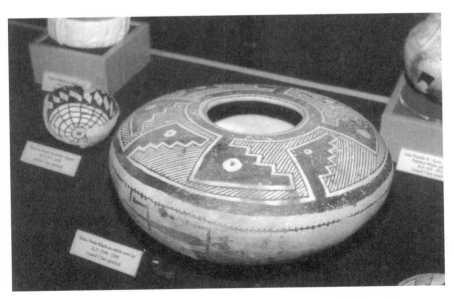

11.3. This Ancestral Puebloan "kiva jar," made about 1200 C.E., is on display at the Anasazi Heritage Center, a Bureau of Land Management museum in southwest Colorado. BLM photo.

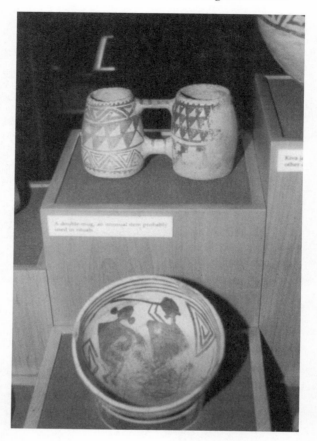

11.4. This Ancestral Puebloan bowl and double mug, made about 1200 C.E., are on display at the Anasazi Heritage Center. BLM photo.

these comments come in the form of questions to the information desk staff and volunteers.

Some of these comments come from local residents whose families have lived here for generations. Many local families have private collections of artifacts, some of which are rumored to be far superior aesthetically to anything displayed in the Heritage Center. Some people resent the fact that the federal government, with its apparently vast resources, cannot match the displays that adorn their mantelpieces and family rooms.

For the most part, these private collections were amassed years ago, from sites on both private and public land, by people unaware or unconcerned with

modern, painstaking excavation documentation. Digging for pots was a popular Sunday hobby that dates back over a century to the first Anglo settlement of the area. It was a livelihood for some ranchers and farmers during the winter months when museums and even Mesa Verde employed them to excavate sites in the young park. Today, especially during hard times, a few local people augment their incomes by hunting for pots on private lands. While they may have an authentic, though casual, interest in the culture these pieces represent, modern pothunters value the artifacts mainly for their aesthetic and commodity value.

But not all disappointed museum visitors are pothunters or local residents. Interpretive exhibit designer John Veverka says that genuine objects have an intrinsic value for all museum visitors (1992:27). Thus it is not surprising that people from many backgrounds and regions visit archaeological museums to enjoy the artistic accomplishments of prehistoric cultures. In truth, many professional archaeologists will admit that they were first drawn to the field by their fascination with the art of ancient people rather than by an interest in statistical analyses of settlement patterns and household debris. If this is true, then why aren't more objects of artistic interest on display at modern archaeological museums such as the Anasazi Heritage Center?

WHY ARTISTIC ARTIFACTS ARE NOT DISPLAYED

There are several valid reasons why museums such as the Heritage Center do not better serve visitors' desire to see artistic artifacts. For one thing, professional ethics as well as legal issues prevent federally funded American museums from displaying items associated with burials, which are the context for many intact and highly decorated pieces. As a matter of policy, the museum does not solicit donations of privately collected artifacts, since it does not want to appear to condone or encourage the looting of archaeological sites. Finally, archaeological museums cannot compete with art-oriented museums, because collections based on aesthetic criteria will always have greater visual appeal than collections representing a broader cultural context.

But there is another, more subtle reason why the public's desire to see many beautiful pots is not treated more sympathetically. Many archaeologists strongly resist displaying artifacts on aesthetic grounds. One archaeologist regards the display of many similar pots together as an embarrassing betrayal of authentic archaeological values and refers to these kind of exhibitions as "just pots in a row." If this line of reasoning were applied to exhibitions of impressionist paintings, the Philadelphia Museum of Art might lock away all but one of Monet's garden paintings on the ground that they already have a good example on display.

LONG-STANDING HISTORICAL ISSUES

The attitude in question is a response to long-standing historical issues in which the concerns of archaeologists come into conflict with the aesthetic appeal of some of the materials they collect. Archaeologists mistrust art-oriented displays or interpretations of archaeological materials because this approach recalls archaeology's origins as a simple fascination with ancient objects and seems to ignore the modern paradigms of archaeological research. Furthermore, an art-oriented approach rarely yields quantifiable data, and artistic classifications are often subjective.

The modern science of archaeology began in Europe several centuries ago as the collecting by wealthy tourists of beautiful objects from the ruined temples and tombs of past civilizations. Gradually it evolved into an academic discipline, the systematic analysis of cultures beyond the reach of written history. At the same time, science and natural history museums evolved from helter-skelter displays of curiosities into reasoned collections arranged to teach according to scientific principles. Along the way, both archaeologists and museum professionals have often come to regret the behavior of the people who founded their respective pursuits. It is in penance that archaeologists avoid supporting any public presentations that remind them of those early days.

Some archaeologists see real danger in treating ancient artifacts as art in a museum setting. According to popular wisdom, this approach encourages the looting of archaeological sites in the search for salable objects, which is a continuing threat throughout the world. Like other regions, the American Southwest has seen a lively trade in salable antiquities for decades, and the pieces command ever-higher prices as they become more rare. Prehistoric ceramics from this area appear regularly on art auction blocks at Sotheby's and elsewhere. According to most estimates, 80 to 90 percent of all known archaeological sites in the Four Corners have been at least partially looted.

Archaeologists want artifacts to be appreciated in archaeological terms, in the context of a developed scientific discipline. Consequently, an artifact is displayed to promote this specific kind of understanding, and a few representative artifacts usually will serve as examples for the purposes of archaeology education.

VISITORS NOT SEEKING ARCHAEOLOGY LESSONS

But visitors to archaeology museums do not necessarily arrive seeking lessons in archaeology. Frequently they come to enjoy the artistic qualities of the artifacts on display. They may want to see a variety of examples (say, of black-on-white vessels) in order to appreciate each of them as a unique object or to

compare them as members of a class. They want to be able to draw their own conclusions—not necessarily an archaeologist's conclusions—about what characterizes this family of objects. For instance, what standards of form, decoration, and quality are implicit in the set they see? These sorts of questions may occasionally matter to archaeologists, but primarily they reflect an art-historical approach. For museum curators and exhibit designers, the real issue becomes: do art-oriented displays send a misleading or harmful signal? Whatever the answer, there is a countervailing risk in ignoring the artistic appeal of the artifacts in the collection—the risk of alienating a part of the public who might otherwise be the museum's strongest supporters in terms of funding and educational initiatives.

In this vein, Jeremy Sabloff of the University of Pennsylvania laments the growing gulf between professional discourse and the language of interested non-archaeologists, and the danger this poses for public support of archaeology:

> Some archaeologists . . . have rejected or denigrated popular writing because it might somehow taint archaeology with a non-scientific "softness" from which they would like to distance the field . . . [but] archaeology's main claim to relevance is its revelation of the richness of human experience. . . . Among the goals of such study is to foster awareness and respect for other cultures and their achievements. Archaeology can make itself relevant—pertinent—by helping its audiences appreciate past cultures and their accomplishments. (1998:871)

Sabloff is referring to the need for popular writing, but his concern also applies to the issue of archaeology as art. If archaeological museums refuse to recognize the appeal of art in archaeology, others will fill the vacuum: looters, unscrupulous artifact collectors and dealers, and the entertainment industry that has given us television shows like *Relic Hunter* and movie characters like Indiana Jones and Lara Croft.

DIVERSITY OF VISITORS, DIVERSITY OF EXHIBITS

A central concern of any modern American museum is how to accommodate the diversity of its visitors—diversity that is geographic, economic, cultural, historic, political, and philosophical. One way to accomplish this is through a diversity of exhibit themes and approaches that complements the museum's core mission.

Visitors to the Anasazi Heritage Center are diverse in all the dimensions noted above. Their desires and demands are sometimes in conflict, and con-

flicts require compromises that constrain the museum's strategy as a museum. Among its constituents are:

- archaeologists, who want to see archaeology explained and want to discourage looting
- Native Americans, who want to see artifacts treated respectfully and displayed in their cultural context, excluding grave goods and other sacred objects that should never be displayed
- primitive art enthusiasts, who want to see more and varied objects of aesthetic value
- museum curators, who want to safeguard artifacts and comply with applicable mandates
- local families and boosters, who want artifacts displayed as trophies of local heritage
- kids, who want to touch, explore, and get a sense of adventure

How do museums create and sustain public support? Where should they start? Museums cannot necessarily expect their visitors to understand and sympathize with the methods and perspectives of archaeologists before they walk in the door. Shouldn't museums try to appeal to visitors on the most universal human grounds, such as the appreciation of art? Danielle Rice addressed this question in a 1997 issue of *Museum News:*

The weight of an educational mission, and the responsibility of pre-
serving and caring for collections, often make museum professionals
forget that most people come to the museum for recreation, for plea-
sure. In their meetings and journals, museum professionals fret that
if they pander too much to visitor tastes, their institutions will sell out.
... The fear is patently absurd. Visitors know the difference between
a theme park and a museum, just as they know the difference between
a cheeseburger and a filet mignon; like most of us in this culture, they
happily consume both. (1997:57)

THE ROLE OF ART

In considering the role of art in an archaeological museum, we should tread lightly in attempting to define *art*. That is beyond the museum's capability to resolve to everyone's satisfaction. For present purposes, museums should settle for a broad, intuitive definition in which an object is appreciated for qualities beyond its utilitarian purpose. Museums should not demand "aesthetic purity," which Stephen Weil defines as "the degree to which an object is free of any

utility beyond its capacity to produce an aesthetic response" (1998:45). This criterion for pure art would exclude most of the non-Western objects museums are concerned with, and many historic Western ones as well.

Archaeologists managing museums would do well to consider that many utilitarian items created by prehistoric people did have artistic value in the eyes of their creators. Such a quality is hard to assess in terms of the quantitative methods favored by archaeologists, but it is nevertheless real and part of the original social context of an artifact. In his critique of how most museums portray Native Americans, Tuscarora Richard Hill points out that "all art has a context. . . . A non-native artist might work in a vacuum, isolated from the larger society and free to express his individuality. But Indian artists have always worked, at least until recently, with the community in mind. They reflect individual creativity within a community aesthetic" (2000:60).

On the one hand, the fact that someone may appreciate a certain artifact as art does not necessarily grant him or her deep access to the worldview of its creator. On the other hand, we take it on faith that all cultures express aesthetic values through the objects they create and that art appreciation is in some degree cross-cultural. Therefore, to consider an artifact as art is to suspend consideration of its cultural context, momentarily at least, in favor of a more pan-human context. But does such a moment threaten the museum's core mission of explaining prehistoric cultures to the public? Of course not. Appreciation of artistic quality can be a point of introduction that leads toward a broader comprehension of another culture.

Joanne Lea believes that

> This debate about curriculum versus collection-based programming is underscored with education program slogans such as that of David Hurst Thomas, cited by Crow Canyon Archaeological Center staff, "It's not what you find; it's what you find out" (Ricky Lightfoot, personal communication: 1997). Although this is an obvious truth to archaeologists on the one level, on another—and certainly for museums—it misses the point: Of course it's "what you find." Museums exist because of what was found; they proclaim it in each of their labeled, properly-lit glass cases, and they attract the public because of it. (2000:318)

Lea goes on to call for exhibits and programs that provide each object with a historical and/or chronological context. Museum displays that provide such connections trump *in situ* displays at archaeological sites where an artifact's larger context is invisible (2000:319). Lea believes that a museum should encourage the visitor to interpret the significance of an artifact based on his or

her own understanding of the available information. This empowerment "acknowledges the constructivist perspective that meaning is given by the visitor to an object from their own experience, as much as it is imparted by the museum" (2000:323).

If Lea and others are correct, a museum must meet multiple goals in presenting its objects on exhibit. It should recognize that the public comes to the museum to find out about archaeology and prehistoric cultures, and that the nature of the beast is that they come to see objects. Some visitors are more interested in the culture represented, while others are more interested in the objects as art. A well-balanced gallery will strive to meet the needs of both extremes in a tasteful manner that keeps in mind the wishes of the descendants of those it portrays.

HOW ANASAZI HERITAGE CENTER EXHIBITS MEET THE DEMANDS

How do the exhibits at the Anasazi Heritage Center meet these multiple demands? We examined the exhibits in the light of exhibit principles advocated by designer John Veverka. Veverka prefers participatory or interactive exhibits, but warns against overloading the visitor with too many of them: "Then the exhibit gallery turns into an amusement park where the educational value is lost to the entertainment value. On the reverse end, art museums are mostly [passive] exhibits and can be very dull and unexciting. The most successful galleries have a well-planned blend of exhibit types" (1992:27).

The Anasazi Heritage Center uses a collection of artifacts on loan to the museum to illustrate artistic themes such as the possible cultural significance of decorative motifs. Attractive, aesthetically pleasing artifacts and displays are employed to draw an audience and perhaps inspire a deeper appreciation of archaeology. Other exhibits on fabrication techniques, or on shapes inspired by natural forms (e.g., gourds and gourd-shaped ceramic vessels), are aimed toward artistic appreciation but not necessarily away from archaeological values. Even photographs of artifacts in situ, if pleasingly done and presented as art, can link aesthetics to archaeology.

The Heritage Center welcomes educational activities and programs involving art that also serve the cause of archaeological sensitivity. Clint Swink, a local artist, periodically conducts workshops in the replication of black-and-white Puebloan pottery, using original vessels from the Heritage Center's collection as models. He requires his students to use the same materials, tools, and techniques of fabrication and firing as did the original artists of a thousand years ago. Swink's students not only hone their ceramic skills but also come to understand something of the environmental context in which the

originals were created; they often become active advocates for the protection of archaeological sites.

One response to the desire to appreciate the art in archaeological materials is to support the manufacture of such replica pieces and to make them available to museum visitors in the gift shop. The replicas sold are handmade, faithful copies and are accompanied by information on time period and provenience. Such pieces cannot be considered forgeries because there is no attempt to deceive the buyer, and each piece is permanently marked as a reproduction on the bottom. Unlike other parts of the world, the area seems to have no circulation of fakes as such, and no problem among researchers and museums of confusing fakes with authentic artifacts.

Oscar White Muscarella, in *The Lie Became Great: The Forgery of Ancient Near Eastern Cultures* (2000), notes a connection between the "collecting culture" and the "forgery culture" and suggests that, among other evils, the market in forgeries abets a larger market in looted and smuggled antiquities. It seems that, in the case of the American Southwest, the replica market actually reduces the demand for authentic antiquities by appealing to people's desire to collect works of art and to appreciate a piece for its intrinsic qualities, without compromising the museum's commitment to interpreting archaeological context in its exhibit galleries.

SUMMARY

In resolving the tension between art and archaeology interests that share one museum under one roof, there is probably no perfect solution guaranteed to please everyone. Legal mandates and the ethical responsibility to safeguard an irreplaceable heritage must necessarily take precedence over other legitimate concerns such as recreation, educational opportunity, and responding to public demand in providing access to what is, after all, public property. But we believe that in many cases, by using creative and multipurpose exhibit strategies, we can satisfy a wide variety of museum visitors.

12 / The Archaeology of Music and Performance in the Prehistoric American Southwest

Emily Donald

Dance, to Native Americans, particularly the more traditional cultures such as the Pueblos, is a central pillar of society. It means far more than socialization. . . . It is living history, a pathway to the future, and an incorporation of the Pueblo interpretation of life and the cosmos around us. It is poetry and philosophy in motion. . . . If there was no one here in San Juan Pueblo to carry on the songs and traditional dances, our whole society might fall apart.

—Estrada and Garcia 1992:93

The compelling quote above illustrates the profound importance of traditional ceremonies to Native peoples of the Southwest. In spite of this, the study of ritual performance has traditionally been the domain of cultural anthropologists because of its ephemeral nature and the critical role of live performers. Archaeologists have addressed ritual, but they have traditionally done so within the context of theorization on the implications of a society's ideology during dialogues on social complexity (e.g., Earle 1997; Kenoyer 1991; Marcus and Flannery 1992), and little if anything is ever presented to the public about specific aspects of ceremony in prehistory, especially music. Instead, any music a visitor to a museum may hear is most likely emanating from the gift shop, and only modest information is presented about any musical instruments actually on display. Much more could be done to research music in the past, and the result would both contribute to an anthropological understanding of the roles of music and musicians in human societies and provide a more

complete picture of the lives of people in prehistory. In addition to contributing to an anthropological understanding of humankind, this kind of information is likely to be of particular interest to the general public, and it is a good way to inspire curiosity about the past and about the activities of archaeologists. Music is something modern people experience almost daily in their lives, and the recognition that people in the past also made music suggests that those people were engaged in activities beyond those related to subsistence, raising an appreciation for their creativity as well as their resourcefulness. This chapter outlines a theoretical basis for research on the social and physical contexts of music and presents some preliminary results of research on the music of the Pueblo IV or Classic period of the Rio Grande Valley in northern New Mexico. It demonstrates not only that museums need not be silent on the subject of music in prehistory out of a perceived lack of information but also that they should not ignore a uniquely universal way of opening a door to the past for the people of the present.

Opportunities to re-create the sounds of past music are rare, though an attempt is currently under way to reconstruct ancient Greek music based on musical scores, philosophical writings, and depictions of musicians in various media (Gewertz 2001). Other efforts have focused on musicological analysis of instruments themselves (e.g., Brown 1967, 1971; Olsen 1986, 1990; Payne 1989, 1991). The physical and social contexts for music are more accessible archaeologically, especially insofar as they are expressions of a group's ideology. It has been argued that ideology is most effective as a source of social power when it is given material form as a ceremonial event with the accompanying paraphernalia, a symbolic object, or a monument and is controlled by a dominant group (DeMarrais et al. 1996). However, there may be a multiplicity of ideologies within any society, and there are certain aspects of ideology manifested as performances that may have no material component, such as the recitation of genealogies or oral histories. Conversely, however, the argument raises the notion that some aspects of ideology *are* materialized in the context of performance and as such may leave some trace in the archaeological record. The performances most likely to have some material component with any consistency will be the most formal ones usually subsumed under the rubric of "ritual." Not all rituals will have material aspects, and not all ideological behaviors that are materialized are ritual in nature, but to the extent that they are related to the broader social organization and integration of the society, one would expect a series of material correlates recoverable by archaeologists.

It is widely recognized that rituals have strong integrative roles, particularly in societies in which leadership is noncoercive. There also appears to be an upper limit on the number of people who can be integrated into a functioning community by means of ritual alone, a figure that scholars looking at ethno-

graphic evidence have found to be about 2,500 to 3,000 individuals. Beyond this point, other, nonritual kinds of measures are necessary to meet the needs of a group, or the group will fission or otherwise disintegrate (Adler 1989:46). Hegmon summarizes the ways in which ritual contributes to social integration: (1) participants in public ritual share transcendent experiences which in turn leads to shared social norms and a sense of social solidarity; (2) ritual sanctifies the content of communication within its context; (3) ritual regulates aspects of sociocultural systems, such as food sharing and scheduling of planting; and (4) ritual publicly defines local groups and regional relationships (1989:6). Groups and relationships are defined by ritual because "ritual can exist only in the specific cultural schemes and strategies for ritualization . . . embodied and accepted by persons of specific cultural communities" (Bell 1992:107). Ritual construction of communal identity is particularly effective because it invokes a precedent of authority that draws upon traditional moral values and nostalgia while maximizing a perception of consensus, even if that authority is in actuality diffuse, inflexible, and more attached to the social office than the person filling it.

The deliberate construction of a ritualized environment can be considered one strategy available to leaders seeking to legitimize their authority when ritualization is defined as "a way of acting that specifically establishes a privileged contrast, differentiating itself as more important or more powerful" (Bell 1992:90). Music is one very effective means of ritualization because it can be both broadly participatory and exclusive, widely practiced yet appropriate for specialization. Such specialization allows for centralization, thereby fostering differential levels of participation and access to ritual knowledge and resulting in a series of social roles with varying degrees of access to sociopolitical resources. However, if we are to investigate strategies of ritualization in prehistory, they must be visible archaeologically. For further insight into this point we turn to the Rio Grande Valley of northern New Mexico.

At the beginning of the Pueblo IV or Classic period (1325–1540 C.E.), the Rio Grande Valley in northern New Mexico had just experienced a major influx of population from people leaving the Colorado Plateau, perhaps in response to a 200-year change in the monsoon rainfall cycle. Archaeological data from areas of the Colorado Plateau just prior to the migration imply instability in integrative institutions. Sites were located in defensive positions, and subregional pottery styles appeared. It is suggested that this period of upheaval resulted in a reorganization not only of population on the landscape but of ritual systems and community integration mechanisms (Ware and Blinman 2000). Others hypothesize that people left the Four Corners area for the Rio Grande and the Hopi and Zuni areas because they felt "social needs for aggregation that could not be met with the environmental conditions of

the times" (Cameron 1995:110). The opportunity to join communities practicing the kachina religion could have been as strong a pull factor as the environment was a push factor.

Whatever the reasons, participation in aggregated communities certainly took place, for at the end of the Pueblo III period and throughout the Pueblo IV period there was a decline in the overall number of sites and an increase in the sizes of the larger sites. Many had 100 or more rooms, and a few contained 300 to 500 or more rooms, with multiple plazas and kivas, and ceremonial rooms embedded in roomblocks associated with or actually serving as kivas. Increased population density and size affected the nature of the interactions among members of pueblos significantly larger than those inhabited in the past. In such instances, "there arises a need for more levels in economic, political, and social decision-making hierarchies that organize human interaction in a community" (Crown 1994:103). Different leadership and integrative strategies were implemented, and this was a time when Pueblo ritual and ceremonialism flowered. Designs on pottery and kiva murals shifted from simple, repetitive symmetry to what Adams describes as "asymmetrical, complex, curvilinear designs, abstract designs, and realistic designs depicting a variety of life forms" (1981:322). The kachina cult became widespread at this time, with variations developing as it spread across the prehistoric Pueblo world (Schaafsma 1994).

This florescence is evident in the architecture of the pueblos from this period. Pueblos were built with enclosed plazas, in contrast to the more front-oriented roomblocks that characterize earlier habitation structures. Kivas became more numerous relative to the number of habitation rooms than had been the case in the recent past. More planning was implemented during construction, and greater control of physical and visual access to community ritual areas is apparent. The large plazas probably facilitated participation at the community level, while kivas served to join representatives of different segments of society (i.e., lineages, clans, kiva societies, etc.) in a more specialized context. In addition, the secrecy provided by controlled access to ritual performance would have minimized conflict over ceremonial practice among newly aggregated groups, maintaining a measure of religious freedom and allowing for the incorporation of newly arriving ritual specialists (Brandt 1980:131). In addition, ritual is most effective as a power resource when it is monopolized, and secrecy is one way such monopolization could have been accomplished (Potter 2000). There is ethnographic evidence that access was controlled not only in terms of physical space but in terms of content as well. The use of vocables (syllables that are not specific words) and language thought to be ancient or otherwise foreign and not understandable by all members of the community also fosters an environment of secrecy (and hence

ritual potency and efficacy), even during a public ritual performance (Hinton 1980; Kurath and Garcia 1970). In sum, the changing social contexts of public and private ceremonial performance space suggest that the mechanisms for social integration and organization differed significantly from those of the past (Snow 1981). The archaeological record from this time contains a greater number of ritual and ceremonial items than were present in preceding periods, and musical instruments are no exception.

A range of objects would have been available for creating ritualized environments across the Southwest over the course of prehistory. Important among them were musical instruments. The earliest instruments that have been described in any detail in publication are seven decorated wooden flutes found by Earl Morris in the Prayer Rock District of northeastern Arizona. These date to 450–630 C.E., which places them within the range for Basketmaker III (Morris 1959). Gourd and tortoiseshell rattles start to appear between 600 and 1000 C.E., as does an early form of the foot drum—an architectural feature observed in some kivas and thought to have served a musical function. Conch shell trumpets, *Conus* shell tinklers, and copper bells were all procured from areas to the south and began to appear after 1000 C.E., about the time that Casas Grandes was beginning a period of growth. Tinklers were in use through the Pueblo IV and V periods, and they appear to have been employed as much for decoration as in the strict musical sense. Evidence from burials (e.g., McGregor 1943) and from kiva murals (Dutton 1963) suggests that they were sewn onto the hems of clothing and dance sashes, and they were traded further east to the plains along with beads, gorgets, and similar decorative objects (Lintz 1991). The trade in copper bells parallels the development of the manufacturing centers in Mexico, but even before those centers collapsed toward the end of the Pueblo IV period, clay bells shaped in imitation of their copper predecessors appear in places such as Awatovi and Pecos as well as in areas of southern New Mexico. Bone rasps also appear at this time (Brown 1971).

Conspicuously absent in the archaeological record is any evidence of the percussion instruments so ubiquitous among the modern pueblos. The only prehistoric southwestern drums known, other than foot drums, are a group of ceramic hand drums from the Medio period at the site of Casas Grandes in northern Mexico (Ravesloot 1988), and there is no evidence that these were traded north. Perhaps, given their secluded location in a highly specialized mortuary context, they were kept secret even from the general population of Casas Grandes and were never produced as trade goods. We know from Pueblo mythology that drums were in use, though the antiquity of the myths is unknown. In an Acoma story, the deity Iyatiku tells Oak Man how to make a drum by knocking the center out of a segment of a cottonwood tree and

covering both ends with elk hide. A drumstick was made from the wood of the same tree, and a rattle was constructed by drying the scrotum of an elk around some sand, then filling it with agave seeds and inserting a handle (Tyler 1975:113). The Zuni recount that the War Twins gave the Coyote clan a pottery drum, which was kept by the clan and brought into the plaza for the Scalp Dance (Tyler 1975:173). In the modern Tewa-speaking Pueblos, drums are owned communally, while other kinds of instruments are owned by individuals (Kurath and Garcia 1970:40). Communal ownership raises the possibility that few drums of any material ever entered the archaeological record if they were considered inalienable possessions in the sense that Weiner (1985) defines them: as goods that do not circulate or that circulate only under particular circumstances, and which are found in the archaeological record only under conditions of special disposal (Mills 2001). If this is the case, it is in strict contrast to other types of musical instruments, which do not seem to have been inalienable objects in this sense. For the most part, other instruments do not appear to have been treated much differently than other personal possessions in their disposal and consequent entry into the archaeological record, though there are some caches of multiple eagle bone flutes found in kivas at Pecos Pueblo that warrant further consideration in this context (Kidder 1932).

There is only one reference to drums in the contact-period historical accounts by early Spanish explorers who came to the Southwest in the 1540s. The expedition that first visited Pecos Pueblo was greeted "with drums and flageolets, similar to fifes, of which they have many" (Winship 1896:491). In spite of this observation, no drums have been found during archaeological excavations at Pecos Pueblo, though flutes, whistles, bells, and rasps have all been recovered. Other early Spanish accounts only refer to flutes, singing, and clapping, as the following examples illustrate. One is a description of women grinding corn on stone *manos* and *metates:* "While they are grinding, a man sits at the door playing a flageolet, and the women move their stones, keeping time with the music, and all three sing together" (Hammond and Rey 1940:255). Another example is in a letter written by Don Antonio de Mendoza to the king of Spain in which he stated: "The Indians hold their dances and songs with the aid of some flutes which have holes for the fingers. They make many tunes, singing jointly with those who play. Those who sing clap their hands in the same manner as we do. . . . They say that five or six get together to play, and that the flutes are of different sizes" (Hammond and Rey 1940:159). Such accounts are clearly not detailed enough for in-depth ethnomusicological analysis, but they are one line of evidence available for determining how the instruments we find in the archaeological record were actually used.

In addition to what we find in historical accounts, ethnographies, and

mythology, important information on the role of music can be gained from archaeological assemblages by analyzing the variability in types and numbers of instruments, the standardization of manufacture, and the development of new kinds of instruments. The assemblages of musical instruments found at Pueblo IV Rio Grande sites differ from those of previous periods. The numbers of bone flutes are much higher at Pueblo IV, and preliminary analysis of flute construction reveals a greater degree of standardization occurring at the regional level. End-blown flutes made from the wing bones of golden eagles with three holes for producing different notes have been found in pueblos along the length of the upper Rio Grande, whereas flutes from previous periods were much more varied in their materials and the number of holes. Standardization is also evident upon examination of bone whistles of the period. People began constructing bone whistles in matched pairs, using wing bones from the right and left sides of individual birds and making the two whistles mirror images of one another. Wind instruments are not the only ones exhibiting similarities across the region. Shell tinklers from the Rio Grande Valley and, in fact, the greater Southwest are consistently around two centimeters in height, and all have the spires of the shells removed and suspension holes near the base. In addition to the regional patterns of instrument morphology of the Pueblo IV period, a greater variety of types of instruments were being used at individual sites, and new instruments were being invented. The earliest bone rasps date to this period, as do the early clay bells. Small whistles known as bitsitsi whistles first appear in pueblos dating to the transition from Pueblo III to Pueblo IV, and some experimentation with the construction of clay whistles took place, though these instances were isolated. Kiva bells (large slabs of basalt, phyllite, slate, and other stones that ring with a clear tone when struck with another stone) are found for the first time in Rio Grande Pueblo IV sites. Thus one strategy for integrating and managing the large, new communities that developed as people migrated from the Colorado Plateau was an increase in ceremonial elaboration that involved both organizational restructuring and changing ritual elements, including sound.

Ethnographic evidence reveals the degree of interrelationship that developed between religious and social authority in the region. Moieties, clans, societies, and kiva groups crosscut the modern Rio Grande pueblos. It is believed that in late prehistory as well as in ethnographic and more modern times, the latter formed the core of the ceremonial organization, and that the members also closely influenced political institutions and appointments. As Brandt observed at Taos, "Since Pueblo governing systems are linked in important ways with these small-group cultures, the establishment of status hierarchies based on secret information in the possession of one group rather than another can have important political consequences" (1980:130). Some suggest that a priestly

hierarchy virtually controlled the political life of the Pueblos (Ware and Blinman 2000). Thus the strategy of ceremonial elaboration and ritualization, coupled with other approaches for building a base of sociopolitical authority, was successful. The changes and adaptations made during the Pueblo IV period set the stage for the Puebloan societies as they existed at the time of Spanish contact. It would be a separate undertaking to explore the degree to which occupation by Spanish and American cultures has affected Pueblo ceremonialism. Certainly monumental changes have taken place, but the management of the Pueblo governments by ceremonial specialists proved to be a method of social organization and integration strong enough to endure centuries of colonial occupation.

While the actual sounds of the music of the prehistoric Southwest are not recoverable archaeologically, the social and physical contexts are. Application of theoretical work on ritual and alternative sources of political authority in small-scale societies to archaeological data in the form of architecture and artifacts can provide insight into the roles of music and musicians in prehistory. In the Rio Grande Valley, changes in the instrument assemblages over time correlate with changes in settlement patterns and spatial organization in ways that suggest fundamental changes in the fashion in which ritual and ceremony were incorporated into the social and political lives of people living in large, aggregated pueblos during the Pueblo IV period. Rather than being relegated to the "Miscellaneous Bone" section of site reports, musical instruments should be viewed in the manner of any other specialized tool—as indicative of the activities of the people who made and played them and the social roles they may have had in their communities. Similarly, incorporating fuller interpretations of musical instruments into museum exhibits has the potential to engage visitors in learning about the past in a more direct way than lessons about objects with which they have had no directly analogous experience. It completes the portrait of past peoples to include their creativity and capacity for self-expression, and it reinforces the experience of our common humanity.

13 / Archaeology's Influence on Contemporary Native American Art
Perspectives from a Monster

Lance M. Foster

American Indian communities and archaeology seem to be like oil and water, not mixing, repelling each other no matter how much they are stirred. Native people are angered by the cultural imperialism and insensitivity shown by archaeologists in the excavation of sites and the treatment of human remains. Archaeologists, meanwhile, see Indians as obstructionists. While the Native American Graves Protection and Repatriation Act and similar legislation have gone a long way to address these concerns, considerable rancor and polemics often still exist when it comes to Native Americans and archaeology. The furor over Kennewick Man is the first example that comes to mind.

And yet, despite the rhetoric of protest and science, another side to the story is overlooked. Media attention is naturally fixed on conflict, but there have been many instances where Indians and archaeologists have benefited from getting past mutual suspicion to enriching each other's lives and understanding. This is probably best known in those collaborative efforts that constructed culture histories for the direct historical approach, which had the added benefit of delineating tribal territories for Indian land claims cases. Less well known is the fact that much of contemporary American Indian art was very much influenced by archaeology, through archaeological excavations and collections.

[Entrance from stage right: An odd and towering figure with two faces and daggerlike elbows saunters over and raises his hand; he removes one of the awl-elbows to use as a pointer during his lecture.]

I am afraid I must interrupt here. When I first began to consider the question of how to come to grips with the slippery ground between Native American art and archaeology, I began the process in a conventional way, as a scholarly work, full of quotes and bibliographic notations, and written in the scholarly third person with many "ones" and "therefores" and "thuses." And, halfway through it, I realized that anyone could have written that paper, given the proper research and sources, and it would have been just as dry and postmodern as you please. But I tossed that into the wastebasket, because I mean to talk about art from the gut, from my experience as both a Native American artist of the Iowa tribe and as an archaeologist.

I have this form, you see, because I will have to talk like one of those two-mouthed, double-faced creatures that my Ioway tribal tales called *Ixdopahi*. As you can see, we two-faced monsters have exposed bony elbows, sharp as awls, which we use to attack with, and we can walk forward or backward, without turning, because we have a face on each side of our heads, front and back. I have had to assume the shape of one of these spirits, because I mean to have two faces, the face of a Native artist and the face of an archaeologist. You will have to decide for yourself which face is looking forward and which is looking backward.

I have always been Native, and I have always been an artist, from my first toddler scrawlings of lions and those Greek monsters called Cyclopes (wow, already another mention of monsters!). But I have not always been an archaeologist, and in fact, this is often a point of suspicion for many of my Native relatives and friends, as if one can never *ever* be both Indian and an archaeologist. But let me try to act as a proper Native, and a proper *Ixdopahi*, and walk both forward and backward as the spirit (and this story) moves me. And beware my elbows.

I attended the Institute of American Indian Arts in Santa Fe as a young man, twenty years old, bound by fate and disposition to be an artist, for I could not do much of anything else. When I was there in 1980–1981, I quickly learned that to be a proper Native, one should rail against anthropologists and archaeologists, for good father Vine Deloria, Jr., decreed it so. So I railed in the proper manner, as a good Indian should.

[Scene: The inside of a stucco studio, a paint-speckled radio blaring out the latest hit from the Rolling Stones, with about ten similarly speckled Indian students intently painting on the canvases in front of them. Among them, one is painting a still life with pottery and kachinas, another is painting a warrior on horseback, still another is referring to an open book with a picture of a Mississippian gorget as he paints elements of the gorget in bright, modern colors.]

At the same time, I noted that many of the young artists were trying to find their artistic expression through reference to ancient artifacts and artworks of the Old People of the many nations. I wondered how one could accuse archaeology of such evils and yet use the fruits of that evil. No, actually I didn't wonder, because it was expedient to be inconsistent in that way, for I could at the same time claim moral superiority as an "anti-archaeology traditionalist" as well as use those materials to create "traditional arts." I continue to be amazed at how few Native artists admit this dilemma.

At that time (and it continues), young Pueblo artists referred to the kiva murals and pottery excavated in the Southwest, kids from the eastern tribes referred to the Mississippian kingdoms with their shell gorgets and copper serpents, and Plains kids referred to Karl Bodmer and George Catlin. And Navajos pretty much referred to anything they wanted, quickly making it "Navajo" somehow, an ability they seemed to have always had.

[Cut to scene of a Hopi woman with her husband, time around the early 1900s, walking through a series of empty masonry rooms. They are walking through a typical "ruin" of the American Southwest; however, they do not call it a "ruin," for would you call your beloved grandmother a "ruin," no matter how decrepit she might seem? The two are walking across the ground, scanning it systematically, carefully picking up one pottery shard, scrutinizing it, then placing it carefully back where they took it. It is disconcerting to see these traditional Hopis acting very much like archaeologists. The following block of text scrolls as we continue to watch them work . . . with occasional fades in and out of Siyatki elements morphed with those of Nampeyo . . .]

Nampeyo (1858–1942) was a Tewan-speaking Hopi born at Hano, First Mesa, Arizona. Her early pottery reflected Hopi designs and motifs that were popular at the time. The Hopi potters during the 1800s used a yellowish to white slip that was heavily applied and often cracked. This style of pottery was an adaptation from the Zuni. Nampeyo was noted for producing good-quality pottery, and she continued to improve her skills and techniques. What set Nampeyo apart from her contemporaries was her use and integration of Sikyatki Polychrome (A.D. 1375–1625) designs and techniques. Nampeyo and her second husband, Lesou, visited Hopi ruins and incorporated into her pottery the ancient painted designs from the pot sherds they collected. Upon examining the sherds they were able to determine that Sikyatki pottery was unslipped and the clay composition consisted of a fine-textured yellow clay. Nampeyo and Lesou were able to locate the ancient sources of clay and began producing unslipped ceramics from

those sources. In 1895, Lesou was hired as a crewmember of the
Fewkes Expedition, which excavated ancient Hopi sites at Sikyatki.
As a result of his participation in the expedition, he and Nampeyo
were able to examine hundreds of pot sherds and whole vessels with
different and novel designs. Not only did Nampeyo reproduce Sikyatki
designs and motifs, she also reintroduced the low-shouldered shaped
pottery of prehistoric origin. . . . The Sikyatki Polychrome style of
pottery is characterized by red and black painted designs against a
highly polished golden background. Sikyatki designs consisted of
geometric designs and animal motifs, such as birds, butter flies, and
Kachina faces. . . . Though Nampeyo duplicated many Sikyatki
pottery designs and shapes, the finished product was not completely
Sikyatki. She was able to integrate the Sikyatki style with her own
artistic talent and personal vision to produce a totally unique style
that was chiefly responsible for the revival of Hopi pottery.
(http://www.sfsu.edu/~museumst/QTVR/content06.html)

[Return to scene of a modern Indian art student working carefully on a Hopi
pot, still with the Rolling Stones blaring, as the look of intense concentration
never wavers from the formation of the pot.]

There was a kind of choice to be made. To be a contemporary and successful
Native artist, it was implied, you derived your individual voice from blending
elements of modern non-Native art (from artists like Christo, Dali, Rothko,
Warhol, etc.) with elements of traditional Native art (pottery, skin clothing,
shields, kachinas, kiva murals, etc.). Kind of mix and match, but be sure to put
in a good dollop of protest and pathos if you want attention and for it to sell
to those sensitive and very rich white souls who wanted to be "in the know"
when it came to "the Indian experience." And of course if you could stick in
an eagle, a wolf, or a buffalo, and match this year's colors selected by interior
decorators, so much the better. But of course, some just cut to the chase and
copied the Native masters like Allan Houser, T. C. Cannon, Fritz Scholder,
and R. C. Gorman, so they could get to partying that much sooner. Ah, those
years of discovery and innocence! I ask your indulgence, but I did tell you
about these elbows of mine.

This kind of artistic integration and influence from archaeological work
was not limited to the turn of the century or to the Southwest or to the Insti-
tute of American Indian Arts. From the early years of tourism, many Native
artists have used artifacts and sites in their art. Some pieces are little more than
reproductions for sale as gift items. One example of such borrowing and varia-
tion can be seen in the variant use by several southeastern artists of the ico-

nography of a Mississippian gorget with four woodpecker heads (see figure 13.1 and plates 22 and 23).

Unfortunately, as nice technically as some of these works are, they do not go beyond their function as a type of icon of perceived "real Indian spirituality," as reproductions and variants produced by "real Indian artists" trying to make a living by making things they know will sell. In a sense, they are handcrafted kitsch. Non-Indian buyers often ask the artist about the symbolism, and the artist must either admit ignorance or come up with a pleasant explanation that will suit a buyer who is looking more for the spiritual importance than for an aesthetic experience. Let me tell you, the average working Native American artists I know are much more concerned about making a living and supporting their family by their art than they are about expressing themselves unsullied by derivation. Derivatives are made because derivatives sell.

Being contrary, however, I wanted to see if I could find salability with derivation as a Native artist. What was I to do for valid artistic inspiration? I started as the Navajo did for a while, borrowing from this interesting bit here and there, cafeteria-style. But that quickly frustrated me, and, being of light complexion, I was open to criticism and ridicule, as some kind of aesthetic wannabe. Being a serious sort, I decided to solve this problem rationally. I would do as others, like Nampeyo, had done and search the shards of my ancestral culture to recombine them in ways both interesting and salable.

My tribe is the Iowa (or Ioway, depending on your mood and dialect; I will use both here to reinforce their interchangeability as well as my own). So I vowed that if I were going to re-create some kind of Iowa art, I had to learn more about the Iowa, somehow, some way: I would discover exactly what constituted "Ioway art." Then I could use that as a point of departure for my own work, and become a successful contemporary Indian artist remaining true to his Ioway traditions, and go shoulder-to-shoulder with the best of those yearning and self-satisfied souls seeking fame and fortune along Canyon Road.

The Iowa were one of those betwixt-and-between people, not fully Woodland, not fully Plains, but, like their Sauk and Fox allies, a people of the tallgrass prairie, or Prairie Peninsula. Unlike bigger (and more researched and collected) tribes like the Lakota, there was very little that was definably Iowa and *only* Iowa. Contemporary Iowa arts and culture took most of their expression from the pan-Indian powwow culture of Oklahoma and the Midwest, with its most notable characteristic being stylized floral beadwork and ribbonwork on a black cloth background. For me to try to come up with something I could build as Iowa art, with an Iowa worldview and Iowa aesthetics, I would

13.1. Line drawing of engraved marine shell gorget from Mississippi, from "Art in Shell of the Ancient Americans," Bureau of American Ethnology, 2nd Annual Report. Washington D.C. Fig. 1d, p. 20 (Holmes 1883; LVIII) (http://www.museum.state.il.us/RiverWeb/landings/Ambot/prehistory/archives/images/art/pages/ptartwoodpecker.html).

have to delve further, into old material-culture studies, like those of Alanson Skinner.

And yet even Skinner's work was not what I needed, for before the Iowa were submerged in this century's pan-Indianism, in the last century they were part of a kind of pan-Woodlandism, with little to differentiate them artistically from the Sauk, the Fox (or more properly, the Meskwaki), the Omaha, the Otoe, the Kansa, the Winnebago, or the Hochunk.

Ian Hodder notwithstanding (and of course in those days I knew nothing of Hodder), there was very little in the way of ethnic boundary markers to be seen in the material culture of the tribes of the states of Iowa and its neighbors, the homelands of the Iowas. The weapons were similar, the clothing was similar, the ornaments were similar. I was yet frustrated in my little scheme of coming up with something that could be seen as "Iowa art" in the same way that scholars differentiate the various pottery forms of the Pueblos, or the way they could say "this is Crow beadwork" and "that is Cheyenne."

So I went back farther, to the archaeological roots of the Iowa, the manifestation that archaeologists called "Oneota." That is not an Iowa term but rather one of those misnomers archaeologists applied early on out of convenience, and one that becomes very much inconvenient in its ability to confuse the tribal descendants and the general public. The Oneota people of Iowa and the surrounding states seem to have evolved *in situ* from indigenous Woodland cultures.

I had found the material roots of what it was to be Iowa/Ioway. Unfortu-

nately, by that time it was about ten years after I had left the Institute of American Indian Arts, and I had escaped the fantastic artistic opportunities of Santa Fe to find myself studying my ancestral culture in the small city of Ames, at Iowa State University, as an archaeological student intern for the U.S. Forest Service. Of necessity my painting took a backseat, but something wondrous happened. I began to paint with new focus.

I decided that, rather then taking archaeological materials and copying or reinterpreting them, I would look at the practice of archaeology itself and at sites rather than artifacts. One painting I called *Tilth* (plate 24), which refers to the composition of soil. It was a three-dimensional column of soil, with images arranged stratigraphically of the various natural forces that went into creating the column. The top layer shows several images of Native American faces and bones, referring to our belief that the top seven feet of soil are made up of the bodies of our ancestors. On top I placed a toy tractor, indicating the temporary nature of the dominant culture as it passes unheedingly across the surface, using the soil's bank account made of the bones and flesh of those who went before.

Another mixed-media painting I called *Northridge* (plate 25), after a housing development in Ames that destroyed a portion of an archaeological site. One house was built on and destroyed a mound, and I photographed the house and placed it on the painting. The painting itself has several mounds intact, with effigies representing the clans and the strings of beads their spirit roads back to the red womb of rebirth. The mound that was destroyed shows that the spirit of the dead's trail to rebirth has been destroyed. Around the mounds, in the trees, the crows sit as witnesses.

The world of art is a funny place, and the world of Native art is no exception. The straddling of artistic integrity and meaning and of salability is a problem all artists must encounter and grapple with. This is even more true with Native artists, because non-Indian markets feel they "know" what is Indian and what is not. The white collector buys the works of (thus rewards) those artists who produce what he or she decides is "Indian art."

In fact, there are many so-called Indian artists who are not Indian at all but who have successfully discerned what is marketable as Indian art. I can think of at least two very successful artists today who do "Indian art" who never actually lie and say they are Indian but who produce "Indian-looking" things and let people believe what they will. A book was recently published (Matthaei and Grutman 1994) that was apparently a book of Indian ledger art, but it was actually a book of faux ledger art, invented by a non-Indian to appear Indian. It looked so Indian that an anthropology professor of mine bought it because he believed it was Indian, and he was crestfallen when I showed him the fine print that told the truth of the matter.

Indian artists are caught in a bind. If they do copies of R. C. Gorman or of kachinas or gorgets, they are called derivative. If they do not do copies of these kinds of things, their art somehow "is not Indian art" and they cannot sell it, and they leave art to do something else. It is the primarily non-Indian market that has defined what "Indian art" is today, not Indians themselves (in fact, the question of who is or is not Indian is an even wilder ride for contention and speculation).

Indian artists who struggle to find their own expression without sinking into kitsch, predictability, or derivativeness sooner or later come to rely on ancestral tribal arts—the older and closer to the source, the better. Ultimately, these sources include materials from archaeological excavations, whether from Ozette or from Spiro. This was as true in the days of Nampeyo as it is today. During the critical time when an artist is finding his or her voice, archaeological materials provide the strongest link to that originality of expression which may give the artist not only an unshakable identity but something "new" to say in the world of art while remaining Indian.

There is much I could and would say to Indian artists of today, especially those in that time of formation, smoothing themselves as they would a pot with a polishing stone. Primarily, I would encourage them to look to the past for what must be expressed anew. But recall Basho's words: "Do not seek to follow in the footsteps of the men of old; seek what they sought."

To the non-Indian collector of art I would say this: remember the old scheme of Leslie White's about the interdependence of the technological, economic, and ideological spheres. Remember that art is produced within the influence of all three of those spheres. Remember that when you buy any art, you are, through the economic sphere, affecting the technological and ideological realms of the artist. Remember, in the same fashion, if you are an archaeologist, that you have the ability to interact favorably with a young Native artist and to reveal the works of the ancestors to new expression and vitality.

And to both I would say, as a two-faced monster with sharp elbows, that I hope I was able to present my point of view without too much injury.

14 / From Rock Art to Digital Image
Archaeology and Art in Aboriginal Australia

Claire Smith and Kirsten Brett

One focus of contemporary archaeological practice is that of achieving more effective communication with a public audience. This is promoted by both funding and ethical imperatives. The current impetus toward archaeological research being supported by private, corporate, and public funds means that archaeologists are increasingly accountable to people outside the discipline. This is compounded by an ethical obligation for archaeologists to relate their research to the people with whom they are working. The challenge that arises is that of explaining archaeological concepts in ways that promote public understanding of the issues involved. Increasingly, archaeologists are responding to this task by using narratives and visual images to inspire and educate the public about cultural heritage. Rock art, in particular, is an important route through which the public is able to gain an understanding of some forms of cultural heritage. For non-Indigenous people, rock art can be experienced as a direct link with the artists of the past. However, the experience is quite different for the Indigenous people who are the descendants of these artists. For them, rock art images are much more than a mnemonic of the past. Instead, these images have a resonance in the present and form an integral part of their contemporary cultural identities.

This chapter investigates the changing uses and meanings of Aboriginal arts from the Barunga-Wugularr region of the Northern Territory, Australia (figure 14.1). The central theme is the manner in which Aboriginal people use visual arts to establish and maintain connections with the world around them. Rock art images are used to convey social and cultural information and to provide visual cues for oral histories. When transferred into a digital format, they can form the basis for educational tools that effectively extend Indigenous forms of instruction.

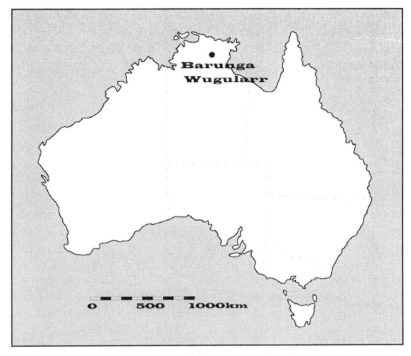

14.1. Location map of Barunga and Wugularr, Australia. Image used courtesy of Barunga-Wugularr communities, Australia.

A LIVING HERITAGE

The invasion of Australia by the British in 1788 has often been portrayed as the beginning of the end of Australian Aboriginal and Torres Strait Islander cultures. Today, it is clear that these cultures have survived. Although their societies have undergone radical change in many parts of the country, Indigenous Australians have drawn upon the inherent flexibility in their cultures to ensure their ongoing survival. The outcome has taken different shapes in different parts of the country. At the time of invasion, Australia had a cultural diversity similar to that of Europe today. Some 200 to 250 different languages were spoken throughout the country, and most Aboriginal people were multilingual. Contact between neighboring groups was a normal part of ceremonial and economic exchanges, forming a network of interconnections (see Horton 1995; Mulvaney and Kamminga 1999).

The visual and performing arts of Indigenous Australians are part of a living heritage that is an integral part of their everyday lives. These arts arise from complex social systems that communicate information about Aboriginal

societies as a whole and about the places and roles of particular individuals within those societies. Knowledge is embedded in extended social relationships and is shared visually through relationships to the land, through artistic expression, and orally through stories. Major contemporary art forms include rock art as well as drawings on bodies, bark, canvas, and paper. Each art object has meaning and is part of a sophisticated and complex way of defining one's self, one's family, and one's place in the world.

Prior to European invasion, rock art was the most enduring form of Indigenous visual arts. Reflecting the diversity of Indigenous cultures, there is enormous variation in the kinds of rock art that exist throughout Australia (see Flood 1997; Layton 1992). In the Sydney region there are rock engravings of fish and sea animals. In Tasmania the art is also engraved, but it is mostly geometric circles and lines. The same is true for the center of Australia, but the overall designs are different. In Cape York and Arnhem Land, recent rock art consists mostly of figurative paintings. In the Kimberley there are Wandjina figures, paintings of the ancestors who lived at that place and whose spirits still reside there. Only one art form—hand stencils, which generally signify a person's relationship to a particular place—is found throughout Australia (Morwood 2003).

Rock art is an important element of the living heritage of Indigenous Australians, one that taps into vital sources of ancestral power. Both the past and contemporary landscapes inhabited by Australian Aboriginal people are imbued with life, potentially dangerous and full of meaning. These landscapes were created in the Dreaming, the creation era during which ancestral beings traveled throughout the land, creating its topographic features through their actions, and finally "sitting down" in one place, becoming a living part of that place forever (cf. Morphy 1991). Frequently, rock art sites were a focus of their activities, and today these sites are often considered visual proof of the existence of these ancestors.

Rock art sites in Aboriginal Australia are not silent and inert depictions of mythological pasts. Rather, they have direct and potent links to the ancestors who traveled the country during the Dreaming. Within the Aboriginal worldview, power flows from inherently powerful ancestral beings to the land, which is given power by the actions of past people and ancestors. In this way, every facet of the landscape is imbued with ancestral associations and ascribed with social identity. As people move through their lands, they learn about the relationships between place and ancestors (C. Smith 1999). Through this they also learn about themselves and their particular rights and responsibilities to the land. Rock art sites play an important role in this process of identification.

In the Barunga region of northern Australia, looking after rock art sites is

one way Aboriginal elders can show that they care for their country and their culture. The action of visiting these sites strengthens both the past and the present. Rock, as part of land, comes already laden with facets of social identity, such as language group, clan affiliation, and moiety (C. Smith 1999). This kind of information does not need to be communicated in rock art because it is already encoded in place.

The interconnectivity of Indigenous Australian cultures is apparent in the manner in which the social division of moiety is implemented. Moiety is an important means by which Aboriginal people in the Barunga region conceive of the world around them. During the Dreaming, ancestral beings assigned everything in the world—people, animals, plants, places—to either the Dhuwa or Yirritja moiety. The management of Indigenous lands is thus structured by a web of complex and sophisticated social interrelationships. In Arnhem Land, for example, "owners" (*gidjan*) and "custodians" (*junggayi*) have a reciprocal custodial relationship. All people have birthrights that place them in an ownership relationship to particular tracts of land and in a custodial relationship to neighboring tracts of land. This system of reciprocal rights and responsibilities is all-pervasive, since all people are owners for some tracts of land and for particular ceremonies and are custodians for others. At a general level, the society is divided into two moieties, Dhuwa and Yirritja. Yirritja people will be the "workers" in ceremonies, such as *Gunapippi*, that are owned by Dhuwa people, and Dhuwa people will be the workers in ceremonies, such as the *Jabuduruwa*, that are owned by Yirritja people. This reciprocal responsibility ensures that ceremonies and land are cared for properly even if people of the preferred "skin" group are not available. Ultimately, all Dhuwa people are custodians for all Yirritja land and all Yirritja people are custodians for all Dhuwa land.

The implications for the practice of art also emphasize interconnectivity. Each moiety is associated with particular colors and proportions. Dhuwa is associated with dark colors, such as black and red, while Yirritja is associated with light colors, such as white and yellow. Similarly, Dhuwa is related to the idea of shortness and Yirritja with tallness. Thus, the black cockatoo is Dhuwa while the white cockatoo is Yirritja. Likewise, the short-necked turtle is Dhuwa and the long-necked turtle is Yirritja (figure 14.2).

One of the most important principles for Barunga artists to follow is that of joining Dhuwa and Yirritja moieties so that they are "in company." Nearly all art forms combine light and dark colors, regardless of the specific identity of the artist or the audience for which the art is made. In rock art, however, moiety is already encoded in place, partly through the color of the rock and partly through the moiety of the land, so there is no need to join moieties

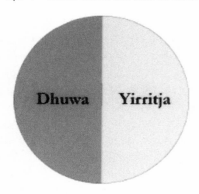

14.2. Moieties: Dhuwa is associated with dark colors, while Yirritja is associated with light colors.

through color. Thus, a rock painting can conform to the principle of joining Dhuwa and Yirritja even if the painting is made in a single color. This means that rock art is often not typical of other contemporaneous art forms.

Throughout Australia, Aboriginal artists painting on rock (and occasionally on other media) have signed their work with a hand stencil. This not only serves as a reminder of the individual artist but in some cases has links to that person's rights of residence. A senior artist and custodian from Wugularr, Paddy Fordham Wainburranga, states: "[The hand stencils] can be there for a thousand years. No bush clothes or anything will remain. In a good cave it will be there for ever and ever. Your son can look, or your grandson. It reminds him of his grandfather, or his old uncle. He belonged to this country. I live here and nobody can shift me out. This is the thing to make children remember. Not only Aboriginal children but all children where ever they live. To make children remember, so children can say, we've got history" (in Smith 1992).

Although the production of rock art is now rare, paintings on bark and other media are important facets of cultural expression—and they provide essential income to people in communities with little or no industries. Bark paintings became popular with collectors during the 1940s and 1950s and are now widely produced for sale (Morphy 1998). These paintings are made from strips of eucalyptus bark that have been flattened, dried, and smoothed prior to being painted with the natural pigments of red, yellow, black, and white. As with rock art, the production of this art is governed by rules laid down by ancestors during the Dreaming.

Certain dances, songs, and designs are held in the custodianship of individuals, inherited from their forebears in the same way that they inherited rights to land or to the enactment of particular roles in ceremonies. Though these art forms are evolving, the philosophy is conservative, looking to the past

for direction and validation. This point is made by senior custodian Billy Lukanawi, who comments: "My father and my uncle they show me painting, why I'm not drawing other one. I got to draw that same one, that same drawing. Kangaroo, turtle, crocodile, rainbow [snake], quiet snake, file snake. I got to draw same way my father, my uncle. I got to follow them same way. I got to do red, yellow and white. I got to put them same way [as they used to do]. My father and uncle, my mother and my grandpa. They used to do same way" (in Smith 1992).

There are conventions controlling the use of designs. For Aboriginal people in the Barunga region, the production of art today is governed by rules established in an ancestral past that still, somehow, exists in the present. Prior to invasion, the penalty for using another person's designs was death. Today it is "death or $1,000" (Paddy Babu, personal communication 1992), but in fact, no one ever uses another person's designs. As in other parts of Arnhem Land (see Morphy 1991), these images are linked to particular tracts of land, and in a sense, using someone else's images would be like pretending ownership to his or her land. Aboriginal people only use the designs to which they have a right, in the same way that they speak only for their own country. These different ways of knowing are rarely incorporated into public archaeology.

DIGITAL DREAMINGS

To make public archaeology more relevant to Indigenous needs, it is important that Indigenous people shape the outcomes of the project (Isaacson 2002; Langford 1983; L. T. Smith 1999). Fundamental to this is acknowledgment of disparities in the knowledge systems of archaeologists and the Indigenous peoples (cf. Bruchac 2000). It is not enough for archaeologists to teach communities their version of archaeology; rather, they need to provide community members with a platform from which to shape an archaeology that has meaning and is useful to them in their knowledge systems.

It was with this intention that archaeological excavations were undertaken at the rock art site of Druphmi. Discussions with traditional custodians and members of the Barunga and Wugularr communities had indicated that a relevant way for archaeologists to give back to the community would be to help them strengthen local culture through the development of cultural education materials that portrayed their stories of Druphmi (Brett 2001a, 2003). The traditional custodians, *junggayis*, have much knowledge to pass on about Indigenous places and lifestyles. Ideally, this knowledge is passed on orally. However, they see the importance of having formal educational materials available to children in addition to this traditional passing on of knowledge. They see educational materials as having the ability to capture knowledge so

that the children can access it at any time, and repeatedly, so that they will remember it: "Old people talk and then bigini [children] can read about it in a book or hear it on a tape. They can understand then 'cause they have it all year round. They can't keep asking, they got to find out. Old people can't read or write. But we know idea, we know the word. We can put it a good way so they can have it in a book or can listen to it" (Peter Manabaru, personal communication 2000).

The education project progressed in three phases. First, children visited Druphmi during archaeological excavations and had stories shared with them by the senior traditional custodian. Second, we documented a visual and oral account of the knowledge that was shared. Third, we developed educational materials that portrayed this knowledge in a culturally relevant manner. This process is outlined in detail in Brett (2001a).

It was important that the children be involved in the project from its outset if the cultural education materials were to have meaning to them. Therefore, children from the Barunga and Wugularr schools visited Druphmi during the excavations. Stories were shared with the children by the senior traditional custodians Peter Manabaru and Jimmy Wesan and by a younger custodian, Freddie Cameron. The knowledge shared on these occasions related to the rock art site that the children visited and therefore was provided in its correct context. The rock art at this site was often used as a springboard for stories about the traditional ownership of the land, local histories, and the value of Indigenous ways of using the land. This process provided the children with a foundation to build on their knowledge at a later date when the educational materials were developed (figure 14.3).

The children learned by walking around the site with custodians and through sitting down with them and listening to stories. The children asked questions relating to the rock art, artifacts, and the country they were exploring. This process was recorded with a mini disc recorder, camera, and video camera so as to enable this information to be drawn on later for the development of educational materials.

The passing on of knowledge from custodians to children at Druphmi occurred in a manner that was relevant to both groups. For the custodians, the site as a whole—and the rock art in particular—acted as a mnemonic reminder of past events, ancestral associations, and the interconnectedness of the site to surrounding country and family. For the children, the giving of this information on-site linked them to the immediate past of their people.

Recording these accounts was an integral part of the education project, as it was important that the materials were developed around what had meaning to the Indigenous community rather than to the non-Indigenous archaeolo-

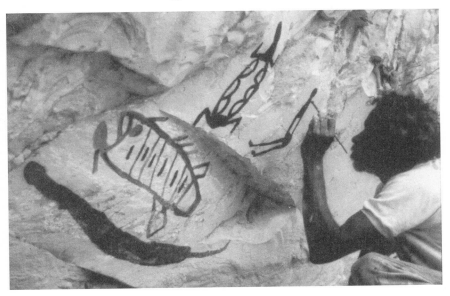

14.3. Peter Manabaru painting at the Yalkmurlering site, Barunga and Wugularr education project. Image used courtesy of Barunga-Wugularr communities, Australia.

gist. These stories gave an oral account of Druphmi, its art, artifacts, and the interconnectedness of the site to the surrounding country and family. An important part of the communication of stories was the choice of language by the custodians. Kriol (the first language of these communities) was chosen predominantly, though the traditional languages of Jawoyn and Ngalkpon were sometimes used to emphasize particular points. This setting thus was used to reinforce the value of Aboriginal languages.

Druphmi is located on country that is of significance to Indigenous people. It is not seen in isolation but as part of a series of significant places along the escarpment on which it is located. This interrelatedness stems from the Dreaming story that tells of its creation. Peter Manabaru's narration of the story (see below) links the movements of the rock kangaroo, *Dorriya*, creating sites during the Dreaming era, to the movements of the old people when they were traveling in the region, prior to living in settlements:

> That little kangaroo been make this. Little kangaroo, but what is his name [in Ngalkpon language]? Him Dhuwa. And from Jawoyn you call him Dorriya. Well he went from here, that Dorriya, that's why that call that Dorriya Gudaluk [another rock art site], he stopped

there. That's why he put down that painting. That's why the old
people have been talking about him, they knew him. He travelled
for a long way making caves.

No ceremony area this. This camping area for blackfella, old man, old
man. They used to come sleep here. They would ask "Oh what place
you want to sleep at Niphim Grong-grong, this one," or might be
they say at Druphmi, or might be they say Dorriya, Dorriya Gudaluk,
longa this way, or might be Bumbaluk, him got a cave there too. Or
might be we go to Yalkmurlering. All this cave area, that Dhuwa been
put that. All the way they got that name. Might be him start from
Dodluk, Druphmi, Nipim Grong-grong, might be Bumbaluk, Yalk-
murlering, Doriya Gudaluk, finish there. (Peter Manabaru, personal
communication 1999)

This story connects this site to other rock art sites in the region, including
Dodluk, Bambaluk, Yalkmurlering, and Doriya Gudaluk. A sense of connec-
tion to Druphmi was created by the Indigenous custodians' passing on knowl-
edge that was not detached from the present. It was part of the present because
it has significance to people in the local communities and their families. Many
people referred to Druphmi as "the old people's place." This does not place it
in terms of time, but in relation to people and country.

The stories were often initiated through reference to the rock art or arti-
facts from the site, such as charcoal, grinding stones, old cans, animal bones,
seeds, or stone tools. The stories told of how to make spears and axes, of using
these to hunt for bush tucker, and the differences between how people used to
eat at Druphmi and how the kids eat in the present. The custodians spoke of
the meaning of the rock art, how the paints were prepared, cooking on fire,
how to make fire, why the rock shelter is such a useful camping spot, and how
people used to camp there. In giving meaning to the artifacts, the stories
linked the whole site to give a portrayal of how the old people lived there:
"Lamjorroc paint a lot of this painting before. Gela [Lamjorroc], this his
country. Waterfall you call him, that's his country. Him finished now. Old
Phyllis walk around. I work for Lamjorroc. This painting been here long, long
time" (Peter Manabaru, personal communication 1999).

This contextual approach to education is apparent in the manner in which
the rock art on the shelter's walls was related to the grinding stones at the site.
Indicating where the grinding had occurred, Peter Manabaru explained that
"they grind them here, and then they make drawing all the way along, might
they used one for red [ocher] and one for yellow" (personal communication
2000) (figure 14.4).

14.4. Peter Manabaru teaching Louise Kennedy about grinding stones, Barunga and Wugularr education project. Image used courtesy of Barunga-Wugularr communities, Australia.

Aboriginal people in the Barunga region recognize three kinds of rock art sites. The first of these is very old rock art that includes both paintings and engravings. This is identified as having been made by "mimis," or other ancestral beings. These forms of rock art can be the actual "bodies" of ancestral beings, where they put themselves on the rock wall. Sometimes these paintings are located in highly inaccessible places, and the location in these places is cited as proof that they could not have been made by people. Such paintings are greatly valued by Aboriginal people not only for their antiquity but because they are an embodiment of ancestral beings. Jimmy Wesan identified this form of rock art at the site of Druphmi: "This one we never do. We didn't do this painting. In olden days, in the Dreamtime we [the ancestors] drawing this" (personal communication 1999).

The second form of rock art was produced by ancestors in the Dreaming, but it needs to be repainted (or renewed) by Aboriginal custodians in the present. Repainting is a way of physically preserving rock art images. It is subject to validation by elders and is usually done only by them. The repainting of such images not only strengthens the Dreaming but also acts as a focus of the power that emanates from the ancestral past. The brightness of the renewed painting gives people today a visual message that the custodians are caring for their culture. This matter is discussed by Jack Chadum: "This painting, him wash away. Nobody been look after him. If this was my country, I'd make him new. And him [would] look good" (in Smith 1992).

The third form of rock art is new paintings. Usually these are secular scenes

of families hunting or fishing. They are often explained as narratives of imagined or past events. Access to these sites is not restricted, and they can be viewed by all members of the society. This type of painting is depicted in plate 26, which Peter Manabaru describes in the following manner: "Blackfella been draw this. Olden days people. Long, long time back. Dalabon people, just like me" (personal communication 2001).

The paintings have different levels of meaning, each of which is specific to the person interpreting the art. These levels of interpretation are determined by the interpreters' age and gender, their life histories and the knowledge that is held within their families, and their position and status within the community (see Elkin 1952). For example, women and men may hold different knowledge of particular images, and *junggayis* and *gidjan* may have different knowledge. The interplay of these disparate forms of knowledge produces multiple stories of Indigenous "country" and places. Each story has its own place within the overall body of cultural knowledge (see Cowlishaw 1999). Moreover, as Merlan (2000) points out, Aboriginal ways of describing place tend to have a narrative character. Such stories are more concerned with what happened at a place than with providing a canonical characterization of that place.

Within this narrative context, it is important to Aboriginal people that rock paintings be "right" for that place. This operates at the level of both the general and the specific. At a general level, traditional custodian Jack Chadum's painting of a man catching a barramundi (figure 14.5) is considered appropriate since the rock art is located at a local fishing spot, called Dodluk. In order to reinforce the painting's appropriateness on a more specific level, Chadum described the man in the painting as being from that "country," the local clan lands surrounding that site. However, the basic scene of a man and a barramundi might be appropriate to many sites throughout this region, so the specific level of knowledge remains primarily with the painter.

In some cases, rock paintings are linked to ancestral beings that have a specific significance to the site in question. An example is the rock painting of the rock kangaroo, *Dorriya,* at a rock shelter called Yalkmurlering, where the image of the rock kangaroo is chosen specifically because it is an important part of the Dreaming history of that particular place. It also links the particular site to other sites in the region, such as Druphmi, which were visited by the ancestral being.

Druphmi is not placed into the distant past, because there are many memories, many things at the site that are relevant to the present. As Jimmy Wesan said to his granddaughter, "We're going to go look at an old house, that's all. There's some painting on the wall" (Jimmy Wesan, personal communication 1999). Freddie Cameron reiterated this comment, "Even if you walk or on the road, if it rain and can't find a house, if on the highway, then walk down and

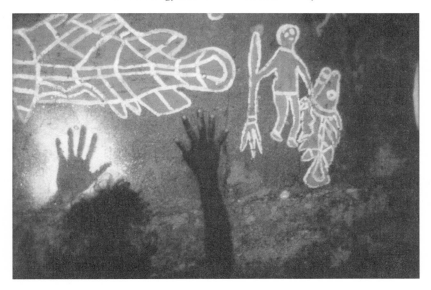

14.5. Jack Chadum's rock painting of a fishing scene at Dodluk, Barunga and Wugularr education project. Image used courtesy of Barunga-Wugularr communities, Australia.

find this place, you can make a fire and stay warm here. This old house, that's all" (personal communication 1999). Druphmi cannot be seen as set in time to the Indigenous people to whom it is relevant. There is a timelessness about it, a continuity. It is part of the Dreaming, part of the people who came and lived there and moved on to another cave, part of when people would take breaks from the Maranboy mines. It is a house just as there are houses now in the community, with art on its walls, just as art appears on walls around the community now.

The stone tools on-site prompted stories of how spears and stone axes were made and what they were used for. The stone tools were usually associated with hunting and cutting bush tucker. Peter Manabaru explained how stone knives, or lauk as he called them, were used, and he demonstrated how to sharpen them: "This one here, this mununga [white person] he call him stone knife or stone spear. But we blackfella we call him lauk. He cuts beef, kangaroo beef. Not knife, that knife from new style that one. But this knife from olden days. They never use knife before, old people, we been look, cut with our own knife. Cut kangaroo and cook. And kill him too, we kill the kangaroo with this one. And spear, might be we put him on a spear, use wax" (personal communication 1999).

Use of the rock art site of Druphmi as an outdoor classroom allowed it to

serve as a platform for empowering the voices of the traditional custodians of the land. Druphmi is located in a landscape over which they have power and for which they have responsibility. At this site the custodians highlighted knowledge vastly different from that which is accessed in a normal classroom situation. And because they were speaking in a traditional setting, they were able to speak with greater authority than if they had been trying to convey the same concepts in the foreign environment of a European classroom, dominated by the colonizer's language and literary ways of communicating knowledge.

The challenge for the educational project became that of developing materials arising from these site visits that captured the authority of these custodians in a traditional setting while at the same time engaging the interest of the schoolchildren. At the rock art site of Druphmi this cultural information was clearly relevant to both custodians and children. What could be done to maintain some authenticity in the presentation of this information while making it relevant to children in a classroom situation?

Consultation with the traditional custodians and other community members indicated that they wanted to have the material made as accessible as possible to children through using Indigenous ways of communicating knowledge. The emphasis was not only on the unsuitability of literary forms as a way of communicating Indigenous knowledge but also on children as active learners who were to be part of the production of knowledge, not just passive recipients: "They don't want to just write them down in the book. They can look and hear talking. Might be. We don't want to just write the stories down in a book. They [children] want them on a tape so they can listen that way. Might be they can help [make the CD-ROM] and might be they can understand a little bit and they can know. They can know from book and might be from [listening to] a story or if I tell them. Well they got to understand like that" (Peter Manabaru, personal communication 2000). "Make like a video [CD-ROM] 'cause I think it might be too hard for them to read" (Jimmy Wesan, personal communication 2000).

The outcome was a decision to pass on knowledge contextually through the production of a multimedia education kit that includes storybooks of narratives told by the children and custodians as well as an interactive CD-ROM. Recordings of the custodians' stories at Druphmi formed the basis of the CD-ROM. The narration of these stories was illustrated by video footage, photographs, and drawings done by the children immediately after their visit to Druphmi. Important people from the community and some of the children were incorporated into the visual material whenever possible in order to increase the children's sense of ownership over this knowledge and to give the

14.6. Submenu graphic for page of the Barunga and Wugularr education project CD-ROM, Claire Smith, Barunga and Wugularr education project. Image used courtesy of Barunga-Wugularr communities, Australia.

material added meaning for them. The CD-ROM is composed of sound, visual illustrations, and graphics. The audio component includes the narration of stories, navigation cues, and music. The visual component includes photos, illustrative pictures, and video recordings. The visual images are used to stimulate oral histories (see figure 14.6) in a process that replicates the manner in which the children were taught by senior custodians at the rock art site of Druphmi.

Australian Aboriginal people have always lived in a world of interconnections and extended social relationships (ATSIC 2001; Smith and Ward 2000), and Aboriginal children today are receptive to oral and visual forms of communication and learning. The interactive CD-ROM was found to be a suitable medium for conveying knowledge in ways that are culturally appropriate to Indigenous people. Indigenous children enjoy using computers for interactive tasks because these visual ways of communicating information form an extension of normal Indigenous teaching practices. In this instance, the CD-ROM was produced in the local language of Kriol, allowing children to sidestep the colonizers' written language and enabling all children to have access to this cultural knowledge, regardless of their literacy level. The latter was especially important, given the low levels of literacy among the children. Apart from this, the CD-ROM allowed children to engage in the materials in a

one-to-one learning situation, similar to the majority of traditional day-to-day learning situations.

In keeping with an Indigenous emphasis on maintaining interconnections and imparting knowledge in a contextual manner, the CD-ROM was designed so that audio related directly to images being accessed by the children. This enabled multiple stories to be intertwined while still keeping them separate, thus allowing the children to choose what they wanted to learn and to what extent they wished to delve into this knowledge. This gave the children a lot of control over their individual learning experiences. Grounded in the flexibility of oral traditions, the children were receptive to the idea that knowledge has many levels and is open to alternative pathways according to the particular situation. This meant that they were particularly keen to engage in this form of education.

Following the custodians' instructions that the children be involved in the process of producing knowledge, ideas for the graphics on the CD-ROM were developed with children from Wugularr school. This was done through having drawing sessions and noting recurring images that were assumed to have broad meaning to the children. To increase the accessibility of these stories, children and a narrator talking in Kriol made the audio navigation cues. These cues were developed (in preference to written instructions and menus) in order to facilitate children's movements through the CD-ROM, regardless of their reading ability. In response to requests from the children, music was used to enhance their interest in the cultural material. Individual children produced storybooks that narrated their own experiences and interpretations in a process that extended the teaching methods of their elders.

The multimedia education kit (Brett 2001b) is an important part of the Barunga-Wugularr Community Archaeology Project. The approach to Indigenous education taken in this study is consistent with recent research that has promoted the value of multimedia in the preservation and promotion of cultural values (ATSIC 1999; Palatella 1998). Brett's research extends previous educational studies, however, through the manner in which the project incorporated Indigenous voice and the extent to which it was shaped by local Indigenous people. The CD-ROM, in particular, promotes and draws upon the traditional strengths of Indigenous knowledge systems and ways of knowing. Like images at rock art sites, it stimulates knowledge by using visual cues to stimulate oral histories. This education kit is now being used in the Barunga, Bulman, and Wugularr schools to promote knowledge of and pride in local Aboriginal cultural heritage. It is providing a culturally appropriate mechanism for Indigenous children from this region to construct knowledge about their lands, their culture, and their histories.

DISCUSSION

Indigenous Australians have always lived in a world of interconnections. Whether they were produced in the past or the present, Indigenous Australian art forms are concerned with making connections between themselves and the world around them. Given Indigenous Australians' history of interconnectedness, the predisposition of their cultures toward visual forms of communication, and the level of control they can have over how they are represented, it is not surprising that they are proving eager to take advantage of communication technologies.

Public archaeology has the ability to fulfill both academic and community needs. This is one example of how archaeology can be part of community building and shows the importance of viewing Indigenous images within their social, cultural, and environmental contexts.

ACKNOWLEDGMENTS

We thank the traditional owner for the Barunga-Wugularr region, Phyllis Wiynjorroc, and her traditional custodians, Peter Manabaru, Jimmy Wesan, and Freddie Cameron. The content of this article was approved by Peter Manabaru. Also, we thank all the children involved in the CD-ROM project.

15 / Archaeology in Science Fiction and Mysteries

David G. Anderson

Science fiction and mystery are among the most popular forms of modern literature. Some of the greatest stories in each genre have centered on archaeological themes, have archaeological endeavors for a backdrop, or have archaeologists as protagonists or, occasionally, the villains. Get archaeologists to talk about what they prefer for light reading, and more often than not they will mention a love for science fiction or mystery novels. Some archaeologists, in fact, own as many books in these genres as in their personal professional libraries. Collaboration between archaeologists and authors is also common. Every writer appreciates fans, especially those able to provide technical expertise and constructive commentary. The acknowledgments of a good many novels in these genres thus include the names of one or more archaeologists or anthropologists. And, as we shall see, archaeologists and anthropologists themselves have written some pretty impressive science fiction and mystery stories.

I read *Mists of Dawn* (1952), by anthropologist Chad Oliver, when I was 10 or 11 years old. I vividly remember its impact and how it helped to kindle my own interest in archaeology. In my conversations with other archaeologists, several have admitted being similarly influenced as children by this volume or by similar kinds of stories in which archaeology played a major role. In Oliver's story, a teenager is accidentally sent back tens of thousands of years into the past in a time machine, to an era when Cro-Magnon and Neanderthal populations were present and competing in western Europe. Oliver, while revered by science fiction fans, was a professor of anthropology at the University of Texas, and his stories provide rich detail on the life of the peoples or beings his protagonists encounter. *Mists of Dawn* vividly portrays life in the distant past and shows that even our distant ancestors were very much like us, real people who, while now largely lost in the mists of time, still lived and loved. In one highly moving episode his protagonist watches one of the Cro-Magnon shamans at work: "In this deep recess of the limestone caverns, far beneath the

surface of the earth, the pitch-black gloom was illuminated by two stone lamps set in the rock walls. The lamps were filled with animal fat and their wicks were soaked twists of moss. In the soft light of the stone lamps, the pale Tloran worked alone, painting with crude clays and berry dyes and charred sticks upon the side of the cave . . . he worked very slowly. . . . He stopped often to survey his work with a critical eye" (Oliver 1952:176). It is not surprising that people who read stories filled with such passages sometimes grow up to become archaeologists.

Our profession gains rich rewards from this kind of exposure. The general public probably gets a better idea about what archaeology is like as a profession from popular books and movies than from all the site reports and technical papers professionals publish combined. Tony Hillerman's *A Thief of Time,* for example, probably let more people know that site looting is a major problem—indeed, a serious crime when it occurs on federal land—than all the warning signs and technical literature on the matter produced by federal agencies charged with cultural resource protection. Indeed, given that popular books sell hundreds of thousands of copies, while most archaeology books are lucky to sell even a few hundred copies, and most technical archaeological papers are lucky if they are read by more than a few dozen of our colleagues, it is in our best interest as a profession to see that the messages in popular books get out.

ARCHAEOLOGY AND MYSTERIES

It is not surprising that archaeologists often like to read mysteries or that mystery writers often focus on our work. Archaeology is like detective or police work. Detectives and archaeologists both employ often very limited kinds and quantities of evidence to reconstruct events in the past. Both sets of professionals make remarkable findings about the past and, when successful, enjoy the respect and admiration of the public. Both have devoted tremendous effort to maximizing the interpretive potential of their data. Indeed, both professions are supported by a wide array of highly trained specialists expert in identifying unusual kinds of evidence, such as hair, fiber, bones, soils, and plant remains. In both professions, being a trained and careful observer is critical so that clues or kinds of data are not overlooked.

Careful provenience control and proper curation procedures are essential to both fields of endeavor; the evidence each profession collects must be carefully noted, recorded, and maintained. Just as a detective notes the position of remains found at a crime scene and carefully draws, photographs, and collects appropriate categories of evidence, and then carefully controls access to these materials so that they cannot subsequently be disturbed or tampered with, and hence can be used as evidence in a court of law, so too do archaeologists care-

fully gather, record, and maintain a wide range of artifacts and other kinds of information as they excavate and conduct their subsequent analyses. The careful documentation of a crime scene is, in fact, almost identical to the procedures used to document an archaeological excavation. The line between the professions is thus quite thin; indeed, archaeologists and anthropologists trained in forensics are often called upon to assist law enforcement personnel.

Both archaeology and mystery writings have broad public appeal, in part because people like knowing how problems are solved, how events of the past can be reconstructed from (often miniscule) evidence found in the present. Well-written mystery stories and technical archaeological reports almost invariably have broad public appeal. Everyone likes a good mystery, but an essential element of a good mystery is that readers know that answers to at least some of their questions will ultimately be provided. The same is true in archaeology, where success is measured not just by what we have found but what we have learned, what the remains tell us about life in the past.

It is thus not surprising that a number of mystery novels have had archaeological projects as backdrops to their story. Given public interest in both fields of endeavor, a well-written book that encompasses both professions is almost certain to do well. Sometimes archaeologists themselves use popular writing as a means of getting their ideas out to a wider public when it might be more difficult to do so through traditional scholarly publications. Gordon R. Willey, for example, one of the most distinguished American archaeologists of the twentieth century, wrote a fine mystery novel, *Selena* (1993). The story contains many observations about what life in archaeology can be like that appear to reflect Willey's own deeply held beliefs. Fiction can thus provide a window into the ideas and insights people have about our profession, providing a perspective we might not otherwise have.

One of the greatest mystery writers of all time, Agatha Christie, was married to an archaeologist, Sir Max Mallowan, whom she accompanied for many years on his expeditions to various parts of the Middle East. Several of Christie's novels, not unexpectedly, have archaeological backdrops, such as *Death on the Nile* (1937) and *Murder in Mesopotamia* (1936). Above and beyond using archaeological themes in her novels, however, Christie did archaeology and archaeologists a major service in her autobiographical *Come, Tell Me How You Live* (1946), in which she describes what it was like to be married to an archaeologist. Filled with honest and amusing anecdotes about life in the field, this book enhances the romance of archaeology while in no way hiding the heat, dirt, insects, logistical problems, and highly varied people encountered in its practice. Christie's description of archaeologists is right on the mark, as the following example shows: "One thing can safely be said about an archaeological packing. It consists mainly of books. What books to take, what books can

be taken, what books there are room for, what books can (with agony!) be left behind. I am convinced that all archaeologists pack in the following manner: They decide on the maximum number of suitcases that a long suffering Wagon Lit Company will permit them to take. They then, reluctantly, take out a few books, and fill in the space thus obtained with shirts, pyjamas, socks, etc." (1946:19). *Come, Tell Me How You Live* should be required reading for anybody who wants to be an archaeologist, and especially for someone planning to marry one. Christie concludes her account by saying about her life with an archaeologist that "it was a very happy way to live" (1946:191).

Whole series of mysteries, of course, exist where the protagonist is an archaeologist or forensic anthropologist. For example, the Amelia Peabody mysteries by Elizabeth Peters (herself a trained Egyptologist) are set in Egypt at the turn of the twentieth century and document the exploits of a dashing female archaeologist married to a character who bears a remarkable resemblance to Sir Flinders Petrie, one of the greatest Egyptologists of the era. Closer to home, Beverly Connor, who has an M.A. in anthropology, has written five murder mysteries in which much of the action is set on archaeological projects conducted in and near Georgia. As someone who has spent much of his career digging in precisely this area, I found Connor's settings and characters both familiar and well portrayed, and it is obvious that she knows the local archaeological scene quite well. I like to tell people that Connor's descriptions of archaeological projects are uncannily like the real thing, although fortunately (at least on the projects I've been involved with so far) no one gets murdered.

Other popular mystery series in which the protagonist is a forensic anthropologist, usually with a strong background in archaeology, include Sharon McCrumb's Elizabeth MacPherson stories, Patricia Cornwell's Kay Scarpetta mysteries, and Aaron Elkins's Gideon Oliver series. That so many of the protagonists in these series are women is not merely authorial license, for in recent years increasing numbers of women have been receiving degrees in anthropological archaeology. Lara Croft (*Tomb Raider*) is the real Indiana Jones of the twenty-first century, although again, thank goodness, real-life archaeology is fairly tame in comparison to what is portrayed in the movies.

Of course, while in most mystery series archaeologists are lionized, or at least treated with respect, professionals do not always receive sympathetic treatment. When murders are set on archaeological projects, oftentimes one archaeologist is solving a murder perpetrated by a fellow professional. Many of us are glad that art rarely imitates life in this regard.

Usually the worst that happens is that readers are made aware of the fact that archaeologists are people too, and not the larger-than-life figures portrayed in the movies or novels. Thus, academic rivalries and politics, competition for grants, and a desire to bask in the glory of a big discovery (usually to

hog all the glory for oneself and keep others from sharing the credit) are the typical motives for tensions existing on projects (and hence creating suspects). Fortunately, while professional and academic politics are often as depicted, archaeologists are a pretty congenial bunch.

The tensions that sometimes exist between archaeologists and the descendants of the people they study is also occasionally explored in mystery novels. In Tony Hillerman's *A Thief of Time* (1988), for example, an Anglo archaeologist is sent his grandparent's bones, a reversal of the treatment many Native Americans have experienced. While this is a minor aspect of the story, the scene's shock value helps convey the message that all people's beliefs need to be treated with respect.

ARCHAEOLOGY AND SCIENCE FICTION

Science fiction also explores many of the same subjects that archaeology does, since it commonly deals with vast sweeps of space and time, envisions different civilizations, and has the aim of transporting the reader to worlds or times unknown or only dimly imagined. In science fiction, one can see where archaeology will likely be in centuries to come, and in some ways the genre is helping redefine our field in the present.

Perhaps the most startling prediction, advanced in dozens of science fiction stories and novels, is that archaeology will likely have a bright future should humanity ultimately go out to the stars and find evidence of other civilizations. The reason is simple: the depths of space and time are so vast, and the life of technological civilizations likely so brief in comparison, that most of the races whose civilizations we encounter will be long gone, and any remains they have left behind will be best studied by archaeologists. Humanity's own 5,000 years of recorded history is insignificant when compared to the 5 billion years that Earth and our own solar system have existed. In a universe upwards of 12 billion years old and containing millions of galaxies and trillions of star systems, innumerable civilizations are likely to have already come and gone. To some science fiction authors the universe is filled, not with many contemporaneous living races, but with the ruins of a vast array of extinct civilizations, each waiting for the patient archaeologist to discover and collect their secrets.

Many science fiction stories are accounts of archaeological fieldwork set on other worlds and exploring vanished civilizations. They often deal with the same challenges modern archaeologists have to face, such as how old the remains are, what the beings who created them were like, and, often most importantly, why these peoples are now gone or extinct. In H. Beam Piper's classic short story "Omnilingual" (1957), a research team trying to decipher the language of an extinct alien race finds the equivalent of the Rosetta stone—

that is, a record providing a common frame of reference easily understood in any language—in the periodic table of the elements. Any civilization beyond a certain level of technological sophistication is likely to have discovered these systematic relationships between the elements and to have used readily identifiable words or charts to describe them. Over the course of the story, the reader is given a wealth of interesting detail on how archaeologists and linguists translate ancient languages. The educational value of well-written and technically sound stories should thus not be underestimated. Some archaeologists, such as Michael Gear and Kathleen O'Neal-Gear, have done a great deal to popularize archaeology and the lives of the people whom archaeology studies.

Some of the finest science fiction stories written in recent years have future generations of archaeologists as protagonists, examining in great detail how they go about their work. A few such novels I have found particularly memorable include Jack McDevitt's *A Talent for War* (1989), *The Engines of God* (1994), and *DeepSix* (2001), all of which examine how archaeologists interact with each other and how archaeological discoveries will likely shape humanity's perception of itself as much as of other races of beings. Likewise, Kim Stanley Robinson's *Icehenge* (1984) has a twenty-sixth-century archaeologist examining the site of one of the last struggles of the twenty-third-century Martian War for Independence, the colony of New Houston, and in the process examines how archaeology can overturn popular wisdom (or deliberately maintained lies) about what happened in the past. In another great story, David Brin's *Startide Rising* (1983), a spaceship crewed by a dolphin, a chimp, and a human finds the remains of a multibillion-year-old fleet of starships and in the process sets the civilized races of the local group of galaxies into turmoil, showing how archaeology's findings may have an impact far beyond that expected at the time of discovery.

Some of the greatest novels in the field of science fiction have explored why civilizations rise and fall and whether and how the actions of individual human beings can shape what transpires. The role of historical process versus contingency (or free will versus determinism) in understanding what causes cultures to change is central to modern history and anthropological archaeology alike (Carneiro 2000). That the themes that have entranced Toynbee and A. L. Kroeber have caught the eye of science fiction writers is thus not surprising. These are the big questions of our existence that fascinate all thoughtful people.

Isaac Asimov's Foundation trilogy (*Foundation* [1951], *Foundation and Empire* [1952], and *Second Foundation* [1953]) examined whether the course of future history can be predicted and the outcome changed through deliberate action. Set some 50,000 years in the future, when humanity has spread across

the galaxy and hundreds of thousands of star systems are united in a great and benevolent galactic empire, the novel deals with the actions of a group of scientists who see the empire's fall coming. It describes how they strive to lessen its impact and shorten the dark age that will follow from tens of thousands of years to a thousand years or less. Plotting the broad course of history for centuries to come, a "Foundation" is placed at the edge of the galaxy, far removed from the turmoil at the collapsing center of the empire. From this Foundation, advanced knowledge is kept alive and ultimately disseminated back into a galaxy that is rapidly losing knowledge of atomic power and interstellar flight. The great plan goes askew, however, when a single individual, unforeseen and operating against the broad tides of historical determinism, emerges and successfully challenges the goals and agents of the Foundation.

Asimov's epic draws on lessons learned from the fall of the eastern and western Roman empires, the role of the Irish monasteries in the rekindling of civilization in the West, and a host of other historical sources. Although Asimov is known as an educator and prolific technical writer, many of his most influential ideas, such as his three laws of robotics, were conveyed to large audiences through his science fiction stories and novels. Archaeology was one of many fields whose contributions Asimov appreciated and used. In a minor scene from *Foundation,* how archaeology is conducted at the time is used to reinforce the idea that civilization's fall is coming. Two of the characters engage in a discussion about whether archaeology could be useful in answering the question of where in the galaxy humanity emerged (all memory of Earth having faded in the intervening tens of millennia since humanity went out to the stars). The decadent scholar from the heart of the collapsing empire is appalled when one of the Foundation scientists suggests he conduct actual archaeological fieldwork instead of rereading the work of others. The best modern archaeologists, of course, are very much aware that their conclusions and interpretations must have a strong empirical foundation and that archaeology is, after all, ultimately based on findings made in the field. The story conveys the obvious lesson that the credibility of an archaeologist's interpretations is closely linked to the extent to which they are based on real-world data. In this case, the fiction writer has an important message for scholars as well as his broader audience.

Asimov's first published book, *Pebble in the Sky* (1950), dealt with a similar question, the role of archaeology in helping humanity understand its origins. In this novel, a mid-twentieth-century man from Chicago is accidentally cast tens of thousands of years into the future, to an Earth when the first (or second?) galactic empire is at its height, but no one knows where humanity's origins lie within the galaxy. The English writing the protagonist employs, however, is eventually recognized by an archaeologist as similar to the oldest

known inscriptions in the galaxy, from settlements in several star systems within a few light years of Sol. Archaeology plays a small but important role in the story, helping humanity discover its origins.

Another science fiction novel exploring similar themes is Vernor Vinge's *A Deepness in the Sky* (1999). In this story, the protagonist, Pham Nuwen, begins his career as a programmer-archaeologist, exploring and learning the secrets accumulated over the thousands of years computers have been in operation, learning the trapdoors, backdoors, and other secrets hidden amid the layers of code.

> We've had computers and programs since the beginning of civilization, even before spaceflight. . . . There were programs here written five thousand years ago, before Humankind ever left earth. . . . And via a million million threads of circuitous inheritance, many of the oldest programs still ran . . . behind all the top-level interfaces was layer under layer of support. . . . When systems depended on underlying systems, and those depended on things still older . . . it became impossible to know all the systems could do. Deep in the interior of fleet automation there could be—there must be—a maze of trapdoors. Most of their authors were thousands of years dead . . . [but if found] the owners of those trapdoors would be like a king forever after, throughout the entire universe of use. (Vinge 1999:224–227)

Nuwen uses what he learns to establish an interstellar trading empire, while wrestling with the ultimate problem of how to keep it going over vast distances and, given sublight relativistic spaceflight, over vast stretches of time. Like Asimov in the Foundation trilogy, Vinge is exploring how and why civilizations rise and fall and examining the role of the great individual in shaping history, using science fiction as a platform for expressing his thoughts.

In an earlier novel, *A Fire upon the Deep* (1992), set thousands of years after the time of Pham Nuwen's empire, programmer-archaeologists exploring an aeons-old data vault unleash havoc on the inhabited galaxy when they discover and release a sentient program of unprecedented destructive capability: "The treasure was far underground, beneath a network of passages, in a single room filled with black. Information at the quantum density, undamaged. Maybe five billion years had passed since the archive was lost to the nets" (Vinge 1992:1).

While archaeologists unleash the problem, the efforts of vast numbers of peoples are needed to resolve it. The message is that archaeologists must also be aware of the possible consequences of their actions. Both of Vinge's novels won the Hugo Award, science fiction's highest honor, for best novel of the year they were published.

Many of the stories not only accurately depict archaeological research activity but also do so in a way that inspires archaeologists themselves. One of the best descriptions I have ever read of the optimism that pervades the start of a dig comes from Kim Stanley Robinson's *Icehenge:* "It was that moment in a dig, before the work has begun, when the site lies undisturbed in its shadows and all things seem possible, when one can imagine the ruins to be . . . the debris of countless lives that can be deciphered and understood, recouped from the dead past to be known and treasured and made a part of us forever. Why, down in those ruins we might find almost anything" (1983:71).

As I write this, I am involved in the start of a large excavation at the Shiloh site in western Tennessee, where we are exploring an Indian mound that is eroding into the Tennessee River. This mound will be partially or totally lost in the next few years. We do not know what we will find inside the mound as we dig, and this makes every day both challenging and exciting. We have this one chance to learn what went on at this site, and we have to make the most and best of it. Archaeology is slow, patient work, especially on complex sites, and we do not know in advance what we will find. Instead, the buried information is revealed to us a piece at a time, over many days, as more and more of the site is exposed. We have to be patient, believing that over the days and weeks of the project the answers to our research questions will emerge.

There are some things we will never know, and that is part of archaeology as well—doing the best we can and trying to tease every bit of information out of the clues left to us, but accepting that there will always be some things that elude us. As Robinson had two archaeologists put it in the conclusion to *Icehenge:*

> What do you think really happened here? . . .
> I think . . . that more has occurred in this place than we can understand.
> And you're content with that? . . .
> Yes. (1983:261)

As archaeologists, we are faced with a dilemma. We want to know about the past, and we devote all our efforts to finding new ways of interpreting the clues left behind, but we must live with the fact that some things may be forever beyond us, that not all the pieces to the puzzle may be present. Nevertheless, what we are able to accomplish can be very satisfying, enough to make the profession personally fulfilling. Most writers do capture and document the passion most archaeologists have for what they do. Indeed, it is a hallmark of the best archaeologists that they put in long hours, all the while feeling that they have never truly had to work a day in their lives.

CONCLUSIONS

Archaeology helps us to understand what it has meant to be human and how other peoples have lived. As such, it explores the same themes that literature, art, and poetry have examined through the ages. Archaeology's subject matter is the stories of all the people who have ever lived, individually and collectively. We are their voices, giving past lives new existence, and in the process we are shaping our own story. We need to think about putting a little more art into our archaeology, that is, making our writing more interesting and more accessible to the public.

16 / RKLOG
Archaeologists as Fiction Writers

Sarah M. Nelson

A novel way to write archaeology is through fiction. This chapter mostly concerns archaeologists writing novels rather than novelists using archaeological data. Since I firmly believe that there are many wonderful archaeological novels, perhaps not quite finished, residing in bottom drawers in offices or bedrooms, I have founded RKLOG (say the letters aloud) Press, whose mission is to publish only novels by archaeologists. Archaeologists write novels for several reasons. They may wish to create a vision of the past that is fuller than site reports. They may write a story in order to think about how a society really lived. Perhaps they wish to try out one kind of vision of the past so as to see whether the parts can hang together. The book will be most successful as a novel if the story becomes paramount and is not subordinated to the archaeology.

Most archaeologists write straightforward descriptions of their fieldwork and/or theoretical treatises, but they draw the line at dramatizing their work. This raises several questions: How legitimate are novels as a way to present archaeology to the public? Does it matter how much the author knows about either archaeology or the particular site? What part does authenticity play? Does novelizing archaeology pander to the "romance" of archaeology—the long ago and far away?

The connection between stories and archaeology appears to be a natural one. When the press reports on archaeology, stories are told that dramatize discoveries, maximize differences, and dwell on controversy over various interpretations. The questions that seem to make the best copy are ones that ask how we got to be the way we are.

Most academics are avid readers, and the impressive list of archaeological fiction that can be found on the web is a testimony to the fact that fiction woven about archaeological facts fascinates many of us. Furthermore, archaeologists often write fiction about our own sites, even if only in our heads.

Peopling the sites is one way to ask social and political questions about them (Spector 1993; Tringham 1991). Fiction is a method explored particularly by feminist archaeologists, because gender has been said to be an "ethnographic" variable beyond the reach of archaeologists. Imagining people in our sites is a window into gender, because males and females must have been present at most sites. To imagine them acting at the side in the "activity areas" we identify requires coming to grips with our possible prejudices about gendered work and gendered play.

In addition to "fleshing out" the sites we excavate, stories are a productive way for archaeologists to reach a wider audience, not just for explaining the cultures we may have helped to unearth, but also to bring to the fore ethical and cross-cultural issues as well as the problems of doing archaeology. The stories may be in the style of "narratives of human evolution," as Misia Landau (1991) persuasively argues. She suggests that even straight academic writing consists of a narrative form, with a hero or heroine and a plot that includes overcoming difficulties. Other stories may be presented as "not necessarily true but reasonable," such as Janet Spector's compelling story of the decorated awl. Her reconstruction of the adventures of the lost awl imagines not only what the decoration might signify (e.g., counting coup on successfully created baskets) but what pride its maker and owner might have felt, as well as their sorrow at its loss. Spector shows that artifacts can frame stories about the humans who made and used them.

But not all stories are good stories. To be a good story (i.e., one that is actually widely read and enjoyed, as well as authentic), an archaeological novel has to have a theme that is relevant to people in the present—the potential readers. Some of these themes will be explored below. But let us continue by considering groups of readers. Who reads archaeological fiction, and why?

THE PUBLIC

The appeal of archaeology is great and could be exploited simply for the purpose of reaching the public and telling our stories. John Terrell (1997) has exhorted archaeologists to tell stories, even in our academic writing. Stories make what we have to say both more interesting and more understandable, thus gaining appeal to the non-archaeologist. How many budding archaeologists devoured James Michener's *The Source* and perhaps were even inspired by it to enter the field? So often strangers tell me how much they love archaeology. We archaeologists are the happy few who are privileged to live other people's dreams. We should share our experiences with approachable writing rather than hiding it in turgid prose. This does not mean that archaeology is not a science or (horrors) that we should dumb down the research. But

the *interpretations* of sites should be accessible and should appear in multiple media.

STUDENTS

The main delight is that fiction about archaeology is a useful pedagogical tool because it makes us think about both the parameters of the past and the experience of explaining archaeology. Although some archaeological interpretations may make us mutter to our mates or scream in outrage to our colleagues, it is actually possible to enjoy fiction that includes impossible archaeological interpretations. Such books can be used as a valuable challenge to our students. Yes, there are great yarns (Auel 1980, 1982), but could Ayla really have invented all those things—bolas, sewing, and pottery—and tamed wolves and horses, too? Not to mention the lion! And, to stick with Jean Auel's *Clan of the Cave Bear* for a moment, her interpretation of the Sungir burial of two children head to head is inventive and interesting. Students can be asked to think about whether the invocation of a brother-sister incest taboo is a possible or even reasonable interpretation. After describing the burial, I ask my students, "If you were writing a story about this burial, what would it be? Is Auel's interpretation compelling? What are the other possible interpretations? What kind of additional evidence would you need to test your hypothesis (or what additional details of the story would make it convincing)?" Thus can undergraduates learn painlessly about generating and testing hypotheses.

ARCHAEOLOGISTS

For archaeologists, archaeological fiction comes in several versions: the kind that makes you gnash your teeth, the kind that makes you laugh, the kind that reaffirms what you already thought, and the kind that teaches you something new. The bulk of this chapter will concern the last kind, but I want to mention some widely read examples before describing a few recent novels with archaeological components that can be read with enjoyment and educational purpose at the same time.

In the makes-you-laugh category I would include all the Elizabeth Peters novels starring Amelia Peabody Emerson, married to a prominent Egyptian archaeologist and no mean practitioner in her own right. You laugh, however, not at the archaeology, which is informed by a real Egyptologist behind the pen name, but at the wonderfully witty way whodunits are written and the delicious appearances of real characters from Egyptian archaeology.

Whodunits lend themselves to archaeological stories, since archaeology itself is often presented as a kind of puzzle. Seeking to understand the site can

be intertwined with the enigma of a disappearance or murder. Furthermore, archaeological sites often have ancient bodies in them, which simply beg for a fresh body to be planted among them. It takes, of course, some archaeological detective work to distinguish the recent from the ancient. In such stories, the interactions of the archaeologists may provide the motive for murder. You remember that field school where one student drove everyone else crazy? The fictional murder is a better solution than the ostracism that often actually occurs in such cases. Or the despicable character can be a professor, the dig foreman, or an unreasonable government agent. Possible story lines abound within our own experiences. For exotic locales, it is also hard to beat the intensive knowledge of foreign places acquired by archaeologists who do fieldwork abroad.

For my press, I look for novels that would be competitive for wide readership in any genre: this requires tight plots, engaging characters, and writing that draws the reader into the story. It turns out I'm picky, as I have found only two to publish so far. Others submitted have had potential but are not yet perfect, and I don't have time to be an editor until I quit my day job (which won't happen until the press breaks even). There is surely a market for these novels, because archaeologists can supply exotic locales, a depth of knowledge of other cultures, and extensive details about the archaeology. Marketing, however, is difficult for a small press, and distributors are not interested in presses with only a few books. But let me tell you about the novels RKLOG Press has published: *National Treasure* and *Spirit Bird Journey*.

At first blush it may seem that *National Treasure* (2000), by Peter Bleed, is not an archaeological novel at all. The main characters seem to be two Japanese swords that were created in medieval times. These swords are considered Japanese national treasures and have been traced to America by two different groups—one made up of gangsters, the other of businessmen—in Japan. Both groups want the swords back in Japan (for their own different purposes), and neither is scrupulous about its retrieval methods. Written by an archaeologist who has known Japan for most of his life, the novel offers much more than a tourist view of Japan or the kind of stereotypes that develop from a lack of insight into the culture. *National Treasure* is not only sensitive to the variations within Japanese culture but also tackles numerous cross-cultural misunderstandings perpetrated by both Japanese and Americans. It is clearly "ethnographic," but what makes this book also archaeological is the focus, as the title tells us, on national treasure (an idea that originated in Japan). The whole question of who owns the past is implicitly examined from a number of points of view, including those of Americans who haven't a clue that they hold in their hands—and feel they "own"—what others consider a part of their birthright. The book is thus rich in potential for approaching this issue from

stances we do not often examine, as well as offering fodder for discussions of our own version of the question, the Native American Graves Protection and Repatriation Act.

My own novel *Spirit Bird Journey* (1999) is another kind of exploration altogether. Its central question is one of ethnicity and difference. The main character is Clara, an adopted Korean, who returns to Korea to study archaeology. She is culturally and linguistically American, but she must come to grips with the Korean culture and language in ways that other foreigners can avoid, because her ignorance of the culture is not immediately apparent. Some of the story occurs on the dig and in other archeological venues, as well as in the presence of *mudangs* (Korean women seers) and in places tourists frequent because of their "ethnic" content. As Clara envisions the prehistoric past of the site she is excavating, she must mediate the tensions between what she "knows" (or has dreamed) and her choices of excavation locations. The prehistoric people have ethnic differences as well as physical ones—the inhabitants of the place where Clara is digging on the east coast of Korea are imagined as Paleoasiatics, or Ainu-like, but another clan over the mountains to the west is imagined as having Mongolian/Chinese characteristics. Through Clara's eyes, the reader gets to know the archaeological evidence while experiencing the lives of prehistoric people. I wanted Clara to participate in the past but not be able to change it, so she appears in the past in the form of a yellow bird, perceived by the prehistoric people as the spirit bird of Golden Flyingbird, the leader of the village.

Death among the Fossils (Durant 1999), written by a well-known archaeologist using a pseudonym, concerns paleontologists in Africa. As is true of most archaeological novels, the setting is exotic (a fictitious country in East Africa), and the reader learns a great deal about modern Africa while imbibing an understanding of the problems that concern the academics in the story. The infighting of the (one hopes also fictitious) scholars is also brilliantly portrayed, as are their attempts at one-upmanship. As a bonus, the process of fossil hunting and recovery is described, along with the hierarchies of players, even among the students. African cultural tidbits spice the book. One of the main characters grew up in Africa but was trained in the United States, providing the reader with a kind of binocular understanding of both cultures.

Two other novels are at opposite ends of the didactic scale, although both teach important lessons. *Death by Theory*, by Adrian Praetzellis (2001), was written as an aid to teaching archaeological theory to undergraduates (and sometimes, it seems, to spoof theory as well). It is an amusing romp with all the worst characters (and some lovable ones) that an archaeologist might encounter. There is the kook who is sure he has evidence of ancient writing, New

Agers who claim the past as their own (in this case a bunch of goddess worshipers), and the uninformed press. Each person and event in the story presents an opportunity to explain some facet of archaeological theory. It is amusing for archaeology professors and helpful to students. Although the situation is outrageously far-fetched, it's not impossible.

On the other side is a novel that is woven around some Viking discoveries in Greenland and Canada. Peter Schledermann (2001) very convincingly suggests a story that could have resulted in these artifacts turning up surprisingly far to the north. *Raven's Saga* is a reconstruction based on the author's intensive knowledge of both the archaeology and the history of the Vikings. When the novel is finished, the reader has vicariously lived the Viking life.

These are all books that the general public can enjoy, with the extra benefit of learning something authentic about other places and times. While authenticity may not be necessary for the story, it is considered an asset for all novels written on topics outside the average reader's experience. Thus historical novels need not be written by historians, but the dust jackets often proclaim the historical expertise of the author. The fact that John Grisham is a lawyer probably helped the sales of his books about legal issues before he became a well-known author. Science fiction is disdained if it doesn't have sound science behind it. Should archaeological fiction be less authentic? Of course, novelists can steep themselves in history, law, science, or any other field, and some are more successful at this than others. For archaeologists perhaps there is also the fun of critiquing another archaeologist's work—how well did they portray the culture of the present, and how well did they weave a story around the known facts of the past?

Novels written by real archaeologists are the most authentic, no matter how good the research team of the non-archaeologist may be. The authenticity of both the dig and the culture that is being excavated are greatly enhanced by the experiences of the writer. And the archaeologist is likely to have been mulling over his or her story for a considerable length of time, giving it a richness that may be lacking in similar stories. To what extent authenticity matters depends on the purpose of the writing. Novels can be written for students, for other archaeologists, or for the general public. For the first two groups, authenticity is usually important.

There is always a tension between the story and the archaeological record. Professional archaeologists will care that the details are correct, that nothing in the story is contrary to what has been found in the ground. Other details must be possible—given what is known about how people, artifacts, and environment interact—based on ethnography. For the sake of the story, imagination must fill in where the archaeological record is silent, but many readers

enjoy knowing that the author has firsthand knowledge of the places written about, the objects unearthed, and even the issues that professionals discuss.

The lure of archaeology is great. The combination of adventure, exotic locales, and discovery is almost irresistible. If archaeologists can take the time to write the stories themselves, it will be a great service to both archaeology and the public.

17 / Capturing the Wanderer
Nomads and Archaeology in the Filming of *The English Patient*

Christine A. Finn

I should preface this chapter with some background concerning its development. I explored the archaeology in Michael Ondaatje's 1992 novel *The English Patient* for a paper on nomads and archaeology presented at a conference on that theme in Siberia in 1996. Developing it further to look at the translation of the novel into film seemed to me a logical move, a means of considering the transformation of text and image over time.

In his foreword to the screenplay of *The English Patient*, director Anthony Minghella (1996) gives us an idea of the passion behind filming a novel that was described by film critic Anthony Lane (1996) as so finely written that it was unreadable. Minghella has said that he was lured to the project because "brilliant images are scattered across its pages in a mosaic of fractured narratives, as if somebody had already seen a film and was in a hurry to remember all the best bits" (Minghella 1996:ix). It was, however, deceptively cinematic, as Minghella conceded, because of the sheer breadth of its locations and imagery. The novel charted a physical geography of desert, Tuscan countryside, bucolic England, the knot [intensity] of a Cairo souk, a ruined villa, a frescoed church, a painted cave . . . it plunged into prehistory, had as its narrative spine the classical gaze of Herodotus, set up World War II, concluded it, and all the while wove together a complexity of personal histories.

Minghella's first draft, producer Paul Zaentz recalls, had too many countries, too many characters, and was 185 pages long. "But," he said, "it demonstrated there was a way to transform an incredibly complex novel into a film" (Minghella 1996:xiii). Over four years, Minghella and Zaentz, with Ondaatje, trimmed and honed and transformed. They were blessed with Ondaatje's vision. The novelist in fact insisted that no one wanted "just a faithful echo" (Minghella 1996:xvii). He observed from his childhood love of cinema that

"movies not only used different materials, they had different cooking times for their great soups, and had to be consumed in public alongside eight hundred other people as opposed to one solitary diner" (Minghella 1996:xv).

Behind the success of *The English Patient* as a film is a story of determination and great passion on the part of Minghella and Zaentz. But that is their story, and I can only touch the surface of it. I want to go in deeper to look at archaeology and its application as a tool to interpret the narrative of film. I suggest that the translation process involved in writing a screenplay from a novel is akin to that of an excavator. In bringing artifacts to the surface, the archaeologist is also working as a translator. In the way that the processes reach through time and context, the two are linked. This might be expressed as a line denoting the duration of the film that is intercut, its narrative sliced through, thus marking the section I will take to excavate later in the chapter. It is this layering that literally gives the novel its depth and that presents such a challenge cinemagraphically: how does a writer-director, in this case Minghella, translate the vertical of palimpsest into the linear format of film? And what is the state of the screenplay lying, in a liminal state, betwixt and between?

Archaeology in *The English Patient* film is both obvious and covert. Painted cave figures swim over the surface of the opening credits, a motif carried through to the Cave of Swimmers location, which will be revealed as a setting for both excited discovery and utter despair. In 1925, the year of the discovery of prehistoric cave paintings at Lascaux in France, the constructivist Lazlo Moholy-Nagy described the ideal of film in terms of "light-space-time continuity in the synthesis of motion" (1987:21). This notion of "light moving in time," William C. Wees's (1992) elegant description of his study of visual perception, draws on the work of Moholy-Nagy and other avant-garde filmmakers, such as Michael Snow (1972). Archaeology could be described as the study of change over time, a response to the relationships among artifacts, bodies, bones, domestic areas, and layers of sediment, to be interpreted spatially, observed through a palette of colors, representing hundreds, perhaps thousands of years. In the desert context of *The English Patient,* some words from the introduction to three eleventh-century Abbasid poets in translation seem particularly apt: "The ancient questions of what a translated poem keeps and what it loses in the passage of one language to another, from one age to another, from one milieu to another, and from one mind to another are questions about psychology as they are questions about linguistics" (Wightman and al-Udhari 1975:28).

There are a number of ways to approach the process of transformation from book to screen. Archaeology is a subject that is increasingly considered in terms of landscape. It is appropriate, then, to consider first *The English Patient's* setting and Ondaatje's sensuous description of sand dunes where "noth-

ing was strapped down, everything drifted" (1992:22); this lends itself to the metaphor of landscape and body, which opens Minghella's screenplay.

LATE 1942. The SAHARA DESERT.
SILENCE. THE DESERT seen from the air. An ocean of dunes for mile after mile. The late sun turns the sand every color from crimson to black and makes the dunes look like bodies pressed against each other.
(1996:3)

The metaphorical potential of such a landscape in film shifts the central love story from that of the patient's nurse, Hana (Juliette Binoche), and the young Indian sapper, Kip, which dominates the book, to the English patient himself (Ralph Fiennes), revealed to be the Hungarian count Lázló Almásy, and Katherine Clifton (Kristin Scott Thomas), the wife of a member of the desert exploration team. Hana and Kip's relationship is much less developed but offers a subtle, restrained balance to the tempestuousness of a secret affair. The all-concealing golden desert and Cairo become the main location, while Tuscany, with its ruins standing proud, is its cool, blue-green, and relatively tranquil antidote.

Unlike photography, cinema allows interaction with the landscape, movement within and without—a mindfulness of location. Minghella, in the foreword to the screenplay, said he read *The English Patient* "in a single gulp" in a room in New York one sweltering summer. "When I put the put the book down, it was dark, and I had no idea where I was" (1996:ix). This confusion of place is appropriate. Ondaatje described the desert as a place where "nothing was strapped down, everything drifted." The desert in the film had to convey not just a place but an idea of freedom and its opposite, possession. It is worth mentioning here something of the background to desert exploration in this context.

The concept of the nomad was already entrenched in the psyche of a particular type of westerner, the explorer, often an Englishman, who was a familiar sight mapping and charting the desert from the early twentieth century. In Ondaatje's novel, Count Almásy is a man enchanted with the idea of freedom associated with the nomads of North Africa in the 1930s. As he says: "The desert could not be claimed or owned—it was a piece of cloth carried by winds, never held down by stones, and given a hundred shifting names long before Canterbury existed, long before battles and treaties quilted Europe and the East. Its caravans, those strange, rambling feasts and cultures left nothing behind, not even an ember. All of us, even those with European homes and children in the distance, wished to remove the clothing of our countries. It was a place of faith. We disappeared into the landscape" (1992:138).

The way the characters in the film deal with the desert highlights how the landscape is regarded by those within (or without) it. It may be the "howling desart" of Alexander Pope, the wilderness of the Gospels, the unredeeming void, the holder of lost souls: to those attempting to map it and hold it down, the desert is thrilling or unbounded chaos. To those who sailed its ocean on camels, it was so much more terrain to be navigated. To some, the lure of the desert was as aesthetic as it was psychological: it yawned out its golden miles in a vista that seemed to hold the sky aloft. It presented, in essence, a terrain free from national boundaries and their associated confines. The desert, then, is seen not only as a place but also as a metaphor for an unbounded life. The zeal for surveying and mapping coincided with the beginnings of ethno-graphical studies, the cognition of "otherness," and the establishment of an-thropology and archaeology as scientific disciplines. Earlier, Napoleon's explo-rations in Egypt, David Roberts's paintings, and Shelley's ponderings on the fate of man by way of Ozymandias had suggested a cautious relationship.

The exploration of this evocative terrain helped to define the West, but as Edward Said (1979) argues in *Orientalism*, the land could be mapped, but its heady scent was all in the mind. The idea of the East was a construct only in the minds of those in the West, and it was given life through writers such as André Gide and Gustav Flaubert, who, Said suggests, gave his Eastern women a voice only through the men narrating their story: "She never spoke of herself, she never represented her emotions, presence or history. He spoke for and represented her" (1979:6). The East was alluring in its wildness and otherness to Victorian and Edwardian readers, and out of this one can see the genesis of the desert fantasy: women arriving in the desert in the company of their hus-bands, being swept away on horseback by a sheik—the personification of the untamed as one vilifying the pristine wife of a "good" man. In *The English Patient* the desert-enamored narrator—Count Almásy—steps out of his con-ventional social position by submitting to a relationship with Katherine, the English wife of another explorer. In one love scene, Katherine acknowledges their duplicity: "This is a different world—is what I tell myself. A different life. And here I am a different wife" (1996:101). The conversation sets up the betrayal—Katherine's visit to Almásy's hotel—which is observed by Clifton, Katherine's husband, from a Cairo taxi (a scene that does not appear in the book). This dynamic is reinforced later by the suicide of their colleague, Madox, who is appalled at the double treachery of adultery and the charges of spying that have been made against Almásy.

To continue, then, with characterization: Ondaatje's novel considers the at-traction of the unnamed and untraceable, and the element of unburdening is retained in the film. The characters appear as though out of a dust storm: a young woman, Hana (Juliette Binoche), who is aching to nurse a man with

no name; Caravaggio (Willem Dafoe), his history rendered in his damaged hands; the Sikh sapper (Naveen Andrews), who trained in England. Like the English patient, who is observed swaddled in bandage through most of the novel and much of the film, their pasts are unwrapped as the narrative unwinds, and the desert is revealed as more than a shifting place on a map.

As Minghella says: "The patient, who carries with him the burden and in some ways the history of his lover, is healed by telling that story, while Hana, his nurse, is healed by shrugging off history and moving on" (quoted in www.geocities.com/Hollywood/Cinema/1280/tep.html). The tension between the free roaming and the settled, the desert and the sown, is central to an understanding of the literature on, or evolving from, the idea of nomadism. As an "ism," it may be seen as a chosen way of life, an abandonment of responsibility, somehow unworthy of the respect meted out to those who have become permanent.

I said earlier that the archaeology, in its literal sense, stood out from the prose, and Ondaatje has noted that it was a theme significant to him, but when I first spoke to Minghella he wondered what of the book's archaeology was left in the film (personal communication 1996). I will speak first about the tangible archaeology and move on to more abstract considerations.

In the novel, the character of the young Sikh bomb-disposal expert, Kip, is developed in England, where he learned his skills. He is taken to the White Horse at Westbury, a real and existing site carved into chalk downlands in 1778, where a bomb landed in the middle of the horse's belly. This image—"Kirpal Singh stood where the horse's saddle would have lain across its back"—would have been cinemagraphically dramatic and set Kip in a new cultural context. In the event, the film—possibly for reasons of cost as well as its narrative—confines Kip's life within the Tuscan landscape, to "now" rather than "then," and the scene was lost.

In the film, Kip inhabits the garden of the Tuscan villa where the English patient is alone with Hana, and later Caravaggio. Production designer Stuart Craig's tactile design produces an abandoned, bomb-ripped ruin, still reverberating—but only just—from its past occupants. Hana progresses through it as though encountering and entering a sealed-up tomb. The screenplay describes it:

> HANA explored a gaping hole in a LIBRARY where the walls have collapsed from shelling. The garden intrudes, ivy curls around the shelves. Bloated books lie abandoned, and there's a PIANO tilted up on one side. Hana presses the keys through the filthy TARPAULIN which covers it. Everywhere there are signs of a brief German occupation. (1996:19)

It is in this ruin, which gradually becomes humanized and healed, that the English patient lies and narrates his story. He is bandaged like a mummy, a point not lost in the screenplay when he explains to an interrogating officer near the beginning of the film that "I have this much lung . . . the rest of my organs are packing up—what could it possibly matter if I were Tutankamun? I'm a bit of toast my friend. Butter me and slip a poached egg on top" (1996:14). In the novel, Ondaatje peers beneath the bandages for another archaeological reference: "Everything about him was very English except for the fact that his skin was tarred black, a bogman from history among the interrogating officers" (1992:96).

Part of the novel's compulsion—and I believe this is deftly maintained in the film—is its mystery. Ondaatje draws on classical writers, medieval Arabic texts, and the reports of explorers; Minghella's skill suggests these references. Such ancient writers as Herodotus, who in his *Histories,* a book central to *The English Patient,* describes in great detail the burial rites of the nomadic Scythians, who "enclosed their ruler's body in wax and placing it on a waggon, carried it through all the different tribes" (Herodotus n.d.). Herodotus left important textual evidence for consideration alongside the archaeological data. In that vein, I would now like to excavate deeper one of the most potent images in the book and film, that of the merchant doctor.

In *The English Patient,* the man of the title falls from the sky in a plane and is saved by members of an unnamed Bedouin tribe who anoint him with oils and wrap him in felt until he is healed. "They found my body and made me a boat of sticks and dragged me across the desert. We were in the Sand Sea, now and then crossing dry riverbeds . . . I flew down and the sand itself caught fire. . . . They strapped me onto a cradle, a carcass boat, and feet thudded along as they ran with me, I had broken the spareness of the desert" (1992:5). The injured airman is visited by a shaman—the merchant doctor. After examining how this image is presented on film and in the text, I will suggest the deeper context from literature, the Middle English of William Langland's work *The Vision of Piers Plowman* (in its original and its modern translation). Minghella's screenplay reads:

EXT. AN OASIS. NIGHT.
THE SOUND OF GLASS, of tiny chimes. a music of glass.
AN ARAB HEAD floats in darkness, shimmering from the light of a fire. The image develops to reveal a man carrying a large wooden yoke from which hang DOZENS OF SMALL GLASS BOTTLES, on different lengths of string and wire. He could be an angel. (1996:2)

The parallel passage in the novel reads:

At twilight the felt was unwrapped and he saw a man's head on a table moving towards him, then realized the man wore a giant yoke from which hung hundreds of small bottles on different lengths of string and wire. Moving as if part of a glass curtain . . . a wave of glass, an archangel. . . . He was known to everyone along the camel route from the Sudan north to Giza, the Forty Days Road. He met the caravans, traded spice and liquid, and moved between oases and water camps. He walked through sandstorms with his ears plugged with two other small corks so he seemed a vessel to himself, this merchant doctor, this king of oils and perfumes and panaceas, this baptist. (1992:9–10)

The image is reminiscent of Passus V, lines 646–652, in William Langland's medieval masterpiece *The Vision of Piers Plowman*. The translation by Henry Wells (1973) reads:

It was late and long when they lighted on a traveller
Apparelled like a pilgrim in pagan clothing.
He bore a staff bound with a broad fillet,
That like a winding weed wound about it.
At his belt he bore a bowl and wallet.
An hundred ampules hung at his hatband,
Signs from Sinai and shells from Galice. (Wells 1973)

And the original of the *Piers Plowman* B text, in the Bodelian Library at Oxford University, is translated from illuminated vellum into these words, edited by J. Bennett for the Oxford University Press:

He bare a burdoun ybounde with a bride liste,
In a withewyndes wise ywounden aboute.
A bolle and a bagge he bare by his syde;
An hundreth of ampulles on his hatt seten,
Signes of Synay and shells of Galice.
(Passus V, lines 524–528, *Piers Plowman* B text, Bodleian MS. Laud 581)

Through this we return to archaeology: "ampules" such as those in museum collections, which were carried by pilgrims and contained healing, holy water. The trail could continue through the inferences of archaeological reports and the series of interpretations over the history of the discipline.

Returning back up the section, as it were, to rejoin the narrative, the merchant doctor is put back within the context of the film. As an image on-screen, the message conveyed is that of healing and salvation. Almásy, Hana, and

Caravaggio are most obviously healed in the process of the film, in different ways. These include the use of water and the analogy of desert with sea. Caravaggio's ampules are vials of morphine.

Ondaatje has acknowledged the inspiration of archaeology in his work; Minghella, when I asked him, was less sure about what remained in the film. Perhaps the cave paintings provide the best example of a theme sustained throughout the film. The description is reminiscent of those made in 1922 by archaeologists Howard Carter and Lord Carnaervon concerning their excavation of the Tomb of Tutankhamun: "By the uncertain light of a candle, a wonderful sight was exposed to our excited eyes."

INTERIOR OF CAVE, FLASHLIGHT
A FLASHLIGHT squirts into the cave. Almásy treads cautiously along the narrow winding passage. He comes to an open cavern and takes his flashlight up to a wall. Almásy is astonished by what he sees.

PAINTINGS EMERGE, figures, animals, ancient pictures, a giraffe, Cattle Men with bows and arrows. Almásy has led the whole party into the heart of the cave. Now Madox comes alongside him at the wall, his flashlight joining Almásy's and increasing the visibility of the paintings. A dark-skinned figure, apparently into the process of DIVING into water, comes clearly into view. Then others, supine, arms outstretched.

MADOX (with audible excitement)
My God, they're swimming! They're swimming! (1996:63)

This image of illuminated painting is echoed later, when Kip takes Hana to see frescoes in a Tuscan church and lights the darkness with a flare, hoisting Hana up on ropes where she swings like a bell.

At the climax of the film, Katherine and Almásy are alone together among the cave paintings in the Cave of Swimmers. The paintings have become part of Almásy's history, after being copied down by Katherine and pasted in the book of Herodotus that is with him at the villa. The Cave of Swimmers is now where Katherine lies injured after her husband, aware of her affair, deliberately crashes their plane in the desert. Almásy goes to get help, but his promise to return is kept too late as he is seized by the British as a spy. We see Katherine struggling to write in the book of Herodotus by the cave's fading light. As the light dies, so does she. And Minghella also leaves Almásy alone in the massive, cooling landscape.

EXT. RAILWAY TRACK. THE DESERT. EVENING.
Almásy, silhouetted against the evening sky, hobbles back down

the track, THREE HUNDRED MILES AWAY from the dying Katherine Clifton, no way now of saving her. He is a tiny speck in the vast desert. His heart is broken. He sinks to his knees in despair. (1996:165)

When Almásy retrieves a plane secreted away in the desert by Madox and returns to the cave, it is now a tomb, as Minghella's screenplay notes:

KATHERINE'S CORPSE lies where he left her—a ghost on a bed of silk and blankets. The chill of the cave has preserved her. She could be asleep. (1996:168)

This appalling but visually arresting image of the lovers lying together, wrapped in parachute silk, "only two latitudes away from the safety of Kufra," is a translation of the poetry of the novel, as Almásy describes: "When I turned her around, her whole body was covered in bright pigment. Herbs and stones and light and the ash of acacia to make her eternal. The body pressed against sacred color" from which Almásy lifts Katherine into his arms (1996:261).

The intensity of the film sequence that follows is heightened by Gabriel Yared's score. The direction—"ALMÀSY comes out of the cave, carrying the bundle of KATHERINE in his arms, wrapped in the silks of her parachute" (1996:172)—is an image weighted with loss. As Almásy staggers to the plane to place Katherine in the cockpit, and the audience is returned to the opening image of the film, the voice-over is Katherine's reading of her last note in Herodotus: "I know that you will come and carry me out into the palace of winds. . . . That's all I've wanted—to walk in such a place with you, with friends, an earth without maps" (1996:172).

CONCLUSION

According to the principles of archaeology, the past may be read from the layers one cuts through, using the supposition that the further one goes back in time, the more the artifacts are bounded by the place where they are found: in a sealed tomb there is a sealed context. In the end, *The English Patient* is about something—someone—out of context: Katherine is "a different wife"; Hana, Caravaggio, and Kip are out of their familiar milieu. But the story itself also hangs on a mistaken context. Almásy, who helped the Germans, is piloting an English plane to take him and Katherine's cobwebbed body out of the desert. He is shot down for being what he is not. He is the "English" patient by dint of the aircraft that had been left for him by Madox. He is given a false identity, and Katherine represents his wife, not Clifton's.

The idea of drifting meaning is important when one considers the position

of the screenplay, as a text, the way it changes and is interpreted and reinter-preted. Minghella has noted the extent to which the published text differs from the script he began shooting with. It could be said that just as archaeo-logical sites are reappraised in the light of new evidence gained from different epistemological processes, often the result of new technology, so the film's script evolves under the enlightened eye of the director, the designer, the cameraman, and the actors. The advent of aerial photography as an aid to archaeology was a by-product of wartime reconnaissance. In *The English Pa-tient,* the aviators both explore and gather information, and even the upright Geoffrey Clifton, like Almásy, is revealed to be not what he seemed.

Islamic archaeological sites seen from the air—such as Tuba in Syria (eighth-century Umaayad), apparently in the middle of nowhere, or the desert bathhouse at Quasyr Amra, with its spectacular paintings and no other build-ing in sight—lack the nomads who would put them in the middle of "some-where." For years the archaeological accent was on the visible evidence, but if we consider the invisible, the absence of evidence for the tent-dwellers—canvas and hide that is lost to the winds—is, according to a modern archaeo-logical truism, absence of evidence, not evidence of their absence. Nomads, by their way of life, provide us with the puzzle of place.

As the film of *The English Patient* opens, the audience is unknowingly con-fronted with a paradox, a kind of life-in-death. We are unaware that the figure in the plane is dead, not sleeping, as Katherine's pale and extraordinarily beau-tiful face emerges out of the cockpit like a Rodin head from alabaster. The paradox of *The English Patient,* a novel of over three hundred pages, is clipped and fine-tuned to its essence over nearly three hours of film. It is only in the broader perspective of the text that we can see the relevance of the scenes and images that Minghella and Zaentz chose to keep among all the apparently cinematic ones they let slip away. They have left invisible trails, like the no-mads who chart their course across the oceans of sand. And as with the inter-pretation of nomads, one is reminded that often what is no longer visible has the most overriding presence.

ACKNOWLEDGMENTS

I would like to thank Anthony Minghella and Michael Ondaatje for their interest in this research. The themes first presented in Siberia were later adapted for a paper in the Oxford Film Seminar series in 1997, and I am grate-ful to Ian Christie for his encouragement of this. I would also like to thank a fellow archaeologist, Melanie Giles, for urging me to read *The English Patient.*

1. Scene from the opera *Zabette*, Act III, Ring Shout: "We gonna have a time. . . . Singin' for a good time. . . . Do you hear us Lord." (Photo © 1999 by Charles Lyon)

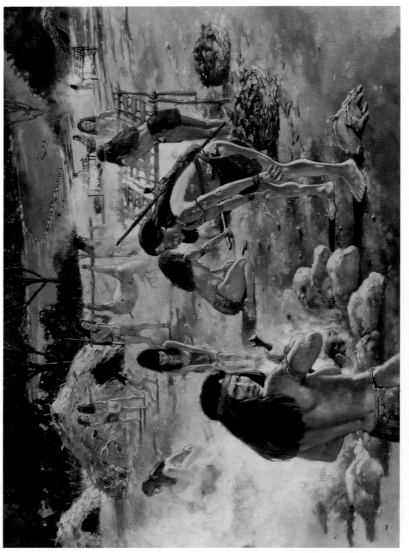

2. Sara's Ridge Archaic site, Martin Pate, artist, © 2001. Used by permission.

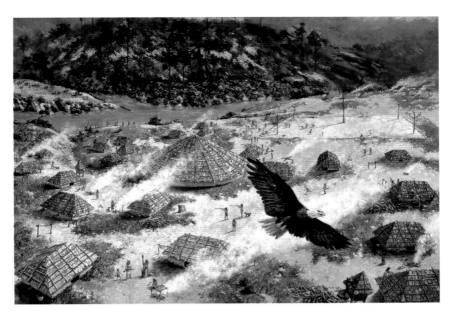

3. Yuchi Town historic Indian village, Southeast Archeological Center, National Park Service, and Martin Pate, artist, © 2001. Used by permission.

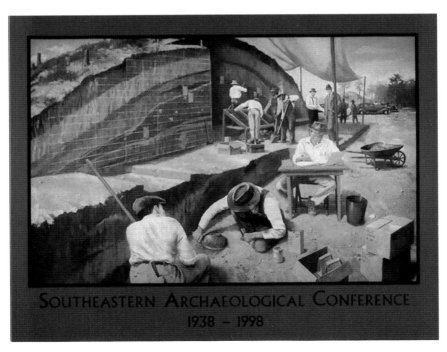

4. Southeastern Archaeological Conference commemorative poster, Southeast Archeological Center, National Park Service, and Martin Pate, artist, © 2001. Used by permission.

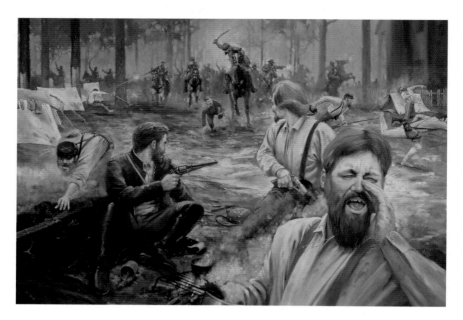

5. *Attack,* Martin Pate, artist, © 2001. Used by permission.

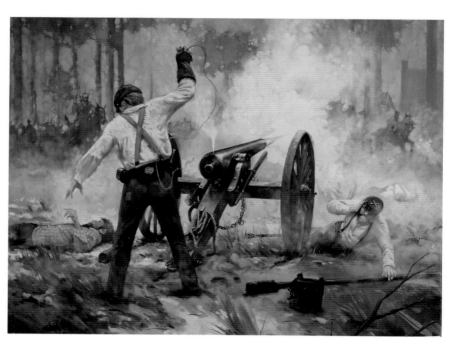

6. *Canister!,* Martin Pate, artist, © 2001. Used by permission.

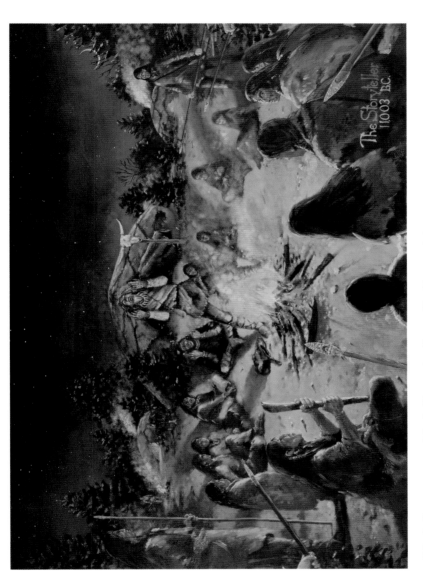

7. PaleoIndian camp scene, Martin Pate, artist, © 2001. Used by permission.

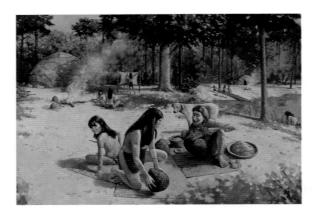

8. Woodland potters, Martin Pate, artist, © 2001. Used by permission.

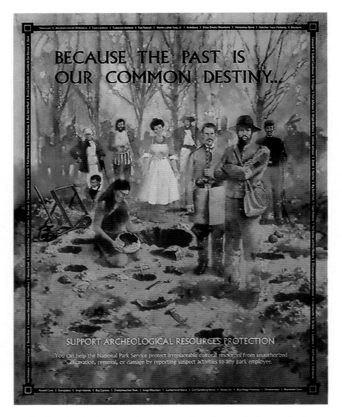

9. Archaeological protection poster, Southeast Archeological Center, National Park Service, and Martin Pate, artist, © 2001. Used by permission.

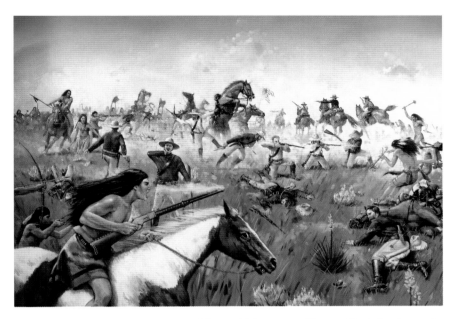

10. *Finkle Finley Ridge,* Little Bighorn National Monument, National Park Service, and Martin Pate, artist, © 2001. Used by permission.

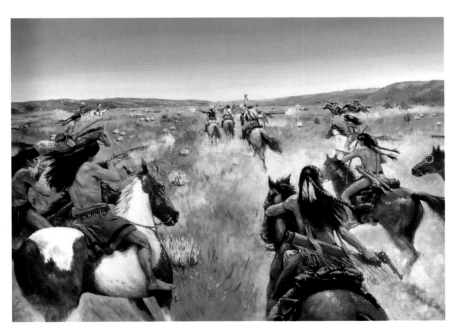

11. *Deep Coulee Retreat,* Little Bighorn National Monument, National Park Service, and Martin Pate, artist, © 2001. Used by permission.

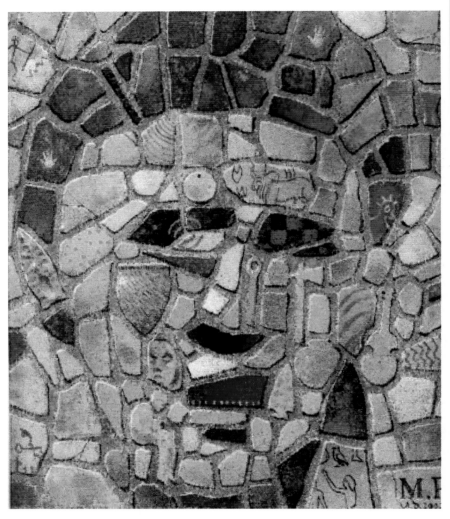

12. Mosaic face, Martin Pate, artist, © 2001. Used by permission.

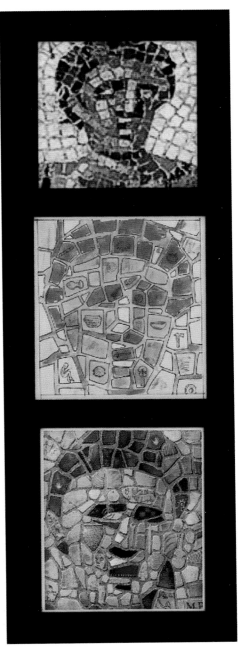

13. Vertical arrangement of mosaic faces,
Martin Pate, artist, © 2001. Used by
permission.

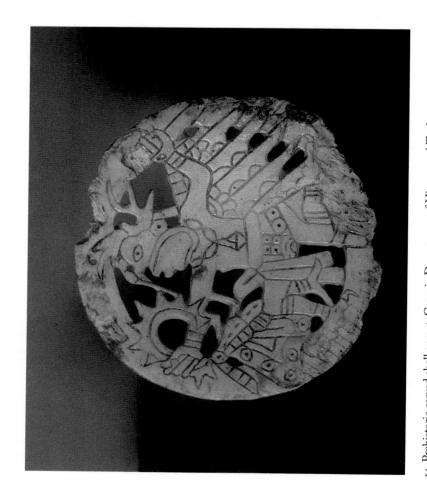

14. Prehistoric carved shell gorget, Georgia Department of History and Trade.

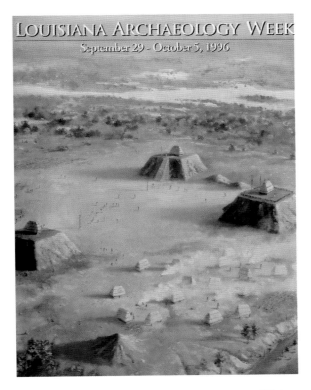

LOUISIANA ARCHAEOLOGY WEEK
September 29 - October 5, 1996

15. Louisiana Archaeology Week poster, Louisiana Division of Archaeology, Southeast Archeological Center, National Park Service, and Martin Pate, artist, © 2001. Used by permission.

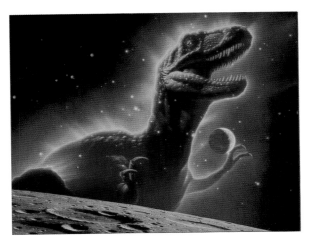

16. Example of dinosaur art, Joe Tucciarone, artist, © 2001. Used by permission.

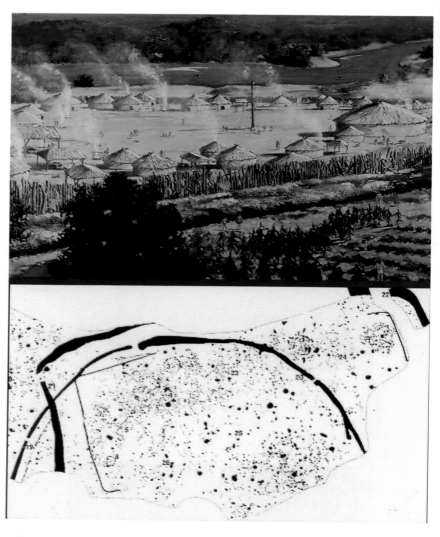

17. Interpretive painting and corresponding archaeological plan map at Rucker's Bottom Mississippian village, showing habitation areas, defensive ditches (thickest lines), palisades, and fence alignments (thinner lines), Southeast Archeological Center, National Park Service, and Martin Pate, artist, © 2001. Used by permission.

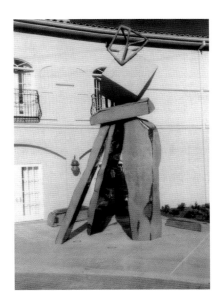

18. *Step in Stone* public art sculpture,
David Middlebrook, sculptor. Used by
permission.

19. Detail of *Step in Stone* sculpture,
David Middlebrook, sculptor. Used by
permission.

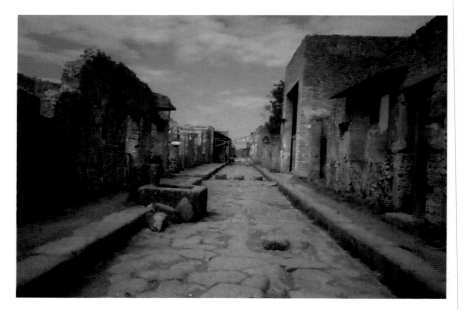

20. Streetscape in ancient Pompeii. Courtesy David G. Orr.

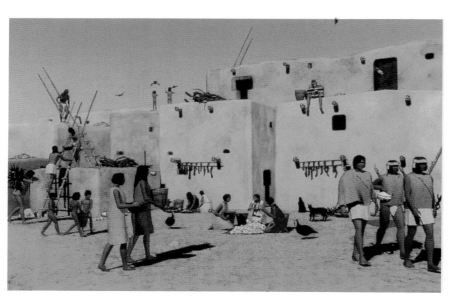

21. Village scene. Art created to teach archaeology: Ancestral Puebloan villagers in south-west Colorado ca. 1100 C.E.. From the computer learning program "People in the Past." © 1997 Public Lands Interpretive Association. Art by Theresa Breznau.

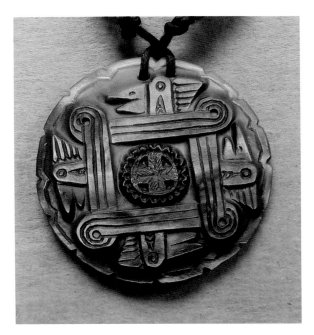

22. Shell gorget carved with four-woodpecker design, Dan Townsend, artist, © 2002. Used by permission. Photo by John Jameson, National Park Service.

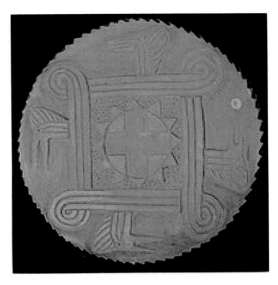

23. Salt Plate Cherokee pot, Chucalissa Gift Shop, University of Memphis. Used by permission.

24 and 25. *Tilth* (left) and *Northridge* (right) by artist Lance Foster, © 2001. Used by permission.

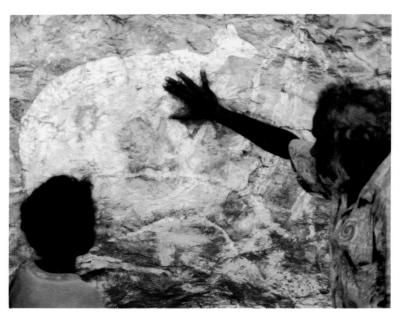

26. Peter Manabaru teaching Anton Plummer about a painting of the rock kangaroo, Barunga and Wugularr education project. Image used courtesy of Barunga-Wugularr communities, Australia.

18 / Is Archaeology Fiction?

Some Thoughts about Experimental Ways of Communicating Archaeological Processes to the "External World"

Nicola Laneri

> The real significance . . . is that the Bible again has apparently been shown to be true, reliable, and accurate, down to the smallest historical detail. Critics who claim that the Bible does not coincide with known history and geography are again shown to be wrong once the physical evidence begins to surface.
> *The account in the Bible is true, and the implications are incredible.*
> —from www.baseinstitute.org, emphasis added

One day during November 2000 I was watching a program on the NBC evening news concerning the rediscovery of the "real Mount Sinai" by two men, Bob Cornuke and William Larry, who belong to the Bible Archaeology Search and Exploration (BASE) Institute (figure 18.1). Cornuke, director of the institute, writes that "BASE exists to reaffirm the Bible as our reliable message of hope from God to mankind. We acknowledge it as our reliable standard of truth. Using the Bible and other historic sources, coupled with scholarly research supported by archaeological evidence, BASE endeavors to dispel the notion that the Bible is a collection of fables and legend" (from www.baseinstitute.org).

Bob Cornuke considers himself "an international explorer," but he is also, and probably more importantly, a retired policeman and a member of his local SWAT team—in short, a person who has spent almost all of his life controlling the reliable truths of people's daily lives. The NBC news program showed

18.1. Bob Cornuke and William Larry of the BASE Institute. Image courtesy Nicola Laneri and the Art-aeology Project.

pictures of Cornuke and his multimillionaire Republican colleague, William Larry, in different poses, but probably the most interesting picture was the one in which Cornuke was portrayed climbing a Saudi Arabian mountain with the Bible in one hand and the American flag in the other.

Since 1988, Cornuke and Larry have visited Saudi Arabia several times in search of valid archaeological traces to confirm their belief that Mount Sinai is not in the Egyptian peninsula, as was supposed until now, but rather in modern Saudi Arabia, corresponding exactly to the location of the mountain Jabal al Lawz (Blum 1998; Cornuke and Halbrook 2000). These traces are presented in the news program as if they are based on an accurate analysis of the archaeological evidences found at the site in Saudi Arabia and proved by the truthful script of the Bible. It is interesting to notice that in the case of the "discovery" of the Caves of Moses the author used a fictional form of communication similar to that of an urban legend, in which a secondhand source is the primary evidence in the support of the truthfulness of the entire story: "A worker at the site said that writings found in the caves indicated that the prophet Musa (Moses) had come through the area with his nation of Hebrews" (from www.baseinstitute.org).

Throughout the television program, Cornuke assured us, the public, of the truthfulness of his words about everything—the expedition, the discovery, the Bible. He communicated to the general public a very strong ideological message, without any hint of doubt about how he has built and coded this message. Through the discovery of the "real Mount Sinai," he plays an active role in the social practices of a specific community of mostly white, nationalistic, Judeo-Christian, middle-class Americans. Cornuke knows exactly who is in his target audience and how to reach them, even without acknowledging to the audience his "fictional" way of interpreting his "non-fictional" evidence.

Unlike Cornuke and other "fringe archaeologists" (Harrold and Eve 1993) who use archaeology with the sole purpose of delivering precise and strong

political messages to nonprofessional communities, we archaeologists have been concerned about theories that center around subjective interpretations of ancient material culture (Lempeter Archaeological Workshop 1997). Such types of research have seen an increase in books and articles on numerous interesting and diverse topics, ranging from self-reflexivity to agency in archaeological contexts, but the messages have been sent strictly to inner academic groups with little interest in social practices and communications to the "external world" (Habermas 1979:67–70). If we continue not to concentrate on the social and political ideas and problems of living communities and not to use archaeology as political action toward their beliefs, we risk a total separation of the field of archaeology within academia from the mainstream system, because "every effort to transform the system which is not accompanied by an attempt to transform attitudes towards the system (and conversely) is doomed to failure" (Bourdieu et al. 1994:3).

The aim of this chapter is to strive toward the creation of the role of the archaeologist as an active player in future constructions of the past by building a work-in-progress dialogue about the role of "external" communication, as well as to answer several questions about communication in archaeology, such as the following:

- How can a communicative message be structured around concepts concerning archaeological processes without necessarily using traditional written and/or oral media, but instead an experimental "artistic language" (Pearson et al. 1994)?
- How can a reliable "communicative pact" be established between the creator of the message and the "spectator" (Casetti 1994; Muller 1994)?
- How can the relationship between fictional and nonfictional archaeology be defined more clearly to broader communities (Shanks 1996b; Stone 1997)?

INTRODUCTION

Archaeology can be viewed as a narrative fiction based upon a subjective interpretation of ancient material culture. This type of interpretation is founded on the analysis of symbols and metaphors represented by ancient material culture and on the constant dialogue between the interpreter (archaeologist) and his or her experience within the archaeological evidence (Tilley, ed. 1993). This process is not static, but fully dynamic. In this scenario, material culture should be seen as a depository of meanings related to the researcher's cultural environment (Dewey 1980), in which "new truths . . . are resultants of new experiences and of old truths combined and mutually modifying one another"

(James 1955:113). Several scholars have already formulated these assumptions, focusing probably more on a theoretical approach to the analysis of ancient material culture than on a practical one (Carman 1995; Hodder 1986, 1999; Kohl 1993; Shanks 1992; Shanks and Tilley 1992; Tilley 1991; Tilley, ed. 1993).

During the 1980s and 1990s the postmodernist approach to archaeological research was able to completely modify the observation, interpretation, and communication of ancient cultural processes and material culture, fighting against a monolithic method of analysis and for an "anarchic view" of ancient worlds in which "the goal of science is to expand knowledge" (Bell 1991:72). This analytical theory of archaeological interpretation has produced a different kind of archaeologist, one who is no longer a simple digger but also a storyteller and a director of theatrical plays, performances, or music soundtracks (Tilley 1993:13). Recently, many scholars have lost their alternative approach in the creation of a narrative practice in archaeology, as noted by Tilley in the introduction to *Interpretive Archaeology*. Tilley, at that time, was suggesting that "interpreting material culture is an active and creative act rather than a passive process amenable to formalization in terms of guidelines for research" (1993:10).

The "active and creative act" of narrating archaeology has mostly been put aside, giving more value to the construction of archaeological texts and "a philosophy of archaeology," as noted by Bernbeck and Meoller (1990), or worse, an archaeology of philosophy (Shanks 1990). In many cases the important concept of "self-reflexivity," based on a need for "reflection into the self, reflection by any individual into his or her own history, motivations, or biases" (Potter 1991:226), results in the creation of a more reliable and subjective epistemology of critical theory in the interpretation of the archaeological processes. However, this method sometimes shifts in the direction of narcissistic self-indulgence (Moore 1994). To reduce such tendencies when practicing archaeological interpretation, we should be aware of the social contexts in which we live (Thomas 1995, 2000; Tilley 1989). We should also make an effort not to concentrate too much on only interpreting ancient individual acts, but rather try to reconstruct ancient communities and their social backgrounds. Using this system, ancient pasts can be reconstructed in various experimental ways, thereby allowing for communication between the interpreter, the creator of the codes, and the listeners, all of whom are in the present (Barthes 1977; Forceville 1994; Habermas 1979; Recanati 2000; Sperber and Wilson 1995). Even archaeologists should think of the past as a place for the creation of fictional stories. In doing this we must be able to create diverse forms of artistic communication directed to a non-academic public (Evans 1993).

Sets of images inside archaeological books and articles have been the

subject of few experimental stimuli, and in most cases images have completely disappeared from theoretical works (Edmonds 1999; Pearson et al. 1994; Shanks 1992, 1996a, 1996b). In contrast, the visual anthropology subdiscipline (see Banks and Morphy 1997; Prosser 1998) has recently become one of the most important analytical tools for the "consideration of human experience" (Banks 1998:9), in which visual and other nonwritten media have been used to explore "human sociality . . . through objects and bodies, landscapes and emotions, as well as thought" (Banks 1998:19).

Moser and Gamble (1996), in their paper at the 1992 EuroTAG conference in Southampton, have pointed this problem out, observing that we should probably place greater emphasis on the use of visual explanation for ancient civilization. We should stimulate the concept of performing as a way of communicating archaeological processes, permanently breaking down boundaries between performers and the audience, between academia, museums, and the "external world" (Shanks 1996b). One of the outcomes of archaeological research should be the constant use of different media (photography, video, audio, writing, smelling, etc.) to experiment with the creation of various artistic languages (Banks 1998; Hodder 1999; Pluciennik 1999). The representation of the past in the present should be thought of as a dynamic project in which fictional stories and messages are created through multidimensional and interacting experiences between the creators of the message (archaeologists, actors, artists, etc.) and the receivers (public). In other words, ancient pasts should be retold in the manner of fictional narrations, in which the narrated stories function as representations of a true past (Barthes 1977:123) and are consumed by the public audience. In the global world of the third millennium we must aspire to a language that is able to communicate to a general public using communicative frameworks similar to those of multinational capitalistic structures (McDonald's, Sony, IBM, etc.; Mort 1990).

In several cases this topic has been directed toward educational (see Malone et al. 2000; Stone 1997; Stone and Molyneaux 1994) and/or entertainment (see Davis 1997; Jameson 1997) targets. In very successful examples, archaeologists have avoided academic jargon during interactions with a nonprofessional public in the display of ancient cultural processes in inner (museums, schools, etc.) and outer (archaeological excavations, parks, etc.) spaces (Potter 1997). But we archaeologists should also be able to experiment and define a proper "artistic language" with which to construct fictional reconstructions of the past and fill out empty spaces.

Recently there have been experimental attempts to move archaeology in new directions; for example, narrative methods of writing have been utilized for the interpretation of ancient material culture and its metaphorical and

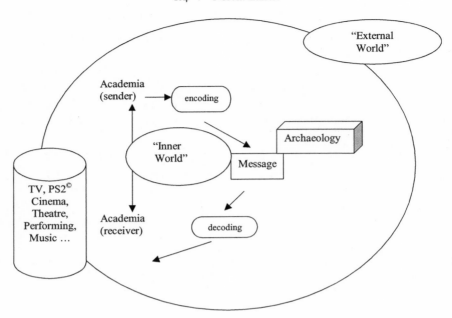

18.2. Academia and the archaeologist. Circle of interaction that excludes the broader social and cultural environment. (PS2$^©$ = Sony Playstation 2$^©$)

symbolic meanings (Barrett and Bartley 1994; Edmonds 1999; Evans 1993; Hodder 1986, 1989b; Olivier and Coudart 1995; Potter 1991; Shanks 1992; Shanks and Tilley 1992; Tilley 1991). But in several cases these experimental practices are still related to an inner academic consumption, where those who write are the same as those who read (Jameson 1997). There is not an outside public to whom these narrative messages are delivered (Evans 1993). The academic archaeologist is not intent on searching for a broader social and cultural environment, in which epistemological capability can be used to establish an experimental interaction with the outside world in the attempt to create different codes of communication that cross academic boundaries (Bourdieu 1990; Potter 1991). Rather, the archaeologist prefers to look inside his or her powerful circle (figure 18.2), losing sight of the problem of social and cultural intercommunication among different cultures (Hall 1976; Murray 1993).

THE CONSTRUCTION OF AN "ARTISTIC LANGUAGE"

I've spent ten years of my life in the professional theatre without ever seeing the people for whom I'm doing this work. Suddenly I can see them. A year ago, I would have been panicked by the feeling of naked-

ness. The most important of my defences was being taken away. I'd have thought, What a nightmare to see their faces!
—Bruce Meyers, qtd. in Brook 1995:6

A language does not necessarily need an established grammar and/or a written text (Fletcher 1989); it could also be an "artistic language" conceived for a precise aesthetic function with rules dictated by the creator (sender) to fortify the signifiers within the message and directed to the listener (Barthes 1977:69–78). When I mention an "artistic language," I am thinking of experimental attempts at constructing languages in which written texts or traditional verbal communications have been substituted by other important mediatic human devices (body, sounds, images, space, etc.) with the goal of communicating a narrative discourse (Banks 1998; Pearson et al. 1994). Since the beginning of the twentieth century, some experimental artistic languages have been developed, such as

- the experimentation made by Dario Fo in his construction of the "Grammelot" idiom, a complete nonsensical language based only on the power of the sound of the voice (Pozzo 1998)
- the use of the body and open spaces in theatrical plays by Peter Brook (Brook 1968, 1995)
- the surrealism and futurism movements' use of experimental visual, oral, and sound techniques of communication at the beginning of the twentieth century in Europe (for their manifestos see Breton 1969 and Marinetti et al. 1914)
- Eisenstein's theory on editing in moviemaking (Barthes 1977:52–68; Eisenstein 1977)

Each language, created by the combination of different media, must have its own "structural autonomy" and political value (Barthes 1977:15), but it must never give an objective description of cultural processes, ancient or contemporaneous, or a final interpretation of the symbolic values involved in them. The constructed language should be based on social gestures (Barthes 1977:73) made by the narrator through the process of representing cultural processes in the present, because "culture is not an object to be described. . . . Culture is contested, temporal, and emergent" (Clifford 1985:18).

In the construction of this narrative representation we have to bear in mind several factors, such as the political and ideological value of the narrated message, the mode of representation of the message itself (Odin 2000), and the functional syntax involved between the sender and the receiver in the active processes of the narration (Barthes 1977:97–117).

To elaborate further: it is possible to visualize the reconstruction of an archaeological context as a theatrical representation in which the insiders (archaeologists) and the outsiders (public) are placed together in an interacting scenario (the archaeologist excavating with the local worker; the museum curator working with the visitor). The message that is created and emitted by the archaeologist should develop throughout a social interaction with the receiver. In this process the archaeologist must understand the fundamental political power of his or her role as well as the "power" of knowledge involved in the creation of the message. Within this context we archaeologists should be aware of our social actions and draw a line between us and the others. Otherwise our role will not be recognizable by the "external world" (Thomas 1995:345).

I propose that our attention should be more focused on the developing theory of action research, an approach most recently used by worker cooperatives in Spain and Norway and by people working within the social sciences, where the interrelation between "outsiders" (researchers, professors, etc.) and "insiders" (the community) can be transformed into a strong intellectual and social practice (Greenwood and Levin 1998). In this system, "experiences emerge in a continual interaction between people and their environment and, accordingly, this process constitutes both the subjects and the objects of inquiry" (Greenwood and Levin 2000).

In archaeology, an experimental theater interaction with an "external" public has been executed by Mike Pearson and his group, Brith Gof (Pearson et al. 1994). In this case, archaeological activities have been portrayed as performance acts in the present, visualized in different theatrical forms using soundtracks, images, and other nonwritten media. Another important example that involves different media and the interaction between archaeologists and a nonprofessional audience on the behalf of the narration of the past is what Mark Leone, Potter, and other scholars have shown us with the Archaeology in Public project in Annapolis, Maryland (Leone and Potter 1984; Potter 1997). To develop better methods for attracting visitors, this group hired a theater director, Philip Arnoult from the Theatre of Baltimore, because in this case, as Potter pointed out, "media expertise" was "essential" (1997:43).

The combination of different specialties (artists, photographers, audio engineers, etc.) is probably fundamental for the strengthening of communication of topics involving cultural processes to a broader public, as Barbara Bender noticed at the TAG conference in Cardiff in 1999. But there are still several questions that come to mind: Why are we teaching students how to write but not how to use a photographic camera or a digital recorder? Why do archaeologists know how to communicate using narrative writing skills but not need additional expertise to make use of other media devices? Why do we archae-

ologists, in many cases, make a distinction between a performer and an archaeologist, when giving a paper at a conference is a performance in itself?

THE ART-AEOLOGY EXPERIENCE

During the last ten years, much work has been done to investigate and solve issues about experimental ways of narrating archaeology. This has been done using nontraditional methods of interaction between archaeologists and the public, such as in the case of the Brith Gof group mentioned above, the archeofiction classes conducted by Masson and Guillot in France (1994), and music soundtracks based on recordings of natural sounds originating from numerous British monuments, produced by scholars from the University of Reading (Lawson et al. 1998; Watson 1997). Despite such interesting efforts, I have noted that the majority of scholars continue to concentrate on the history or epistemology of archaeological communication, both in museum and academic contexts, instead of formulating the basic structure of the message itself. I believe, as emphasized throughout this chapter, that it is strictly necessary to develop the field of performing archaeology and the interaction between academia and communities who are involved in the construction of the past in order to foster the communication of cultural processes in which material culture is represented by all objects consumed in the past, recent or remote, from the ancient ritual to the Coca-Cola bottle.

These theoretical beliefs instigated the creation of "The Art-aeology Experience: Bringing the Present to the Past" by a group of people that included myself and other Italian and international artists, photographers, archaeologists, and anthropologists. (To experience one of the projects of the "The Art-aeology Experience," enter the CD-ROM published with this book. For more information on our forthcoming projects, visit www.geocities.com/ darmius_nic.) To participate in the projects of "The Art-aeology Experience," the only requirement is to share in the ability to communicate the diversity of human structures using any type of contemporaneous art form, such as music, painting, cinema, sounds, performance, and conferences, ultimately creating diverse languages that communicate cultural processes, both ancient and contemporaneous. In "The Art-aeology Experience" one loses one's identity, thereby giving way to a fluid group that has the potential to fit into every single space and interact with every possible community. Our projects are never final; rather, they are thought of as dynamic dialogues between the group and the "external world" (archaeologists, communities, artists, etc.) (figure 18.3).

In the next few paragraphs and in the CD-ROM that accompanies this volume, I have tried to reconstruct excerpts from two projects in "The Art-aeology Experience" in the hope of better illustrating our vision. The first ex-

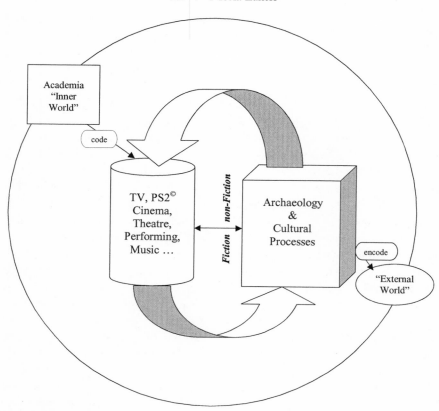

18.3. Network of available media and proposed circle of interaction. Archaeologists should be able to communicate to the "external world" translating the academic codes into a more simple language that can fit with other products consumed by the general public. To reach this target we should build a network through use of available media with the purpose of creating a fictional and artistic language to narrate ancient pasts.

ample is *An Archaeological Soundtrack for an Imaginary World,* presented at the TAG 1999 conference in Cardiff. This project was produced at the archaeological site of Titris Höyük, Turkey, between the 1997 and 1999 field seasons. It is divided into four songs and four sets of images. The soundtrack was made by recording and remixing sounds from the site and the daily lives of the local Kurdish people, coupled with asking the archaeologists to answer the question, Why archaeology? The slides contain images created by both the Kurds and the archaeologists, mixed together to represent the contradictions that emerge from the collision, overlap, and intermingling of these two differing cultural

and religious worlds (Western/Kurdish-Turkish and Islamic/non-Islamic). In the same way, images of archaeological and non-archaeological objects are put together (beer cans, Coke bottles, educational tools from the elementary school in which we established our center, etc.) as symbols of the experiential life of these two completely different worlds (see figures 18.2 and 18.3).

The second project, *Stratigraphy*, represents an "excavation" of different ethnic "layers" in New York City's neighborhood of East Harlem. This soundtrack is based on an dialogical discourse between the "conservation" of the Italian tradition, represented by the words of Rosa Morrone, the owner of an Italian bakery in East Harlem since the 1950s (on the left channel of the soundtrack), and the neighborhood's "innovative" facade, expressed by the words and work of the Puerto Rican painter-muralist-chalker James De-Lavega (on the right channel). The images and objects that form this project embody the diverse ethnicities (Italian, Puerto Rican, Mexican) now present in the neighborhood and reveal how diverse forms of cultural interactions (peaceful and violent) between these groups have led to the re-creation of "new" material culture (e.g., espresso made with an Italian coffee machine and Puerto Rican coffee; pizza prepared by Mexicans; Italian Madonna statues dressed with real hair—a Hispanic tradition—and worshiped by Asians) shared among all of these communities and remade throughout the cultural, functional, and ritual transformation of their values during the last century.

The third project, entitled *An Imagery Soundtrack for a Real Archaeological World, Volume II: Museums* (available in the CD-ROM included with this book), is a short movie that documents sounds, images, and phrases from two of New York City's most important museums: the American Museum of Natural History (AMNH) and the Metropolitan Museum of Art (MMA). The museums' physical locations within the city plan—at opposite ends of Central Park—serve as a metaphor for their differing interpretations of archaeological materials, related to the AMNH's scientific approach and the MMA's fine arts approach. During this short tour, sound will meet images of objects from the two museums, images will meet texts dedicated to the use of "culture" by the curators of these museums, and all together will give a brief idea of the politics of display used since 1869–1870 by curators of the AMNH and the MMA and how visitors have responded to these cultural exhibits.

Daniele A. Mascitelli, a member of "The Art-aeology Experience" from Rome, Italy, had the following comments:

> As a player in the "Art-aeology Experience," I have to say that it has been a very captivating experience, especially in the case of the first project, *An Archaeological Soundtrack for an Imaginary World.* Since I

have never been in an excavation campaign, and not even a Kurdo-Turkish one, I had to get inside that atmosphere (and the theoretical problems touched by the project itself) by listening to recorded sounds and looking at pictures. I was surprised that sounds can be so communicative, even in the archaeological field (stones really have sound!).

Playing and mixing sounds to re-create those situations—namely an "imaginary world"—cast an amazing spell that enabled me to get myself into those situations as if I were really present in them—so that the "imaginary world" became concrete, though only in its representation. The real and concrete sounds, stolen from a context, contributed to the re-creation of a new context (a framework and a canvas at the same time), a new reality in which I was not only a passive part but an active one too.

DISCUSSION

Monuments create public dream-space in which, through informal and often private rituals, the particularities of one's life make patterns of meaning.

—Taussig 1992:46

To conclude this chapter, I would like to jump back to the story that was described at the beginning and analyze the communicative value of the message found in Bob Cornuke and Larry Williams's search for the "true" and "real" Mount Sinai. The BASE Institute's "code" for a "true" archaeology has been delivered using different media (e.g., television and the internet) in order to provide insights to the general public about the possibility of searching for "The Truth." This authority belongs neither to the "policeman" nor to the person Bob Cornuke nor to an academic group, but rather to the Bible and to the American flag. Cornuke and his colleague have created a perfect meta-representation of an archaeological discovery—in other words, a "statement *about* an imaginary situation" (Recanati 2000:343). They achieved this by understanding their target audience and how to reach it. Both the Bible and the American flag embody similar signifiers that are instantaneously recognizable and therefore easy to deliver and to code, so that "members of the audience use their knowledge of these conventions on the one hand, and their knowledge of the signal and of the context on the other, to infer the message" (Sperber and Wilson 1995:26).

The social gesture of BASE is effectively construed because it reaches "all the participants in the communication process" (Sperber and Wilson 1995:26).

The authority they possess for a certain kind of public can never be contested or embellished, even with the addition or opposition of any imaginable scientific and/or academic authority. Their archaeological "truth" exists because it has a strong ideological foundation.

We archaeologists must face the reality of BASE's message and accept the truthfulness of a fictional or "fringe" archaeology as part of a process in which a message is constructed and delivered through all possible media. The last few years have seen the development of worldwide communication (using internet, cellular phones, satellite dishes, and other devices), which has become one of the most effective and powerful tools of so-called globalization. We archaeologists should understand the social and ideological importance of this transformation and how a message built in the middle of nowhere could have an impact in communities several thousand miles away (Hodder 1997, 1999). In this scenario we should better define our politically and socially active roles in every community, while being aware of the conservative power that is leading worldwide and influencing the general public and their understanding of the past, which is usually shaped by mainstream messages that have strong ideological and religious roots.

Archaeological communication outside the academic world is replete with various forms of fictional representations of the past, from Lara Croft (*Tomb Raider I/II/III*) and other Sony Playstation 2 (PS2) video games to the movie *Gladiator* and the television show *Neanderthal* (on Channel 4 in the U.K.). We must confront the idea that it is possible to consume archaeology in the same way people use McDonald's. "Fast-food archaeology" exists, and we cannot cast it aside as belonging to an undesirable "external world." We archaeologists must decide to be part of this game, focusing on the concept of understanding the "others," which will give us the ability to mirror ourselves through mutual experiential interchange. In our own way we could even code a "fast-food archaeological message" in which the fictional production of the past is part of the power of the political action that we, as citizens of the "external world," generate through the creation of the message itself. Paraphrasing Shanks's words, I think we should not ignore *Gladiator* or condemn Sony PS2 as vacuous; instead, we should understand their fictional values and learn how to use them (Mackenzie and Shanks 1994:40). Otherwise, our knowledge will continue to have little or no impact on the process of communicating mainstream messages about either reconstructed or fictional ancient pasts. And we will continue to reside inside our cages (academia or museums) without noting that a method placed next to a theory overlaid by an interpretation will likely be enough not only to answer archaeological questions but also to build additional boundaries between "archaeology" and the "external world."

ACKNOWLEDGMENTS

This article was written during my stay (2000–2001) at Columbia University's Department of Anthropology as a Visiting Scholar with a Fulbright Fellowship. I want to thank Professor D. Freedberg (director of the Italian Academy for Advanced Studies at Columbia) for giving me the chance to use the offices of the Italian Academy; Professor M. Taussig for sponsoring me; and Daniele A. Mascitelli and Duncan Schlee for being part of the "Art-aeology Experience" from the beginning and having trusted its purposes. I am also indebted to Karen Abend for editing this paper.

19 / *Crafting Cosmos,* Telling *Sister Stories,* and Exploring Archaeological Knowledge Graphically in Hypertext Environments

Jeanne Lopiparo and Rosemary A. Joyce

In 1994, Rosemary Joyce began a long-term collaboration with two non-archaeologists on a hypermedia project based on ethnohistoric materials about sixteenth-century Aztec society. Joyce's collaboration on *Sister Stories* (Joyce et al. 2000) has led her to view hypertext presentation as a potentially powerful medium for the representation of not only archaeological interpretations but of the archaeologist's process of arriving at an understanding of a past society (Joyce 1998, 1999, 2001, 2002).

Over the same period, we have worked as part of UC Berkeley's Multimedia Authoring Center for Teaching in Archaeology (MACTiA, http://www.mactia.berkeley.edu), teaching undergraduates and graduate students how to use multimedia authoring tools in representing archaeological practice and interpretation. As part of her association with MACTiA, Jeanne Lopiparo developed a prototype hypermedia project, *Crafting Cosmos,* which pursues our goal of using this new technology to make the *process* of archaeology more accessible to nonspecialists and specialists alike.

In this chapter we interweave accounts of our goals and strategies in these two works. Both of these works use the possibilities of art to try to convey to those who immerse themselves in these new media a better sense of how as archaeologists we construct tentative, contingent, and multiple interpretations of the past. The works thus both represent something about a possible past and simultaneously enact the creation in the present of representations of possible pasts.

We have developed some opinions about the merits of hypermedia for archaeology, and the effects it is capable of achieving, from the years we have spent in the development of these works, in a community in which the values represented by such works have been actively debated. Because our two projects have had different development histories and exist at present in two quite different forms—one a web publication, the other a work to be distributed on CD-ROM—we also have a practical basis from which to assess the relative merits of different technologies. And the fact that the two projects—while sharing much in philosophy, development history, and goals—are nonetheless strikingly different means that the comparison between them serves to illuminate the creative range that digital media enable. Although we are wary of speaking for an entire medium, we take the opportunity here to reflect from our own exchanges on the medium and its effects and to comment on some of the broader issues implicit for archaeology in computerized hypermedia.

GOALS, PROCESSES, AND RESULTS: SOME GENERAL COMMENTS

Our primary shared rationale for creating computerized hypertexts is that this medium allows the creation of more effective multivocal representations of the past. We argue that

> multivocal electronic narratives should not seek to resolve contending views. Instead, they have the potential to expose the ways people with different views differentially use material remains. The messiness introduced should be seen as a strength, and a microscale representation of the macroscale of healthy archaeological dialogue already extending between different texts. . . . It would be difficult to create a single linear text that accomplished this. While the dangers of the medium—particularly anonymity of voices and the flattening of all information to the same degree of authority—cannot be evaded, they are actually not unique to electronic media. (Joyce 2002)

We realize our attempts at multivocality in *Sister Stories* and *Crafting Cosmos* differently, but in both cases the multilinear linking capacity of hypertext allows us to provide multiple entry points that balance the relative dominance of the different voices. Exploiting the generative effects of hypermedia, we engage the reader as a collaborator in the construction of archaeological interpretations. As the reader chooses to follow particular links, he or she creates a unique juxtaposition of primary data and secondary analyses that shape an experience that, while constrained by the sources, is irreducibly unique. The

reader enacts the process of archaeological interpretation that we would like to model in these works.

Like others using computerized hypermedia, we acknowledge both that these are not the only media in which to make such attempts and that they are not unproblematic means to accomplish these goals. In fact, our experiences in developing our projects have made us intensely aware of both the current limitations in realizing the promise of hypertext and the actual impossibility of completely vacating the position of authority implicit in authoring such works in the first place. A few comments on the developmental histories and relative technical limitations of *Sister Stories* and *Crafting Cosmos* provide one way to begin to assess the medium as a whole.

Sister Stories was originally developed in *Storyspace,* a hypertext authoring environment, as a freestanding collaborative hypertext. Rosemary Joyce selected sections from the *Florentine Codex,* a multivolume work compiled by the sixteenth-century Spanish Franciscan friar Bernardino de Sahagun (Sahagun 1950–1982). She presented these texts to her collaborators arranged as a schematic map, placing selected texts in spatial relations intended to recall the places and times Nahuatl speakers in sixteenth-century Mexico would have associated with these texts. This was facilitated by the interface of *Storyspace,* in which the writer creates "spaces" as containers for text and can move these around, nest them in hierarchies, and link them to each other using a number of approaches, some creating multilink "paths" from space to space (see Joyce 1995:23, 31–35, 39–59 for discussion of the development and features of *Storyspace*). Her collaborators, Michael Joyce and Carolyn Guyer, writers of hypertexts and critics of hypertext (Guyer 1992, 1996; Guyer and Petry 1991; Joyce 1995, 2000), took the initial spatially mapped and linked hypertext and wrote inside it, remapped it, and created new links throughout the text. Rosemary Joyce also undertook new writing and linking in the multiply authored hypertext during this phase. By the end of this collaborative authoring process, the *Storyspace* version of *Sister Stories* consisted of 313 "spaces," integrated by 1,811 links and 603 paths, containing 40,423 words (equivalent to approximately 162 standard "typed" pages).

The intention at this point was to publish *Sister Stories* on CD-ROM in *Storyspace* format. This would allow people who owned *Storyspace* complete access to the work, potentially enabling others to rework the hypertext themselves. But over the period of development of *Sister Stories,* the World Wide Web matured, changing the context of publication. The final published version is a website that, while containing all the content of the freestanding version, has been adapted to the dominant hypermedium. In the process, the work gained a much richer visual appearance and a level of graphic communication developed for the web presentation by Carolyn Guyer. Features of lay-

out within the page that are routinely possible on websites were not feasible in *Storyspace*. The published work uses graphics to help signal and underline the different voices in the work, adding a layer of narrative complexity and perhaps helping to allay the disorientation that could be experienced in the original.

What is lost is perhaps harder to see, and arguably there are losses on two levels. First, it is still the case that HTML scripting is not as rich a form of hypertext as an environment like *Storyspace*. In creating the original work, Rosemary Joyce employed a tool that could identify every text with key phrases (such as "red feathers") and automatically link them, providing paths through the material that had little overt narrative or interpretive authorial intention. This allowed the discovery of associations that were previously unsuspected. Once established, these links could be maintained in the HTML version. But the ability to select and traverse the paths linking these references cannot be reproduced. *Storyspace* also provides the ability to navigate up and down nested spaces, or through spaces on the same structural level; to achieve this effect in HTML would require construction of an interface mimicking structure that the HTML version, with its simpler hierarchy, does not have.

But perhaps more significant than the loss of complexity in the hypertext features themselves is the fact that the web-based version is not open in the ways that the *Storyspace* original could be. Unlike the original, it is difficult, perhaps impossible, to obtain an overall sense of the structure and linking of the work. In theory a reader can create his or her own web page linking to the published work and thus open it up. In practice, this sort of interplay between websites maintains a greater boundary between original authors and reader-authors than adding to a *Storyspace* version of *Sister Stories*.

Crafting Cosmos illustrates other issues raised by the dominance of the World Wide Web as the preferred medium for hypertext dissemination. Jeanne Lopiparo developed the prototype of this work as a freestanding hypermedia production staged on CD-ROM, and successive revisions have maintained this technical basis. This has allowed the refinement of a very rich hypertext which, unlike *Sister Stories*, was conceived from the beginning as a multimedia presentation. It includes animation and sound as well as still images and text. For this work to be made available on the web, either the richness and graphic complexity would need to be compromised or the audience would be narrowed to those individuals with high-speed internet access and the most advanced browser capabilities.

The challenges presented by the World Wide Web are not unique to these two projects. They resonate with issues raised by others writing about using the web as a medium for archaeological publication. We expressly disclaim an authoritative position from which to assess the effectiveness and success of the

web as a communication device for enhancing public appreciation and understanding of archaeology or as a medium that might allow, create, or nurture greater communication and inspiration among archaeologists. But we find ourselves echoing sentiments expressed by many others who have thought about the impact of this new medium.

Early research on the use of hypertext systems in museums (Shneiderman et al. 1989) established that making information available through hypertext systems changed both the intensity of use and the nature of the connections that could be made by nonspecialists given access to a database. Research like this reinforced an intuitive sense on the part of many archaeologists that hypermedia might allow us to overcome the barrier between researchers and the public. Beginning equally early, writers raised cautions about the prospect of new forms of power relations that might be enabled and concealed by the apparent openness of hypermedia. Thus, museum photo archivist Christopher Burnett (1989:16–17) called into question "universalist" hypertext projects that purported to attempt to make "everything" accessible, promising to link all archived information in one immense network. Writing ten years later, archaeologist Martin Hall (1999:42–46) challenged utopian claims that the internet is destined to foster democratic connections and open access to information. Rather than being inherently liberating, hypermedia require being democratized (Tringham 1998), ideally through a combination of re-envisioning the forms of hypermedia, spreading the knowledge required for people to create hypermedia works of their own, and explicitly addressing limits in availability of technology.

Carol McDavid (1999) exemplifies these keys to the realization of the promise of web-based hypermedia in the development of a website (http://www.webarchaeology.com/html) for the Levi Jordan Plantation in Brazoria, Texas. This site explicitly aims to incorporate reflexivity, multivocality, interactivity, and contextuality. McDavid describes the underlying metaphor of the site as a "disembodied, expanded, fragmented, and multivocal conversation" between specialists and nonspecialists. Biographical sketches representing the multiple participants foreground multivocality. The same strategy is employed in *Sister Stories* to draw attention to the presence of distinct participants with different viewpoints. Hypertext linking is extensively used to establish contextuality in the Levi Jordan Plantation site. Here, McDavid points to one of the effects of hypermedia most widely appreciated by archaeologists. Our disciplinary interests in contextualization are well served by the multiple kinds of linking that can be established in hypermedia. *Crafting Cosmos* makes extensive use of hypermedia contextualization through its central visual metaphor of the "world tree."

One of the major areas of concern that McDavid raises is the difficulty in

realizing interactivity on the site. Because the public engaged in the project has uneven access to technology, McDavid is aware of the potential of "interactive" technology to decrease participation rather than increase it. Her emphasis has been on developing *content* interactively rather than producing "interactive" features built into the site, which might be obstacles to participation by interested browsers. She also calls attention to the fact that the current technology of the web, as well as CD-ROM products, prevents readers from creating new links and thus undermines their ability to realize fully the possibilities for interaction.

The ability to modify a work, or simply to archive one's own unique pathway through it, is a significant basis for distinction among superficially similar hypertexts. Michael Joyce (1995:41–43) used this contrast as the basis for distinguishing between exploratory and constructive hypertexts. In exploratory hypertexts, the reader is like the player of a game, experiencing a world set before him or her. In constructive hypertexts, the reader's ability to create something new, even if it is only a history of a particular traversal of the hypertext, engages the reader as a collaborator in the creation of the work.

Most archaeological use of hypertext is, by virtue of limitations in the technology employed, exploratory rather than constructive. One way to partially overcome this unavoidable limitation in the currently dominant hypermedia of the web is to distribute development of hypertexts dealing with the same archive across multiple authors, who might even address different audiences. The multiple websites developed for the Çatal Hüyük project (Hodder 1999; Wolle and Tringham 2000) provide a well-documented example. The commitment of the Çatal Hüyük project to allowing access to field records as rapidly as possible might seem at first glance like the kind of utopian project Burnett (1989) questions. But in place of the totalizing goals of universalizing projects that imagine it would be possible to present "everything" in some completely evenhanded fashion, the Çatal project provides access to archives that are clearly marked as contingent approximations of knowledge actively being constructed by participants, including excavators and specialists forming multiple project teams.

Ian Hodder (1999) emphasizes the importance of dialogue in the main project site (http://catal.arch.cam.ac.uk/catal/catal.html), which features exchanges with proponents of the goddess movement. The fact that multiple New Age and goddess movement websites link to the archaeological website exemplifies the one way that the World Wide Web is superior to CD-ROM hypermedia as an open medium. While any one site is itself closed, links can be established from other contextualizing sites to reinterpret anything published on the web. As Hodder (1999) notes, such recontextualization can connect different audiences to the main archive. Such recontextualization can

open specialized material to nonspecialists by framing different questions and adopting different language. An alternative website for Çatal managed by the Science Museum of Minnesota (http://www.smm.org/catal/home.html) provides an interface for children that links to the main project site.

There is no theoretical limit to the number of such "portals" that might be imagined by different scriptors (Joyce 1995:42) constructing hypertexts that would recontextualize the Çatal archive in different ways. The main limitation to participation remains uneven access to technology and web-scripting skills. But to produce constructive hypertexts that transform the material, it will also be necessary to follow the lead of thoughtful archaeologists like McDavid and explicitly identify the values that we seek to exemplify in our hypermedia productions.

For both *Crafting Cosmos* and *Sister Stories* we can provide substantial analysis of the effects we intended to produce and the strategies we employed to accomplish our goals. Our longer analyses of our theoretical commitments and the way we used hypertext to exemplify them are published elsewhere (Joyce 2002; Lopiparo 2002). In each case, we employed aspects of the hypertext medium that allowed us to represent through form something that we felt was difficult to capture in explicit commentary. Use of this new medium allowed us to follow William Gass's (1970:55–76) exhortation to show, not tell, our stories. At the risk of oversimplifying the rhetorical potential of new digital media, we reflect in the pages that follow on the formal effects of the medium for each of our projects.

JEANNE LOPIPARO ON *CRAFTING COSMOS*

Crafting Cosmos is an exploration of how hypermedia allow connections to be made among diverse types of information to represent the many avenues through which we come to understand and interpret past societies. It is simultaneously an exploration of the use of material culture in the past in creating and re-creating society. Finally, it exemplifies one way we might embody and humanize our interpretations in order to convey the significance of the theoretical concept of human agency. I grappled with ways to compose hypermedia to encourage the audience to explore nontraditional expressions of academic arguments. The work reflects both the multilinear, often unmethodical genesis of academic explanations and the many sources of inspiration, imagination, and accident that generate them. I was particularly concerned with how to visualize and embody abstract arguments. Central to my work is the proposition that culture only exists in its enactment, so my challenge was creating a work in which readers reconstruct and "reenact" narratives of the past.

The form of *Crafting Cosmos* consequently embodies repetition, or recur-

sion, which is the experience through which members of society learn how to act and, through acting, constitute society (Giddens 1984). Modern readers mimic the structuration of ancient societies as well as the structuration of modern archaeological interpretations.

This effect was accomplished through linked visual metaphors for navigation. The first navigational element of the project is *time*, based on the cyclical notions frequently described as being inherent in Classic Maya calendrics. *Crafting Cosmos* draws parallels between how Classic Maya societies created meaning in their present and how archaeologists reconstruct meaning in the past and create new meaning in their present. Through the navigation of *time*, represented by the icon of the Mayan calendar, readers can explore parallels between archaeologists' interpretations of how the Maya interwove past and present and how archaeologists partake in the same project.

The second navigational element is represented by four craftspeople in the corners of the navigation page (Scribe, Weaver, Sculptor, and Cultivator). This navigational element focuses on how people as crafters create their own universe through daily practices and embed their understandings in material culture. My own investigations of domestic production in the Ulúa Valley, Honduras, serve as a case study. This navigation begins on the level of the household. Household industry and household ritual include practices that were means of performing and inscribing ideals and meanings, including in the material culture archaeologists analyze.

The third metaphor for navigation is most fundamental to the argument that hypermedia can be used to represent complex theoretical concepts of structuration and practice theories, the structure-agency dialectic, to make readers understand it through experience. The structure-agency relationship is conceptualized metaphorically through the Mayan symbol of the world tree, which represents the tripartite division of the Mayan universe. The upper-world—the realm of the "gods" or supernaturals associated with the creation of the earthly world—represents "structure." The earthly world—the realm of humans—represents the daily practices of agents. And the underworld—the realm of the ancestors—represents the "traditions," roots, and specific histories that constrain and define the circumstances and choices of agents. The tree itself is an axis mundi to connect these levels of the universe, their interactions representing the dialectical processes of structuration.

Because of the inherent difficulties of representation, the most difficult aspect of the project was the reinstatement of people into my arguments that emphasize the importance of human agency. After many failed attempts at animating people, I was inspired by Patricia Amlin's movie of *The Popol Vuh* made by animating figures from Classic Maya polychrome vessels. I decided to make figures from polychrome vessels "speak" using animated quotes from

ethnohistoric and ethnographic sources. This allowed another opening for the exploration of how archaeologists use these and similar sources to narrativize the past. The excerpts resonate with the ideas that are being expressed about crafting, creation, production, memory, and ancestors, creating juxtapositions that include interpretations of their meanings to the original speakers or writers—*and* of their uses in archaeologists' writing of the past.

ROSEMARY JOYCE ON *SISTER STORIES*

Sister Stories is a representation of multivocalic dialogue. In archaeology, the term *multivocality* is used for attempts to reflect the varied perspectives different people might or do have on the past (see comments by Ruth Tringham in Bender 1998:86–87; compare Hodder 1999:159–161, 173, 183, 195). Mikhail Bakhtin used the term *polyphony* for the successful representation of multiple voices, with equal integrity, in his study of Dostoyevsky's novels. Attempts to represent multivocality in archaeology are intended to create archaeological works that are successful in the same way that great novels are, that convey a sense of peopled reality that can only be shown, not stated step by step (Joyce 2002).

Achieving polyphony is, however, extremely challenging. Great novels require writers who can capture the sound of many different voices. Archaeological efforts at multivocality have used many strategies. In *Sister Stories* we achieve multivocality by capturing a series of collaborative conversations. The texts we began with were themselves transcripts of interviews, conducted by unnamed bilingual assistants of the Spanish cleric Bernardino de Sahagun. The unnamed speakers whose words were recorded were Nahuatl-speaking nobles looking back nostalgically on the world that was destroyed by Spanish conquest. Much of what they spoke were quoted speeches and songs, formal oratory employed on ritual occasions. Through this quoted speech, other voices crept into the original narrative.

As modern collaborators in constructing *Sister Stories,* my coauthors and I engaged in dialogues about the context and meaning of passages I selected, organized, and sent to my non-archaeologist colleagues. Some of these exchanges were incorporated verbatim in the final version as quoted e-mails. Throughout the work, we all varied our speaking voice. But consistently we told retrospective stories, even if they were fragmentary ones, adopting the same relative position as the unnamed speakers in Sahagun's collected texts. And at various points, one or another of us directly addressed the reader we anticipated, implicating these readers as equivalents to Sahagun's bilingual assistants who interviewed the Nahuatl elders.

The medium of hypertext allowed this to work, both as an authoring

strategy and as a reading experience. In putting together the work, we sent versions of the electronic text back and forth. At each place where one of us was inspired to respond to a recorded voice, the hyperlinking technology of *Storyspace* let us add text without destroying what was already there. Readers of the completed work engage in their own dialogue with our recorded voices and the quoted voices of the Nahuatl speakers. Readers respond to what they find interesting, tracing complex and unique paths through the book-length text. As in *Crafting Cosmos*, built in to *Sister Stories* is an experience of recursion, as links circle back on themselves. As with all socially learned meaning, hypertexts use repetition to reinforce understanding. By looping through original texts, commentaries on them, and reactions to them, readers of *Sister Stories* mimic the actions of archaeologists working with similar materials. They come to understand the process of archaeological interpretation without having to be told that this is how it works.

CRAFTING COSMOS, TELLING *SISTER STORIES*

The discourses surrounding hypertext repeatedly return to its role in the ethics of knowledge creation, particularly its potential to produce writerly texts that blur the boundaries between author and audience. By creating openings for seemingly infinite possible readings, hypertext can subvert the authority created by the linear narrative tropes typical of academic writings and used to advance monologic arguments.

In our archaeological writing, we wish to take seriously the ethical implications of Bakhtinian dialogism (Joyce 2002; Lopiparo 2002). This requires us to consider critically the methodological implications of *how* we write the past. We want to replace practices presenting closed and monologized views of past societies with forms of representation that allow for the inherent dialogism of multiple and often contradictory lived experiences *and* our multiple and often contradictory means of understanding them. We want to consider the traces, mnemonics, embodiments, or "artifacts" of thought as situated in their particular contexts, through a thick description of everyday life. We are trying to expand our notions of the limits of the possible to consider and account for multiple conceptions of past societies. Because there is and was no singular meaning, we face the challenge of conveying this polyphony, not just through multiple interpretations, but through multiple presentations.

As a number of authors both within and outside archaeology have noted, the new medium brings its own challenges that must be addressed for it to work to advance positive developments. For us, this potential rests on an understanding of the nature of meaning-making in archaeology that is grounded in a specific theoretical literature that is anti-relativist and anti-determinist,

which we think provides a possible grounding for responsible archaeological practice in a multicultural, multivocalic world. Some of what we want to say cannot be said in words alone. Hypermedia allow us to use form to convey our vision of the collaborative, recursive production of meaning fundamental to social life and understanding in the past and today.

References Cited

Acker, Finley
 1899 *Pen Sketches*. McLaughlin Bros., Philadelphia.
Adams, Charles
 1981 The View from the Hopi Mesas. In *The Protohistoric Period in the North American Southwest, A.D. 1490–1700*, edited by David R. Wilcox and W. Bruce Masse, pp. 321–335. Arizona State University Anthropological Research Papers No. 24. Arizona State University Press, Tempe.
Adler, Michael A.
 1989 Ritual Facilities and Social Integration in Nonranked Societies. In *The Architecture of Social Integration in Prehistoric Pueblos*, edited by William C. Lipe and Michelle Hegmon, pp. 35–52. Occasional Papers of the Crow Canyon Archaeological Center No. 1. Crow Canyon Archaeological Center, Cortez, Colorado.
Aine, H. Roux
 1861 *Herculanum et Pompei: Recueil General*. Fermin Didot Freres, Paris.
Asimov, Isaac
 1950 *Pebble in the Sky*. Doubleday, Garden City, New York.
 1951 *Foundation*. Doubleday, Garden City, New York.
 1952 *Foundation and Empire*. Doubleday, Garden City, New York.
 1953 *Second Foundation*. Doubleday, Garden City, New York.
ATSIC (Aboriginal and Torres Strait Islander Commission)
 1999 *Digital Dreaming: A National Review of Indigenous Media and Communications. Executive Summary*. Woden, ACT: ATSIC.
 2001 *Aboriginal and Torres Strait Islander Commission Web Site*, online: http://www.atsic.gov.au (accessed October 10, 2001).
Auel, Jean
 1980 *The Clan of the Cave Bear*. Bantam, New York.
 1982 *The Valley of Horses*. Bantam, New York.
Aula, Salvatore
 1778 *Antiquitatum Romanarum Epitome ad Usum Seminari Neapolit*. 2 vols. Naples: Vincentium Ursinum.

Baker, Tony
1997 Art and the Folsom Point. World Wide Web, URL:
 http://www.ele.net/art_folsom/art_fols.htm.
Banks, Marcus
1998 Visual Anthropology: Image, Object, and Interpretation. In *Image-Based
 Research: A Sourcebook for Qualitative Researchers,* edited by J. Prosser, pp. 9–
 23. Flamer Press, London.
Banks, Marcus, and Howard Morphy (editors)
1997 *Rethinking Visual Anthropology.* Yale University Press, New Haven.
Barrett, John C., and E. A. Bartley
1994 A Conversation in Two Acts. In *Archaeological Theory: Progress or Posture,*
 edited by Iain M. Mackenzie, pp. 152–161. World Archaeology Series.
 Avenbury, Hampshire, England.
Barthes, Roland
1977 *Image—Text—Music.* Noonday Press, New York.
Beaudry, Mary C., Lauren J. Cook, and Stephen A. Mrozowski
1991 Artifacts and Active Voices: Material Culture as Social Discourse. In
 The Archaeology of Inequality, edited by Randall H. McGuire and Robert
 Paynter, pp. 150–191. Blackwell, Oxford.
Bell, Catherine
1992 *Ritual Theory, Ritual Practice.* Oxford University Press, Oxford.
Bell, James A.
1991 Anarchy and Archaeology. In *Processual and Post-processual Archaeology:
 Multiple Ways of Knowing the Past,* edited by Robert W. Pruecel, pp. 71–82.
 Southern Illinois University Press, Carbondale.
Bellicard, Jerome C.
1753 *Observations upon the Antiquities of Herculaneum Discovered at the Foot of
 Mount Vesuvius.* D. Wilson and T. Durham, London.
Bender, Barbara
1998 *Stonehenge: Making Space.* Oxford, Berg.
Berlin, Ira
1974 *Slaves without Masters: The Free Negro in the Antebellum South.* Pantheon,
 New York.
Bernbeck, Reinard, and Andrea Meoller
1990 The Cambridge Seminar on Post-Structuralism and Archaeology: A
 Reaction. In *Writing the Past in the Present,* edited by Frederick Baker
 and Julian Thomas, pp. 90–93. St. David's University Press, Lampeter.
Bhaskar, Roy
1978 *A Realist Theory of Science.* Harvester, Brighton, U.K.
Binford, Lewis R.
1962 Archaeology as Anthropology. *American Antiquity* 28:217–225.
1983 *In Pursuit of the Past.* Thames and Hudson, London.
Bleed, Peter
2000 *National Treasure.* RKLOG Press, Littleton, Colorado.

Bloomfield, Morton W., and Charles Dunn
 1989 *The Role of the Poet in Early Society.* D. S. Brewer, Cambridge.
Blum, Howard
 1998 *The Gold of Exodus.* Simon and Schuster, New York.
Boker, George Henry
 1929 *Nydia: A Tragic Play.* Edited by Edward Sculley Bradley. University of
 Pennsylvania Press, Philadelphia.
Bongers, Aurel, et al.
 1973 *Pompeii: Leben and Kunst in den Vesuvstädten.* Villa Hugen, Essen.
Bourdieu, Pierre
 1990 *The Logic of Practice.* Cambridge University Press, Cambridge.
Bourdieu, Pierre, Jean-Claude Passeron, and Monique De Saint Martin
 1994 *Academic Discourse, Linguistic Misunderstanding, and Professorial Power.*
 Stanford University Press, Palo Alto.
Brandt, Elizabeth
 1980 On Secrecy and the Control of Knowledge: Taos Pueblo. In *Privacy and
 Secrecy: A Cross-Cultural Perspective,* edited by S. Tefft, pp. 123–146. Human
 Sciences Press, New York.
Breton, Andre
 1969 *Manifestoes of Surrealism.* University of Michigan Press, Ann Arbor.
Brett, Kirsten
 2001a Lenimbat Brom Jad Oldintaim en Tudei En Wek Bla Tumoro. A Commu-
 nity Education Approach: Towards a More Relevant Indigenous Archae-
 ology. Unpublished B. Archaeology (Honors) thesis, Flinders University,
 Adelaide, South Australia.
 2001b Druphmi—Ola Oldintaim Mob. Unpublished multimedia educational
 package for Barunga and Wugularr Schools, Northern Territory.
 2003 Lenimbat Brom Jad Oldintaim en Tudei En Wek Bla Tumoro. A Commu-
 nity Education Approach: Towards a More Relevant Indigenous Archae-
 ology. Thesis abstract in *Australian Archaeology.*
Brilliant, Richard
 1979 *Pompeii: A.D. 79: The Treasure of Rediscovery.* Clarkson N. Potter, New York.
Brin, David
 1983 *Startide Rising.* Bantam Press, New York.
Brook, Peter
 1968 *The Empty Space. A Book about Theatre: Deadly, Holy, Rough, Immediate.*
 Simon and Schuster, New York.
 1995 *The Open Door: Thoughts on Acting and Theatre.* Theatre Communications
 Group, New York.
Brown, Donald
 1967 The Distribution of Sound Instruments in the Prehistoric Southwestern
 United States. *Ethnomusicology* 11(1):71–90.
 1971 Ethnomusicology and the Prehistoric Southwest. *Ethnomusicology*
 15(3):363–378.

Bruchac, Marjorie

2000 Odzihozo and Amiskwolowoakiak: Earthshapers and Placemakers. Reflections on Algonkian Indian Stories of Giants and the Landscape. Paper presented at the annual meeting of the American Anthropological Association, San Francisco.

Bryson, Norman

1983 *Vision and Painting: The Logic of the Gaze.* Macmillan, London.

Bulleid, Arthur, and Harold St. George Gray

1911 *The Glastonbury Lake Village.* Glastonbury, Glastonbury Antiquarian Society.

Bulwer-Lytton, Edward

1849 *The Last Days of Pompeii.* Reprint of 1849 edition. Grosset and Dunlap, New York.

Burnett, Christopher

1989 Hypertext Computer Applications for Picture Collections: Representing the Fabric of the Archive. *Visual Resources* 6:1–18.

Cameron, Cathy

1995 Migration and the Movement of Southwestern Peoples. *Journal of Anthropological Archaeology* 14:104–124.

Carman, John

1995 Interpretation, Writing, and Presenting the Past. In *Interpreting Archaeology: Finding Meaning in the Past,* edited by Ian Hodder, Michael Shanks, Alexandra Alexandri, Victor Buchli, John Carman, Jonathan Last, and Gavin Lucas, pp. 95–99. Routledge, London.

Carneiro, Robert L.

2000 *The Muse of History and the Science of Culture.* Kluwer Academic/Plenum Publishers, New York.

Carnes, Mark C.

2001 Introduction. In *Novel History: Historians and Novelists Confront America's Past (and Each Other),* edited by Mark C. Carnes, pp. 1–25. Simon and Schuster, New York.

Casetti, Francesco

1994 The Communicative Pact. In *Towards a Pragmatics of the Audiovisual: Theory and History,* vol. 1, edited by Jurgen E. Muller, pp. 21–32. Nodus Publikationen, Munster.

Chadwick, Nora Kershaw

1942 *Poetry and Prophecy.* Based on papers given before the Anthropology Society of the British Association from 1937 to 1939. Cambridge University Press, Cambridge.

Chadwick, Nora

1971 *The Celts.* Penguin, Harmondsworth, England.

Chalmers, Alan F.

1982 *What Is This Thing Called Science?* 2nd ed. Open University Press, Milton Keynes, Buckinghamshire, England.

Champion, Timothy

1996 The Celt in Archaeology. In *Celtism,* edited by T. Brown, pp. 61–78. Studia Imagologica, Amsterdam, Netherlands.

Chapman, Malcolm K.

1992 *The Celts: The Construction of a Myth.* Macmillan, Basingstoke, England.

Christie, Agatha

1936 *Murder in Mesopotamia.* Collins, London.

1937 *Death on the Nile.* Collins, London.

1946 *Come, Tell Me How You Live.* Collins, London.

Clay, Edith (editor)

1976 *Sir William Gell in Italy: Letters to the Society of Dilettanti, 1831–1835.* Hamilton, London.

Clifford, James

1985 Introduction: Partial Truths. In *Writing Culture: The Poetics and Politics of Ethnography,* edited by James Clifford and George E. Marcus, pp. 1–26. Berkeley: University of California Press.

Coles, Bryony, and John Coles

1986 *Sweet Track to Glastonbury: The Somerset Levels in Prehistory.* Thames and Hudson, London.

Collis, John

1996 The Origin and Spread of the Celts. *Studia Celtica* 30:17–34.

Cornuke, Bob, and David Halbrook

2000 *In Search of the Mountain of God: The Discovery of the Real Mt. Sinai.* Broadman & Holman, New York.

Cotter, John

1958 *Archaeological Excavations at Jamestown Colonial National Historical Park and Jamestown National Historic Site, Virginia.* Archaeological Research Series No. 4. U.S. Department of the Interior, National Park Service, Washington, D.C.

Cowlishaw, Gillian

1999 *Rednecks, Blackfellas and Eggheads.* Allen and Unwin, Sydney.

Crown, Patricia

1994 Community Dynamics, Site Structure, and Aggregation in the Northern Rio Grande. In *The Ancient Southwestern Community: Models and Methods for the Study of Prehistoric Social Organization,* edited by W. H. Wills and R. D. Leonard, pp. 103–117. University of New Mexico Press, Albuquerque.

Cunliffe, Barry

1979 *The Celtic World.* Bodley Head, London.

1991 *Iron Age Communities in Britain.* 3rd ed. Routledge, London.

1993 *Danebury: Anatomy of a Hillfort.* Batsford, London.

1997 *The Ancient Celts.* Oxford University Press, Oxford.

Davies, Robertson

1950 *At My Heart's Core: A Play in Three Acts.* Reprinted in 1991 in *Two Plays: At*

My Heart's Core and Overlaid by Robertson Davies, pp. 13-92. Simon & Pierre, Toronto.

Davis, Karen Lee

1997 Sites without Sights: Interpreting Closed Excavations. In *Presenting Archaeology to the Public: Digging for Truths,* ed. John H. Jameson, Jr., pp. 84–98. AltaMira Press, Walnut Creek, California.

De Caro, Stefano, et al.

1992 *Alla ricerca di Iside: Analisi, studi, e restauri dell'Iseo pompeiano nel Museo di Napoli.* Arti s.p.a., Rome.

Deetz, James

1977 *In Small Things Forgotten: The Archaeology of Early American Life.* Anchor Press, Garden City, New York.

1993 *Flowerdew Hundred: The Archaeology of a Virginia Plantation, 1619–1864.* University Press of Virginia, Charlottesville.

Della Corte, Matteo

1965 *Case ed abitanti di Pompei.* Fausto Fiorentino, Naples.

DeMarrais, Elizabeth, Luis Jaime Castillo, and Timothy Earle

1996 Ideology, Materialization, and Power Strategies. *Current Anthropology* 37(1):15–31.

De Vos, A., and M. De Vos

1982 *Pompei, Ercolano, Stabia.* Laterza and Figli s.p.a., Bari.

Dewey, John

1980 *Art as Experience.* Perigree, New York.

Deyhim, Mehrbanoo Nasser (translator)

1993 *An Iranian in Nineteenth-Century Europe: The Travel Diaries of Haj Sayyah, 1859–1877.* Introduction by Peter Aver. IBEX, Bethesda, Maryland.

Dietler, Michael

1994 "Our Ancestors the Gauls": Archaeology, Ethnic Nationalism, and the Manipulation of Celtic Identity in Modern Europe. *American Anthropologist* 96:584–605.

Dillon, Myles

1947 The Archaism of Irish tradition. In *Proceedings of the British Academy* 33:245–264.

Durant, Isadore [pseudonym]

1999 *Death among the Fossils.* University of New Mexico Press, Albuquerque.

Dutton, Bertha

1963 *Sun Father's Way: The Kiva Murals of Kuaua.* University of New Mexico Press, Albuquerque.

Earle, Timothy

1997 *How Chiefs Come to Power: The Political Economy in Prehistory.* Stanford University Press, Stanford.

Edmonds, Mark R.

1999 *Ancestral Geographies of the Neolithic: Landscape, Monuments, and Memory.* Routledge, London.

Eisenstein, Sergei M.
 1977 *Film Form.* Harcourt, San Diego.
Elkin, A. Peter
 1952 Cave Paintings in Southern Arnhem Land. *Oceania* 22(4):245–255.
Elston, Robert G.
 1997 Issues Concerning Consulting Archaeologists in the United States. *Society for American Archaeology Bulletin* 15(5):20–24.
Entralgo, Petro Lain
 1970 *The Therapy of the Word in Classical Antiquity.* Edited and translated by L. J. Rather and John M. Sharp. Yale University Press, New Haven.
Eppes, Josephine
 1850– Diary covering her honeymoon visit to Italy with Richard Eppes. Mss1
 1851 Ep734 b9 October 3, 1850–February 22, 1851, and Mss1 Ep734 b10 cover their visit to Italy. Manuscripts in the Virginia Historical Society, Richmond.
Estrada, Julio, and Peter Garcia
 1992 Bridging the Past and Present. In *Musical Repercussions of 1492: Encounters in Text and Performance,* ed. C. Robertson, pp. 89–99. Smithsonian Institution Press, Washington, D.C.
Evans, Christopher
 1993 Digging with the Pen: Novel Archaeologies and Literary Traditions. In *Interpretative Archaeology,* edited by Christopher Tilley, pp. 417–449. Berg, Providence.
Evans, Sara M.
 1989 *Born for Liberty: A History of Women in America.* Free Press, New York.
Finn, Christine A.
 1999a Fieldwork: Archaeology and the Poetic Past of W. B. Yeats and Seamus Heaney. Unpublished Ph.D. dissertation, University of Oxford.
 1999b Words from Kept Bodies: The Bog as Inspiration. In *Bog Bodies, Wetlands, and Sacred Sites,* edited by B. Coles, J. Coles, and M. S. Jorgensen. National Museum of Denmark and the Prehistoric Society, Copenhagen.
 2000 The Bog as Body Image. In *Archaeological Sensibilities,* edited by Fiona Campbell and Jonna Hansson. University of Gothenburg, Gothenburg.
 2001a A Rare Bird. *Archaeology* 54(1):43.
 2001b *Artifacts: An Archaeologist's Year in Silicon Valley.* MIT Press, Cambridge.
 2003 *Past Poetic: Archaeology in the Poetry of W. B. Yeats and Seamus Heaney.* Duckworth, London.
Finnegan, R.
 1970 *Oral Literature in Africa.* Clarendon Press, London.
Firstbrook, Peter
 2001 *Surviving the Iron Age.* BBC, London.
Fletcher, Roland
 1989 The Messages of Material Behavior: A Preliminary Discussion of Non-

Verbal Meaning. In *The Meaning of Things: Material Culture and Symbolic Expression,* edited by Ian Hodder, pp. 33–39. One World Archaeology Series. Unwin Hyman, London.

Flood, Josephine
1997 *Rock Art of the Dreamtime: Images of Ancient Australia.* Angus & Robertson, Sydney.

Forceville, Charles
1994 Pictorial Metaphor in Billboards: Relevance Theory Perspectives. In *Towards a Pragmatics of the Audiovisual: Theory and History,* vol. 1, edited by Jurgen E. Muller, pp. 93–111. Munster: Nodus Publikationen.

Furguson, Leland
1992 *Uncommon Ground: Archaeology and Early African America, 1650–1800.* Smithsonian Institution Press, Washington, D.C.

Garguilo, Raffaele
1861 *Recueil des Monuments les plus Interessans du Musee National etc.* Four parts in two volumes. Naples.

Gass, William H.
1970 *Fiction and the Figures of Life.* Knopf, New York.

Gell, William, and John Gandy
1852 *Pompeiana: The Topography, Edifices, and Ornaments of Pompeii.* 3rd ed. Henry G. Bohn, London.

Gewertz, Ken
2001 Muses Return: Scholar Gives a Voice to Ancient Music Silent for Millennia. *Harvard University Gazette* 96(29):3.

Gibb, James G.
1998 *London Shades: A Play in Three Acts.* Performed in October 1998 and October 1999 at the London Town Historic Site, Edgewater, Maryland.
1999 *Revolutionary Spirits: A Play in Two Acts.* Performed in April 1999 at the London Town Historic Site, Edgewater, Maryland.
2000a Imaginary, But by No Means Unimaginable: Storytelling, Science, and Historical Archaeology. *Historical Archaeology* 34(2):1–6.
2000b Reflection, Not Truth, the Hero of My Tale: Responding to Lewis, Little, Majewski, and McKee and Galle. *Historical Archaeology* 34(2):20–24.

Giddens, Anthony
1984 *The Constitution of Society: Outline of a Theory of Structuration.* University of California Press, Berkeley.

Goethe, Johann Wolfgang von
1911 *Goethe's Travels in Italy: Together with His Second Residence in Rome and Fragments on Italy.* Translated from the German by the Rev. A. J. W. Morrison and Charles Nisbet.

Gombrich, Ernest H.
1960 *Art and Illusion: A Study in the Psychology of Pictorial Representation.* Phaidon, London.

Gray, Harold St. George, and Arthur Bulleid
1948 *The Meare Lake Village,* vol. 1. Taunton, Taunton Castle.

Green, Miranda J.
 1986 *The Gods of the Celts.* Alan Sutton, Gloucester, England.
 1989 *Symbol and Image in Celtic Religious Art.* Routledge, London.
 1992 *Animals in Celtic Life and Myth.* Routledge, London.
 1993 *Celtic Myths.* British Museum Press, London.
Greenwood, Davydd J., and Morten Levin
 1998 *Introduction to Action Research: Social Research for Social Change.* Sage, Thousands Oaks, California.
 2000 Reconstructing the Relationships between Universities and Society through Action Research. In *Handbook of Qualitative Research,* edited by Norman K. Denzin and Yvonne S. Lincoln, 85–106. Sage, Thousand Oaks, California.
Gregorovius, Ferdinand
 1911 *The Roman Journals, 1852–1874.* Edited by Friedrich Althaus. George Bell and Sons, London.
Gusman, Pierre
 1924 *Mural Decorations of Pompeii.* B. T. Batsford, London.
Guyer, Carolyn
 1992 Buzz-Daze Jazz and the Quotidian Stream. Presented in the session "Hypertext, Hypermedia: Defining a Fictional Form" at the annual meeting of the Modern Language Association, New York.
 1996 Fretwork, ReForming Me. *Readerly/Writerly Texts,* Summer.
Guyer, Carolyn, and Martha Petry
 1991 Notes for *Izme Pass* Expose. *Writing on the Edge* 2(2).
Habermas, Jurgen
 1979 *Communication and the Evolution of Society.* Beacon Press, Boston.
Hall, Edward T.
 1976 *Beyond Culture.* Anchor Press, New York.
Hall, Martin
 1999 Virtual Colonization. *Journal of Material Culture* 4:39–56.
Hammond, George P., and Agapito Rey
 1940 *Narratives of the Coronado Expedition, 1540–1542.* Coronado Cuarto Centennial Publications. University of New Mexico Press, Albuquerque.
Harding, Sandra
 1991 *Whose Science? Whose Knowledge?* Cornell University Press, Ithaca.
Harrington, J. C.
 1955 Archaeology as an Auxiliary Science to American History. *American Anthropologist* 57(6):1121–1130.
 1957 *New Light on Washington's Fort Necessity.* Eastern National Parks and Monuments Association, Richmond, Virginia.
Harrison, Thomas
 1998 Herodotus and *The English Patient. Classics Ireland.* Vol. 5. University College, Dublin.
Harrold, Franklin B., and Raymond A. Eve (editors)
 1993 *Cult Archaeology and Creationism: Understanding Pseudoscientific Beliefs about the Past.* University of Iowa Press, Iowa City.

Hatfield, Henry Caraway

1943 *Winckelmann and His German Critics.* King Crown Press, New York.

Hawkes, Jacquetta

1946 The Beginning of History: A Film. *Antiquity* 20:78ff.

Heaney, Seamus

1975a *Wintering Out.* Faber and Faber, London.

1975b *North.* Faber and Faber, London.

1979 *Field Work.* Faber and Faber, London.

1984 *Station Island.* Faber and Faber, London.

1996 *The Spirit Level.* Faber and Faber, London.

1999 Introduction. In *Bog Bodies, Wetlands, and Sacred Sites,* edited by B. Coles, J. Coles, and M. S. Jorgensen. National Museum of Denmark and the Prehistoric Society, Copenhagen.

Hegmon, Michelle

1989 Social Integration and Architecture. In *The Architecture of Social Integration in Prehistoric Pueblos,* edited by William C. Lipe and Michelle Hegmon, pp. 4–14. Occasional Papers of the Crow Canyon Archaeological Center No. 1, Crow Canyon Archaeological Center, Cortez, Colorado.

Henig, Martin

2001 On a Cornelian Heart Which Was Broken. In *Outside Archaeology: The Past and the Poetic Imagination,* edited by Christine Finn and Martin Henig. BAR/Archaeopress, Oxford.

Herodotus

n.d. *The Histories,* Chapters 71–72.

Hewison, Robert

1987 *The Heritage Industry.* Methuen, London.

Hibbert, Christopher

1987 *The Grand Tour.* Methuen, London.

Hides, Sean

1997 Material Culture and Cultural Identity. In *Experiencing Material Culture,* edited by Susan M. Pearce, pp. 11–35. Leicester University Press, New York.

Hill, J. D.

1995 *Ritual and Rubbish in the Iron Age of Wessex.* British Archaeological Reports (British Series) 242, Tempus Reparatvm. Oxford University Press, London.

Hill, Richard

2000 The Museum Indian: Still Frozen in Time and Mind. *Museum News,* May/June:60.

Hillerman, Tony

1988 *A Thief of Time.* Harper and Row, New York.

Hinton, Leanne

1980 Vocables in Havasupai Song. In *Southwestern Indian Ritual Drama,* ed. C. Frisbie, pp. 275–305. School of American Research. University of New Mexico Press, Albuquerque.

Hodder, Ian

1982 *Symbols in Action*. Cambridge University Press, Cambridge.

1986 *Reading the Past*. Cambridge University Press, Cambridge.

1987 *The Archaeology of Contextual Meanings*. Cambridge University Press, Cambridge.

1989a Writing Archaeology Site Reports in Context. *Antiquity* 63:268–274.

1989b Post-modernism, Post-structuralism, and Post-processualism. In *The Meaning of Things: Material Culture and Symbolic Expression,* edited by Ian Hodder, 64–78. Unwin Hyman, London.

1991 Interpretive Archaeology. *American Antiquity* 56(1):7–18.

1997 Relativising Relativism. In *Archaeological Dialogues 4:2,* pp. 192–198. Leiden University Press, Leiden.

1999 *The Archaeological Process: An Introduction*. Blackwell, Oxford.

Horton, David R.

1995 *Encyclopedia of Aboriginal Australia*. Canberra: Aboriginal Studies Press.

Howard, David Sanctuary

1984 *New York and the China Trade*. New-York Historical Society, New York.

Hume, Ivor Noel

1994 *Here Lies Virginia: An Archaeologist's View of Colonial Life & History*. Rev. ed. University Press of Virginia, Charlottesville.

Hurd, John Codman

1858 *Laws of Freedom and Bondage in the United States*. Vol. 2, pp. 100–109. Little, Brown, Boston.

Hyder, William D.

1997 Basketmaker Spatial Identity: Rock Art as Culture and Praxis. In *International Rock Art Conference (IRAC) Proceedings,* vol. 1, *Rock Art as Visual Ecology,* edited by Paul Faulstich. American Rock Art Research Association, Tucson, Arizona.

Isaacson, Ken

2002 Building for the Future. In *Indigenous People and Archaeology: Proceedings of the 29th Annual Chacmool Conference,* edited by T. Peck and E. Siegfried. The Archaeological Association of the University of Calgary, Alberta.

Jackson, Kenneth

1964 *The Oldest Irish Tradition: A Window on the Iron Age?* Cambridge University Press, Cambridge.

James, Simon

1998 Celts, Politics, and Motivation in Archaeology. *Antiquity* 72:200–209.

1999 *The Atlantic Celts: Ancient People or Modern Invention?* British Museum Press, London.

James, William

1955 *Pragmatism and Four Essays from "The Meaning of Truth."* Meridian Books, New York.

Jameson, John H., Jr.

1997 Introduction. In *Presenting Archaeology to the Public: Digging for Truths,* edited by John H. Jameson, Jr., pp. 11–20. AltaMira Press, Walnut Creek, California.

2000 Public Interpretation, Education, and Outreach: The Growing Predominance in American Archaeology. In *Cultural Resource Management in Contemporary Society, One World Archaeology 33,* edited by Francis P. McManamon and Alf Hatton. Routledge, London.

2003 Public Archaeology in America. In *Public Archaeology,* edited by Nick Merriman and Tim Schadla-Hall. Routledge, London.

Jashemski, Wilhelmina

1979 *The Gardens of Pompeii, Herculaneum, and the Villas Destroyed by Vesuvius.* Vol. 1. New Rochelle, NewYork: Caratzas.

1993 *The Gardens of Pompeii.* Vol. 2. Appendices. Caratzas, New Rochelle, New York.

Joyce, Michael

1995 *Of Two Minds: Hypertext Pedagogy and Poetics.* University of Michigan Press, Ann Arbor.

2000 One Story: Present Tense Spaces of the Heart. In *Othermindedness: The Emergence of Network Culture,* edited by Michael Joyce, pp. 123–130. University of Michigan Press, Ann Arbor.

Joyce, Rosemary A.

1998 Telling Stories. Paper presented at the SAR Advanced Seminar "Doing Archaeology as a Feminist." Margaret Conkey and Alison Wylie, organizers. School of American Research, Santa Fe, New Mexico.

1999 Multivocality and Authority: Implications from a Hypertext Writing Project. In the session "Thinking beyond the Boundaries: Alternative, Critical, and Multivocal Perspectives on the Presentation of the Past." Kevin Bartoy, organizer. Society for American Archaeology, Chicago.

2001 Making Collaborative Meaning in Archaeology: Archaeologists, the Internet, and Our Publics. Paper presented at the annual meeting of the Society for Historical Archaeology, Quebec, Canada.

2002 *The Languages of Archaeology.* Blackwell, Oxford.

Joyce, Rosemary A., Carolyn Guyer, and Michael Joyce

2000 *Sister Stories.* World Wide Web, URL: http://www.nyupress.nyu.edu/ sisterstories. New York University Press, New York.

Kane, Sharyn, and Richard Keeton

1994 *Beneath These Waters: Archeological and Historical Studies of 11,500 Years Along the Savannah River.* Savannah District, U.S. Army Corps of Engineers, Savannah, Georgia, and the Southeast Archeological Center, National Park Service, Tallahassee, Florida.

1998 *Fort Benning: The Land and the People.* U.S. Army Infantry Center, Directorate of Public Works, Environmental Management Division, Fort Ben-

ning, Georgia, and the Southeast Archeological Center, National Park Service, Tallahassee, Florida.

1999 *Fiery Dawn: The Civil War Battle at Monroe's Crossroads, North Carolina.* U.S. Army, Fort Bragg, North Carolina, and the Southeast Archeological Center, National Park Service, Tallahassee, Florida.

Kane, Sharyn, Richard Keeton, and John H. Jameson, Jr.

1994 A Publication for the Public: The Richard B. Russell Cultural Investigations Popular Volume, World Wide Web, URL: http://www.cr.nps.gov/seac/beneath.htm. Online article dated April 20, 1994. Southeast Archeological Center, National Park Service, Tallahassee, Florida.

Kenoyer, Jonathan Mark

1991 The Indus Valley Tradition of Pakistan and Western India. *Journal of World Prehistory* 5(4):331–385.

Kidder, Alfred V.

1932 *Artifacts of Pecos.* Papers of the Southwestern Expedition No. 6. Yale University Press, New Haven.

Kimball, David

1991 *Italian Opera.* Cambridge University Press, Cambridge.

Klein, Terry H.

1999 The Problem and Promise of Cultural Resource Management in the United States. Paper presented at the World Archaeological Congress 4, Capetown, South Africa.

Kohl, Philip

1993 Limits to a Post-processual Archaeology (or, The Dangers of a New Scholasticism). In *Archaeological Theory: Who Sets the Agenda,* edited by Norman Yoffee and Andrew Sherratt, pp. 13–19. Cambridge University Press, Cambridge.

Kohl, Phillip L., and Clare Fawcett

1995 Archaeology in the Service of the State: Theoretical Considerations. In *Nationalism, Politics, and the Practice of Archaeology,* edited by Phillip L. Kohl and Clare Fawcett, pp. 3–18. Cambridge University Press, Cambridge.

Kurath, Gertrude Prokosch, and Antonio Garcia

1970 *Music and Dance of the Tewa Pueblos.* Museum of New Mexico Research Records No. 8. Museum of New Mexico Press, Santa Fe.

Landau, Misia

1991 *Narratives of Human Evolution.* Yale University Press, New Haven.

Lane, Anthony

1996 Review of *The English Patient. New Yorker,* November.

Langford, Ros

1983 Our Heritage—Your Playground. *Australian Archaeology* 16:1–6.

Lawson, G., I. Cross, C. Scarre, and C. Hills

1998 Mounds, Megaliths, Music, and Mind: Some Thoughts on the Acoustical

Properties of Archaeological Spaces. *Archaeological Review from Cambridge* 15(1):111–134.

Layton, Robert
1992 *Australian Rock Art: A New Synthesis.* Cambridge University Press, Cambridge.

Lea, Joanne
2000 Teaching the Past in Museums. In *The Archaeology Education Handbook: Sharing the Past with Kids,* edited by Karolyn Smardz and Shelley J. Smith, pp. 315–325. AltaMira Press, Walnut Creek, California.

Lempeter Archaeological Workshop
1997 Relativism, Objectivity, and the Politics of the Past. In *Archaeological Dialogues 4:2,* pp. 164–184. Leiden University Press, Leiden.

Leone, Mark P., and Parker B. Potter, Jr.
1984 *Archaeological Annapolis: A Guide to Seeing and Understanding Three Centuries of Change.* Historic Annapolis, Annapolis.

Leone, Mark P., Parker B. Potter, Jr., and Paul A. Shackel
1987 Toward a Critical Archaeology. *Current Anthropology* 28(3):283–302.

Leppmann, Wolfgang
1968 *Pompeii in Fact and Fiction.* Elek Books, London.

Lintz, Chistopher
1991 Texas Panhandle-Pueblo Interactions from the Thirteenth through the Sixteenth Centuries. In *Farmers, Hunters, and Colonists: Interaction between the Southwest and the Southern Plains,* ed. Katherine Spielmann, pp. 51–70. University of Arizona Press, Tucson.

Lopiparo, Jeanne
2002 Third Dialogue: Crafting *Crafting Cosmos:* A Hypermedia Exploration of Materiality and the Dialogic Creation and Recreation of Classic Maya Society. In *The Languages of Archaeology,* edited by Rosemary Joyce. Blackwell, Oxford.

Mackenzie, Iain M., and Michael Shanks
1994 Archaeology: Theories, Themes, and Experience. In *Archaeological Theory: Progress or Posture,* edited by Iain M. Mackenzie, pp. 19–42. World Archaeology Series. Avenbury, Hampshire, England.

Maiuri, Amedeo
1960 *Pompeii.* Libreria dello Stato, Rome.

Mallet, David
1759 *The Works of David Mallet.* A. Millar, London.

Mallory, James
1986 Silver in the Ulster Cycle of Tales. In *Proceedings of the Seventh International Congress of Celtic Studies,* edited by D. Ellis Evans, John G. Griffith and E. M. Jope. University College, Cork, Ireland.

1989 *In Search of the Indo-Europeans: Language, Archaeology, and Myth.* Thames and Hudson, London.

Malone, Caroline, Mary Baxter, and Peter Stone
2000 Education and Archaeology. In *Antiquity 74: 283*, pp. 122–218.
Marcus, Joyce, and Kent Flannery
1992 Ancient Zapotec Ritual and Religion: An Application of the Direct Historical Method. In *The Ancient Mind: Elements of Cognitive Archaeology*, edited by Colin Renfrew and E. B. W. Zubrow, pp. 55–74. Cambridge University Press, Cambridge.
Marinetti, Filippo T., et al.
1914 *I manifesti del futurismo*. Lacerba Editore, Florence.
Martin, Brian
1993 The Critique of Science Becomes Academic. *Science, Technology, and Human Values* 18(2):247–259.
Masson, Pierre, and Helen Guillot
1994 Archeofiction with Upper Primary-School Children, 1988–1989. In *The Presented Past: Heritage, Museums and Education*, edited by Peter G. Stone and Brian L. Molyneaux, 375–383. Routledge, London.
Matthaei, Gay, and Jewel Grutman
1994 *The Ledgerbook of Thomas Blue Eagle*. Illustrated by Adam Cvijanovic. Lickle Publishing, New York.
Mau, August
1902 *Pompeii: Its Life and Art*. Translated by F. W. Kelsey. Macmillan, New York.
McDavid, Carol
1999 From Real Space to Cyberspace: Contemporary Conversations about the Archaeology of Slavery and Tenancy. *Internet Archaeology 6*, URL: http://intarch.ac.uk/journal/issue6/mcdavid/toc.html).
McDevitt, Jack
1989 *A Talent for War*. Ace Science Fiction Books, New York.
1994 *The Engines of God*. Ace Science Fiction Books, New York.
2001 *DeepSix*. EOS, Harper Collins, New York.
McGregor, John C.
1943 Burial of an Early American Magician. *Proceedings of the American Philosophical Society* 86(2):270–298.
Megaw, J. Vincent
1970 *Art of the European Iron Age: A Study of the Elusive Image*. Harper and Row, New York.
Megaw, Ruth, and Vincent Megaw
1989 *Celtic Art from Its Beginnings to the Book of Kells*. Thames and Hudson, London.
1995a The Nature and Function of Celtic Art. In *The Celtic World*, edited by Miranda J. Green, pp. 345–375. Routledge, London.
1995b Paper Tigers, Tilting at Windmills, and Celtic Cheshire Cats: A Reply to Tim Taylor. *Scottish Archaeological Review* 9–10:248–252.
1996 Ancient Celts and Modern Ethnicity. *Antiquity* 70:175–181.

1997 Do the Ancient Celts Still Live? An Essay on Identity and Contextuality. *Studia Celtica* 31:107–123.

Meltzer, David J.

1979 Paradigms and the Nature of Change in American Archaeology. *American Antiquity* 44(3):644–657.

Melville, Herman

1955 *Journal of a Visit to Europe and the Levant, October 11, 1856–May 6, 1857.* Edited by Howard C. Horsford. Princeton University Press, Princeton.

Merlan, Francesca

2000 Representing the Rainbow: Aboriginal Culture in an Interconnected World. *Australian Aboriginal Studies* 1–2:20–26.

Mills, Barbara

2001 The Archaeology of Inalienable Possessions: Social Valuables and the Formation of Collective Prestige Structures in the Greater Southwest. Revised version of a paper presented at the 66th Annual Meeting of the Society for American Archaeology, New Orleans.

Minghella, Anthony

1996 *The English Patient: A Screenplay Based on the Novel by Michael Ondaatje.* Miramax Books, New York.

Moholy-Nagy, Laslo

1987 *Painting, Photography, Film.* MIT Press, Cambridge. Originally published in 1927.

Moore, L. E.

1994 The Ironies of Self-Reflection in Archaeology. In *Archaeological Theory: Progress or Posture,* edited by Iain M. Mackenzie, pp. 43–56. World Archaeology Series. Avebury, Hampshire, England.

Morphy, Howard

1991 *Ancestral Connections: Art and an Aboriginal System of Knowledge.* University of Chicago Press, Chicago.

1998 *Aboriginal Art.* Phaidon, London.

Morris, Elizabeth Ann

1959 Basketmaker Flutes from the Prayer Rock District, Arizona. *American Antiquity* 24(4):406–411.

Mort, Frank

1990 The Politics of Consumption. In *New Times: The Changing Face of Politics in the 1990s,* edited by Stuart Hall and M. Jacques, pp. 160–172. Lawrence & Wishart, London.

Morwood, Michael

2003 *Visions of the Past.* Allen and Unwin, Sydney.

Morwood, Michael J., and Claire E. Smith

1996 Contemporary Approaches to World Rock Art. World Wide Web, URL: http://www.une.edu.au/Arch/ROCKART/MMRockArt.html.

Moser, Stephanie, and Clive Gamble

1996 Revolutionary Images: The Iconic Vocabulary for Representing Human

Antiquity. In *The Cultural Life of Images: Visual Representation in Archaeology,* edited by Brian L. Molyneaux, pp. 184–212. Routledge, London.

Muller, Jurgen E.

1994 Towards a Pragmatics of the Audiovisual: An Introduction. In *Towards a Pragmatics of the Audiovisual: Theory and History,* vol. 1, edited by Jurgen E. Muller, pp. 7–20. Nodus Publikationen, Munster.

Mulvaney, Derek J., and John Kamminga

1999 *The Prehistory of Australia.* Allen and Unwin, Sydney.

Murray, Tim

1993 Communication and the Importance of Disciplinary Communities. In *Archaeological Theory: Who Sets the Agenda,* edited by Norman Yoffee and Andrew Sherratt, pp. 105–116. Cambridge University Press, Cambridge.

Muscarella, Oscar White

2000 *The Lie Became Great: The Forgery of Ancient Near Eastern Cultures.* Styx, Groningen.

Mytum, Harold

1991 Castell Henllys: Iron Age Fort. *Fortress* 9:2–11.

1996 *Children of the Hillfort.* Pembrokeshire Coast National Park, Haverfordwest, Wales.

1999a Castell Henllys. *Current Archaeology* 161:164–171.

1999b Pembrokeshire's Pasts: Natives, Invaders, and Welsh Archaeology: The Castell Henllys Experience. In *The Constructed Past: Experimental Archaeology, Education and the Public,* edited by Peter G. Stone and Philippe Planel, pp. 181–193. One World Archaeology series 36. Routledge, London.

2000 Archaeology and History for Welsh Primary Classes. *Antiquity* 74:165–171.

National Park Service, U.S. Department of the Interior

1991 *National Register Bulletin 15: How to Apply the National Register Criteria for Evaluation.* U.S. Department of the Interior, National Park Service, Washington, D.C.

2000 The Effective Interpretation of Archeological Resources. Final draft course of study, Stephen T. Mather Training Center, National Park Service, Harper's Ferry, West Virginia.

Nelson, Sarah Milledge

1999 *Spirit Bird Journey.* RKLOG Press, Littleton, Colorado.

Odin, Roger

2000 Semio-pragmatique du cinema et de l'audiovisuel: Modes et institutions. In *Towards a Pragmatics of the Audiovisual: Theory and History,* vol. 1, edited by Jurgen E. Muller, pp. 33–47. Nodus Publikationen, Munster.

Oliver, Chadwick Symes

1952 *Mists of Dawn.* John C. Winston, Philadelphia.

Olivier, Laurent, and Anick Coudart

1995 French Tradition and the Central Place of History in the Human Science: Preamble to a Dialogue between Robinson Crusoe and His Man Friday. In *Theory in Archaeology: A World Perspective,* edited by Peter Ucko, pp. 363–381. Routledge, London.

Olsen, Dale A.
1986 Towards a Musical Atlas of Peru. *Ethnomusicology* 30(3):394–412.
1990 The Ethnomusicology of Archaeology: A Model for the Musical/Cultural Study of Ancient Material Culture. In *Selected Reports in Ethnomusicology*, vol. 8, pp. 175–197. University of California at Los Angeles Press, Los Angeles.

Ondaatje, Michael
1992 *The English Patient.* London, Bloomsbury.

Orr, David G.
1978 *Roman Domestic Religion: The Evidence of the Household Shrines.* Aufstieg und Niedergang der römisehen Welt, pt. II, vol. 16, part 2, pp. 1557–1591. Walter De Gruyter, Berlin.
1983 The Roman City: A Philosophical and Cultural Summa. In *Aspects of Graeco-Roman Urbanism,* edited by Ronald T. Marchese. BAR International Series 188. Walter De Gruyter, Berlin.

Otto, John S.
1977 Artifacts and Status Differences: A Comparison of Ceramics from Planter, Overseer, and Slave Sites on an Antebellum Plantation. In *Research Strategies in Historical Archaeology,* edited by Stanley South, pp. 91–118. Academic Press, New York.

Palatella, John
1998 Pictures of Us: Are Native Videomakers Putting Anthropologists Out of Business? *Lingua Franca* 8(5):50–57.

Parker, Roger (editor)
1994 *The Oxford Illustrated History of Opera.* Oxford University Press, Oxford.

Payne, Richard
1989 Indian Flutes of the Southwest. *Journal of the American Musical Instrument Society* 15:5–31.
1991 Bone Flutes of the Anasazi. *Kiva* 56(2):165–177.

Pearce, Susan M. (editor)
1994 *Interpreting Objects and Collections,* pp. 9–11. Routledge, London.
1997 *Experiencing Material Culture in the Western World.* Continuum International Publishing Group, Leicester University Press, Leicester, England.

Pearson, Mike, Julian Thomas, and Michael Shanks
1994 Theatre/Archaeology. In *Drama Review 38,* pp. 133–161. University School of Art, New York.

Piggott, Stuart
1968 *The Druids.* Thames and Hudson, London.

Piper, H. Beam
1957 Omnilingual. *Astounding Science Fiction Magazine* 58(6):8–46.

Pluciennik, Mike
1999 Archaeological Narratives and Other Ways of Telling. *Current Anthropology* 40(5):653–678.

Potter, James
2000 Ritual Power and Social Differentiation in Small-Scale Societies. In *Hier-*

archies in Action: Cui Bono?, ed. Michael W. Diehl, pp. 295–316. Center for Archaeological Investigations Occasional Papers No. 27. Southern Illinois University Press, Carbondale.

Potter, Parker B., Jr.

1991 Self-Reflection in Archaeology. In *Processual and Post-processual Archaeology: Multiple Ways of Knowing the Past,* edited by Robert W. Pruecel, pp. 225–234. Southern Illinois University Press, Carbondale.

1997 The Archaeological Site as an Interpretive Environment. In *Presenting Archaeology to the Public: Digging for Truths,* edited by John H. Jameson, Jr., pp. 35–44. AltaMira Press, Walnut Creek, California.

Pozzo, Alexandra

1998 *Grr . . . Grammelot: Parlare senza parole. Dai primi balbettii al grammelot di Dario Fo.* Bologna: CLUEB.

Praetzellis, Adrian

2001 *Death by Theory.* AltaMira Press, Walnut Creek, California.

Prettejohn, Elizabeth

1997 Antiquity Fragmented and Reconstructed. In *Sir Laurence Alma-Tedema,* edited by Edwin Becker and Elizabeth Prettejohn, pp. 35–42. Rizzoli, New York.

Prince, Oliver H. (editor)

1822 *Digest of the Laws of the State of Georgia.* Act 512. Grantland and Orme, Milledgeville, Georgia.

Prosser, Jon (editor)

1998 *Image-Based Research: A Sourcebook for Qualitative Researchers.* Falmer Press, London.

Ravesloot, John C.

1988 *Mortuary Practices and Social Differentiation at Casas Grandes, Chihuahua, Mexico.* Anthropological Papers of the University of Arizona No. 49. University of Arizona Press, Tucson.

Recanati, Filippo

2000 The Iconicity of Metarepresentations. In *Metarepresentations: A Multidisciplinary Perspective,* edited by Dan Sperber, pp. 311–360. Oxford University Press, Oxford.

Renfew, Colin

1982 *Archaeology and Language: The Puzzle of Indo-European Origins.* Jonathan Cape, London.

Reynolds, Peter J.

1979 *Iron Age Farm.* British Museum Press, London.

2000 Butser Ancient Farm, Hampshire, UK. In *The Constructed Past: Experimental Archaeology, Education and the Public,* edited by Peter G. Stone and Philippe G. Planel, pp. 124–135. Routledge, New York.

Rice, Danielle

1997 Making People Mad. *Museum News.* May/June:57.

Robinson, Kim Stanley

1984 *Icehenge.* Ace Science Fiction Books, New York.

Ross, Anne

1967 *Pagan Celtic Britain.* Routledge, London.

1995 Ritual and the Druids. In *The Celtic World,* edited by Miranda J. Green, pp. 423–445. Routledge, London.

Sabloff, Jeremy

1998 Communication and the Future of American Archaeology. In *American Anthropologist* 100(4):871.

Sackett, James R.

1986 Style, Function, and Assemblage Variability: A Reply to Binford. *American Antiquity* 51:628–634.

Sahagun, Fray Bernardino de

1950– [original ca. 1569] *Florentine Codex: The General History of the Things of*

1982 *New Spain.* Translated and edited by Charles E. Dibble and Arthur J. O. Anderson. The School of American Research and the University of Utah Press, Santa Fe and Provo.

Said, Edward

1979 *Orientalism.* Vintage, New York.

Santayana, George

1894 The Power of Art. In *Sonnets and Other Verses.* Stone & Kimball, London.

Savory, Herbert N.

1976 *Guide Catalogue of the Early Iron Age Collections.* National Museum of Wales, Cardiff, Wales.

Schaafsma, Polly, ed.

1994 *Kachinas in the Pueblo World.* University of New Mexico Press, Albuquerque.

Scheldermann, Peter

2001 *Raven's Saga: An Arctic Odyssey.* Coruus Press, Calgary.

Schiffer, Michael B.

1976 *Behavioral Archaeology.* Academic Press, New York.

Schrire, Carmel

1995 *Digging through Darkness: Chronicles of an Archaeologist.* University Press of Virginia, Charlottesville.

Schuyler, Robert L.

1970 Historical and Historic Sites Archaeology as Anthropology: Basic Definitions and Relationships. *Historical Archaeology* 4:83–89.

Shanks, Michael

1990 Reading the Signs: Responses to Archaeology after Structuralism. In *Archaeology after Structuralism: Post-Structuralism and the Practice of Archaeology,* edited by Ian Bapty and Tim Yates, pp. 294–340. Routledge, London.

1992 *Experiencing the Past: On the Character of Archaeology.* Routledge, London.

1996a Photography and Archaeology. In *The Cultural Life of Images: Visual Representation in Archaeology,* edited by Brian L. Molyneaux, pp. 73–107. Routledge, London.

1996b *Classical Archaeology of Greece: Experiences of the Discipline.* Routledge, London.

Shanks, Michael, and Christopher Tilley

1992 *Re-constructing Archaeology: Theory and Practice.* 2nd ed. Cambridge University Press, Cambridge.

Shneiderman, Ben, Dorothy Brethauer, Catherine Plaisant, and Richard Potter

1989 Evaluating Three Museum Installations of a Hypertext System. *Journal of the American Society for Information Science* 40:172–182.

Shone, Donald

1963 *The Displacement of Concepts.* Tavistock, London.

Silberman, Neil A.

1989 *Between Past and Present: Archaeology, Ideology, and Nationalism in the Modern Middle East.* Anchor Press, New York.

Smith, Claire

1992 *Jungayi Care for Country.* Video documentary produced for Barunga-Wugularr Community Government Council.

1999 Ancestors, Place, and People: Social Landscapes in Aboriginal Australia. In *The Archaeology and Anthropology of Landscape: Shaping your Landscape,* edited by Peter Ucko and Robert Layton, pp. 189–205. Routledge, London.

Smith, Claire, and Graeme K. Ward

2000 *Indigenous Cultures in an Interconnected World.* Allen and Unwin, Sydney.

Smith, Linda Tuhiwai

1999 *Decolonizing Methodologies: Research and Indigenous Peoples.* 2nd ed. Zed Books, London.

Snow, David

1981 Protohistoric Rio Grande Pueblo Economics: A Review of Trends. In *The Protohistoric Period in the North American Southwest, A.D. 1490–1700,* edited by David R. Wilcox and W. Bruce Masse, pp. 354–362. Arizona State University Anthropological Research Papers No. 24. Arizona State University Press, Tempe.

Snow, Michael

1972 An Interview. In *Form and Structure in Recent Film.* Vancouver Art Gallery, Vancouver.

South, Stanley

1977 *Method and Theory in Historical Archaeology.* Academic Press, New York.

1997 Generalized versus Literal Interpretation. In *Presenting Archaeology to the Public: Digging for Truths,* edited by John H. Jameson, Jr., pp. 54–62, AltaMira Press, Walnut Creek, California.

Spector, Janet

1993 *What This Awl Means: Feminist Archaeology at Wahpeton Dakota Village.* Minnesota Historical Society Press, St. Paul.

Sperber, Dan, and Deirdre Wilson

1995 *Relevance: Communication and Cognition.* 2nd ed. Blackwell, Cambridge, Massachusetts.

Starke, Mariana
 1839 *Travels in Europe, for the Use of Travelers on the Continent, etc.* 9th ed. A&W Galignani, Paris.

Stearns, Peter N.
 2001 Why Study History? Online Essay, URL: http://www.theaha.org/pubs/stearns.htm. American Historical Association, Washington, D.C.

Steen, Carl
 1990 The Inter-Colonial Trade of Domestic Earthenwares and the Development of an American Social Identity. *Volumes in Historical Archaeology IX.* The South Carolina Institute of Archaeology and Anthropology, University of South Carolina, Columbia.

 1999 Pottery, Intercolonial Trade, and Revolution: Domestic Earthenwares and the Development of an American Social Identity. *Historical Archaeology* 33(3):62–72.

Stewart, Susan
 1994 *On Longing: Narratives of the Miniature, the Gigantic, the Souvenir, the Collection.* Duke University Press, Durham.

Stone, Peter G.
 1997 Presenting the Past: A Framework for Discussion. In *Presenting Archaeology to the Public: Digging for Truths,* edited by John H. Jameson, Jr., pp. 280–287. AltaMira Press, Walnut Creek, California.

Stone, Peter G., and Brian L. Molyneaux (editors)
 1994 *The Presented Past: Heritage, Museums and Education.* Routledge, London.

Stopford, Jennie
 1987 Danebury: An Alternative View. *Scottish Archaeological Review* 4:70–75.

Taussig, Michael T.
 1992 *The Nervous System.* Routledge, New York.

Terrell, John
 1997 [comment on] "Archaeological Narratives and Other Ways of Telling" by Mark Pluciennik. *Current Anthropology* 40:671.

Thomas, Charles
 1986 *Celtic Britain.* Thames and Hudson, London.

Thomas, Julian
 1995 Where Are We Now? Archaeological Theory in the 1990s. In *Theory in Archaeology: A World Perspective,* edited by Peter Ucko, pp. 343–362. Routledge, London.

 2000 Reconfiguring the Social, Reconfiguring the Material. In *Social Theory in Archaeology,* edited by Michael B. Schiffer, pp. 143–155. University of Utah Press, Salt Lake City.

Thompson, Peter
 1999 *Rum Punch and Revolution: Tavern-going and Public Life in Eighteenth-Century Philadelphia.* University of Pennsylvania Press, Philadelphia.

Tilley, Christopher
 1989 Archaeology as Socio-Political Action in the Present. In *Critical Tradi-*

tions in Contemporary Archaeology: Essays in the Philosophy, History and So-cio-Politics of Archaeology, edited by Valerie Pinsky and Alison Wylie, pp. 104–115. Cambridge University Press, Cambridge.

1991 *Material Culture and Text: The Art of Ambiguity*. Routledge, London.

1993 Introduction: Interpretation and a Poetics of the Past. In *Interpretative Archaeology*, edited by Christopher Tilley, pp. 1–30. Berg, Providence.

Tilley, Christopher (editor)

1993 *Interpretative Archaeology*. Berg, Providence.

Trigger, Bruce

1978 *Time and Traditions: Essays in Archaeological Interpretation*. Columbia University Press, New York.

1989 A *History of Archaeological Thought*. Cambridge University Press, Cambridge.

Tringham, Ruth

1991 Households with Faces: The Challenge of Gender in Prehistoric Architectural Remains. In *Engendering Archaeology: Women and Prehistory*, edited by Joan Gero and Margaret Conkey, pp. 93–131. Blackwell, Oxford.

1998 Multimedia Authoring and the Feminist Practice of Archaeology. Paper prepared for the SAR Advanced Seminar "Doing Archaeology as a Feminist." Margaret Conkey and Alison Wylie, organizers, The School of American Research, Santa Fe.

Twain, Mark

1869 *Innocents Abroad*. Vol. 2. Harper, New York.

Tyler, Hamilton

1975 *Pueblo Animals and Myths*. University of Oklahoma Press, Norman.

Urry, John

1990 *The Tourist Gaze: Leisure and Travel in Contemporary Societies*. Sage, London.

Van Gennep, Arnold

1960 *The Rites of Passage*. Translated by Monika Vizedom and Gabrielle Caffee. Routledge, London. Originally published in 1909.

Varone, Antonio, et al.

1990 *Rediscovering Pompeii*. Herma di Bretschneider, Rome.

Vermeule, Cornelius

1964 *European Art and the Classical Past*. Camridge: Harvard University Press.

Veverka, John

1992 Where's the Interpretation in Interpretive Exhibits? *Legacy* 3(5):16–28.

Vinge, Vernor

1992 *A Fire upon the Deep*. Tom Doherty Associates, New York.

1999 *A Deepness in the Sky*. Tom Doherty Associates, New York.

Wallace-Hadrill, Andrew

1994 *Houses and Society in Pompeii and Herculaneum*. Princeton University Press, Princeton.

Ware, John A., and Eric Blinman

2000 Cultural Collapse and Reorganization: The Origin and Spread of Pueblo

Ritual Sodalities. In *The Archaeology of Regional Interaction: Religion, Warfare, and Exchange Across the American Southwest and Beyond*, ed. Michelle Hegmon, pp. 381–409. Proceedings of the 1996 Southwest Symposium. University Press of Colorado, Boulder.

Watson, Aaron
 1997 Hearing Again the Sound of the Neolithic. In *British Archaeology 22*, p. 6.

Weed, William Speed
 2000 What Did Dinosaurs Really Look Like . . . and Will We Ever Know? *Discover* 21(9).

Wees, William C.
 1992 *Light Moving in Time: Studies in the Visual Aesthetics of Avant-Garde Film*. University of California Press, Berkeley.

Weil, Stephen
 1998 The Art Museum as a Palace. *Museum News*, November/December:45.

Weiner, Annette
 1985 Inalienable Wealth. *American Ethnologist* 12:210–227.

Wells, Henry W. (translator)
 1973 *The Vision of Piers Plowman* by William Langland, translated into Modern English. Sheeds and Ward, London.

Wightman, George B. H., and A. Y. al-Udhari (translators)
 1975 *Birds through a Ceiling of Alabaster: Three Abbasid Poets*. Penguin, London.

Willey, Gordon Randolph
 1993 *Selena*. Walker and Company, New York.

Willey, Gordon R., and Philip Phillips
 1958 *Method and Theory in American Archaeology*. University of Chicago Press, Chicago.

Winship, George Parker
 1896 The Coronado Expedition, 1540–1542. *Bureau of American Ethnology, Fourteenth Annual Report*, part 1, pp. 339–613. Government Printing Office, Washington, D.C.

Wolle, Anja C., and Ruth Tringham
 2000 Multiple Çatalhöyüks on the World Wide Web. In *Towards a Reflexive Method in Archaeology: The Example at Çatalhöyük*, edited by Ian Hodder, pp. 207–217. British Institute of Archaeology at Ankara Monograph No. 28. McDonald Institute for Archaeological Research, Cambridge.

Wood, Gordon S.
 1994 The Wandering Jewish Prophet of New York. A Review of *The Kingdom of Matthias: A Story of Sex and Salvation in Nineteenth-Century America* by Paul E. Johnson and Sean Wilentz. *New York Review of Books*, October 20, pp. 56–58.

Wright, Terrence C.
 1994 Heidegger and Heaney: Poetry and Possibility. *Philosophy Today* 38(4): 390–399.

Yamin, Rebecca
 1998 Lurid Tales and Homely Stories of New York's Notorious Five Points. *Historical Archaeology* 32(1):74–85.
 2003 Alternative Narratives: Respectability at Five Points. In *The Archaeology of Urban Landscapes,* edited by Alan Mayne and Tim Murray. New Directions in Archaeology Series. Cambridge University Press, Cambridge, in press.
Yentsch, Anne E.
 1994 *A Chesapeake Family and Their Slaves: A Study in Historical Archaeology.* Cambridge University Press, Cambridge.
Zanker, Paul
 1988 *Pompeii: Public and Private Life.* Harvard University Press, Cambridge.

Contributor Affiliation and Contact Information

David G. Anderson
Southeast Archeological Center
National Park Service
2035 E. Paul Dirac Drive
Johnson Building, Suite 120
Tallahassee, Florida 32310

Kirsten Brett
Department of Archaeology
School of Cultural Studies
Flinders University of South Australia
GPO Box 2100
Adelaide, SA. 5001
Australia

Mary R. Bullard
5 Sunview Terrace
South Dartmouth, Massachusetts 02748

Emily Donald
Columbia University
92 County Road 78, Box J
Santa Fe, New Mexico 87501

John E. Ehrenhard
Southeast Archeological Center
National Park Service
2035 E. Paul Dirac Drive
Johnson Building, Suite 120
Tallahassee, Florida 32310

Christine A. Finn
The Institute of Archaeology
University of Oxford
36 Beaumont Street
Oxford OX1 2PG
United Kingdom

Lance M. Foster
Iowa Tribe of Kansas and Nebraska
59-777 Kapuhi Place
Haleiwa, Hawaii 96712

James G. Gibb
Independent Scholar
2554 Carrollton Road
Annapolis, Maryland 21403

Margaret A. Heath
Heritage Education Program
Anasazi Heritage Center
U.S. Bureau of Land Management
P.O. Box 758
27501 HWY 184
Delores, Colorado 81323

John H. Jameson, Jr.
Southeast Archeological Center
National Park Service
2035 E. Paul Dirac Drive
Johnson Building, Suite 120
Tallahassee, Florida 32310

Rosemary A. Joyce
Department of Anthropology
University of California, Berkeley
Kroeber Hall #3710
Berkeley, California 94720-3710

Sharyn Kane and Richard Keeton
Writers and Editors
4173 Brandon Ridge Drive
Marietta, Georgia 30066

Nicola Laneri
Istituto Universitario Orientale
di Napoli, Italy, and
The Italian Academy
for Advanced Studies in America
932 Schermerhorn Hall
New York, New York 10027

Jeanne Lopiparo
Department of Anthropology
Kroeber Hall #3710
University of California
Berkeley, California 94720-3710

John P. McCarthy
Historic Preservation Specialist and Archaeologist
PennDOT Districts 5-0 & 8-0
Engineering District 5-0
1713 Lehigh Street
Allentown, PA 18103

David Middlebrook
School of Art and Design
San Jose State University
One Washington Square
IS Building, Room 221A
San Jose, California 95192-0089

Harold Mytum
Department of Archaeology
University of York
The King's Manor
York YO1 2EP
United Kingdom

Sarah M. Nelson
Department of Anthropology
2000 E. Asbury
University of Denver
Denver, Colorado 80208

David G. Orr
Valley Forge National Historical Park
P.O. Box 953
Valley Forge, Pennsylvania 19482

Martin Pate
32 Wesley Street
Newnan, Georgia 30263

Claire Smith
Department of Archaeology
School of Cultural Studies
Flinders University of South Australia
GPO Box 2100
Adelaide, South Australia 5001
Australia

Michael J. Williams
Anasazi Heritage Center
U.S. Bureau of Land Management
P.O. Box 758
27501 HWY 184
Dolores, Colorado 81323

About the Editors

JOHN H. JAMESON, JR., is a senior archaeologist with the National Park Service's Southeast Archeological Center in Tallahassee, Florida. His 20-plus years of federal service have encompassed a broad range of projects involving archaeological fieldwork and cultural resource management in several regions of the United States and overseas. A recognized leader in public archaeology, he is a key player in the development of training courses for park rangers and archaeologists in the effective interpretation of archaeological resources. Jameson is the originator and coordinator of the Center's Public Interpretation Initiative, a long-term public outreach program, international in scope, that has involved numerous government-sponsored symposia, training workshops, seminars, and publications on the topic of public education and interpretation of cultural resources. He was the compiler/editor of a major work on the public interpretation of archaeology: *Presenting Archaeology to the Public: Digging for Truths* (AltaMira Press, 1997). With a strong interest in promoting public education and access, as a collateral duty, he created and maintains the Center's World Wide Web site, one of the most popular internet sites dedicated to archaeology.

JOHN E. EHRENHARD heads the National Park Service's Southeast Archeological Center. As director of that facility, he oversees archaeological and cultural resources technical assistance programs for the Service in the southeastern United States, the Commonwealth of Puerto Rico, and the U.S. Virgin Islands. With over 30 years of experience as a professional archaeologist, Ehrenhard has conducted or overseen research in several regions of the United States and traveled extensively throughout the world. The author or coauthor of multifarious books, monographs, and articles, he is recognized as a national leader in the federal archaeological stabilization and preservation efforts and a key facilitator of the Service's heritage education and public outreach programs.

CHRISTINE A. FINN holds a doctorate from the Institute of Archaeology at Oxford University, U.K., where her doctoral thesis examined the relationship between archaeology and Anglo-Irish poetry, to be published in 2003 (Duckworth). She is a research associate at the Institute of Archaeology and lectures and writes internationally on the past and its links with other disciplines. Author of the highly acclaimed *Artifacts: An Archaeologist's Year in Silicon Valley* (MIT Press, 2001), she brings a strong stage and television background along with a literary perspective to the subject of archaeology and its connections to the arts.

Index